For the Ordinary Artist
Short Reviews, Occasional Pieces & More

*For David & Post
with affection, ever—
Bill*

Bill Berkson

BlazeVOX [books]
Buffalo, NY

For the Ordinary Artist:
Short Reviews, Occasional Pieces & More by Bill Berkson Copyright © 2010

Published by BlazeVOX [books]
Printed in the United States of America

Book design by Geoffrey Gatza
Cover art by George Schneeman
Back cover photograph by Connie Lewallen

First Edition
ISBN: 978-1-60964-005-7
Library of Congress Control Number 2010906700

BlazeVOX [books]
303 Bedford Ave
Buffalo, NY 14216

Editor@blazevox.org

publisher of weird little books

BlazeVOX [books]

blazevox.org

Also by Bill Berkson

Poetry:
Saturday Night: Poems 1960–61
Shining Leaves
Recent Visitors
100 Women
Blue Is the Hero: Poems 1960–1975
Red Devil
Start Over
Lush Life
A Copy of the Catalogue
Serenade: Poetry & Prose 1975–1989
Fugue State
25 Grand View
Parts of the Body: a 70s/80s Scrapbook
Same Here
Our Friends Will Pass among You Silently
Goods and Services
Portrait and Dream: New & Selected Poems
Costanza
Lady Air

Collaborations:
Two Serious Poems & One Other, with Larry Fagin
Ants, with Greg Irons
Hymns of St. Bridget, with Frank O'Hara
The World of Leon, with Larry Fagin, Ron Padgett et alia
Enigma Variations, with Philip Guston
Young Manhattan, with Anne Waldman
Hymns of St. Bridget & Other Writings, with Frank O'Hara
*What's Your Idea of a Good Time?: Interviews & Letters
 1977–1985*, with Bernadette Mayer
Gloria, with Alex Katz
Bill, with Colter Jacobsen
Ted Berrigan, with George Schneeman
Not an Exit, with Léonie Guyer

Criticism:
Ronald Bladen: Early and Late
The Sweet Singer of Modernism & Other Art Writings
Sudden Address: Selected Lectures 1981-2006

Editor:
In Memory of My Feelings by Frank O'Hara
Best & Company
Alex Katz, with Irving Sandler
Homage to Frank O'Hara, with Joe LeSueur
The World Record, with Bob Rosenthal
What's with Modern Art? by Frank O'Hara

Cover collage by George Schneeman, *Untitled*, paper on board, 1997. Collection: Estate of George Schneeman.

Many thanks to Elizabeth C. Baker, Ida Panicelli, David Cohen, William Peterson, Michael Famighetti, Carlos Villa, Ingrid Sishy, Judy Bloch, Jarrett Earnest, David Levi Strauss, Phong Bui, Robert Gluck, John Tranter, Mar Hollingsworth and Renny Pritikin.

Special thanks to Connie Lewallen, Katie Schneeman, and Julien Poirier.

to Carlos Villa

Contents

For the Ordinary Artist

Divine Conversation
Art, Poetry & the Death of the Addressee

Perhaps we ought to feel with more imagination.
—John Ashbery, "The Recent Past"

For with regret I leave the lovely world men made
Despite their bad character, their art is mild.
—Edwin Denby, "Ciampino—Envoi"

My theme tonight is conversation—conversation and its disconnects, you might say—or discontents, of which I am maybe one, so tempting it is to become a scold (but I'll try to avoid that). Conversation may be the intense, extended talk people generate among themselves, but also a kind of telepathy between the things some people do and those others who don't but find them interesting to confront, and then the things that follow from that, and so on, everywhere. I mean, the ongoing exchange, like of gasses in and out of the body, that you hope never ends and know to be brief, unruly and meant to be enjoyed as such. In substance, conversation is made of words that occur and flow in circulation to form what is at times momentarily, and otherwise quite timelessly, a discourse, and to that extent, a company. "He read his new poem before the entire conversation," a Parisian reported of an event at Mme. Rambouillet's salon in the early 1600s, the kind where Pascal or La Rochefoucauld talked or listened, or wouldn't listen, while the writers of the time, Jean Racine or La Fontaine, recited from their latest work. In the Renaissance, a type of picture showing Jesus and Mary seated in a company of saints standing around was called a Sacred Conversation.

"He got into a conversation that had started before him," said Boris Pasternak of his fellow poet Osip Mandelstam. I quote a great deal because things other people have said or written have become part of my experience, and to that extent, are there for me to say and say again, as much part of my vocabulary as anything else I could possibly invent. Saying these things over and over, I imagine a time when I forget who said what. Authority, surely, is not the issue. The thing said solidifies to a neat genetic energy bundle, and accordingly one feels impelled to add to it.

"Continue the conversation" is a prompt I've heard more or less at my back for most of my writing life. The phrase implies a continuum of art as a field or social gathering, across which possibilities move, change, emerge and reduplicate over time, not necessarily in chronological order, and with the understanding that no mode, old or new, can ever be said to be dead, as in utterly out of the question, snub it as you may. Ezra Pound said the best criticism of a work of art is the next work. In normative criticism, the best of the rest takes the form of insightful prose appreciation; the worst is mere showing off or some obstreperous opinionator pulling your coat. To operate within it as a field renders false the schoolmaster's concept of history as a forced march. History is where artists and art works converse; a lot of it is just beating the bushes, though surely

there will be discernible highs and lows, healthy and unhealthy conditions. In this setting, every artist, even the oddball or hermit, is a breed of party animal incapable of being oblivious to what's in the air.

Among painter and poet friends, the artist most in the air this year has been Poussin, thanks to the recent show of his landscape paintings at the Met. The salient thing about the official critical response to the Poussin exhibition was that there wasn't any. All the serious attention of the art press went to the Courbet show running at the same time in another part of the building. It's as if the vogue-ish magazines knew exactly what to do with Courbet, who had kicked off the rage in modern times for great bad painting and who otherwise had most of the right stuff for quick success in a newly surging art market: a loopy-minded radical, provincial sharpie preternaturally wise to all available attention-getting strategies. To some eyes, stacked next to Poussin, Courbet ranked suddenly (and perhaps just this once) as a somewhat cheesy egotistical bungler with many interesting, even daring ideas and a hard time executing them. The type of criticism, rife today, that measures significance according to set notions of the state of the contemporary soul elevates a lesser artist as not only symptomatic of a supposedly general malaise, but everybody's cultural just dessert. We brought it on ourselves, this miserable art, they tell us. The press for Poussin brought only perfunctory, somewhat cryogenic accounts of his place in 17th-century painting culture and no sense that his art could be felt as relevant to how life is lived now or how wide open, sensuous, often stirring and full of light many of the paintings are.

Seeing the Poussin show repeatedly with different friends—at least half of them painters as surprised as I to be responding so deeply to an artist who before occupied only a curious sidebar in our affections—felt like entering that company the painter made for himself in Rome, the poets and scientists and the intellectual laypersons who were his major patrons. Part of the excitement was to experience the conversational element of the pictures in its inclusivity, which is amazingly prismatic and one source of Poussin's uniqueness as a metaphysical painter, what he himself called his *honnêteté*. Letting your imagination wander through the depicted space, you see clearly the address of figure to figure, figure to dramatic incident and all of those to the registers, across the painted cloth, of landscape and weather, and then, after all that, the address, in the way of unfolding, of the whole picture to you as you look, and as you look to comment on it, or listen, to whoever is looking alongside you at the same time, too. It's not that the paintings are simply conversation pieces, but you feel the beauty, order and passion generated from talk and mutual contemplation, the common culture of story, where antique myth was still a common thread and philosophy a thing sociable people did together.

In his large paintings of mythological figures in nature, Poussin becomes a great and generous storyteller, but you have to get up close and linger to see how great. Allow for that, and the nuance is enthralling. (Nudged out of your reverie, you realize the museum is closing in 20 minutes and you and your friends had better move on to the next room.) In a note to me about how uncanny are some of Poussin's details, the painter Mitch Temple remarked, "Atmospheres are divine, incidents profane." Then again, the incidents and atmospheres together "smack of soil and fate," as Pasternak said

of those moments where art leaves off and a heightened sense of unselfconscious existence takes over. In terms of solidity and sensation, you could see in Poussin what Cézanne saw in him; in fact, seeing some of Poussin's architecture, trees and rocks, his greens and blues and underlying clay, you see Cézanne.

Everything good happens among friends—kindred souls, if you like (and if you *do* like, the qualification is no way restrictive). There is no "World" and "community" likewise must be all in the making, or what my e-mail server calls "Local Contacts." If you and I or few of us had a week to talk together, and then another and another, over a year we might accumulate a culture. My view of Poussin is conditioned by the imagined intensity of feeling between him and his friends for the pictures and what went into them—such is culture, in which the terms—and each new term, like for us (or for me now) "Poussin"—keep circulating. Part of what I do is dwell on certain interests over time, usually finding that what at first seems to be a scatter of unrelated scraps-in-progress reveals itself, without much conscious effort on my part, as a constellation or galaxy, maybe not completely intelligible in overall shape but the connections dot-for-dot are like synapses firing.

As it happened, my final seminar at the Art Institute involved a last-ditch effort to have graduate students experience the terms of modern art free of the abstract preconceptions they have had hammered into them. I wanted the student to see paintings and sculptures in public collections as if the art was right before their eyes—to conduct, as Barnett Newman said he and his confreres were doing, an assault on the catalogue—and to tell in class what they had seen. Gene Swenson once remarked that the theory of Cubism was more visible than the pictures themselves. That was 40 years ago, in 1966, so you can imagine—given the superimposition since of language *away* from what it's supposed to be about—the uphill trudge. But there were consolations. The best students were theorists in the classic sense of attentively taking in whatever phenomenon was set before them. Especially memorable was an exchange with one of the students, Rives Granade, who, after studying Matisse's 1905 sketch for *Joie de Vivre* at the San Francisco Museum of Modern Art, called the picture "creepy." The psychedelic dabs and squiggles of Matisse's Fauvist vision bothered him, and likewise the way the smears of color resolved figuratively into pink male and female nudes, trees and goats, all of that lolling, shimmying, voluptuary stuff. Which was terrific, to the point, all of that should be bothersome—and besides the great thing was, he was really looking, which, as I've said, was just about the whole point of the seminar. Rives in contact with Matisse's paint had become that prime addressee, an audience of one. That he had mistaken the scene for the Garden of Eden with evil writhing imperceptibly in the boughs—some ninety degrees off target—was a later revelation, and understandable.

Matisse's raucous little painting, sometimes called *Bonheur de Vie* (if you come to San Francisco, you can see it anytime), offers a glimpse of daily life in the Golden Age, a time before neediness and struggle, outside of comfort, and a subject of mounting urgency that heated up as modernity developed its strange, irony-ridden mix of expectation, resentment, wonder and despair. In Matisse the pastoral infusion finally boiled over; it certainly hasn't been seen or heard of since. The Golden Age, nostalgia for a time that never was, and its complementary dream of a perfect future, Utopia's road to

nowhere, through revolutionary politics posthaste, were modernity's gifts to its own ill-fitting sense of itself. Where did all that go? "We will all drink champagne beneath the willow trees" went the old anarchist anthem, long lost in static of ironical qualification (not to mention coercion and mass murder). What good now is the vision of a beautiful life to us who can barely conceive of any likely alternative to the tarnished, arguably leaden one we are used to? Is the Golden Age worth remembering? You bet—because the vision as Matisse reveals it, is neither so abstract nor far-fetched; it exists in the apprehension of a moment that includes one's deepest feelings for the world as one finds it, as it is.

> So, a note scribbled to myself in the midst of Rives' and my exchanges:
> *A Quoi Bon, asks Baudelaire in the Salon of 1846*
> *(Well, OK, he asks this of art criticism, but he has just finished an equally profitless boosting of art to deaf middle-class ears.) What's the good?*
> *Le Bonheur de Vie, says Matisse—not in fact some remotest Age d'Or but that we have bodies; there are trees and water and light and air—and art. All sustaining things accessible via senses and as such primordial (hence, Golden, even, arguably, good).*

Think of "Modern" as a place *gone to*—how long since we've been Sailing to Modernity? In Emanuele Crialese's film *Nuovomondo/The Golden Door*, an alert Italian immigrant boy undergoes IQ testing before immigration officials at Ellis Island. The mysterious Englishwoman Charlotte Gainsbourg looks on, then questions the reasoning behind the test. Astonished to learn that the latest data show that intelligence can now be measured genetically, she says: "You have a very modern vision." Modernity's deepest nostalgia, it turns out, is for the present tense. Actuality is missing, missed most of the time. The issue of sensation, what Matisse's picture conveys above all else, seems tied vitally to appetition—literally, a taste for living and the will to live. Berthold Brecht in his journals took up Wordsworth's promise of a poem's efficacy "to haunt, to startle, to waylay" and wondered at "a possible criterion…. Does it enrich the individual's capacity for experience?" And so Brecht finds: "Poetry is never mere expression. Its reception is an operation of the same order as, say, seeing or hearing….a human activity, a social function of a wholly contradictory and alterable kind, conditioned by history and in turn conditioning it."

The Golden Age—*aetas aurea*—is an ancient fantasy of the primitive good life that became for a while a modern dilemma. Even before Matisse tried to enter it, the site of his happiness—essentially, down by the riverside with no clothes on ("made in the shade," as the saying goes)—became in other, equally desperate hands "anytime but now, anywhere but here." The stoicism underwriting Poussin's *Et in Arcadia Ego* meets the Matissean rage for relief from the grime and missed connections of modern life half way. Poussin went to Italy to find antique remnants as well as how to paint; a couple of years after *Joie de Vivre*, Matisse went there, too—to Tuscany and Umbria with the Steins, to see the Giottos and Pieros—after which his images of unfettered human existence intensified, enlarged and became more complex and heartfelt.

Anyone who has ever gone to Italy knows that conversation there, even if you don't have much Italian, is a big part of life and an enormous pleasure. The language as

such, its exceeding outward show, involving not just mouth and ear but the whole of the body in play, Mandelstam called "a sort of immemorial Dadaism." (*"CHE SUCCEDE?"*) And, for locals and visitors alike, the art—especially early Italian painting and sculpture of the 10th to the mid-15th centuries—is famous for its healing properties. Not just good art, but transforming, because it takes you there, allows you a "there" to go to that feels situated just-so. Nearly two or three hundred years of healthy painting culture didn't happen by itself; and when it stopped, the turn off into inferior showmanship marked a huge general loss akin to spiritual desolation. Europe's real "renaissance" occurs in the 300 years before 1450, after which the soul sails out of it. The evidence in Italy of something gladly remaining, if only in the climate of the towns and the mostly ruined art works kept there, is what keeps those of us who love it going back for more. It is an amazing country in that one never has "done" it all; there's always this place or other you didn't get to and so say "next time" in hopes that you'll get another shot.

Two summers ago, I went to Turin because the Bruce Nauman exhibition organized by my wife Connie Lewallen was opening at the Castello di Rivoli, just outside town, in view of the Piedmontese Alps. After some time apart while she worked on installing Nauman's works and I visited elsewhere with friends, Connie and I spent a couple of days traveling alone together and then geared up in Turin for the official opening festivities. Turin surprised me by being an attractive city with many of the refinements I had expected and missed in the other big towns, Pisa and Bologna, visited for the first time on that trip. The morning before the opening I went to the extraordinary Museo Egizio, the Egyptian Museum, which many people had said was the absolute must-see of all the sights of Turin. This collection, older than that of the Cairo Museum, was begun by the locally dominant Savoy family in the 17th century. On the ground floor was a dark gallery with dramatic spotlighting on two facing rows of monumental statues, images in basalt and diorite of pharaohs and gods. There were twenty-one alone of the warrior goddess Sekhmet, and others of Thutmos, Amentop, Hathor, Amon, and smaller portraits of their wise-old functionaries. I am not an Egyptologist; I don't like dramatic lighting (which in this instance was especially fancy, created, like they say, by a famous Italian movie-set designer); and statuary I often find confusing: How do you talk to a statue? There is something ghastly in it like the mummy's curse; because, as with sarcophagi, even if nothing's really inside, just more stone, you're always aware that something is, or was. Sculpture is an intrinsically haunted medium. Nevertheless, like most people, I am susceptible to the succinct grace of ancient Egyptian sculpture as to the high, dry exquisite forms and light of prime-time Italian painting. My first art experience, aside from comic strips and a smattering of distinguished pictures that I grew up with at home, was the mystical one of entering that eerie stone enclosure, the Perneb tomb at one end of the Grand Hall at the Met and seeing through an aperture the resemblance of another face staring out at me, so wide, with big pupils and a lot of heavy eyeliner.

On location, as it were, at the Museo Egizio, one after another of these mostly seated figures addressed me as if directly. While they stayed in character, I felt alterations. The Hathor figures were especially striking; seated high-up in the dimness around, and on the face lifted smoothly engraved lips communicative of benign-beyond-belief

assurance from out of nowhere. That gratuitous aspect is really the mystery, all the more so because, idle as I was, a lesson in how to be wasn't what I walked over for. Rather than a subjugating hauteur, the votive figures presented a steady receptivity—as the French say, *bien dans sa peau*, easy in one's skin—so that I was seeing not just beautifully designed forms but unforced examples of decorous ways to sit topped off by great "winning" smiles. The persistence of that smile is a sculptural device going on theological. If you kept your eye on the physical expression, the ineffable parts could wait, explication deferred. Obviously, a high simplicity discovered in a museum isn't yours for the taking, like a postcard of the thing. The idea became experimental; hours after exiting, I felt welcome to participate in it if I could.

At the Nauman opening, and later hearing Rob Storr talk in the Castello auditorium on Nauman and his work, I was still wondering about art and ethical grandeur and how the Egyptian artists could show the balance so readily. On stage, Rob discussed the virtues of the Nauman show and of Nauman's art generally, impromptu—a few notes jotted on a small scrap of paper fed into rapid, emphatic, fully worked-out sentences, almost every word dovetailing with reverberations from that part of the morning spent in the Egizio. "What I assume you shall assume"—Rob startled me, quoting Whitman, then commenting on Whitman's, and, by extension, Nauman's, generosity, the open sociability of each towards the addressee: "The poet is interested in who you are."

Because Rob's talk wasn't written out and probably will never be, I'm taking the liberty of quoting from it here at length. Referring to "the role Nauman gives to ethics in his work" and going on as the translator converted his American phrase by phrase into Italian on the spot: "Nauman is not unaware of what goes on around him. He is an artist who uses the notion that there is not just the responsibility to reveal mystic truths but also to behave well as an artist." Rob said that these days many artists either "start with a discomfort that they transpose to an abstraction and never bring it home, or else take their personal drama and turn it into melodrama. The rigor of Bruce's work is that it is always personal and never melodramatic, and it is always about a subject who could be you or who could be me but never about a subject which will never come home to either one of us."

Lecture over, the evening's Nauman celebrations went on. Talking afterwards at dinner with Rob, telling him eagerly of my Egyptian trance hours before, we began a bit haplessly devising a short list of artists—David Hammons and William Kentridge, for two—whose works, like Nauman's, deliver the goods with a strong sense of a curious someone home at both ends of the delivery route. But list making was not to the point; the conception of a definitive ethics goes nowhere. Even so, there was a lot to pursue. As Rob and I said our goodbyes, I had the feeling that for the two of us to have touched on ethics at all was to have entered into a cabal.

How to proceed in the arts, how you spend your life as an artist is seldom the topic of anyone's work but an element always there to be inferred by whoever appreciates art's sometimes awkward but nevertheless incontestable status as a form of human behavior. "What kind of thing is that for a grown man to be doing?" is an interesting question to ask if a grown up is doing the thing and another grown up is asking. At a

certain point, you wonder what, if any, truth is involved, or is what you see just a lot of hard work and materials batting the air. "Poetry," Ted Berrigan once said, "should be something real, not just an interesting lie to tell you mother." The truth that Storr was advancing about Nauman arises within range of the luxury and vertigo of artistic commitment: an artist may be possessed of a sense of appointed task, but, given that the sense is always fleeting, what is to be done? The assertion that this or that isn't art is a surefire conversation stopper, and to cede the decision to institutional say-so is as much as to leave culture to the commissioners. Let the commissioners believe it if they like, but the engaged viewer should look to her own devices. Art's behavioral indeterminacy leaves each instance of it forever open to question. In the face of the brief public furor this past year over showing video images of animals bludgeoned to death in a public square, the excuse for which remains unclear, the pronouncement by one of the curators in charge that "The space of encounter is sacrosanct" thudded down as a vain piece of sacerdotal folderol. The terms of every moral code require, perhaps daily, periodic testing—but, even allowing for all sorts of unpredictable goings-on inside the white cube, one should never be prepared to check one's humanity at the door.

Mandelstam's essay "On the Addressee" is a thoughtful poet's attempt to find connections along a grid. A number of things Mandelstam envisions as analogous to poetry—a letter to a friend, a communing with one's own soul or a message in a bottle to be retrieved at some unknown destination—he puts in contrast with "pseudo-civic poetry and tedious lyrics….flying on powerful wings to a providential addressee." The presumptive message-driven art you see in galleries and contemporary museums today knows what it's about and addresses a providential generality, the culture at large, which doesn't exist, or exists so vaguely that it has been substituted for in the minds of artists and administrators by a nebulous synecdoche, the professionalized circuit of the art magazines, museums and business people.

Arthur Danto remarked recently that contemporary art no longer has any enemies, which may be true, but largely because it also has no friends. In fact, it has no society, really, beyond the confines of the art world proper. Sixteen years ago, Adam Gopnik wrote an article for *The New Yorker* called "The Death of the Audience," in which he told of going as teenager with his parents to the opening of the Guggenheim in 1959 and being struck by the size and sophistication of the audience, a crowd of people, many of them artists, and many more what used to be called "educated laymen," mostly professional people (doctors, lawyers, psychoanalysts and the like) who took an interest in the arts, which then still included, as normal fare, theater, dance, concert music, poetry, as well as painting and sculpture. According to Gopnik, that audience—the serious museum-going public—was no more. Gopnik has since publicly regretted the piece insofar as he couldn't have foreseen how 10 years later the museums would be full again, fuller than ever, with audio guides selling daily by the gazillions, but his major thesis still holds. By contrast with his late-50s Guggenheim epiphany, he told of going to the opening of the Richard Prince show at the Whitney the year he wrote the article, 1992, and then back the following day. The opening was jammed with the artist's friends and associates and other insiders, but when he returned the next afternoon it was so quiet you could hear a pin drop. Gopnik's sense was that although Prince's work proposed to

address weighty issues within American culture at large, there was no large culture for it, only those who already had a stake in furthering its existence.

My own experience early on, well into the 1970s anyway, was that artists regularly spent long hours in one another's studios and intensely criticized each other's work, and so did the critics, many of whom were artists themselves, and those who weren't argued separately. By the mid-1980s, if you asked an artist what other artists visited their studio you would hear "No one. I don't let anyone in my studio who might steal my ideas." That was when the talk in New York lofts turned intensely to real estate. At the same time, critics told me they never go to the studios: "Artists are boring," they would say, or else express the fear that a critic known for intimacy with studio environs would lose major shares of critical power. Art now has no friends because so many hungry care givers are in the way. In the 1940s Clement Greenberg remarked on the bone-crushing isolation suffered by the best artists then in New York; they were isolated because the cultural establishment had no use for them. Artists now—unless they work hard not to be—are isolated, perhaps more definitively, sucked into individual sensory-deprivation chambers, by trained teams of globally deployed handlers, whose engagement with the art and what it means is neither here nor there. We all know, in this prolonged time famine that stunts contemporary life, there are only so many hours on the ground, between flights. And, once on the ground, as David Levi Strauss recently suggested, the bus is full: Enough artists—with all these excellent people in the know on board, who needs more art?

In the perplex of recent human history, the certainties of today's academic ideologues look arrogant to the point of soullessness. Marxism, accurate in its structural understanding, has only a general theory of ethics. By now, the idea that art, artists, and, more to the point, art students are born on the side of fair play—willfully tidy classroom Marxists all—is normal and wrong. It is important to have a firsthand, vivid sense of the issues and stakes involved in philosophical discussion, for which literacy is a good start and intelligent conversation (including talking back aggressively to what you read) an advanced requirement. But the talk has to advance beyond the citation or précis of what you have read; as Storr said, you want it brought home. What Kant or Kristeva has written regarding this or that is of no particular consequence unless you make it so; depending on what you see in what is written, what you say or do in turn is the only realization it may ever find.

What you get from doing and/or looking is very different from what you get from reading about something or what it is supposed to mean. Looking behind the curtain to see the Wizard, seeing how a thing works is interesting, but not as interesting as that it works. At the "Action/Abstraction" show at the Jewish Museum recently, Connie and I followed in the tracks of two men—one of whom, wherever a picture was accompanied by a wall text, rushed to take in the text (usually a generality from Clement Greenberg or Harold Rosenberg), which he then read aloud, and afterward jumped back and, waving in the direction of the picture, called out "*See?!*"

On the front page of the syllabus for my seminar on the culture of modern times I warned: "My subject is not teachable." The uncertainty and taste for chaos modernity has espoused have proven to be its great strengths, which may be why we find them—

first in our student years and afterward, if we buy into the game—endlessly, fearfully shut away, with other defective things, by instruction on all sides, secrets the Age of Reason was privy to but decided against making public. As Robert Smithson said, all clear ideas tend to be wrong. It seems that the complexities and sheer ordinariness of what really happens when someone writes a poem or paints a picture are pedagogically unspeakable; you can't be tested on them. A little over a year ago, in response to an *Art In America* special issue on art schools, an art student at UCLA posed the $64,000 question: "I often wonder," she wrote, "is my goal to make art, or is [it] to contribute the next step in art-historic discourse?" To say, as Franz Kline did of Barnett Newman, that the way someone works shows how he thinks art should be seems almost exotic now.

When I was starting to learn about New York art at the end of the 1950s, there remained among artists and critics a strenuous criticism that identified artistic activity as clearly admirable or not in behavioral terms and permitted free use in critical writings of the word "exemplary." It was really quite extraordinary to learn the local idiom of art then—to hear that a straight edge in a painting could be deemed too gray-flannel by association, or, conversely, that a subtle orange patch was truly "Trotskyite." Such responses may sound silly now, but the passion and agility behind them exercised an almost mystic glamour.

The wonderful elder poet Edwin Denby was someone I learned to look to then. Sensible in every way, better known even today as the best dance critic, Edwin already had lived an extraordinarily full, interesting life and stayed alert and open for more. Alongside Denby's poetry and dance writings, his stories of deKooning are by now classic reminders of the sort of ethos I can more or less only hint at here:

> *Talking to Bill and to Rudy for many years, I found I did not see with a painter's eye. For me the after-image (as Elaine de Kooning has called it) became one of the ways people behave together, that is, a moral image. The beauty Bill's depression pictures have kept reminds me of the beauty that instinctive behavior in a complex situation can have—mutual actions one has noticed that do not make one ashamed of oneself, or others, or of one's surroundings either. I am assuming that one knows what it is to be ashamed. The joke of art in this sense is magnanimity more steady than one notices in everyday life, and no better justified.*

I've reread that passage constantly over 50 years, I've quoted it many times before, but only in preparing this talk saw how Edwin advances his "moral image" anecdotally. Like Ovid's telling of the Golden Age, practically the whole thing is couched in negatives, and the final throwaway line, on its moral high note, begins stealthily as an aside, then springs open to a quick relief—relief from what Denby reminds us is the normalcy of shame.

In a remarkably similar instance, Robert Creeley recalled, "It used to be said of William Carlos Williams that the literal fact of his being there gave us one clean man we could utterly depend upon, that nothing could buy his integrity"; that neither Williams, nor, as Creeley goes on to say, deKooning, exemplary for himself as for Denby, "let us off the hook of our pretensions, bullshit, faking, laziness, you name it." It was Williams who had said, years earlier, looking at a baby he had delivered in the ward at the Rutherford hospital, "You mean to tell me *that*'s full of Original Sin?"

Obviously, being a bearer of artistic integrity is not the same as, doesn't promise, being a nice person, much less an all-around good guy. Usually, when something rings true, you remain aware, in this vale of distinctions, that other things (often things by the same artist) can appear false, indecorous, or sadly so limited as to be puerile or plain stupid—your run-of-the-mill bad art. (The question of whether art can be said to be evil—truly reprehensible in some final way—was raised in the forum over showing those bludgeoned-mammal images in San Francisco, and was quickly left aside, an embarrassment nobody beside the philosopher-critic who raised it wanted any part of.)

Creeley reminds us that the Greek for "clean" sits squarely on one prong of the root for the word "sincere." Hence, Pound's useful assertion that technique is the test of a writer's sincerity, and a little down the line, Alex Katz's ambition "to make a painting so proficient technically that if you say it's bad you're going to have to say the man's character is bad." Responding to the young dancer Freddy Herko's complaint in *The Floating Bear* that Paul Taylor's dances weren't made "with love," Edwin Denby wrote an angry letter to the editor: "Herko," Edwin fumed, "is judging Taylor by an idea. This idea—the idea of love and art and the Unsoiled Life—is shit. If Taylor fails by that, he's doing fine. Herko had better watch his language."

An upbeat notebook entry, July 16, 2008, after a trip to L.A.:

Marlene Dumas—People tend to find her too heavy, which to me is strange because her pictures make me happy. The happiness comes from a sense of truth, but truth is never unalloyed heaviness or gloom, so there must be something else at work. She is funny in the way Guston is (and Guston's Kafka, and Goya's dog, too); the terrible lumpy thing shown so plainly, evil so homely, the pain it causes so beyond-absurd, the moralist cackles madly as when reading Hannah Arendt's account of how Eichmann rose through the S.S. ranks. (Arendt said later she wrote her book in a kind of rapture.) The multiple heads are glories, including the "Face of Jesus" series. Why do they move me so thoroughly?

Given the state of things, unremitting gloom ranks low to middling in my idea of a good time, which includes an admittedly half-gutted sense of decorum. Dumas has said that a strong response to her distressed, predominantly female figures doesn't require identification with her experience of them but that "contemplation of the work (when it 'works') gives a physical sensation similar to that suggested by the work." The so-called "truth effect," absurdly discredited in photography, operates here at a different level. Truth is not resemblance but a gist markedly in accord with fact and feeling, literally a true-ing up with the world as you find it, with all the attendant instabilities every which way. It's in those terms, truth defined as hitting on an indeterminate eventuality, that what an artist makes can be said to be "a real right thing."

In the last stanza of "Elegy—The Streets," the longest of the poems published in his first book *In Public, In Private*, in the 1940s, Denby writes:

Familiar tone within three thousand years
Verse is a civilized, a friendly habit.
Nature and money thrust us close, and sunder;
Verse makes less noise and is a human wonder.

I doubt that any of the keywords in those four lines (working backward, "wonder," "friendly," "civilized," "familiar") can be found in the current issue of any art magazine, or for that matter, in what little passes for poetry criticism nowadays, or else in poetry itself.

Criticism tells you what is there. Art should show you something. Without its gratuitous aspect, poetry loses its necessity, and also that dosage of insanity that, as Denby says exists in classical ballet, "does everyone a great deal of good." An Iraqi poet was asked on NPR what poetry meant to him. He had read some poems that reflected the violence he and others at home dealt with daily and others that didn't—conventional love poems, landscape observations, philosophical musing and such. "The aim of poetry," he said, "is to keep the language from going insane."

In poetry, for it to work, both reader and writer need to be aware that every word counts (for or against the poem, that is). A poem is built word for word, one then another, like frame by frame, shot by shot, in a film. Without dictating an authoritative point of view, a poem can tell (like beads) the words—phrases you can turn here or there towards what might want to be said. That's part of poetry's sensational impact, where, at the edges of meaning, words return to their peculiar physicality (which then provokes undreamed-of connotations). It occurs to me that this sensation business, maybe because it was so much in the air for the painters at the time, has been with me from when I began to write seriously. A poem's coherence may hang by a thread. Snap that thread, a kind of pattern recognition takes charge, and it is this that sometimes defers or erases syntactic probity, granting the poem a discrete, believable (because no less connectable) ethos all its own.

"Was that a real poem or did you just make it up yourself?" a member of the audience asked a poet who then delightedly passed it on to another poet, and eventually it became the title of yet another well-known poet's lecture. The question was similar in quick contact and naïve splendor to the perception Rives Granade had of Matisse's crazy little picture. Art may not provide a reason to live, but enough of the time, for those engaged in it, it is amazingly encouraging. For those who make a habit of it, art or poetry may make a life; being in it is life to them. The extent to which that confluence is about being who you are—the dream of staying in character—may be only by default, as emphasis on the strictly personal usually is. What one looks for is the moment, like a room you can cross, where fact and myth converge so as to be indiscernible. The world helps the artist by revealing mystic truths. Destiny means you are carrying something. Hesiod fell asleep under a tree, woke up, ripe for poetry; those around him understood this, that the Muses gave him something. I remember Ed Ruscha telling me how, when driving around L.A., he could see power and rightness in a phrase or image staring out so pointedly at him that he felt obliged to use it, pass it on.

"Let me recite what history teaches. History teaches," another old song, the ending of Gertrude Stein's portrait of Picasso. Imagine her reciting the poem to his face. For those in the know, all of history comes down to that, the recitation and the inspired chat that ensues. Wherever it is you have arrived, as if according to plan, at whatever is. You were expecting a detour? Stein said she knew she was popular because she had a

small audience, and that's pretty much the state of poetry over centuries, the healthier varieties as ever avoiding melodrama and cant. Art-world art, steeped in the vagaries of cant, could use a small audience to learn who its friends are. Shoptalk goes on oblivious.

2008

Pounding the Pavements
Short Reviews 1980-2008

Alfonso Ossorio

This was a cleanly mounted retrospective of 40 years' work in three rooms plus sculpture garden and a slide show. There were drawings, paintings, watercolors, relief assemblages called "Congregations," an environmental wind-sculpture, and views of Alfonso Ossorio's grand, ongoing domestic project, the decoration of house and grounds on his fifty-five-acre estate on Georgica Pond, The Creeks. Ossorio is a cosmopolitan intellectual who keeps finding new means for cosmetic fantasy among the highs and lows of modern art styles. He has absorbed a lot, and transforms clearly in terms of rather puzzling intentions. Nerve, erudition, and an artisan's trained eye for materials are his strong points; his weakness lies in an awful, and ostensibly careless, esthetic. His works are ambitious and weird.

Almost all the pleasant surprises were in the early drawings. Ossorio began his career as a fine Neo-Romantic draftsman and calligrapher. His education included studies of primitive and medieval artifacts as well as, obviously, Durer and Bosch, and a youthful apprenticeship in genteel Anglo-American craft traditions, book design in particular. He was born in 1916 in Manila and grew up in England and America. By the mid-1930s, he was designing intricate and attractive book jackets for New Directions. In the 40s, he did powerful super-realist portrait drawings of Auden, George Barker, Frieda Lawrence (met when he eloped to Taos with his first wife-to-be), and Ida Lupino. His line was slow but frontal, and images had pull. *Ida Lupino* looks like a pouting, slightly windblown saint beset by a plethora of pale squiggles and scratchy darks. That was 1946, and, as Ossorio says in the catalogue interview, "she was nearing the end of her career as an ingénue.... The portrait is one of a woman making decisions."

About that time, Ossorio too was turning 30 and making some weighty decisions. His works of the next 10 or so years suggest a sudden, nearly catastrophic, crash course in, and *of* modernity. Pollock, Still, and Dubuffet were the acknowledged influences of that phase—personal friends and collaborators whose works Ossorio was among the first to collect. And Masson, Dalí, Mathieu, and Picabia seem to have had their effects on him as well. What tends to look like automatism with otherwise large, central schematic details was avowedly bio- or anthropomorphic in thought. In any case, the previously fine-lined images appear yanked apart, attenuated, snared as much as defined by briar patch calligraphies. The pictures get bigger, the paint thickens and looms, and the subject matter looms too—"forms and shapes," he would say, "dictated by ideas rather than by appearance." The best works here, to my mind, are the least impacted: a huge all-over, beautifully detailed cartoon called *Klan Picnic,* and *Nevertheless* (the first of two paintings with that title), an exact density of two-tone overlay, poignant and austere.

The "Congregations" prefigured today's "trash and flash" school of relief and freestanding assemblage by quite a few years, especially the emblematic or "altarpiece" kind. (They don't, on the other hand, deal with anything like the exuberance of Joe Brainard's large 60s constructions like *Japanese City* or *Prell.*) Ossorio's assemblies, though theatrical, aren't really funny or sexy; they definitely lack funk. They tend to be maximally

dense and objectively repellent. The colors are stains, not tones, and blare entropically. Marble fisheyes, horns, bones, scrap wood, money, syringes, dolls, ropes, whips—a sort of wheel of quivering no-meat conception—lay embedded in mostly translucent, mostly synthetic glues. The feel for plastic is equivalent to that for wood. The surface depth is such that you don't distinguish much besides the armature of design, a constant easy symmetry. The fabled "Satanic" pulse of these works may well be true and intentional: they bespeak a love of (or anyhow fascination with) "immobility," a.k.a. Inertia. Illustrationy underpinnings are maintained or maybe develop in process; there are masks, tabletop topographies, anecdotes, all resolute in their ambiguities. There are some good ones like *No Masks* and *Siblings* that breathe.

The rest of the show was recent watercolors—delicate and more calm, and resembling sweetly muted tie-dye stains—and color-slide projections of the new environmental sculptures and landscaping at The Creeks. The Creeks, in fact, stands as Ossorio's most compelling achievement thus far, a testimony to his unique and genuinely civilized energies and a sublime *folie*.

Art in America, November 1980

Robert Hudson

Robert Hudson is now 47 years old. If you were looking for a clear overview of his progress, this exhibition of 24 years' work was small help. The immense selection was too large for the allotted space. A jumble effect predominated, and a general fractiousness ensued. Because jumble is inherent in the work, its doubling was unfortunate. Hudson tends to generalize his materials, and the show tended to generalize his art, especially in terms of color. There were sculptures, paintings, combines and constructions, drawings with and without collage, and ceramics ensconced in vitrines. The overall look was unified in sensation and constant in skill, but confused, or possibly all too blithe, about what there was to be seen, about its meanings.

Hudson's best sculptures, paintings, and combines—as distinct from his ceramics, which are more candid and imagistic—suggest highmindedness in a general way—about art and man and nature, for instance, or about the perceptibility of space. They are compound models or maps for meditations on kinds of conjured space and the integrations that might be plausible among discrepancies. Sometimes the works describe spatial regions that, like those in science fiction, exist only elsewhere. As models or maps, the sculptures have no real scale and impart no immediate feeling beyond a genial sense of handiwork. Paint versus steel makes discrepancy in the sculptures thoroughgoing. In the 60s pieces, truncated volume plus paint makes everything seem a transition. The 70s pieces each have one too many parts, some of which, though, are incidentally delicious, like the splintered glass in *Still Works*, 1970. Steel is puckered, painted, poked, shredded, coiled, and squashed to look like plastic, rubber, wood, and bone. Structures are built

from horizontal supports upward, with escalating shapes, and you see them sequentially that way too. They risk being bottom-heavy. There are occasional movable parts and a degree of constructivist bathos: how many ways to break a parallelogram, to short-circuit an ellipse?

The recent pieces are more extravert and sparse and also larger and inviting. Some have central figures that work as armatures for standard shapes and suggest studio self-portraits. The figure in *Hot Water*, 1982, has elbow joints for hands and an open cube that spins like a soccer ball on the toe of an L-square. Like the ceramics, the new large paintings bespeak a more forthright delicacy and glee, as well as more negotiable space, in a manner that might be called "designer Cubism." Like the sculptures, they reduce themselves to less than the material tensions they propose. Partly, this reduction has to do with an identifiable Northern California bent for busywork, for tireless hands-on, cosmetic dickering with which many a local artist transmutes indigenous energy to embroidered mush. Hudson's anthology style accommodates the mush as well as saying something ironic about single-minded styles. His lesser works tend to be jokes (conceits, mostly) that are pedantic about art. His trottings-out of other modern artists' marks of style remain exotic and rhetorical because the marks are deprived of their prime meanings and not given new ones. His fascination with Native American art, avowedly more prime for him, comes across as more for real, as if he could actually make the meanings of Hopi or Northwest tribal cosmographies his own and ours, which would be no small thing.

Meanwhile, Hudson's mode remains the rural pastoral, which amounts to nostalgia and fantasy while aspiring to genuine magic. Genuine magic is hard to come by. The centerpiece construction of the show, *Running through the Woods*, 1975, is about magic working through nostalgia to arrive at a possible ceremonial present. It doesn't quite arrive. It's a statement of the relation of nature to man-made things. A deer, a stuffed one, is displaced in an array of useful objects and junk, or, as a young painter put it, "trapped in K-Mart." It's also an image of the artist's nature vis-à-vis his materials and styles and (with a globe between the ears) the world. It's an atypical Hudson and a provocative one. Hudson has identified his work with a paradox. The danger for any paradox is that it may be dismissed. For Hudson, the time may be ripe for something more in the way of declarative fact.

Artforum, December 1985

Robert Mangold

Robert Mangold has always been a steady, decorous painter of considerable scope— likable if you like passionate, vigorous abstract art with a methodology of understatement. He has interested himself in arguing general shapes into specific images, usually by modifying them with distinctive monochromatic color spread evenly across the

whole support; Mangold has said: "Edges make the structure, the colors make the surface." The results have been paintings that are not merely pure and simple but clear and resonant, like correct declarative sentences that are delivered in a firm, modest tone but that nonetheless contain sudden jogs of logic. This "mid-career" exhibition of thirty-nine paintings and drawings surveys a period of terrific expansion in Mangold's technical vocabulary: surfaces incised with graphite lines, canvas instead of masonite supports, and more color applied more variously. These recent paintings are richer in both ostensive and implied sensations. For one thing, color has been heightened and multiplied (more than one per painting since 1977, and as many as four since 1983). For another, Mangold has unleashed his surfaces' powers of suggestion, with no concomitant loss of mystery or fact.

Mangold calls himself an "intuitive" painter, which means that he proceeds without any master plan. Each work looks pretty much its actual size—that is, the pictures don't lean on size (or on a general esthetic of scale) but use size individually. There are images appropriate to just about every set of dimensions, and some of the most telling ones are fairly small. Paintings in similar formats make absolutely antithetical statements. The large *X Painting 2 (green)*, 1980, tends to shoot outward across its seams in four directions at one, while *Three Red X Within X*, 1981, compresses at the panel abutments and is a marvel or rock-hard stillness. Similarly, the tricks on logic that the interior lines perform—amounting to perceptual charades on geometrical figures—are provisional, slightly malicious devices for catching the eye so it first delays, then settles and fixates on the whole image. The images have more character than these tricks imply and are more than rational. The colors are superb (more than nice) and set up solid fields that sometimes refer to liquid or gaseous states (air, sky, fire, mist) but rarely to other solids. *Distorted Circle With a Polygon (blue)*, 1972, appears as a silhouette of a little frame house (as ideally proportioned by Alberti, perhaps), but the blue is wild and "yonder," barely checked by the lasso of graphite that reinforces the edge.

The "Four Color Frame Paintings" of 1984 introduce "countenance" (Willem deKooning's eminently right term for literal character in painting) differently. The oval line in *#9* really does say "face," just as the colors of the joined rectangles—red, lime green, pale blue over green, and cadmium yellow—could be signs of the most clement weather. In *#5* the signs are more complicated: the pale brushing green at the top is "air": the red at the bottom, "gravity": at left, a glaze of sienna over the same red is "density": the radiant yellow opposite, "light." There is additional incident in the way the pencil line seems to thicken and change aspect as it crosses the colors and in its qualification of their identities as well.

Mangold's images suggest an unimpaired idealism. They come across with the quiet authority of sensible facts. They are memorable and right, proof that, as Adrian Stokes put it, "Formal arrangements can sometimes transmit a durable imagery."

Artforum, January 1986

Tom Stanton

For his life-size installation *Palace Rudel*, which covered the whole of the Nelson Gallery, Tom Stanton transmuted a nebulous character fiction into a solid, walk-through setting as copious in its "clues" as it was void in exegesis. The piece itself was coherent, exquisite, and fraught. The telling, so to speak, occurred in the observer's wanderings through a web of plausible, if wholly imaginary, coordinates marked by painted sheetrock, bric-a-brac, colored lights, a sound system, video, and a cracked plastic clock stopped at 8:40 and five seconds of an Earth day. A story went with it but was kept in the wings, a sort of "McGuffin" or sequence of false leads that lured one back to immediate sensations in the spaces provided. The story was there, much like any other, for one to be lost in it. Meanwhile, with some lingering, Stanton's surehanded spatial syntax increased in familiarity and took hold, eerily.

In the form of a transcription of Stanton speaking in the character of Jack del Ray (which was emphatically not part of the piece), the handout legend had it that the "palace" had been a nightclub housed in a grandiose tower built circa 1935 by one Earl Rudel on a desolate stretch of the lower California coast. Like the Spanish mission that preceded it, the tower and its appurtenant structures went up in smoke under mysterious circumstances. The residual setting showed the original components sans human occupants. Of Earl Rudel, his wife Kathryn, their perhaps not-so-human son Eddie, Skipper Al Waring, and the manager del Ray, only this multi-media legacy remained.

To see it, you passed through the short, rust-red wedge of the Lobby, with a couple of tiny landscapes set in votive niches and a screened vitrine revealing an aquarium-like array of drift matter and sand. You were released into the high, wide space of the Tower Room with its dance floor, banquettes, and bandstand empty but intact. A tapedeck issued faint echoes of dance music and a mixed saxophone version of foghorns and trains. Orange and yellow lights coming through two large "windows" registered the consummate storyline moment, as did, seemingly, a painting of a spaceship on the far wall. In once corner was the Tent (a lounge?) which you could enter by crouching down into a narrow, triangular cul-de-sac. In another corner was the Office, also a wedge but unenterable though it had a working door. ("*Lots* of eccentric angles," as Stanton/del Ray said, "lots of mysterious space inside.")

Beside the Office, fuzzy, fragmented scenes of life at the Palace were played out on videotape by the painters Harry Fritzius and Christopher French and the performance artist Jane Pagnucco. Past a painted freighter's bow, into the Palace Museum. In it, these items: a portrait of Eddie (by Earl?), a Mexican *retablo* of a kneeling figure worshipping a crucified Christ suspended above the California desert, an altar with an offering of discolored plastic "skin." Finally, through another door, you came to Eddie's Room—a dark, chill place transected by an enormous ladder construction on the floor and bordered at one end by a mural of Earl's Airstream trailer. On the far side, a little television set rested on a sidetable, emanating a low, tidal hiss. (Eddie's room was cold, they say, because Eddie was an alien and aliens require lower temperatures for their

wellbeing, but then so do ghosts.) In the shade of a pale yellow deskchair lay another strip of skin.

Palace Rudel was an overlay of disappointed dreamtime (as in James Joyce's sense of a pier as a "disappointed bridge"). There was the persistent feeling that Stanton's fiction might crystallize, as his brief monument to it had, and that the whole place might at any moment come alive—which perhaps it did at the closing night performance event, which I missed. Nevertheless, the suspense was nourishing.

Expo-See, February 1986

"Image/Word: The Art of Reading"

The theme of this exhibition—the cohabiting of verbal and visual materials in ostensibly visual artworks—was formalist and timely. In his essay for the catalogue, Barrett Watten says, "The works....argue to be read rather than interpreted, and the act of reading by the viewer is intended, explicitly by many of the artists, as part of the work." He also says that "the work is addressed directly to the way it is understood. This act of understanding will involve, inevitably, a politics and a practice on the part of the viewer."

The common stance of the nine "Image/Word" artists is to be formally and/or strategically shrewd, thematically complex and declarative as to their intentions, which are mostly honorable in terms of what Watten calls "social space": they want to unveil the uncertainties and deviousness of public language so that its real and often multiple meanings can be confronted openly and perhaps changed. Among the works exhibited, Michael Lebron's composite Cibachrome prints, which have the look of public-service messages, are the most sophisticated. They propose an alternative rhetoric, and because their shrewdness bears upon a cool-headed manipulation of peoples' lives, they are doubly chilling. In *Contempt: a tool for modern times,* 1985, the good-news blurb proclaiming the "tool" partially obscures the actual product. The image is a diagonal shot of a major thoroughfare with a windbreaker lying spread in the foreground, overlaid by a text about "smart management" methods. In her "War Comics" diptychs, 1985, Lisa Bloomfield reshuffles images from old *Life* magazines into layout variations on the theme of tension and release. Underscored by snippets of narrative ("They spoke about the fear of suffocation / There was nothing to do but comply"), the "caught" citizens of 40s peak-period photojournalism bear an uncanny resemblance to the shadowy figures of period movies (Carol Reed's *The Third Man,* say, or Orson Welles' *The Lady from Shanghai*). Monique Safford's uses of titles and captions are more syllogistic. To arrive at the point of *Bird Watching in Ethiopia,* 1984—it's about feminist rage—you rummage among low-affect clues (an Ingres odalisque and attendant in a montage tilted over a text: "....someone awoke in a sweat, thinking as whipping boys think. So began the refusal.").

Some doses of pedantry proved inevitable. Connie Fitzsimons' *The Object Is Positioned/The Position Is Preserved,* 1985, was rescued from rhetorical aimlessness by dint of its clunky execution. Its four panels and two columns of wall text were uniformly mis-

scaled and the paintings of two museum-piece throne chairs were more inane than their point about the absurdities of empire. In Tad Savinar's silkscreens, witty messages pick up formal slack. His best was *The Cure*, 1985, with its rebus of prescribed leisure activities. Pedantry is also a byproduct of this culture's protracted skill at "seeing into and seeing into" (in John Ashbery's phrase) its own syntactical debris. A case in point is Mitchell Syrop's *Lift and Separate*, 1985, a sort of semiotic board game to while away meanings in a rhapsody of see-through attitude identification, which would be endless though of small use. (Shrewdness here comes full circle and spins off into self-contempt.)

The agreeableness of the New Langton Arts space—a spacious and beautifully skylit avant-garde protectory—seemed to delay many of the works' prospective efficacies. Those works that argue for more open public situations (such as Lebron's) looked bright but stranded in cold storage as it were, pending delivery to their rightful contexts. Allen Ruppersberg's mock fairground posters were alone in seeming perfectly homeless, insouciant as to whatever context. And Bob Jones' *Words That Cut*, 1985—a volley of catalytic insults and photographs printed on cardboard bottle-rocket wrappers—could work anywhere, but only if the fireworks were permitted to be set off (which in this instance they were not). The most exemplary position in this show was occupied by Edgar Heap of Birds' *Death from the Top*, 1983. A portable and necessarily homeless monument to social identity (as registered in the near destruction of the Cheyenne Indians), it is magisterially matter-of-fact and as sad as the logic that provoked it. In his catalogue statement, Heap of Birds writes, "….we find it effective to challenge the white man through our use of the mass media. As in American business and culture, in order to survive one must communicate a mass appeal."

Artforum, February, 1986

Robert Arneson

Robert Arneson's sculptures and large color drawings about nuclear war are direct statements of a private orientation toward the subject. He is dealing with his understanding, as a citizen, of a probability that society seems to cherish as ardently as it denies. The subject is vulgar and no fun: it is ugly. Its symmetries—the symmetry, for instance, of a cloud from a nuclear blast—are dull. But the projected spectacle of a world totaled in its own karmic knot is endlessly enticing; it's *the* media barrage par excellence (a "bomb" in common parlance, being both high and low on the scale of public outreach). Gertrude Stein concluded her essay "Reflection on the Atomic Bomb" (1946) with the prescient remark that "everybody gets so much information all day long that they lose their common sense. They listen so much that they forget to be natural." As Stein perceived, the machinery itself isn't interesting, but a common sense about its capability is (or would be if we had it).

Arneson's approach is natural; he is neither oracular nor shrewd. His conceit—that of registering nuclear catastrophe in memoriam, in an ironically predated hindsight—is a plausible naturalism that he delivers in a lowball, high-affect style with impeccable technique. The works, particularly the bronzes and drawings, are gorgeous, but their sting is no less real. The gallery installation made plain their discreteness; each work had plenty of elbow room and there was no impression of manifesto, no noise to drown out the face-to-faceness of singular address. The show could be seen as an extension of what Arneson had been doing all along. I'm thinking of his early ceramic "toilet" pieces, of his more recent portraits of other artists enmeshed in their own handiwork, and of the astonishing and right memorial bust of San Francisco mayor, George Moscone, the rejection of which by the San Francisco Arts Commission in 1981 was a significant denial of the place of accurate personal witness in a public occasion. Arneson has insisted regularly on pulling the wool from the eyes of a public that arguably needs a less obstructed world view. In *War Memorial,* 1983, a drawing of a severed head amid a whirl of slogans, acronyms, and tabulations, occurs a line that could stand as the motto for Arneson's work as a whole: "BETTER SAID THAN DEAD." That feeling of social urgency, to which anyone is accountable, is Arneson's public message.

As a kind of posthistory history artist, Arneson sees his subject partly in terms of salient, communicable facts and partly as fable, with villains and victims and no heroes save the dead, who even when represented as fragments—bronze-blasted skulls with maelstromlike eye sockets and glyphs of scientific/political slang fossilized in their crowns—retain the inherent dignity of their former wholeness. The most telling of the bronzes is *Minuteman,* 1983, a head impaled on a cross that doubles as a missile shaft, a self-likeness squished on one side as if struck full force by the logic of the artist's own contemplations.

As for the hapless villains, the managerial agents of this fix, they are the military men who accept and conceivably relish their fate of deploying lethal nuclear commodities, to whatever end. Riveted to this task these guys scream "Fuck!" to the upper air. *General Nuke,* 1985, heaves a gut-wrenching grunt to deliver his payload, the issue of which has already settled beneath him: a column of black squirmy corpses, mounted like commemorative cannonballs on a granite base. Conversely, the heavily glazed, bestial chiefs of staff in *Coo Coo* and *Dead Serious,* both 1984 and *Sarcophagus,* 1984-5, for all the fierce detailing of their essential natures, are conceptually thin; they can't be that "other," that remote. Oddly enough, in the painted version of this motif (*Joint,* 1984) they appear more accurate and lifelike. The bright, bloody tones of all the drawings recall those of Delacroix's *Death of Sardanapalus,* (which might be reexamined as an emblem of millennial necrosis). In the gallery, while peering at Arneson's hand-drawn "printout" of *Nuclear Weapons Effects,* 1984, a nice old lady muttered, "Look at all the *harm* it does!" (I think she'd gotten to the line about how many sheep and cattle would be killed within 700 miles of the hypocenter).

What if this project of Arneson's were no big deal—in the microclimates of art and nuclear politics, it both is and isn't—but a beautiful honest piece of work? By positing a form of sensible behavior for an artist citizen, and by making it stick with the

best language at his disposal, Arneson has done a brave and important thing. At this level, at least, his message is bound to resonate.

Artforum, March 1986

Joel-Peter Witkin

Over the past six years, Joel-Peter Witkin has gotten a sudden wide reputation as a sort of upstart Rasputin of the silver print. But, as even this limited traveling retrospective (forty prints from 1974 to 1985) reveals, his stylistic progress has actually been slow and fitful, and his subject matter—an eclectic theosophy with blaring sexual overtones—has developed apace. Witkin works in series. The series have titles such as "Contemporary Images of Christ," 1970-74, "Evidences of Anonymous Atrocities," 1975-77, and "Journeys of the Mask," 1982—and he also works from preliminary drawings, one of which, a pencil sketch for the furled pose of the androgyne in *Helen Fourment*, 1984, is included in the show. What are not included are Witkin's more pointedly violent scenes of bodily penetration and abuse (*Arm Fuck*, for instance, or *Testicle Stretch with the Possibility of a Crushed Face*, both from 1982), presumably with the understanding that, where an unsuspecting public is concerned, enough is enough (and it *was* enough to garner a goodly barrage of protest letters).

Witkin's imagery, or perhaps just his choice of models—many of them dead, including fetuses, and live ones with abnormal physiques—is pretty generally offensive. It's meant to be, even though there's nothing inherently wrong about his choices, much less about the natures of the models themselves. Witkin does play on his audience's supposed capacity for shock, its incredulity (which is matched only by its gullibility), its manic distrust in the face of life or death, its millenarian torpor. Playing loud, and at the same time tempering his imagery with a highly artificial technique, he tests how declarative and how imaginative photography can be.

Witkin's world view (assuming that it pertains, in fact, to "this" world) is benign, horrific, dense—a raging solipsism ultimately delirious in its associations. Since Witkin is technically ingenious, this combination is vital and practically unassailable. He is a precision worker with no letup on the surface. He calls his pictures "conditions of being," and so they are—but so, for that matter, is anything. Ontologically, he's working with both a stacked deck and a depleted one. If anything, it's the exclusivity, the perpetual zeroing-in on deregulated human types and proclivities, that makes the work cumulatively less profound than it might be. A perennial catch: how to gainsay the dumb-bunny taboos of this culture without also seeming to dote on them? Witkin's mediating conceit is to provide a looking distance—enforced by syrupy edges, multiple interior frames, and just-right, shallow studio placements—together with surfaces so emphatic and glamorous (albeit sometimes coyly loaded with connotations of past art) that the photographs'

grosser details are effectually the last things you see, so evenly does each shot burst and spread, persisting, as Witkin says, "sealed in time."

That sealant quality, like dry ice, is fascinating for its literalness. Strained past theatricality, an event, a place, and a character exist only in the print, which is a heavy dose of managed light, tone, and emulsion; documentation is incidental. Witkin's models are hardly themselves; they are transfigured (and occasionally traduced) by masks, hoods, hot black blotches and cutouts from art reproductions, and otherwise festooned with drapes, straps, vegetables, endless gear. What's missing? Most noticeably, air and life. The models are the armatures for Witkin's professed need for symbols, and to that extent, their humanness really is traduced: they appear as functional as the writing on the wall. On them are hung the light, the stuff, the frames of grueling events, to which they fully submit. Their physical extremes—extreme corpulence, extremely hung, extremities in extremis—accede to Witkin's bizarre and flagrant willfulness to flesh out space.

Artforum, April 1986

Tom Marioni

In the videotape shown at New Langton Arts accompanying a set of retrieved and refashioned items from his Museum of Conceptual Art (MOCA, the industrial loft that he used as a center for his art activities from 1970 to 1984), Tom Marioni says, "I intend to hang onto the past—that's why I like San Francisco so much." The past as Marioni displays it is both autobiographical and objective, an adumbrated nexus of erstwhile events and things that bear their own stamps of timeliness and formality. Every form in its own way, he implies, is poignant. His care for the forms things take is monumental (in the sense of continual reminiscence), delicate, uncommonly sweet, and tidy. His back-up strengths are compactness of execution and a slight edge of opinioned irony.

The centerpiece of the installation at New Langton Arts was *The Back Wall of MOCA 1970-1986,* 1986, a new, idealized version of the original loft wall with its "accessioned" hard-edge-type stretch of paint, the shape of which was first seen in the early days of MOCA's occupancy when the previous tenant's printing equipment was removed, unmasking the bare lower and side areas of the surface. (The plot thickened progressively with a "vandalizing" of the found painting by the performance artist Darryl Sapien, a "restoration," with straighter edges, by David Ireland, and eventually the wholesale demolition of the loft building when the property changed hands in 1984.) The installation version was made of paint on canvas with wood stripping, conduits, and a vent salvaged from the site, and (a Marioni "signature" touch) dim yellow floodlighting. On a facing wall, an oddly slanting display of memorabilia—flyers, notes, postcards, and photographs from the years 1970-1981—yielded a ready-made history of the salad days of Conceptual and performance art. On a third wall was a framed relic from the original wall—a thin shard of yellow plaster shaped more or less tellingly like a knifepoint.

The installation at Eaton/Shoen amounted to a mini-retrospective of sculptural tableaux, adjusted ready-mades, and prints done since 1972. Marioni is interested in the exchanges between locale and human activity: an area of wall where a shadow is cast, a city or country where the citizens perform certain characteristic tasks. Some of his images are residual; all suggest a transience of forms. The "nations" pieces show the strangeness of national identities as received ideas. They are ironic enshrinements of those ideas. In *The Italians, Part 1*, 1984-85, a pizza cutter, its blade gold-plated and its handle painted black, stands on end behind sealed cruets of oil and wine; the support is a trim, spindle-legged sidetable, and the backdrop is a lithograph with a diagram of the inner ear and a floor plan of a Florentine basilica by Leonardo. Conversely, the print for *The Germans, Part 1*, 1984-85, has an oculist's diagram and silhouettes of the fronts of trains, and the tableau—two beer bottles in a breadmaking form and a Baroque plaster flourish in a surgical pan—rests on a dark brown, dysfunctional-looking umbrella stand.

The most recent piece and the magnum opus of the show was *The Marriage of Art and Music (For Los Angeles)*, 1985. A large still-life tableau partially activated by spotlighting and "framed" by a waist-high railing in the foreground, it is a solidified quandary, a net scrambling of the muses' accoutrements, a verge signified by the inclination of one shadow (that of a copper plate in the outline of a violin sound box) toward another (a telescope on a tripod with two white twelve-inch LPs appended, its outline equating and old-fashioned movie camera). The "marriage" as announced isn't so much occurring as pending, as the last note of the implied processional drifts away.

Marioni has made Conceptualism into a genre—hence the original "museum" qualification of his enterprise and its latest extension as "The Academy of MOCA." His pieces simply face and gently assign placement to the observer; they don't test much. Their succinct manners anticipate meaning in ways that leave all meanings open and plausible and none very important. They are nevertheless sensible bemusements, recapitulations of Marioni's mild concern.

Artforum, May 1986

Terry Allen

After a lost war, as one imperial poet had it, one should write only comedies. Of the Vietnam "adventure," however, the multiple dislocations, both public and private, have left next to nothing of what comedy most requires: a consensus about what's really funny, or even bearable, if the residual facts of defeat are taken into account. So, whenever possible, we don't much take them into account, or, if we do, our tally is a cumulative void framed by after-thoughts that fail to resolve, never click, but weigh in with an insistence like that of meaning, except that they are dumb throughout. As historical voids go, "Vietnam" signifies only the latest, the most salient—a special case,

perhaps, in the wide swath it has cut through the collective soul, as well as in the stunning cheapness of its ironies.

The constructions and drawings in the latest installment of Terry Allen's "Youth in Asia" series seem to acknowledge all of the above. They at least try to probe the dearth of common sense and to dignify and give substance to the ironies. Neither propaganda nor analysis, they cast a somewhat shaky light on (or from within) the imperfect, albeit resolute void.

Allen's task has a built-in melancholy. Its signal organizational element is lead. A complementary device is chewing gum, which Allen uses in different-colored wads for details. (He also uses bamboo, paint, stuffed animals, playing cards, skills, and natural wood frames.) With sheets of smooth, malleable, heavy-but-soft-looking, dull-gray metal as their "skin," the constructions have an overall sullenness, quasi-comic and sepulchral by turns. Seen across a room, they are about as funny as squared-off lead balloons. Up close, the combinations of surface restraint with funny and/or sad details can be spellbinding.

In *Ghost Wheel 1968*, 1986, a stuffed parrot on a bamboo pole presses his beak to the image of what looks like a distant nebula (Allen says it's a bottom-less lake in New Mexico known as Blue Hole). Beneath the parrot painted panels show two jays, blue and red, locked in stages of sexual combat. The rest is sheet lead with stamped-in verses about birds, one of them a poem of yearning written by an internee in Theresienstadt, a German relocation camp. Verbal devices stamped in metal recall dog tags and other panoplies of war. They are ancillary to the imagery, which, conversely, is treated rebus fashion, like words. The words themselves nurse the images along toward specific meanings. The boxlike lead base of *Fantasia*, 1986, notes the number of Vietnam war casualties from each state (Colorado leading with 5,448). Other pieces have "things to do" poems, elegies, country-and-western-type prayers. A floor construction, *Grace*, 1985, has quietude; its memorial inscription reads, "for one moment / the anger is gone / but that's all."

The largest piece in the series, the *Battle of Santa Rosa*, 1984, includes vocabulary lists in Vietnamese, Spanish, and English. Reading across three sections, from left to right, you find *"tee tee"* (dress), *"paquento"* (small girl), and "woman's dress." The sections are connected by an outline of hills, and each is adorned by a different kind of hair (dog, cat, human). A black figurine of Buddha tilted on a pool-table-green spread confronts a tiny chewing gum cross. The "battle," Allen says, "refers to the battle we all go through getting through a day."

Allen has done his homework on the void at street level. Shoring up these fragments of ambient trauma, he is a kind of topical mapmaker bringing into focus and managing to connect the dots, dark as they are, that bear witness to what Frank O'Hara called "the enormous bliss of American death."

Artforum, Summer 1986

Italo Scanga

Fairfield Porter once said of the Italian abstract painters of the 50s that they had a "common sense of humor that prevents them from taking their art seriously enough. They are like wise clowns inhibited by a knowledge of the vanity of all human effort." The same might be said of Italo Scanga, a Calabrese by birth and a naturalized Californian as if by temperament. His sculptures are spirited without pressure. He seems to want them to have style and meaning but cheerfully refuses to go flat-out for either. Hence, his best pieces are the most easygoing, the ones in which his materials—wood, mostly, but he also uses glass, rope, wire, gourds, and other found things—are left pretty much to their own devices. Scanga's work refers generally to furniture, and as with most furniture, a handy and untroubled arranging of nice-looking stuff would seem to be preferable and enough.

Among the best works in the retrospective organized by the Oakland Museum (which is sending the show on national tour) are the earlier pieces dating from 1972-76. These are votive, or rather mock-votive, floor-and-wall tableaux of glass bowls, white cubic blocks, popular religious prints, and twine-or straw-girded farm implements. The blocks serve as pedestals for the objects, and the prints—images of saints in simple wood frames—are splashed with watercolors suggestive of blood or, as in *Immaculate Conception,* 1976, airborne semen. They are blithe, inconsequential, and decorous. Similarly, the trimmed-off branches, carpentered strips, and rude chiseled bowl of *Potato Famine Trough,* 1979, have a live succinctness, which the strut-and-suspension work serves mainly to showcase. Wires, as Scanga uses them, are strictly servile; as Gertrude Stein said of commas, they have "no life of their own."

By comparison, Scanga's more ambitious projects tend to get in their own way, and in the way of their parts. They fall over themselves. They represent, in fact, a potent pathos, that of an inherent pastoral impulse caught in a Mixmaster of late-industrial-age styles. Perhaps this is what the series "Fear," 1980, is really about, even though its stick figures are supposedly set upon by lighter-weight concerns such as success, drinking, and the metric system. In the vale of generic figuration, they court ambiguity to a fault. Their nostalgia is such that they forget to be present. A present-tense conviction is also missing or baffled in the sentiments of the "Monte Cassino" group of 1983. These tall, shocked witnesses tell no tales; they are blankly solicitous.

Toyed-with styles are the furnishings of the latest work in both shows. There are cubist veneers and Giorgio de Chirico-like humanoid armatures and trouble over color. Thick oil color over lacquer seems to barricade the solid forms. For instance, in *Red Figure with Banjo,* 1984, a pileup of painted arcs and wedges clings to the planes like a kudzu vine. In *Metaphysical III,* 1985, this overload is mitigated by areas of clear shellac through which the wood is visible. There are wooden shoes, musical instruments, table legs, frames, balls, toy animals, letters, and a cuckoo clock. But the real hero of the brighter new pieces is rope, which functions either as a spine or as coiffure and is sometimes varnished so that it glistens.

Artforum, September 1986

Mark Rothko

The local talk about this traveling retrospective of Mark Rothko's works on paper centered on the unfortunate restrictions placed on the works' visibility by the show's organizers, the Mark Rothko Foundation and the American Federation of Arts. Presumably, the disadvantages to public viewing were residual of the great care lavished on conservation. But the experience was, as one viewer put it, "like seeing a drive-in movie in the afternoon." Stuck behind formidable shields of glass or Plexiglas, many of the pictures simply failed to appear, and others made what were at best tenuous showings within a gridlock of reflections. Such effects proved especially impassable for the late dark acrylic-and-ink washes. Surely there were other, better ways to protect and at the same time allow access to these great pictures.

As Elaine deKooning said, "Rothko's art supervises the clutter of daily life; it straightens things out." What no installation could obscure, and what stood most revealed among the eighty-odd works, sketches, and studies, was the range Rothko commanded once he arrived at his proper means. "I allow myself all possible latitude," he said, and his works on paper show that this was true, and also some kind of miracle. They show it without exactly paralleling his works on canvas, in fact without occurring much at all between 1950 and 1958, the period of Rothko's consolidation.

The miracle of Rothko's progress can be read as twofold: first, his arrival out of early flailings, variously dour and frenetic, at the point of a bold, singular, luminous statement; and second, his capacity for keeping that statement as an improvisation. Improvising over the void is the ultimate Symbolist pursuit. A more familiar strategy, that of merely recognizing the void and redesigning its coordinates (its ruts, even) deflates the symbol in favor of optical and cultural recognition. At any rate, that's the strategy we find familiar in painting now. What Rothko found as he pursued subjective content was an active void, a generative blank that doubled as a matrix. In this he connected with Philip Guston, who was spiritually his nearest neighbor. From the same zero ground, Guston retrieved forms that moved toward solidity, while Rothko decanted an evanescence, what the poet Larry Fagin has called "the most powerful evanescence on the block."

Where Rothko's immense canvases draw the viewer out of himself and into areas of mutual reverie, his paintings on paper, even the largest of them, are more conversation, more exquisite in terms of touch. A kind of harrying touch (including frottage, rakings, burnishings, and masked-out shapes) constitutes virtually the only compelling quality in the transitional mid-40s watercolors. By the early 50s, in the two-to-four-tone formats with the middle distance dissolved, touch is congruent with placement and the instantaneous jolt between tones. Both touch and tone in the final "mauve" pictures of 1968-70 are surprising. The fluid strokes have a semipermeable silkiness like that of the mist in a Chinese mountain view. Each image manages to hang by a thread to the material plane. Rothko seems to have wanted a breathing space, in the form of a single, central, paler strip, between the major color shades. The strips didn't ring true, and in the best two of three of the series you can see that he blotted them out. The white, ruled margins on these sheets are thin, inert, and a bit factitious, but they do reinforce the

required buoyancy throughout. As in earlier works, there is also some iridescence from layering at the inside edge.

Rothko was really out there. The "expanding and quickening" he valued had actually clotted and palled, and he used the looser, spacious, sweeping strokes in these works to see it through at the end, grandly.

Artforum, October 1986

Bill Dane

"Well, it's a fantasy problem," says a Sunday comic-strip frame on the shop window partition in one of Bill Dane's recent photographs. The window dressing view *Shreves, San Francisco*, 1982, shows a big teddy bear mummified in funnies and sporting a pair of Chinese plates, each with the same image of an exotic garden with butterfly. It's an apotheosis of desperate, pointless artifice, and you realize the whole shot's about getting to heaven and finding it just like home.

The stuff of this world, as Dane finds it, is preternaturally pictured, dolled up, or in one way or another on display. Repeatedly, he uses the photographic sheet as an exemplary void and presents whatever fills it as a dubious simulacrum, a scale-model pleonasm of human desiderata and bypassed hope. The implication is that these conditions meet their parallels in daily life—in the cramped glitz of restaurant décor, in the imploring eyes of a two-headed goat (in *Ripley's Believe It or Not Museum, San Francisco*, 1984). The vulgarity of things treated thus isn't the point, nor is their functional status in the stratagems of marketing; if anything, Dane shows that these things don't matter, they're empty, but we invest them with such rage for efficacy, for magic, that they must be real and therefore count for something.

In the 15 or so years since he switched from painting to photography, Dane has gone some lengths toward refining an idiosyncratic technique. The intensity and wit in his black and white pictures get their punch from a few basic formalities. Dane likes sharp in-camera editing and alignments of detail along a constant central axis. (Off-center details he plays close to the edge or as disquieting abrupt notches in the corners.) His formalism isn't self-aggrandizing; you don't notice it at first so much as later, when you wonder at what has kept your attention drawn to the photographs' peculiar sights. Transformation of peculiarities is less the issue than the achievement of poignancy through their exact placement. The method isn't foolproof and neither is Dane's wit: there are some foolish-looking duds and cartoonish one-liners, like *New Yorker* jokes. His recent work has a greater, more impetuous energy spread across the frame—an effusion partly due to training on closer shots and otherwise on the consistent wackiness of his motifs.

Most of Dane's views are of things simulated to begin with (effigies, toys, relics, painted skies and paper seas), though some are of natural things (an enormous, veering

eel) in artificial settings (a dim aquarium tank), and one (a deer at the bottom of a shallow pond with a burst of light at its breast) is of death plain and simple. The sense that most of these things aren't going anywhere is foremost; it's alleviated only by the occasional semblance of motion in the photographer's reflected flash, which becomes Dane's stamp (and which in the aquarium picture makes an eerie ripple, like moonlight, on the tank bottom). His soft, slow touch seems to want to coax the life in his life-simulating subjects to declare itself and thereby to answer our gaze. One image in the show, *Nut Tree, Vacaville, California*, 1985, works just that way. We see a floppy orangutan draped head forward over the back of a life-sized stuffed zebra in a window crammed with other, smaller stuffed animals and potted plants and trees. It's a tender, loaded, dumb, pathetic, hilarious mess—a clear enigma—and the ape's glassy stare just about acknowledges our awareness of it.

Where does Dane himself figure in this, aside from being somehow at home with these arrangements? There's something mock-classical about his style, but it's not spiteful or condescending; in fact, it projects little in the way of an attitude save the rudimentary one of choice and fascination. Our puzzlement and dismay notwithstanding, the photographs show a care for the measure of particular life in things (deployed in whatever unlikely, silly splendors) as against their contingent use and even their meanings. Dane has cast himself as a surveyor of ceremonies stuck deep in our wishful, ornamental glut, our fuss.

Artforum, November 1986

Rupert Garcia

The Rupert Garcia retrospective of 17 years' work was timely, not as a summation (as an artist, Garcia is a young 45) and not because of the quality of political statements in the work, but because it caught the artist amid an efflorescence. Together with the small gallery sampling of new work, it left one with that giddy, off-the-diving-board sensation one prays for, and least often expects, from a mid-career survey.

Garcia is known as a California-born Chicano painter and printmaker who devised the boldest, most succinct silk-screen images during the third-world poster movement of the late 60s and early 70s and who helped found the important Bay Area venue for Chicano-Latino art, Galeria de La Raza. Inflected with sophistication about contemporary styles (primarily those of Andy Warhol and James Rosenquist, though you can see traces of Ellsworth Kelly, Robert Indiana, and Tom Wesselman too), his posters content themselves with fast, precise efficacy. As signs populated by heroes and victims (from the stalwart Emiliano Zapata to the implied figures pinioned by barbed wire in *Cesen Deportación* (Stop Deportation, 1973), they are singular and blatant, stylistically sure but a bit reined in. They accomplish purposeful transformations—remaking printed images into vivid social emblems—but their range is limited by the quick-shot

communicability of the squeegee look. With his mid-70s shift to pastels (and to uncommonly large formats for that tender medium), Garcia's work picked up scale and density without (at first, anyway) slowing down its messages. In *Inez Garcia*, 1975-77, for instance, the intimacy of pastel, projected into large scale, turns a nonintimate subject (a woman standing trial for killing the man who raped her) into a palpable identity that confronts and tells more than news items about her could convey.

Not all of Garcia's portraits deliver such a punch. In fact, practically the entire series of re- (or de-) constructions of famous artist's self-portraits, 1980-84, seems aimless and tired. In the last two years, however, Garcia's skills have developed more apace with his seriousness. Dividing horizontal sheets with composite imagery, he opens his pictures up to multiple meanings, making them more volatile to the understanding as well as more substantial to the eye. In *Hermana á Hermana* (Sister to Sister, 1985) and *La Virgen y Yo* (The Virgin and I, 1984), smokelike finger smudges and sharp darts of color sustain the surface field across abutting images. Such touches add to the ominous aspects of dark, fuzzy silhouettes. In *Inside/Outside*, 1985, the blackness of a shredded hut is engulfed at the heart of a splendid blue mountain. Garcia's chalk tones match lushness with horror; the brilliance of a Guerrero mask and that of a bullet wound become sensibly equal.

Garcia says, "Now many political works seem trying—embarrassing to one's eyes." In fact, most political art produces a hothouse aura, which—presumably—would be the last thing it's after. Political iconography regularly takes on the narcissistic assurance of exotic plant life; either cloying or laboriously thought up, it represents an indigestion of reality. Garcia shuns that kind of embarrassment. His pictures are stylized but don't feel stylized, which means you experience them as facts, as documents, and something more. So far his basic subject is human dignity, a fragile sense of worth literally under fire. Or else it is the dignity of artistic rightness versus the need to dignify an all-too-recognizable social content. Or the image of the fully conscious citizen-artist faced with heavy trading in images of a strife that refuses artistic control.

Artforum, December 1986

San Francisco Video Festival:
Alan Rath, Jeanne C. Finley, George Kuchar

The "preconstruction" setting of this video-gallery-to-be turned out to be less manageable than had been anticipated, what with stacks of plywood and Sheetrock waiting in the wings (or, anyhow, the foyer). Nevertheless, Alan Rath's three new electronic sculptures, Jeanne C. Finley's pair of slide-cum-video presentations, and George Kuchar's motel-room environment for his videotape *Weather Diary I* all commanded their discrete spaces bravely. In fact, since the installations together shared a high degree of wreckage and calamity content, the ambient topos of renovation took on an especially ironic charm.

Rath's materials include video monitors, conduits, computer chips, power supplies, and steel plates, all of which function as they were designed to do. His sculptures are spirited by an unsheathed constructivist glee that is undercut by their malicious imagery. Because the images on the monitor screens are animated, there's a kinetic, figurative element, a sense of live action that dovetails with the nonfunctional parts—a tripod, a cage, a hospital tray—to embroider explicit social themes. The nuts-and-bolts-plus-circuitry veneer displays a delicate, shiny inventiveness, which is superseded by a sharp mental sting. In *Bill, Bob and Barney*, 1986, a video frame buffer induces the diagram of an artificial heart to twitch. *Opposable Thumbs*, 1986, shows tandem images of hands (one male, one female) clicking in and out of open and grasping positions behind a laboratory cage. Similarly, the automated images of human eyes on video monitors in *Voyeur*, 1986, seem paraded at (an autobot's?) arm's length from the trunk of that boxy, tube-legged remnant of self-recognition. Rath's sculptures recall earlier, milder work by Jean Tinguely and Nam June Paik, as well as Robert Rauschenberg's "Oracle" radio sculptures of 1965, but his aligning of electronic smarts with an "informational" topicality eases his assimilation into the video context. Rath has devised a clean stratagem for seeing into the spaces between self and other by mixing the two.

Finley's slide-dissolves work conceptually; as movable parts in narrative, the images float in a kind of colloidal suspension. A taut, bare-bones orderliness pervades these "fictional illustrations of factual episodes" (as Finley refers to them); they might have taken their cue from Emily Dickinson's line, "After great pain a formal feeling comes." Finley uses clinical statistics and other quasi-scientific nonsense (a slide displaying the words, "Losing a loved one—risk: 40 days") as counterpoints to the near-Surrealism of her photographs (a bare bedroom inhabited only by a Darth Vader mask and an inflatable globe) and the real realism of her domestic subjects. Finley's formality locates pain as if to determine its exact size. The "size" a feeling is, is funny. Finley means to bring these masses of free-floating data (including their discrepancies and preposterous syllogisms) back home, to see if they can tell us about ourselves and help connect our privacies. The shrewdly chosen sound-track music is effective: in *Risks of Individual Actions*, 1985, Frank Sinatra sings "The World We Knew" ("Over and over / I keep going over...."), and the song's lugubrious arrangement hurts. This is tough-minded, gut-grabbing work.

Kuchar exudes catastrophe as standard fare in his natural habitat, which might be identified as the Grotesque Sublime. Because video has no scale (and Kuchar's films thrive on the scale of the freakishly grandiose), in *Weather Diary I*, 1986, he lets frontality suffice and keeps his images close to the vest. (Typically, the taping was done on a shoestring, with virtuoso technique—edited in the camera, a Sony 8-mm video camera). The diary form provides the hook: it is May and our protagonist has stranded himself in a bleak motel on the margin of Oklahoma's Tornado Alley—"whatever did happen here came and went." Righteously watching the 24-hour weather channel and chatting up the neighbors, Kuchar trashes the incoming meteorological data with his own special obsessional wrecking ball. He is a thoroughly limber American Fellini. He's also some kind of great actor, with a voice that modulates like Jack Kerouac's and pierces like

Fiorello LaGuardia's. He transmutes: "The sky a hideous mass of VCRs and Magnavox consoles." He muses: "No storm today—Mother's Day." He reflects: "Last night's storms were like a dream—a wet one." When conditions permit, he shows you crystalline vistas of the Oklahoma plain, huge clouds, and a nearby stream. Interestingly, weather is a hot topic in video nowadays—for example, the electrical storm in Bill Viola's *I Do Not Know What It Is I Am Like*, 1986, and the rough seas and tornadoes in Doug Hall's *The Plains of San Agustin*, 1986. But where the others stay outside the weather, the better to study its esthetics and codes, Kuchar insinuates himself as its virtual center, its "eye." Perhaps he is the real Storm Fiend.

Artforum, January 1987

"Second Sight"

The theme designed to hold together the variety of paintings and sculptures in this biennial show was both tenuous and ambivalent. Loosely paraphrased, the curator Graham Beal's catalogue essay's main argument ran like so: that where Modern art "on the whole" denied the past, a sign of the present rage for content is to be found in newer artists' espousals of antique styles and/or subjects as "aids to meaning." Ideally, a theme show should gather force and add to the effects of individual works. This one fizzled and subtracted and left one with a feeling of greater vacancy in the departments it claimed most to address. With its allusions to a "more serious concern with meaning" and the expression of "humanist ideals and issues," the accompanying literature posited an inclusivity, a scope, which few of the artists on hand tried to deliver. To do so, they would have had to surmount both irony and nostalgia. The slurred conception made most of them appear just adequate and only a very few better than that. If anything was revealed by the show itself, it was the general ease with which these artists settle on both irony and nostalgia, and more especially the latter.

The "Second Sight" artists were Hermann Albert, Edward Allington, Siah Armajani, Roger Brown, Harry Fritzius, Douglas Higgins, David Hollowell, Komar and Melamid, Christopher Le Brun, Carol Maria Mariani, Ann McCoy, Stephen McKenna, Odd Nerdrum, Giulio Paolini, Earl Staley, M. Louise Stanley, Pat Steir, Michelle Stuart, and Mark Tansey. The group was fairly divided between nostalgia for content and nostalgia of style. Komar and Melamid parody nostalgia, while McCoy parades it—in terms of an unambiguous meaning system—by the numbers. Like McCoy, Stuart presumes upon meanings in nature by invoking cultural precedents. The precedents don't aid, but are, the meaning. Both Brown and Albert gloss over creaking archaic stage machineries with bright midstream-modern styles. A kind of Promethean nostalgia is explicit in Fritzius: he tries to steal two divine fires at once—the steady blaze of old masters and the acetylene flicker of Action Painting—and ends up with smoldering remnants of the two together.

Nostalgia can often be identified as a confusion of tradition and anachronism. The meaning of an anachronism lies in the gap between at least two connotations, stylistic or otherwise, and the rupture of temporal meanings releases a silliness. Shrewd deployments of multiple ruptures make Tansey's art jokes funny (*The Key*, 1984, is his funniest, because least circumstantial, picture). Silly ideas of tradition in the classicizing paintings of Staley, Stanley, and McKenna make for kinds of pictorial doggerel. Paolini's window-dressing reprise of the bloody episode of Nessus and Deianira demonstrates to what remote corners such classical verities have been consigned. He shares with Mariani a laundered classicism. As Carter Ratcliff has observed, "Mariani's figures all hold their breath"; they are idle stylistic precedents waiting for a meaning to nudge them into gear.

Nerdrum, Hollowell, and Staley all practice what used to be called "symbolic" realism. Predicated on tight rendering and coruscating figure arrangements, it's an intriguing conservative genre that never quite went away. Staley's version recalls the typical 1930s American regionalist offshoot, while Hollowell's floats on an urbane finesse. Nerdrum brings to his curved horizons and eerie lustres the show's greatest conviction and an uncanny (if sometimes stultifying) balance. Of all the painters, Nerdrum shows the clearest preference for how a painting ought to be. Steir's paintings exist passionately as a force with natural human implications, though lately she leaves the "how" of it to wander in the maelstrom of her mimicry mix.

Modern artists never stopped using what they could of the past. The Futurist moratorium on traditional usage was superseded by any number of calls to order and impervious continuities. History outlives the chronology invented for it. For an artist, it is an exposed field or matrix, not a forced march. Unlike artists, our critics and curators tend to thrive on short memories. Terrific memory lapses fuel the cottage industry of Modern/post-Modern thesis making and rinse the long-term, standard range of accessible styles and meanings in nonsensical light. The most telling quality of the present show was its superficial look of latter-day 20s/30s Art Deco dislocation—not surprising in view of the classicist yearnings and otherwise flailing pluralism of *those* decades. The proof of "Second Sight" was no clairvoyance but a normal circumspection: as they say on the street, "Goes around, comes around."

Artforum, February 1987

Nell Sinton

Nell Sinton is a sensibility painter, meaning that her feelings about a specific motif are peculiar to the way she shows what she sees of it, to the paint strokes she uses; she discovers what she feels by painting it. At 76, she has a well-founded local reputation for painting in various modes and for making box constructions and large, intricate collages. (One of the latter—*Gough Street from Fort Mason*, 1985, in the present show—features an actual bite-size paint chip from the Golden Gate Bridge in its center.) That her sensibility

once overreached her motifs is manifest in the fantastic whorls and striations that in earlier paintings spell vitality adrift or a subjective caprice. Only for the past three years has she used, as she says, "the landscape as a focus." She is less sure of what that focus implies, of its sufficiency, than the East Coast counterparts her new pictures call to mind—Jane Freilicher and Nell Blaine, among others—but she is more sure of its possibilities than any of the erstwhile or continuing "Bay Area figuratives" with whom she has sometimes been linked.

Very little else in art makes sense as much as taking something real and painting it. But one of the oddities of the Bay Area is how few good painters there do just that and keep on doing it, as realists, and especially in terms of the local landscape. Put too briefly, the reasons for this involve an inherent overearnestness about meanings (making sense is different from preparing a digestible meaning) and a contrary tendency toward interiorizing whimsy. Neither approach says much for the nature of appearances. And then there is the daunting appearance of the coastal environment itself, with its regular dosage of stupefying picturesqueness (including color riots in the acid range), and its relative geologic infancy and dramatic crosscurrents of weather, all amounting to a Pacific-Rim vernacular that won't stay put.

In this regard, Sinton's new landscapes and interiors are unusual and brave. They rock with a healthy duality. They go, as John Marin once recommended, "to the elemental big forms and the relatively little things that grow on the mountain's back, which if you don't recognize, you don't recognize the mountain." Sinton now uses her sensibility to augment and connect, not to overwhelm or typecast, what's in front of her. There's the sensation of having taken a plunge into each view and reemerged with an order previously only half-suspected. The firmest connections are those made in low horizontal formats—in *Alta Plaza, Six Flights with Figures,* 1984, for instance, where a stretch of ebullient blue lawn throws two trees like scarves about its shoulders, and a white-shirted figure near the top appears to be taking final steps toward assumption into sempiternal fog. Sinton also manages to catch the tricky San Francisco light, its milky obdurateness—buttermilk in the "Alta Plaza" images, charred lactose in *Bay View, Storm,* 1986. In *Embarcadero, Four Columns,* 1985, distinctions of street and sky in haze are neatly scoured, a wet cobalt wraith of the San Francisco-Oakland Bay Bridge bisection the whole. The interiors, with plays of dark wood furniture against blasts of picture-window daylight, are more large scale and moody and a bit suspect in their felicities: do shadows actually mottle a room's walls and chairs into perfectly blended orange and blue fields, or is that a decorator's fancy? On the other hand, the inside/outside arrangement of *Bay View,* 1986, is a honeycomb of succulence and precision. It is as if by casting a harder look at appearances Sinton has defined what her sensibility contains, which is something sharper than her previous glissando attacks allowed. The pleasures she takes in her hometown's nature are delectable, candid and markedly unhedged.

Artforum, March 1987

Diane Andrews Hall

Diane Andrews Hall started out as a painter in the late 60s and left off in the 70s to collaborate on video and performance pieces with her husband Doug Hall and the conceptualist group T. R. Uthco. Images and ideas generated by her camera work on those pieces resurfaced in the paintings she began making 6 years ago, and her current interest in weather and landscape runs parallel to Doug Hall's: his videotape *Storm and Stress,* 1986, and her new pictures share particular motifs—the ocean at Baker's Beach in San Francisco, dark clouds massing in New Mexico skies—as well as a passion for improvised constructivist framing and dissolves. The pictures locate motions of sea and sky as powerful, temporal quasi states of matter observed in freeze-frame.

Clouds and waves aren't objects, but our views of them can make them seem so. Hall combines distinct views—using multiple panels or insets within a single panel (often based on the a priori framing that photography affords)—so as to orchestrate different atmospheric weights and durations. The weather comes parsed in sets of prismatic incident, each bearing its load of absence and fullness, rapture and resolve. This is sumptuous conceptual painting. The light is the factual one of color stuck on canvas; it doesn't spread so much as agglomerate, and it refracts like the weather. The succinct, no-blur brushmarks define substance in a sky's drift, suggesting not only immemorial sunsets and storms but flowers, flesh, seashells, drapery, and other sensuous things. Each overall arrangement is the setting for at least one infinitude, along with its hints of footlooseness and grandeur. Infinitude is there, but it's boxed and cropped, scaled down and delivered in order to be perceived. To that extent, Hall's subject is the traditional Romantic enclosure of nature under sublime conditions—the delectation of a whirlwind under glass. Not content with Romanticism's ornamental responses, she augments enclosure to investigate the dimensions of the sublime. Surplus effusion is strictly ruled out.

Hall's will to method is formidable, if not always on target. She fashions sharp-edged insets and flat low bands and sticklike strips and spindles of solid ground that seem to hem or cut the atmosphere without being touched by it. There's a brittleness to her horizons that makes you trust them less either as bearings or as footholds. When her devices click, they send the multiple sensations of climate trumpeting forward at once, heraldically. Gazing at the frontal burst of *Suspended Horizon,* 1986, is like being privy to a humane cosmogony. It has what Emerson called the "inexplicable continuity" of water. Other, more tyrannical designs create edgier, jostled effects. Hall seems more at home when she lets sensuousness and straight observation get the upper hand. A beach scene in three slightly separated panels, *For Those of Us Who Love to Be Astonished,* 1986, partakes of a kind of "pararealism." In each panel the dark beach gives onto a span of gradually different light—it's the same late-in-the-day moment throughout, but nature (as is its intermittent wont) has divided itself in the act of being seen.

Artforum, April 1987

Nayland Blake

In Nayland Blake's conglomerated sculptures, the links—often literally those of little brass chains—seem to have come ready to hand, like prepositions materialized. The connections they make between one thing and another and between things and words have the sudden strength of the obvious. Contemplating each discrete piece is like contemplating the rightness of a cliché that hasn't worn itself out by insisting too much upon its perfection but provokes the same meaning (or delay of meaning) to issue forth every time. The mechanical logic involved in this aligns with the mechanical character of assemblage generally, the sense that everything can and will "go" with anything else. The abrupt conceptual flash yields to a sort of languor of accomplished relations.

At the age of 27, Blake has plunked down his considerable talent squarely in the tradition of the insouciant, nasty conceptual object. The thirty-two pieces in this show, all done between 1985 and 87, were arrayed under the general heading of "Inscription," and accompanied—in the artist's statement in a leaflet accompanying the show—by a caution that they be seen not just as objects but as props. "A prop," he explained, "is an object that exists in an ambivalent space between presence and absence." There were low-set table displays, wall hangings, paintings, drawings, reliefs, and freestanding works. Each piece tackled a different topic, and each in its way was surefire. Most of them had a close-up aura of the dusted-off thrift-shop antique. Blake uses a lot of haplessly ornate stuff— silk or nylon cords with tassels, velveteen-lined presentation cases, engraved lettering, brass plaques, bell jars, an octagonal wood plinth. Some of the freestanding works have ingenious stoollike supports; in *500 Kisses*, 1986, it is a high pedestal covered by a fringed velvet square on which rests a set of flashcards. These flashcards are to be snapped up by viewers and pitched toward a black fedora on the floor. Displayed on a low table, *Object with Case*, 1987, is a smoothed-out umbrella cape chained to an empty black evening bag; on this fabric is printed the word "IDIOLECT" while a plaque identifies the bag as "*La Nuit*." (The conundrum is enhanced by the bag's lying wide open on its side, evoking the contours of a hippopotamus's yawn.) *Kissing Nixon*, 1986, is more direct, consisting of a croquet mallet with black fire-iron tines at the butt end and a nameplate bearing the title phrase tacked midway down the shaft.

Words, the way Blake uses them, become the ultimate props, delaying our apprehension of things much as they prompt our anticipation of their ulterior meanings. It's as if the reconstructed objects have picked up words to try them on for size, or for density perhaps, to play whatever role each bit of language might suggest. As a device for probing among such mental furniture, language thus appears at its most vague, sluggish and forlorn—a counterirritant to the brio with which Blake has assembled the actual objects. The most nakedly verbal of his pieces, *Credo,* 1986, epitomizes the ambivalence he seems bent on maintaining at the core of his work. Two streamers of gold cardboard letters spell out, one above the other, "LIES TO FRIENDS" and "LIES ABOUT FRIENDS," attached to the wall so that together the two lines of letters form a tarnished, clownlike grin.

Artforum, May 1987

Gordon Cook

Gordon Cook died in 1985 at the age of 57. The current traveling show of his work, organized by the Oakland Museum, concentrates on his paintings, which he turned to seriously in his early 40s with some prescience that they would be accepted as more "big time" than his prints. His paintings are beautiful—many of them achingly so—but his prints are great, especially the etchings done in his mid-30s and those of the last two years of his life, when he renewed his fascination with the printing process after a nine-year hiatus. The privileges of paint are materialistic, even though paintings depend for their excitement on things happening immaterially a little in front of and a little behind the painted surface. There are more great works on paper without paint than there are paintings in the world.

Black-and-white etching is the static medium par excellence. From the first, even in his youthful studies with Stanley William Hayter and Mauricio Lasansky in the Midwest, where he grew up, Cook found in the control and precise shifting values of intaglio a vehicle for a vision that was by turns stately and delirious. Taking in hand its capacities for denoting adjacent contours and for bringing out flash areas of what he called "printed white," Cook added mystery elements of discrepancy in scale and speed. He shows you how thoroughly the delineations of a thing can look like what they're supposed to represent and yet keep tugging suggestively at the possibility of their representing something else. For example, in *Headlands V*, 1964/85, the sandstone and brambles of a coastal promontory are rendered to show every vein, complexly; the image's resultant shagginess seems about to bestir itself, poking its rude snout irritably into the surf (which bears a tiny sailboat in its outer reaches) for relief. Cook worked such plates directly at his landscape sites. The "clean, straightforward journeyman job" he prided himself on ended up, more often than not, a piece of magic.

Like his etchings, Cook's paintings advance the transforming powers within everyday things along with those of the medium at hand. (In some of his paintings, the weave of linen support, though brushed with a solid scrim of color, shows through, becoming part of the realism of the scene.) His best-known paintings are unconditional still lifes—or, rather, still lifes of objects that, in the process of being observed, make their own conditions. Solitary hats, bottles, jars, a blood sausage and other comestibles, and toys pose in the midst of fastidious tonal gray or mauvish settings. Like Wayne Thiebaud's settings, Cook's are horizonless and moot. But Cook's specimens from the world of things don't project tension or duress the way Thiebaud's do, nor do they present themselves as essentially manipulable. Quickened by a shadow whose force lines seem independent of the object's center of gravity, the emotion in each image is specific: a militant, spoilsport rage in *Party Hat*, or *Wood Foot's* incipient glee; or the gentle, upside-down self-doubt of the watercolor *Top Cut*.

The degree of technique Cook mastered for his oil paintings looks limited, erratic, but no less suited to his themes (or, mostly, he suited his themes to *it*). His late pictures were represented in the gallery show in their variable strengths. Although the drawings he did of stick figures from 1983 on are charming, the paintings of the same

series appear to have given him trouble (they're overextended, like official portraits)—probably because their models for once were objects not just noticed but devised by him. The best of the late works center on the cylindrical Point Richmond gas tank visible in the folds of coastline across the bay from Cook's home on Russian Hill. A kind of guardian spirit of the bay, shimmering and swelling and flattening with the changes of light and weather, the Richmond tank served as the ultimate mooring for Cook's eye—for his alertness to the coherent life of things apart from human purposes.

<div align="right">Artforum, Summer 1987</div>

George Lawson

George Lawson is a 36-year-old Floridian who lives in San Francisco and has been showing regularly there since the mid-70s and more recently in New York and West Germany. He co-curated the three-gallery "Open Image" exhibition in San Francisco last winter, featuring recent German abstract painting—most of it consistent with his own latter-day reductivist principles. Those principles assert the importance of an individual focus on the exact properties of painting as painting, the essential practicality of which might be summarized by Whitehead's remark to the effect that "a mood of the finite thing conditions the environment."

In the case of Lawson's closely harmonized multipanel works, the trimness of the immediate environment (Lawson's format of finite, squared-off grids) is conditioned beyond itself—and beyond its restraints—by the mood of each frankly beautiful color and the specific sensations the colors together confer on the viewer. Unlike much reductivist work, these build expression from a fundamental agreeableness; they are decorous without resorting to the "touch," or they suggest that premeditated beauty is toughness enough.

For this show, a single large painting, bracketed to a thick sheetrock partition along one side of the room, occupied the main gallery space. The painting, *Good and Bad Government,* 1986, is made of eight rows of sixteen nearly foot-square terracotta floor tiles distributed at one-inch intervals and aligning with a sepia-colored snapline grid. The tiles are painted in eight colors—about sixteen different tints in all, ranging across shades of slate, light blue, pales and dark gray, mauve, pink, mocha, and various clayey reds. The sequence of colors in the first (top) row is repeated in reverse in the bottom (eighth) row, the second in the seventh, etc. (and the same holds true for the vertical rows too), except that in the middle a glitch occurs with the substitution of a gray for a pink. The allegorical title, a reference to Ambrogio Lorenzetti's fresco cycle (1338-40) in the Palazzo Pubblico, Siena, is a provocation. It suggests an abstraction greater than that of Lawson's literal paint: conversely, it serves notice that the true test of an allegory is the perceptibility of its actual surface—literally, what gathers meaning to its bounds.

There's a kind of prima facie stateliness in Lawson's colors and in the way they match the earthly tones of Ambrogio's bunched-up buildings in *Effects of Good Government*

in the City. In Lawson's painting, the labyrinthine image made by swatches of different colors side by side is understandable because it's the only thing to see. The paint is smeared by assorted vertical touches and an occasional swirling stroke. The style is as transparent and objective as a grammatical declension. Looking at the arrangement head-on, there is no blanket effect: the parts stay parts and, although you can soft-focus (and thereby generalize) them into segueing tangentially, your eye keeps returning to their distinctions. It's the gentle specificity of each part, together with the quasi-regular pattern and clarity within closeness of tones, that governs the painting.

Artforum, September 1987

Leon Borensztein

Leon Borensztein, who was born in Swidnica, Poland, and came to California from Israel in 1978 at the age of 31, makes contemplative documentary photographs that take off from his journeyman's work as a portraitist for a commercial agency. The job allows him to be, as he says, "an observer of a variety of people"—westerners who, singly or as couples or family groups, have sought out the agency's services or responded to its promotional campaign. Having finished taking a custom color portrait, Borensztein will often ask his clients to stay on for additional black-and-white shots, adjusting their poses only so far as requiring them not to smile (which some do, regardless).

Here the props and stage machinery of the makeshift studio setup are confidentially laid bare: Borensztein uses the rather wan accoutrements of an impersonal photographic genre as devices for taking the measure of a subject at hand. Thus, the social situation is doubled. The pictures have a dual shock of intimacy and dislocation, a commonplace formality that catches the sitters midway between their private and public selves. This neither-here-nor-thereness puts each one's identity teetering on the line. Their persons are exposed in the noncommittal, studied moment of having their pictures taken in more or less familiar environments—at home, or a corner of a hotel or shopping mall—first neutralized, then made lumpily theatrical by the dim trick of cloud pattern on a portable paper backdrop. In such refractive isolation, everyone, though completely in character, looks unusual as well as a little bit the wrong size.

Borensztein sees ordinary people plainly, with a straight-ahead, blessedly unsardonic focus that jogs across the frontal, mostly full-body views. His format, consistently higher than wide (the images are all twenty by sixteen inches), acts as a kind of proscenium, as perfect a frame for the glowing, lithesome *Young tap dancer, Fresno, 1986*, as for the heavy-duty, imperious *Black woman with fox fur, San Francisco*, 1983. Within this well-regulated middle distance—give or take a few raggedy edges where the screen ends and you get glimpses of the room or corridor beyond—Borensztein intensifies the camera's lapidary advantage with contrast and detail. In *Military family, Fresno*, 1985, a way of life seems to hinge on the lay of the wife's tanned hand over the white of her husband's parade-dress glove. In *Newlywed couple, Madera, CA*, 1985, the flash has fixed on

the bride and left the groom beaming in halftone shade; she's sitting, he's standing, and you can tell she's the taller of the two (many of Borensztein's marrieds are of markedly unequal physique).

Impeccablĕ as such details are, there's something consistently out of synch about them, just as there is about the people whose stations in life they serve to represent. Borensztein seems devoted to the idea of searching out an unmasked, essential Americanness, but he isn't greedy about the point and his people don't look especially American in any generic or contemporaneous sense. If anything, they embody a feeling of American previousness (of being leftovers from the fabled melting pot, perhaps) or of an allegorical realm for which "America" is just the name that comes readiest to mind. Perceptual mismatches notwithstanding—or is it Borensztein's instantaneous good will to respond to the incongruous facts of just about any soul?—it's the heartfelt, emblematic sociability of these likenesses as they hold your eyes that makes them memorable.

Artforum, October 1987

John Roloff

John Roloff is known for his site-collaborative ceramic installations, including the many forms of "ship"—his inclusive symbol—that frame them. Roloff grew up on the Oregon coast and attended the University of California at Davis with the idea of becoming a marine geologist. Engaged with what geologists call the Picture (or Big Picture) of metamorphic planetary events with "deep-time" millennia, he explores that larger reality or piecemeal, vertiginous timescapes in a contemplative mood, not as a would-be scientist but sensibly, with an eye to its human and emotional implications. One aspect of his sculptural installation *Vanishing Ship (Greenhouse for Lake Lahontan),* 1987, was that of an observatory for glimpsing temporal activities in nature, a kind of tableau vivant of geologic process. *Vanishing Ship* expressed in a limpid image the slipperiness and vulnerability that inform both short- and long-term life on earth.

Conceived doubly along the lines of 19th-century English greenhouses and simpler lineaments of ancient seagoing vessels, the framework of the piece was a precipitous, mostly transparent glass and white-painted steel enclosure in the shape of the forward half of a sinking ship, mounted and sealed flush to the gallery floor. The ship tilted as it sank, pitched along the keel line at an angle like that of steeply dipped geologic strata. (It's the same angle taken by the upper-most ice floes in Caspar David Friedrich's painting *Polar Sea.)* Early on, the white metal struts showed orangish signs of corrosion, and those, together with the overall sense of glass seeming to tighten visibly between bent steel constraints, gave off a melancholic tingle.

Inside were silt, water, algae, rocks and a gull feather, all gathered from Pyramid Lake near Reno, Nevada, a remnant of the Ice Age inland sea known as Lake Lahontan.

(What is a gull feather doing amid this inland aggregate? An island in Pyramid Lake is an ancestral breeding ground for seabirds.) The rocks were tufa, a knobby calcareous deposit from the Pleistocene epoch. From a small cistern below floor level up through two spray nozzles at different points along the keel, the water circulated; it dribbled down the inner faces of the glass panes, carrying silt to the muddy bottom where it pooled to a 1-inch depth. Interestingly, of all the parts of the piece, this mechanical drip system appeared the most improvised as well as the most immediately fragile.

Robert Smithson once wrote, apropos of monumental sculpture, "A million years is contained in a second, yet we tend to forget the second as soon as it happens." Though the earth, with its intraconnections, may be the center of everything that is our actuality, we tend to misremember actuality, and concentrate instead on the culture that overlays it. Favoring a cultural solipsism allows us to forget that nature makes sense. In those terms, *Vanishing Ship* had the force of a pristine reminder, a compact hymn to actuality as much as a clear-eyed lament for humankind's stunted, or otherwise waylaid, physiographic imagination.

Artforum, November 1987

Sam Tchakalian

In the mid 60s, when he was in his 30s, Sam Tchakalian hit upon the economically inflected abstract idiom that has served him every since. It's true that the basic look of his latest paintings is practically indistinguishable from the look of those of ten or even twenty years ago, but a stabilized design—in Tchakalian's case, of reduplicative troweled-on, canvas-wide bands of solid and/or blended color—needn't imply any dearth in the ideas-and-passion department. Tchakalian has his design motif down pat the better to intuit and locate his passion; at least, that, rather than a sameness, is what you see when his pictures accomplish their utmost, with no loose ends.

Of the ten paintings and nine monoprints in this show, roughly half reveal original ways that mellifluously applied knifeloads of two or three close-keyed colors can modify or heighten their mutual propensities for atmosphere and light. Nearly all of the rest consolidate earlier finds and maintain a scrupulous dexterity. As diminutive pearls go, the monoprints, especially those in narrow horizontal formats, are the genuine article. In the works on canvas, when Tchakalian errs, it's usually on the side of overreaching or haste or both; his exuberance can let a painting slip away or pull itself apart. The blue, red, and pink of *Let's Go Dancing*, 1984, are pungent, but, through too willful handling (on the order of second thoughts), the image goes haywire and the whole painting ends up finicky. Another trouble area is titles: Tchakalian's tend to undercut his pictures' transcendent force with jokey, self-deprecating asides; thus, *Bagel Time* and *Horse Feathers* are tacked onto a couple of paintings (both from 1987) whose compacted strengths deserve more candid, if not necessarily loftier, annotations. On the other had, the

spellbinder of the show, *Magic Door*, 1987, delivers exactly what its title promises and a thing or two extra: a billowing imminence.

At first glance, Tchakalian's ridged and scooting trowel marks suggest that some tremendous slam-bang immediacy is in the offing. When it doesn't arrive, there's a small disappointment, but then you realize the pictures aren't meant to provide that kind of virtuoso immediacy at all. Thick or thin, Tchakalian's paint is more deliberate and evanescent than the welters of its surface activity let on. It communicates slowly and unevenly—stealthily, almost—by nuance. The parallel, panoramic sweeps establish an allover unified space that coordinates subtle distinctions, like poignant though blurred recollections of the changes in weather on a particular day, rather than all-inclusive statements. Separately, a green streak and a pink underglow among the chrome-yellow zones of *Tent Talk*, 1983, spell "incident" much as drumrolls within the run-on rhythms of minimalist music. The pictures have their surface divisions the way people have arms and legs; their individual characters assume those attributes, but the fundamental dynamics of character come from elsewhere.

Similarly, you sense that whatever left its tracks across the girth of *Magic Door* wasn't the hand or tool of the painter so much as an elemental power, whether a sudden gale or a millennial glacial shift. The edges of each taut horizontal sweep both contain and dispel notions of distance and depth. The light is assimilated like reflections of clouds on water or, even more the reflection of a reflection—an afterimage.

Artforum, December 1987

Christopher Brown

Christopher Brown is a young virtuoso painter from the Midwest who in recent years has been identified locally as one of the hopes of San Francisco Bay Area painting. His paintings are full of contradiction. As a virtuoso, theatrically sure of his paint, he puts everything in the right place, and in his new pictures' reconnoiterings of Chinese cultural themes he has included more of "everything" than before. A line drawing of a take-out carton may stand for Brown's initial subjective procedure, as the assorted Mao icons and tags of ancient Chinese philosophy, art, and architecture may show his will to synthesis, his criticality. But, pointed as such details are in their associations, they don't represent the pressure behind the paint, and thus look ornamental. The free-floating subject matter registers as subsidiary to an otherwise ironclad aptitude for design and for transubstantiating rushes and stabs of color. Partly because the reverse is generally the case with Bay Area painting, Brown is an anomaly on the scene. Paradoxically, he has developed from a slightly earlier Bay Area tradition, a jagged lineage of colorists and draftsmen that includes Elmer Bischoff, Richard Diebenkorn, and Wayne Thiebaud as well as Joan Brown and William Wiley. To this tradition, Brown has brought an extraordinary set of skills and a gift for accurately recapitulating his enjoyment of them

without (so far, at any rate) wedging them, or being wedged by them, into the confines of a single style.

All of this may be by way of saying that Brown is a roving academician with a difference. The difference is his idealism, brimming palpably with an eagerness about how he wants his painting to be. His handling of color, for instance, as dashing and weighted as Bischoff's, is studious but never imitative or pedantic (neither does it really let go); its inventions almost always carry a big feeling of pleasure in air and light. Slats of a pale, placid green can be a permeable as lake water and as unyielding as a barn door. A paler chrome yellow can come in sets, like early morning light on ripples of water or the scans of oscillating interplanetary pulses.

Brown's new pictures hint at such variables of materiality and distance, of the ineffability of "sides" in space: the dimly imagined far side of Earth (i.e., China) or the inner physics of art, its uncharted content. The incidental images in *A Chinese Entry*, 1987—pagodas, paper lanterns, a Coke bottle, an ellipse, a section of the Great Wall, and various smudged heads—are sudden sketchy blips in a stabilized fiction of space scored and stretched edgeward by the regulating device of luminous, stavelike horizontal strips. In other pictures, such as *Eighteen Blossoms* or the magisterial pastel *Marco Polo in China*, both 1987, the strips broaden and tilt to make a lapping perspective of contained parallel planes, an accommodating matrix.

Brown is engaged with the life of forms. Where his scale in the large works goes slack, in the smaller ones—the pastels and oils on board in this show—it is exact and expands. His tactile surface flows counter to the diffusion of his ruminative impulse, which nevertheless has led him to a fundamental revelation: that of painting's inextricable duplicity, its double skin.

Artforum, January 1988

Andrew Noren

For all of its intoxicated virtuosity, or maybe because of it, Andrew Noren's *The Lighted Field*, 1987, strikes the eye as a latter-day "early" film. Its surface energies are sparked from a retrenchment in cinematic self-consciousness; it has the novelty of a quasi-primal proposition about film's transforming capabilities and reflexiveness. Since transformation is Noren's theme, to watch him fire up those capabilities and mobilize them is to be transfixed by a magic-lantern display of recorded light and shadow outstripping solid matter in a rapture of shared deliquescence.

The Lighted Field is a silent, tightly built, 61-minute crescendo arrangement of accumulated black-and-white footage, some of it personal, some retrieved from the newsreel archive where Noren works. Although there is no plot (and no titles or credits either), the elements of a story line—an improvised parable or thesis—are strung together and suspended in a choppy succession of frame-to-frame phenomena.

The film begins with a close-up play of light on water. From there, it charges through variations on ephemeral motifs: a gauze curtain shunting daylight at diverse angles around an open window, a sleeping man and collie on a bed, train shadows across an elevated transit platform, an incandescent array of glassware stacked in a dish drainer, a pair of vintage 1940s fluoroscopic skeletons in motion, a woman whispering a secret in a boy's ear. One cut goes from a military execution by hanging to a couple of diving German shepherds in reverse motion above a stream, and another from a graveyard to a vegetable patch.

Diagrammatically, the succession is symmetrical and centrifugal: the rush of mostly single-frame images and spondaic cuts pivots on an episode of silhouetted self-portraiture in an angular double mirror, a black-hole-cum-"Rorschach" scheme that divides both the film loop and its main character, the filmmaker's shadow, in two. That shadow self is also the film's regulating conceit; it's cast at other times on walls and gravestones, and in the final shot it melds with the dark side of a tree, one arm raised in triumph. Like much of what goes before, the upbeat ending has a chill factor.

The film's sluicelike dispersal grid abstracts, even as it triggers, the viewer's wonder. In this collision course of sights, the montage catches every image just ahead of, or behind, meaning. It leans stressfully on the metaphorical proclivity of film to become a memento mori—each frame closer to the last. The image world is a still life paradoxically animated by the shutter's brief click and then again kineticized by discrete frames falling against a beam of light. The ultimate agent of Noren's "field" is the projection screen from which high-contrast lights and darks rebound with the intermittent slices, flares, and thuds. Thus, everything reflects its own existence as a haunted celluloid fiction, by turns melancholic and clinical: the drawer opening and closing with a cat in it is a kind of camera; people mounting the train platform are forms of footage; the entire film is a grave/garden. Noren himself says that *The Lighted Field* is "an alchemical fable," which rings true enough, given that alchemy's long-range goal is to memorize the cosmos while finalizing in spirit its present tense.

Artforum, February 1988

Viola Frey

Since the early 80s, Viola Frey has been prodding the outer surfaces of her ceramic sculptures to get the physical form together with a patchy, transfiguring impetus. In going for this extra vitality, she's moved away from a prior refinement. Now thick, drawling paint and pitted overglazes coat the figurative contours, mimicking enlarged effects of light and shade and suggesting internal anatomy, too. Sometimes the modeled forms are so swamped as to seem complicated supports for high-keyed painting; at best, however, the paint helps the eye follow each volume around from any angle so the figures' three-dimensionality appears more blatant. It's as if Frey were purposely reversing the

procedure that Jean-Paul Sartre claimed for Alberto Giacometti's thin people: she's putting the fat back on space.

Of the eight ceramic pieces in this show, five were isolated male or female figures about one-and-a-half times life-size. These huge statues hold themselves up within a centerless gravity. Four of them—two nudes and two suited figures supported on big flat feet and towering with chunky sections stacked from the hips up—seem absorbed with keeping themselves coherent and in balance; like cigar-store Indians, they look breathless and cramped. Their petitioning gestures turn clunkily inward. It's not a giganticism that enjoys itself as Niki de Saint-Phalle's "Nanas" or Claes Oldenburg's aggrandized household objects do. Frey's private giants are helpless in their excess the way real-life giants are. Perhaps her message is that modern humanity's self-image ranks grossly among nature's overstatements, and therein lie both its despair and its charm. In that respect, the curled-up *Untitled (Prone Man)*, who has an unconventional antique grace, is the most candid of the big works: his frame assents wistfully to gravity where the others seem thwarted, consigned to android musings on how to manage their upright, extended hulks.

The other three sculptures were compacted figure groups in the round. More temperate than the single figures, they take Frey's paint less lugubriously and enjoy freer, coordinately implied motions. Each group, set upon its mock-formal plinth, stands for a scaled-down mental set, a tableau of sculptural impulses and memories. *Untitled (Surprised Group)*, facing in one direction only, heaps art-historical figurines at the feet of a couple of Frey's sturdier businessman characters while, in the background, a female nude clamps a hand over her mouth. The piece has an ingenious, airy symmetry, an abstract clarity that defines all the characters sociably—you know them, and more than that, you feel you *want* to know them.

Frey wants to bring the inside out and the outside in. In sculpture, this means allowing the surface to dissolve between vagaries of what the three-dimensional object resists making visible. Frey's painted sculptures always imply either more or less than "skin." On the other hand, her drawings (represented in the gallery by thirteen large works in pastel or charcoal on paper) accommodate contrary directional shifts with no dissipation of surface. Why do sculptors' drawings often appear so especially accurate and limber? Frey's indulge her sense of incident; they reveal a storytelling bent that freestanding sculpture can't help but deflect.

Artforum, March 1988

General Idea

The prospect that General Idea's AIDS poster, 1987, modeled on Robert Indiana's mid-1960s LOVE image, might achieve a cultural visibility like that of its predecessor is discomforting but maybe inevitable. LOVE started out as a painting and proliferated as prints, sculpture, trinkets, and eventually an eight-cent stamp. Despite a foursquare

hardiness and glints of Op-ish rapture, it always exuded a locked-in anerotic somnolence. A commentary on either image's verbal component would be negligible, although AIDS, unlike "love," doesn't shift much in its connotations. General Idea's metonymic hook seems obvious: the horrors of the AIDS pandemic in the 80s cancel, or anyhow overlay, the wishful love ethos of the 60s.

At best, the dryly crafted logo, which is neither profound nor crassly cynical as a piece of image management, may be serviceable as a blanket public-service reminder. General Idea has moved Indiana's colors around just enough to preserve the balanced format; the blue/green/red registrations and the broken monosyllable still wittily impede a single-focus reading. But the AIDS image lacks the self-supporting geometry and typographic grace of the original design; instead, it breaks into top-and-bottom episodes, with the netherparts awkward and squat, undermining the bulwarklike initials up top. Does that make sense? To the extent that the space between official representations and people's actual experience of disease and dying is patently out-of-kilter, it does.

The AIDS serigraphs covered all four walls of the large inner room of the gallery as well as a number of facades at the outdoor sites. Another, smaller room had a set of similarly square paintings and constructions using the standard copyright sign stained or appliquéd with leather on bleached and frayed blue denim. These were hung on expanses of plywood tongue-and-groove paneling that suggested a boutique with a "frontier" theme. The "copyright paintings" are duds. Their intentional relations to Jasper Johns' "targets" (what else would a widely stenciled "c" centered in a circle suggest?) seems only half-conscious. The conscious social trick involved—that nobody owns the copyright sign—amounts to a tautology that goes nowhere. It's another case of the obvious being made to resonate less meaningfully than it should.

As a whole, this show demonstrated that, for all their suavity, the members of General Idea (A.A. Bronson, Felix Partz, and Jorge Zontal) have succumbed to a self-academicizing fixation: that of turning a playful criticality into species of regular work. General Idea's critiques—their mock-mercantilism and specialty-act media blitz—tend to boomerang. In their videos, three of which were screened in the gallery's third, outer room, such reflexiveness reaches a fever pitch. Amid the dancercising poodles and obligatory Schnabel-bashing in *Shut the Fuck Up*, 1985, there's the eerie sense of Zontal's carrying on a *Taxi Driver*-type mirror conversation with himself as he delivers the title refrain: "When there's nothing to say, shut the fuck up." The AIDS posters argue greater significance, if not effectually more nerve, than a pack of art-world poodle jokes. The poodles were triumphs of throwaway promotion. The AIDS posters are almost too smart for anyone's good.

Artforum, April 1988

Robert Ryman

Robert Ryman spreads white paint across his mostly square-ish supports as if to make a hyperbole of essential surface. His new "Charter Series," designed as a "meditative

room" for Gerald S. Elliott's apartment in the Hancock Tower in Chicago, interprets the plain monochrome surface and its few, carefully adjusted enclosures like a social dancer showing you the mystifying thrusts in a rudimentary box step. Each painting is a fabricated fact, a virtuoso performance of refined contrasts, a meticulously blank façade in which nuance of tone and assembly is everything.

Ryman's five paintings aren't images. They require a minimum encounter of 30 seconds to make any kind of dent. Inspect the surface and you see a wealth of detail seemingly more unusual and quirkier than its sum; turn away (or leave the room) and you wonder if you saw anything particular at all. The aphoristic sweep makes the clearest recollection of detail seem desultory. As in William Carlos Williams' poem "The Descent": "no whiteness (lost) is so white as the memory / of whiteness."

Charter, 1985, which could be considered the prototype for the series, states a theme that the other, later pictures sift through and expand. This is an array of two white near-squares and three raw-metal rectangles done on a single, bent aluminum sheet that slips vertically along, then away from and back to the wall where the upper "square" begins and ends. It's fastened near the edges at the top, upper middle, and bottom by bolts. The protruding boltheads join in the pictorial mix by twos, dotting the corners and peeking out from the shade cast by the cantilever. The object's variegated light unfolds and regathers with an arcane orderliness like that of circular breathing in music.

The remaining four works look breathless by comparison. Closely modulated by grainy aluminum flanges along which separate fiberglass panels are fitted and horizontally aligned, they're more representative of the Ryman we know. *Charter II* follows sensibly as a caprice, syncopated and disorienting, a sentence with a dangling participle—a seemingly random stubby piece of raw flange with a mitered end pointing to another, longer piece which in turn butts to a bolthead. Elsewhere the flanges settle in as regular optical dividers, fulcrums of energy—bars, really—that discriminate between fields of unaccented white and provide slight embankments, or ridges, for the eye to rest. Preponderant whites make the glints and solidities of hardware (the bars, the boltheads) more acute. Where the partially painted center bar in *Charter III* charts a wide, barely shifting symmetry, like a device in celestial navigation, a pair of similar bars in *Charter IV*, makes a down-to-earth contraction. *Charter V*, the centerpiece in the San Francisco installation, adds a shimmering perpendicular that takes a two-tone lift from middle to top like a high, bent trumpet note.

Ryman is a conservationist of the angelic literal. One effect of his no-image is that you must see each painting firsthand each time to have any idea—besides general ones like those given above—of the particulars of its apparent (and perceptually full) blankness. No painter owns white because all whites are subjective. Ryman uses white, just as he uses approximations of the square, to maintain an open singularity, a residue of which accumulates intelligibly past the edges, so the viewing space and the viewer both appear distinct, educated, and momentarily glad.

Artforum, May 1988

Doug Hall

The sculptural installations, mixed-media paintings and drawings, and other wall pieces and videotape screenings that Doug Hall arranged for this gallery show had an air of waiting out their own apocalypse—an apocalypse of excess allusion and piled-on metaphor, of dysfunctional meanings at hypercritical mass. Meaning in art is equated (in the critical sector at least) with power. Hall's longstanding fascination with images of power, whether raw or contrived, demagogic or meteorological, has led his art to the verge of an irradiated stasis where delays or sudden outages of meaning are the norm.

Color-coded cruciform symbols limned in charcoal and shellac on square paper bristle with an inadequacy to their received content. Accumulated (and inassimilable) meanings tend to wipe each other out, or avoiding the tabula rasa effect, their plethora equivocates. Equivocation is the edge that Hall's work plies. It's his form of sublimity. In his levelheaded way, he indicates a series of precipices that in turn give onto a cultural vortex of ostentatiously dovetailed response mechanisms.

What Hall calls "the insidious triumph of form over content" is also delirious; its issue is that perpetually chilling novelty among historical artifices, the empty emblem. Thus, *Josef Stalin*, 1984-88, consisting of two separate rectangular panels—a yellow-velvet horizontal above a larger vertical of red-painted glass, both locked in heavy steel frames—presents a stacked image of no intrinsic charge; its referent is supplied from the outside, prosthetically. Similarly, the meaning of an installation piece called The *Arrogance of Power*, 1987, seems to slip away from the space of bright yellow wall between the title etched in a small square brass plaque and the slender pillar mounted on a truncated-oval steel platform. The pillar, slit down the front, discharges lengthwise a plain black nylon flag.

Hall takes the idea of esthetic distance literally. He makes distance operative, and in his best pieces, it is precisely distance—for example, in the videotape *Storm and Stress*, 1986, the capacity to mentally locate the coordinates of a lightning flash on the horizon—that resounds. Elsewhere, the opposition of object and meaning is salutary because it forces awareness of the changeable character of materials: the ability of stretched velvet to absorb light, or how steel plate can look both obdurate and tired. In *Storm and Stress*, the inset view of a tornado takes its charge from the fact of its being studied remotely (by Hall in his role as technocratic guide) within what appears to be the makeshift "theater" of a NASA lab.

Distance, like meaning, is reversible. Hall says, "The storm is in the mind; the lightning is in the room." Looking at where anything is or what's next to it may be the closest to objective definition one can get. As a Conceptualist, Hall doesn't theorize so much as use his intelligence to get a clearer look. As a satirist, he is never other than oblique. In the openended series of "newspaper drawings," begun in 1981, he takes up black and red oil stick to close in upon and cover the post-and-lintel formatting of blocks of type and halftone cuts that make up front-page news. The process is a kind of thermal scanning, with orderly colors glossing over dead spots in the official text. If the day's page heats up in blips of suspected meaning, less text is obliterated.

One headline that reads "DIGGING FOR BODIES" lies across the top of an otherwise defaced sheet, the marks on which resemble geologic strata. Another drawing parallels the chthonic loops and tensions of Hall's mock history portraits: a large, square headshot of Elliot Abrams commands the upper center of the spread above two progressively smaller images—first of Albert Hakim conferring with his lawyer, then of the Reagans presiding at an Israeli state visit. The encrypted page amounts to a phantasmagoric joke: connecting one informational blip with another builds no bridge (no language, really) but rather leads one slip further into composite oblivion.

Artforum, Summer 1988

Yvonne Jacquette

Yvonne Jacquette is the kind of realist who, as Constable said of Ruysdael, communicates an understanding of what she paints. Painting everyday life as seen from above, she follows realism's way of intensifying the seemingly casual visual perception so that its deeper necessity stands revealed. Her understanding admits the tangled nature of her subject: a separate view on the world every time, within reach of melancholy but spared the more topical forms of fuss. She has made the luxurious airborne overview her specialty without dramatizing its alien's-eye peculiarity. Architecture, streets, traffic, topography, and—where the view is telescoped—people on the go are distinguished first for themselves, each in character rather than serving an abstract conception about how things do or don't fit. Thus the larger abstraction—the surface-wide image as a whole—emanates from the pressures of vivid detail.

Jacquette's new pictures are mostly New York cityscapes. Taken at oblique angles from airplanes and the upper stories of commercial building, they extend an unconventionally open attitude toward managed, albeit intractable urban space. They tell of city life in a city-dweller's terms—spectral, bludgeoned, wobbly or dour, unpredictably entranced but ever watchful and a bit hunched. Three large triptychs, each an array of discrete views, focus on local luminosities. There are new elements of power in large right-angled shapes commanding corners of the frame edge and keyed-up hot colors for synaptic traffic tides. A titanic planar splurge of blue neon glowers above street level where dusky figures strut solitary or by twos, oblivious. Each neighborhood suggests a banner topic heading: the polymorphous nocturnal reverie of *Times Square Triptych II,* 1986-87—electric signs for food, drink, and stereo equipment angling around "Porno Tramp" and "Hope Erotic Interlude" marquees (all of it lapped up by the squiddish white traceries of headlight beams); a quintessential, cloud-smudged "night burn" in *Triboro Triptych at Night II,* with busy thoroughfares like lava flows searing the groundplan, and demonic smoulderings in the vortices of cloverleafs. Then, in the convex, enpaneled scenes (progressively higher and pulled back) of *Reflected Façade (Whitehall Street) II,* 1987, a daytime lower Manhattan lightens up, tumbled in harbor breezes, and the climate

dominates like drapery. An exact euphoria: how steel and mirror-glass agree with air and water on mutual jounce-and-ripple effects. And a paradox: tonal attentions to miniscule detail (grains in an orange office desk echoing corrosions on the Governor's Island ferry's hull) allow that nothing's peripheral to the picture's overall projectile punch. The gridded surface is the whole point of focus, like a screen.

At their further removes, Jacquette's rural views (in this show, some pastels of Texas and the Midwest) show the cellular patterns set out where nature and management comingle: a sawtoothed woods, a porous quilt of plowed fields and, cutting across both, a pair of dusty roads. All such material life has its human implications, to which the pictures bear witness. But these images are primarily clear about seeing. Each one allows for seeing more from edge to edge than the eye could ordinarily hold. The intensification of optical face value derives from a double insistence: complex notation adjusted to meet painting's objective order of space and light. Jacquette's repeating streaks and striplings of color indicate shifts of awareness as much as the diverse motions within an image's fixed imaginary air and bulk. For every flickering intricacy, there is a breath, an interval intelligently applied.

Artforum, September 1988

Deborah Oropallo

Deborah Oropallo's paintings might be classified as a new, piquant kind of Magic Realism. They don't resemble the old, mid-century, mooning kind; less private, more assertive, and precisely melancholic, they live up to the term better, and more literally. The gem of this show was a small painting called *Lemon Vanish*, 1988. In it a lemon and a black top hat (props gleaned directly from Manet's bag of tricks) occupy the center of a compact field, fixed by burnished swaths of light ocher and deep, icy green. A pair of perforated ellipses diagrammed on the hat's crown testifies that the lemon is inside the hat. The joke on appearance is enjoyable because the painting itself is so lucid and forthright.

At 34, Oropallo has cultivated a remarkable range of skills and styles, from brisk trompe-l'oeil rendering to moody latherings of free-form paint. (Her surfaces are elaborately layered, then sanded down and covered with a hard, gleaming film of either varnish or encaustic.) Still, her project continues to be a youthful one of pulling together a pictorial idiom and intuitive thematic premises brightly out of bedrock materials. A virtuoso ahead of her conceptions, she's looking for a way in. The themes of the recent large pictures draw on Americana of a particular order: front-page newspaper stories of disasters, natural or technological, from the past hundred or so years. Lines of type depicted freehand across some of the canvases suggest a ghostly sort of "voice-over" antiphony. (They also recall the lettering in Mexican *retablos*.) Each image carries a proviso of survival, or at least the implication that, despite the magnitude of the calamity, life goes

on. As ideas go, Oropallo's are none too deep, but to the extent that they provide metaphors for picture making, they manage. *In Partial List of the Saved*, 1988, three columns of names are limned over a profile image of the Titanic afloat; the rust-colored names are of passengers who drifted away from the wreck in lifeboats. Other pictures allude to tornadoes, an earthquake, a plane crash, a circus fire, a mining accident, the bombings of Hiroshima and Nagasaki, and the recent drama of a girl trapped in a well. Uniqueness of incident is honored by a specificity of compositional attitude for each. The unifying factor is light: most of Oropallo's big pictures contain an Eakins-ish light, broad and pale and impinged upon by multitudinous darks, a brand of chiaroscuro that amounts to its own form of Americana. Commanding the top quarter of *Dictator*, 1988, this light is prodigious; it sparks the composite imagery without interrupting the subterranean suspense within which half-focused memory objects merge.

Julia Moore (1847-1920), who was known as the Sweet Singer of Michigan, wrote awkward verses about such events as train wrecks, drownings, epidemics, and casualties of the Civil War. Moore's work was unintentionally absurd and Oropallo's is not; nevertheless, the parallel seems worth noting. Oropallo's wit, when it shows, is sharper than the artist appears willing to allow—it's shy of itself. Her pictorial sincerity outstrips her topical subject matter. Her most ambitious paintings—on their way to becoming "machines," in the 19th-century, salon-blockbuster sense—communicate large-scale distress for which the ostensible correlatives (news items that trigger conditional feelings at best) seem comparatively picayune and remote. The smaller, plainer pictures, on the other hand, harbor no such dilemmas; they are armed with fate.

Artforum, September 1988

Roger Hankins

Roger Hankins has hit upon something rare: a painterly conceptualism that, far from being remorseful or snide about its parameters, pounces with glee at the sight of them. In 1984, while visiting New York from California, Hankins wandered into a discount art store and, fascinated by a stock display of cheap, handpainted still-life pictures, managed to acquire a set of them at bulk rate. Since then, he has continued to stockpile examples of the same, more-or-less-anonymous items, using them as the material grounds for his own painting. Seventy years earlier, in the dim light of a train compartment en route from Paris to Rouen, Marcel Duchamp had added two tiny marks of red and green gouache to a bleak commercial print of a winter landscape and inscribed the title *Pharmacie* near the bottom. (Duchamp liked the fact that his impulsive highlights resembled the tinted bottle common to pharmacy window dressings at the time.) Hankins may have taken a cue from Duchamp's gesture, but the operations he performs on his found originals are anything but a show of Duchampian visual indifference. He sees the oddball object with a painter's eye. The pictures he retouches are assembly-line products, many of them reduplicative (that is, the same image limned the same way twice). Carted by the

truckload to motel showrooms and frame stores and promoted under the rubric "original oil paintings," they're done in an antiquated quick-stroke, by-the-numbers technique that by the 40s had devolved into a staple of popular illustration and of "famous artist"-type correspondence schools. They have been made to satisfy the ground rules for a standardized fine-art depiction without any recourse to looking at the things they represent: there are grapes that resemble fuzzy unripe olives, apples pale as turnips, happy-face cherries with preposterously elongated stems, as well as antiquarian-cum-artsy setups featuring violins, books in leather bindings, and an occasional quill.

Hankins goes after these genres with an assortment of generic Modernist moves. The original arrangements—or fair-sized portions of them—still show. Imbedded within, or slicing through their formulaic tabletop schemes are geometrical abstract shapes and/or sketchy brush or palette-knife daubings that look as pictorially at home as anything on the surface. In *Zero Tolerance*, 1988, a long-necked, viridian wine bottle pokes up from the folds of a white cloth alongside a pile of different colored rectangular patches that holds a peonylike splurge of scumbled pink and white in its midst. Rather than the old idea of nonart jolting a fine-art context, the stylistic intervention makes for a peculiarly free-floating symbiosis. The intrusion of live characters into the animation space of *Who Killed Roger Rabbit* has a similar deracinating effect. The viewer's double take hinges on a seamless coherence of near opposites.

Hankins communicates with the given object, transliterating its surface to pronounce such secrets as it would not have been expected to contain. His procedure sometimes attenuates by its own mildness, its susceptibility and resolute friendliness toward the original image. In terms of visual recognition, the ultimate impact of the paintings is not theoretical, but sensually ecstatic and poignant. As signs go, their adventitious geometries and loose, expressionist glyphs look just as fleeting and artificial as the retarded apples of the workaday formula painters. Nevertheless, the idea is still to make a painting. It's the knowing, sanguine complication that rings true, both visually and mentally. Hankins's rigor consists in keeping his touches sociable, nimble and light.

Artforum, October 1988

David Park

David Park had a way of making the human figures in his late pictures seem timeless in their solidity and placement yet fleeting in character; the more relaxed Park was with his paint, the sturdier they became. They might be the stand-up schematic remnants of some Golden Age; they might be trees. Such figures were represented in this show of works on paper by seven undated ink-wash drawings and a dozen gouaches from the series of gouaches Park did in 1960, within the last four months of his life. They exemplify Park at his most declarative and vibrant. The rest of the selection comprised drawings in pencil, chalk, watercolor, crayon, and felt-tipped pen from the mid 30s on, and a large collage of portrait heads from 1952-53. The pencil drawings show various modes of compression

and an innate quirkiness. Park liked to give his figures little if any headroom against the top edge of the sheet; he regularly made his male figures raw-boned and lanky and the women rotund and squat.

Park's few years with abstract painting in the 40s led him to a stronger grasp of the whole surface and how to divide it into large, simple units. The Art Deco-type Cubism he had adapted for his sequence of "Old Testament Themes," 1934, was clean-cut: in fact, the drawings in that series resemble studies for relief sculpture. The bold, plain colors of the final gouaches come across as succinct and a bit detached from one another; within their overall spaciousness, they have the tidy, stabbing gradations of woodcut layers. By contrast, some of the no-less-spacious halftone nudes done in ink appear as if built of ashes.

In his last years, Park combined the two salient thematic impulses of his work, the domestic and idyllic. He saw the ceremonial in odd chunks of space occasioned by people in contemporary settings. He trusted his memory for such things and finally trusted his art to reveal them. The late figures unfold from uncertain environs. They are models of Park's feeling for a humanity wedged between rootedness and deliquescence. The light that sets each of them off is peculiar, sometimes catastrophic, never nebulous. It beams in abruptly from behind, settling along the contours of shoulders and legs and feeding the pressure that makes a facial caricature—constructed of fat shorthand strokes for a nose, eyes, an ear or two, a neatly turned-up (or, in profile, strangely puckered) mouth—look to have burst against the surface plane.

Given that pressure, it's amazing how much breathing space Park managed to allot his people, even when they're huddled en masse. Among the gouaches, *Group of Ten* may be about solitude in the herd, but its ebullience is cumulative: the tangent figures gang up on the light, redirecting it in a fitful fugue effect. In *Woman with Baby*, a remarkable tenderness issues from the equating of touch with the flicker of light across bodies. An isolated figure, such as the one in *Rowboat*, appears more tense; twisting with his oars against the flash of sun, he becomes a piece of time, a kind of waywardly reflexive clock.

Artforum, November 1988

Wayne Thiebaud

Although both David Park and Wayne Thiebaud would be termed figurative painters, the differences between them are more immediately apparent than their similarities. Thiebaud came into prominence a year or so after Park died. His position just outside the general Bay Area Figurative scheme is as peculiar as Park's was within it; neither of them ever fit the penumbral psychologizing mold, as it developed, to the extent, say, that Elmer Bischoff preeminently did. Park was, and Thiebaud is, a painter of discrete images located in spaces charged by scrutiny, as well as by the manner of depiction. One difference is that Park's spaces tended to be filled up as extensions of his subjects' flesh,

and Thiebaud's, until recently, have been bare repositories for mostly impersonal objects. Another has to do with background: Park's work was rooted (however shallowly) in a latter-day beaux-arts tradition, whereas Thiebaud's began deep in commercial illustration.

Especially interesting in this compendious traveling show, "Works on Paper, 1947-1987," are the drawings and watercolors Thiebaud did from the late 40s through the 50s and the watercolors and oil sketches since 1985. This is not to slight the works of the intervening years; they are simply more familiar. The 40s-50s pictures don't challenge the assumption that Thiebaud hit his stride in 1960, when he settled into painting still lifes of food displays, so much as they provide a view of the finesse he had accumulated to make his peculiar vision stick. By 1947, when he laid down a few brisk cubist parallelograms for the ink drawing *Rock and Sea*, Thiebaud had already spent ten years as a cartoonist, layout designer, and illustrator. (He would arrive at this decision to become a full-time painter two years later.) Schematically, the distinction between *City Street*, 1952, and *Lighted City*, 1986, isn't great. Both are watercolors syncopated in ways that recall John Marin, but the earlier work is all strong shape and no sensibility, while the newer one has the sparkle of forms coalesced from a high yield of fantastically opulent hues.

Thiebaud's handling and color are task-specific, so that a single motif can be transformed in many ways through different processes over time. In drawing, his style is no-style, as neutral as Sargent and similarly decisive. (As ever, his characteristic gesture is revealed in the heavily delineated shadow, which detaches itself from the figure to suggest another, parallel existence.) As for color, the different reds in *Two Paint Cans* and *Ribs*, both 1987, have a tactile meatiness that could be wrought only in oils. The new watercolors of San Francisco slopes are elastic in density. In *Ocean City*, 1987, two panoramic masses of wash-and blot tones engulf the sliced and dappled contours of buildings and streets. *Blue City Ridge*, 1986, is a single, nearly uniform blot. *Civic Downgrade*, 1986, divides into separate bands of deep black charcoal and bright oil paint, so that the restless composite view percolates.

Another surprise appears in the watercolor *Running Figures*, 1987, which picks up a narrative thread Thiebaud abandoned in the late 50s. The "running" of the title must be a pun on how the compact couple (male and female on a beach) is rendered—each in a dribble of orange silhouette. It's one of those pictures that gets everything oddly right, including the liquid properties of the medium it's made from. Thiebaud is a past master of floodlit dislocation. He now seems absorbed by more intricate zones of facts, emulsified in their own light.

Artforum, November 1988

Hung Liu

Hung Liu is a Chinese artist who now lives in Texas. She received formal training first in her native country during the Mao regime and recently in the conceptualist-oriented graduate program at the University of California, San Diego. "Chineseness," in one form

or another, but especially in its migrant forms, is the basic theme of the two installations she did at separate sites here. The more general themes are movement and difference—especially the difference, say, between being Chinese in China and in America, or between immigrants' anticipations of wealth and the fake gold leaf on Chinese-American temple money.

All movement passes through, or perhaps ends in, difference: as Liu says, "Everybody is some kind of alien." The larger of her works, *Resident Alien*, 1988, dealt elegantly with points of brittle cross-cultural distinction. Around an empty, *L*-shaped office space she assembled paintings, wall drawings, and groups of objects (temple money, abacuses, fortune cookies) associated with Chinese ethnicity and immigrant experience in the Western states. This complex array was bordered on all but one wall by a frieze depicting a man doing tai chi. Conceptually, the viewer's course paralleled the large-scale cultural transience implied by the images on the walls and pillars of the room. The static setting for modes of dislocation—"China" as a kind of non-site, with its effects shunted to the provisional contemplative limbo of sheetrock, plaster, and bare concrete floor—served to x-ray the viewer's own cultural baggage. On the pillars, Chinese characters spelled out a litany of 488 classic family names, as well as a selection of poems written on the walls of the U.S. Customs post at Angel Island by those detained there between 1910 and the beginning of World War II. One painting showed a 19th-century shrimp junk afloat on San Francisco Bay; this image registered a mediating distance between two bigger images—a dejected "slave girl" standing at a muddy Chinatown intersection and the "Beauty" from a Tang scroll. In other pictures, a blow-up of a monstrous cartoon featured a multi-armed Chinese laborer grabbing jobs away from American youth, and a representation of a "green card" (the official sign of resident-alien status) had the artist's mug shot, fingerprint, and the words "Cookie, Fortune" in place of her real name.

In a sense, the fortune cookie stood as the *chi* (or "life-energy center") of the piece. Four spotlit mounds of them—the largest one signifying "Old Gold Mountain," an early Chinese name for San Francisco—were set at widely spaced intervals on the floor; more were placed for the taking in a carton at the entrance. The "fortunes" were lines of ancient Chinese poems in English translation; mine read, "Someone comes home on this night of wind and snow."

On the face of it, Hung Liu's other installation, *Reading Room*, 1988, is a far simpler proposition. Installed in the community room of the Chinese for Affirmative Action headquarters (the actual site, the Kuo Building, once housed the city's first bookstore), it may be maintained as a permanent fixture, replacing the travel posters that ordinarily have occupied the walls there. In the form of a three-foot-high "scroll," a mural, with objects attached, tells the long history of Chinese writing and books, and ends at a case displaying four rows of modern Chinese reading matter. (Although the community room is sometimes used for reading, there are rarely any Chinese-language books to be found in it.) Liu's selection included such items as *The Pinyin Chinese-English Dictionary*, a D. D. Wang bilingual opus from 1987 entitled *What You Should Know About Life Among Americans,* and a Chinese translation of Dante with florid 19th-century European illustrations. Liu has poised her projects, sans resentment or polemics, on the

edge between agitation and the impulse, as indicated in *Resident Alien*, to "narrate systematically and in full detail." With all the attendant ironies, the result in both works is a wide understanding made palpable.

Artforum, December 1988

Richard Hickam, Paul Klein

A few years ago, Jasper Johns was quoted as saying, "Art is either a complaint or appeasement." By dint of their specific, ripe, and sometimes raucous colors, Richard Hickam's paintings appease with an old-fashioned effusiveness which is mostly a matter of handling. The subjects—most of them human figures in boxy abstract spaces—tend to be still or in positions of flatly arrested motion or thought. Hickam's characters exist privately. Many of them, like the imaginary moments they occupy, are made up as the painting goes along. By contrast, the nude or seminude male figures in Paul Klein's large, painted photographs, although similarly alone, exemplify an idealist's public distress. Klein's planned dream images are emblematic complaints of isolation and confinement stated in general psychological terms. Commanding separate sides of a single gallery space, the works of these two artists had something to say to one another but in different languages.

Hickam is an ex-Photorealist who now works predominantly in the tradition of what might be called "unimproved" gestural realism. He's a Midwesterner with a taste for California-type painterliness. There are Richard Diebenkorn-inspired areas of blocked-out color, dashing strokes that recall Elmer Bischoff or David Park and a nude with look-alike older cousins in Wayne Thiebaud or even Mel Ramos. But none of these resemblances get in the way of Hickam's conviction; the energy and humor of his pictures have nothing to do with style. The profile figure of a woman in *Carmen's Crinoline,* 1986, takes up an awkward pose—knees bent, back straight, head slung forward, hand splayed, in a kind of implausible dance step—against a pileup of rectangles that suggests architectural shifts. At her eye level bobs a miniaturized beach ball. The picture is done busily, piecemeal, with a different texture for each part, so that the woman's character is delivered as a sequence of edges among other edges. All the edges clunk in the suspended moment without falling apart.

Where Hickam's people come from is as much a mystery as the spaces they're in. The officer in *Stiff Upper Lip* and the ingénue in *Remembering Young Girls with Soft Hearts,* both 1988, have an averted, wistful, Edwardian look straight out of *Masterpiece Theater.* They're both contemporary and not, or if contemporary, they're decked out in nostalgia wear. Even the "mini" in *Woman with Yellow Skirt,* 1983, has a vinyl 60s flair at odds with the direct, present-tense body image: the torsion and pinpoint glance and mop of brown, shoulder-length hair are all perfect 80s. It's that rare form of studio nude that doubles as an intensive portrait of an actual person.

Hickam's pictures thrive on their discrepancies, and his characters deepen and breathe on account of them. Discrepancy in Klein—between his figures and their settings, between the photographic sheet and the paint he applies to extend an image—occasions a perceptual duress in which nothing is real in itself. The effect is of a rabid portentousness chewing up the available space. Klein blends faint life-size exposures of models into high-contrast shots of abandoned urban rooms, then uses paint to clinch the mood. (Paint on photographic stock may be inherently gruesome.) The rooms retain bleak traces of domestic use: sinks and bathtubs glare from ratty recesses; an empty toolbox occupies an area of spattered floorboard next to a beer can. Some blue paint seems to stand for the dankness of a tiled wall, as dull red does for bursts of flames in passageways. The men hover in the foregrounds, sometimes pinioned by beams and rafters, often bearing traces of flame. In dislocated contrapposto gestures out of Old Master paintings, they betray a grisly, futile humanism. Where Hickam is boisterous and eager, Klein is dark and dour, and his images are made all the more nightmarish by the elegant malice of their fabrication.

Artforum, January 1989

Michael Tracy

For *Santuarios*, his installation here, Michael Tracy made the exhibition space over as a chapel. He had the main gallery's high walls painted dark gray and deployed along them, and on bases throughout the room, a large selection of the exquisitely traumatized ritual objects he's been making during the last ten years. Thick, stumpy cruciform assemblages, crepuscular shrines and paintings and iridescent bas-relief panels drew illumination from the skylight overhead, bristling in spectral heaps of semipermeable catastrophe, a chthonic mulch.

These lurid memento mori contrasted with the cool, clean lines of wooden grillwork partitions and furnishings—including a couple of large uninviting chairs and a confessional—all built to specifications for the show by Mexican craftsmen. Tracy dedicated the chapel to the recent war dead of Nicaragua and El Salvador and the Mexican *mojados* (wetbacks) traversing the border near San Ygnacio, Texas, where he lives. Altogether the installation had a loaded, no-false-notes, incontrovertibly ceremonial look. This was augmented by the fact that it was used on two occasions to enact the Roman Catholic Mass: once for the local Hispanic community, and again for healing the AIDS epidemic.

Tracy's type of mixed-media art can be as enthralling as it is gross. A legend has grown around how his things have been worked over—covered with acrylic gel and metallic powers, exposed to the Texas weather, doused with blood and urine, interred and exhumed, stuck this way and that with pointed instruments (beside standard-issue knives, swords, and spikes, some lethal-looking, outsized sewing needles), and eventually hung with almost every available votive and reliquary item, from hanks of hair to tin and

brass *milagros*. Paradoxically, the traces of this accumulated, immolative *brut*, gutted and gut-grabbing, congeal into objects of dazzling preciosity, in which transcendence appears hopelessly mired. That they might be just outrageously beautiful objects gives the art-world congregation pause: the esthetic success triggers a reflexive shame. (It's as if the more he harasses his materials the prettier they get.) If an expiration of social cruelty is yearned for, even palpably at hand, it is also forever deferred—a casualty of the art's seductive, insistently decodable ideographic surface.

Tracy's iconography builds to one long, deracinated prayer—operatic, noble, tremulous in the coloratura range. But his prayer's actual weight makes of it an obdurate delay. The point may be that his offerings can be provisional at best, that their very dysfunction pinpoints the blind spots we've cultivated against communion with the world's ills. Their prime efficacy is to make the viewer, as Tracy says, "sensitive to other people's pain," without any real hope of assuaging that condition. Following a desperate theology of liberation, his gouged icons embody—and embroider—secular horror by lumping it together with a refashioned religious myth. Their project, though, is not so much to adorn the cross as to penetrate it, to probe the truth beneath its veneer, extrude its pulp. The confusion involved here is proportionate to the viewer's capacity for taking such exacerbated sacramental imagery to heart as anything other than a theatrical conceit. As theater, Tracy's chapel was momentous and awesome, and perhaps that is efficacy enough. Its down-and-dirty perversity inspires belief. That neither Tracy's sincerity nor his power to project it is in question is extraordinary to being with. Does his religious art have a hope in hell? As Jack Kerouac once said, "Walking on water wasn't built in a day."

Artforum, February 1989

Harry Fritzius

Even before he began showing 4 years ago, Harry Fritzius was typecast as a shamelessly wayward Romantic fabulist, laying his heart bare in the wrong epoch. But his is really as timely as any other post-History history painter. In pursuit of a grand manner, he has run up against a sublime as knowingly degraded as Ross Bleckner's and as erratically self-propelled as Julian Schnabel's. Like theirs, Fritzius's big statements are based on an attitude of will in place of belief. His low is a kind of mock frenzy set thrashing among great, hoary themes; his high is a poignancy as calibrated as despair.

The show here featured anywhere from ten to fifteen paintings, depending on when you saw it. (Typically, Fritzius would snatch some of the works back from the gallery for further alterations. And there was one last-minute addition, a luminous *Pietá*.) With his flamboyance intact but somehow judiciously stabilized, Fritzius has turned his art into a more finely honed version of itself, now coiled tightly within its own range. Gathering together his gifts as a painter and making them click more consistently, he's gotten himself out of the way of his work.

Fritzius's allegorical approach is both literate and manic. Negotiating the shallow depths of his pictures—or else getting lost in their melted-prism effects—you sense that, behind all that thwarted imagery, there lurks some personal, outlandish, possibly harebrained, cosmic scheme, like D.H. Lawrence's or William Blake's, capable of generating an art of exceptional power and illumination. But Fritzius's reorderings of iconography are esoteric without any visible system. In place of system there is method, the hands-on method of fashioning an image on paper or unstretched canvas, then tearing it up and recombining the parts—either by shuffling bits and pieces or just by transposing halves.

The new pictures are secured by black asphaltum spread flat between figures and drapery as well as at the borders. Almost every one of his patchwork surfaces accommodates tumbled fragments of an episode from the life of Christ. Although the arrangements tend toward either an irregular square format or horizontal frieze, everything in them seems to happen vertically. The best is *Portrait of an Old Man*, which reads as a moralized landscape of which the multiple views, like cropped chunks from some demented thicket, double as a kaleidoscopic anatomical index. Other pictures show backdrop moons, masks and ribcages, humanoid frames of assembled, dusty-looking vegetable matter, and a succulent rose amid trumpeting thorns. Their lavishly wrought surfaces appear inexorably haunted by antique figures, condensed as if from drifts of partial yet troubled recall.

Fritzius's major theme is pity as experienced in the bewildering pause between catastrophes. His atrophied Christs offer no respite. The one in *Pietá* is a life-size puppet with dowels at the joints (and the *mater dolorosa* is a bramble bush); another in *The Last Supper*, has rocks in his heart. Across the room was an "expulsion" with the two primordial nudes pressed together, Adam to Eve's rear, a faint, milky wash spilling over their limbs, the milk of human lust perhaps. Such images evoke the power of suffering recollected and understood as prophesying more of the same. At once gruesome and elegant like throwaway screams, they advance a distinct form of emblematic contemporary grandeur—what Wallace Stevens called "the stale grandeur of annihilation."

Artforum, March 1989

Richard Shaw

Richard Shaw's imagistic porcelain sculptures fool the eye just enough so that you look harder to recognize what's really there, and to see how impeccably the sculptural image matches the familiar thing, or set of things, it represents. In *Before & After*, a milk carton among painter's gear (paint tube, brushes and a crumpled rag) in a tabletop relief is slip cast from a real carton. The cast carton's waxy surface recreates—through the miracle of Shaw's ceramic-decal invention—all the appropriate colors and print: block letters say "CLOVER" next to a dumb drawing of a cow with a sprig in its teeth. The actual-size

object is there all right, sitting pretty in nothing but its brittle, three-dimensional skin. Pointless as the exact resemblance may seem, the mild deception is disturbing at first, then hilarious.

Most of Shaw's new pieces replicate clusters of the functional stuff commonly found in an artist's studio and, along with those, the studio environment itself, suggested by painterly touches associated with sensibility-based realist painting. A series of pigment-strewn, wall-mounted palettes displayed as heraldic emblems of craft contain improbable faces or landscape smears. In *Moon & Sea*, a tiny fish head and a crescent slice of lemon are set gleaming on an expanse of turbid blue and white paint. Some of the still lifes rest on palettes, too; others have as their bases thin, square-ish, ragged-edged slabs. Shaw complicates their objective surface look by introducing paint-as-paint together with brushed-up color and pencil streaks meant to render specific local light. The light that sweeps across these things sometimes yield what Shaw calls "the bare-light-bulb effect," but it imitates just as well the phenomenon of changeable sunlight floating and zooming around the San Francisco Bay region where the artist lives. This extra pictorial dash—a porousness at odds with porcelain's customary smooth, hard sheen—breeds sets of paradoxically congealed and fluctuating moments: in the renderings of ephemeral light, volume dissipates and atmospheric eddyings become part of the objects' skin.

Also included in this show were nine collaborative drawings Shaw did through the mail with the surgeon and amateur artist John Montgomery. Just as the sculptures take off on painting, the drawings simulate collage. Cleanly executed in colored pencils, ink and watercolor, these works offer up flowers, vases, poker hands, ocean liners, anatomical figures, commercial logos, Superman and Popeye. Despite their decorative spaciousness—which, as collages go, is comparable to Motherwell's and different from the usual compressions of Shaw's assemblagelike sculptures—a lot of these combinations resemble some of Jess's paste-ups. According to Shaw, the only ground rules were that both he and Montgomery could feel free to raid one another's image repertoire and that neither would tell who drew what. Be that as it may, Shaw's is obviously the presiding sensibility here. Listen closely to his near silence and you detect something stronger than whimsy: a fiendishly syncopated delight about things being exactly what they seem, and then some.

Art in America, March 1989

Don Van Vliet

In his previous guise as the musician Captain Beefheart, Don Van Vliet always invoked the powers of ceremonial delirium. His interventions along the byways of three-chord rock 'n' roll floated funky, insistent, atonal guitar clusters around sublunar garglings in a strange amalgam of Howlin' Wolf and Tex Ritter. (With titles like "Woe Is a Me Bop" and "Lick My Decals Off Baby," the songs are raucous nonsense of a high order.) It doesn't necessarily follow that the same person who made that music would make Van Vliet's paintings, but the congruent urge to extrapolate magic from mess is there.

Van Vliet's pictures epitomize what might be called everyday expressionism, a species of normative, free-style painting that permits images to obtrude capriciously among swoops of color, like clouds billowing into the shapes of circus animals. In this, their mannerisms bear an odd resemblance to those of such California Abstract Expressionists as Frank Lobdell and James Budd Dixon, who in the 50s went in for a brash, nominally direct attack on the void, the better to arrive at a firsthand, meaningful iconography. Van Vliet's intentions may be much the same as theirs, but he is at his best as a modest improviser of fantasy landscapes. Pulling flings and squiggles together into singular, animated motifs, his pictures sometimes recall the brilliant abstract renditions of hill towns by the Greek-American painter Aristodemos Kaldis.

Van Vliet has his nature two ways, both as paint-and-canvas and as loosely defined figuration. Large textures of bare canvas stand for a painter's wilderness preserve. Similarly, a white-faced baboon suspended amid a rush of vertical splotches implies an imagination caught up in its own primal and compendious bestiary. As in children's art, where nothing is particularly observed, the world appears stated as entirely mental, with each cursory sign fully lit within its environs. None of Van Vliet's paintings has an overall, specific light, and the scale of each is simply commensurate with the general size of the handmade marks. Van Vliet uses a manageable array of basics—lathers of vanilla white that set the overall tone; a lot of straight tube colors (cerulean, cadmium orange light, vermilion, and the many ochers) modulated by another favorite, a pale peach. The recognizable figures include griffins, swans, roosters, suns, and moons, a truncated mastodon, a mountain, and a flat patch of knifed-on forest green that says "tree." There are also corkscrew glyphs and much fussing at the corners. Most of the animal figures are black. Black is the color of automatist delirium, but the truly strange thing here is how insouciant and deflated Van Vliet's visions seem.

Artforum, April 1989

Larry Rivers

This was a delicious show, upbeat and consistent. Larry Rivers exhibited thirty-five new paintings from the past 2 years, most of them foamboard wall reliefs done by mounting cut-out chunks of images previously painted on paper or canvas, cutting the mounts to match the contours, and then reassembling the pieces. The raised areas stick out as much as six inches. They can appear even thicker, but so smooth is the flow of detail, you sometimes forget that they project at all.

The latter effect is a reverse illusion: you see a flat surface hopping with dramatic, shallow spatial shifts of the kind that most Modern painting has led you to expect. Next, you see the complex sculptural trick for what it is: a mongrel busy work construction that diverts the artist's graphic acuity so that it reenters the picture by the back way. Rivers' use of figures from photographs similarly intensifies the viewer's

recognitions. Tracing with his zip-smudge-and-squiggle line, he animates the given resemblance, identifying pungencies of character that photography's luck with detail habitually misses.

The showstoppers here comprise a series of four outsized, revisory homages to Marcel Duchamp's *Nude Descending a Staircase.* Each of the pictures splits the original denatured motion study into halves, interpolating the image of a doll-like anatomical nymph walking down a flight of wooden stairs. Glossing Duchamp's wood tones, Rivers makes gradations of single colors extend from their fullest saturations at the nude girl's contours, thus giving each painting its own peculiar overall cast. *Seventy-Five Years Later: Indigo,* 1987, is veiled in blue—the gaudy tint, say of a *Miami Vice* bedroom interlude. The frontal nude is sensually exact and dreamlike in her containment. A caricature of a caricature (Duchamp was doubly taking off on academic *boudoir* painting and on Cubism at its inception), the whole image rocks with uncertainty: do we dream or jerk awake, laughing?

What John Ashbery calls Rivers' "slashing indirection" plays on the discrepancies between figures and their surroundings, between human inclination and official memory. He can blend telling bits of history or else invent connective tissue of a strictly pictorial kind, releasing the recognizable figure into vectored space so that an abstract energy extrudes. *Dancer in an Abstract Field: Fred Flying II,* 1987, sings with that sort of dispersive energy. *Umber Blues—Portrait of Dick Schwartz,* 1987, has an opposite emphasis, not breezy at all. Here, a heavy, naked brown figure, seen both kneeling and reclining, intently hoists a saxophone amid lumps of tossed, pale-blue bedding. The blunt nakedness commands space catastrophically, like a juggernaut.

Rivers is one of the few painters who can do more than is necessary to a picture and not have his efforts look like overtime fuss. If he makes work for himself, that's his reality principle and his pleasure, both. Because he thinks with his technique, he is committed to putting stumbling blocks in the way of his felicities, lest his thought run glib. His new paintings are all the more remarkable for their color, which proceeds in great choral sweeps—tempered, dulcet, and true. For a while, in the past decade or so, it looked as if Rivers were just keeping his hand in, succumbing to a propensity for the merely chic. Even the lightweight pieces in this show—the takeoffs on underwear ads, for example—have something full-blooded about them. Rivers is rounding out his genius.

Artforum, April 1989

Robert Mapplethorpe

Robert Mapplethorpe is primarily fascinated with skin—human skin and its correlative among the skins of plants, of objects. The skin of photography he identifies with the full fabric of a print, so that instead of floating on top of the sheet, his images seem

embedded, crystallized like pigments in a frescoed wall. That is one reason—a material one, at least—why his framed prints succeed as powerful decorative objects with meanings that outstrip their private or documentary, and often prurient, interests.

Mapplethorpe's photographs of nudes usually emphasize the body's sculptural look. Obviously, the more carefully tended bodies—Lisa Lyon's for example, or those of the photographer's many black male subjects—have been self-sculpted with special attention to musculature. Such images presented in the manner of dynamic *tableaux vivants* suggest a prolonged scrutiny at the camera end that foils (without deadening) the viewer's sense of the live body as inherently in motion. When Mapplethorpe photographs sculpture, as in the pictures he showed last December, this effect is reversed: in close-up, the sculpture's implied motions are jogged, if not totally released. With calculated shocks from studio lamps, details emerge glistening (or else undergo drastic shadings), the background chimes in as an opaque counterforce, and the artificial figure seems about to breathe.

The nine photographs here were of sculptures of male figures (plus a masculinized Pallas Athena) in Mapplethorpe's collection. The figures incline or gesticulate mostly against pure, no-atmosphere black or white tones. In one very tricky exception, a full-length Christ removed from its crucifix stretches partly across a bed of gravel, partly down a recessive black silhouette that flatly echoes the "Y" of the slender, arms-wide gesture. The other images are truncated, either because the photographer has zeroed in on a figure's upper parts or because the whole image is just a head or a bust.

At first, these new pictures look modest enough. They're dimensionally smaller and perceptually faster than many of Mapplethorpe's images of the past few years. In fact, for most of them, the reduced size makes for a redoubled intensity within the square format that's been the artist's trademark all along. The gelatin silver prints in their wide, black frames argue compression the way statuary does. Smack up against the surface of *Italian Devil*, an armless bronze figure bares his teeth, seething in a hiss of implosive pain, which might have to do with the bare, polished slab of shoulder he raises to our view—or more generally, with a definitive evil.

Mapplethorpe is snagging complexities from edge to edge of his images, loading their contemplative artifices in ways he hasn't done before. *Continuous Profile of Mussolini* spotlights what looks to be a wooden version of R.A. Bertelli's famous ceramic portrait head (in the Imperial War Museum, London) so that one side is dark and still while the other appears to spin (as Bertelli intended) along its grooves. The picture has the additional, strategically awkward note of a slightly curved black triangle masking the upper left corner, as if the whole witnessing process—for Mapplethorpe, for the viewer—was meant as a protracted seizure, a double take on flux and fixity, identity and dissolution, combined.

Art in America, April 1989

Michael Gregory

The first paintings Michael Gregory showed five years ago were large, square-ish oils on canvas showing haystacks, bushes, and fallen trees set forward in open fields. Mysteriously engulfed by flames or left smoldering in the aftermath of some intensely localized apocalypse, the natural objects in them seemed to sputter in a dialect of irritably debased pastorale at the outer limits of contemporary experience. In his new pictures Gregory has pulled back for more general, though no less cryptic, views of the same allegorical "elsewhere" terrain. Now he paints long, horizontal panoramas, with varnished tar and chiaroscuro glazes over plywood panels prepared with gessoed cotton fabric—an antiquarian technique that lends a further déjà-vu eeriness to the proceedings. Each prospect is shot with sunlight from behind layers of cumulus. The obfuscating effect is bewildering: preternatural revelation surges across the fields, the glimmering trees, the mud flats—but who's to read it? Instead of a decipherable comfort, the ripeness of unassimilated nature stands loaded with moot intimations of deprivation and fear.

Within his consuming ambient blur, Gregory accounts for human presence reductively. In *As If Twelve Princes Sat Before a King,* a trumpeting sunset spans the pale slip of industrial beadwork that dots the far rim of a bay, as viewed from a seemingly molten tidal estuary. The diminished focal points intensify distance in every direction. The steel-wool clouds, incinerated in black and red, coruscate against each other and the dabs of sun. That meager horizontal rim where the eye ekes out its bearings is, as Gregory has said, "where we live."

Max Friedlander once identified the pictorially low horizon as "always and everywhere a sign of advanced contemplation of nature." Gregory's horizon lines are like nerve ganglia contemplating nature's otherness while immersed in its repercussions. They're seismographic. Much as they rationalize space, they can derange the sense of time within the space of a single painting. In *Deviant Fall,* for instance, the opposite sides of a meadow are marked by two trees, one flowering and the other with reddened leaves—separate seasons embodied by flashes of tonal adjustment in an unbroken vista.

Gregory is no ironist ringing changes on a historically lapsed Romantic vision. He could be the genuine article, a latter-day initiate to Keats's "penetralium of mystery," trying to locate an arcane refulgence that culturally can't be parsed. His subject is nature as an excess that defies any concept of necessity. It is neither a picturesque garden nor an innocent victim of human management. It is not an art object. Those Barbizonian oversaturated greens, that low-lying, late-afternoon haze echoing George Inness at his most recondite—finally, such dusty stylistic resemblances don't compute at all; they cancel out. Gregory is an original. His studio inventions—all views, after all, are imaginary or partially recalled from actual sites—bespeak moods specific to an inscape where, as Boris Pasternak said, "things smack of soil and Fate."

Artforum, May 1989

Masami Teraoka

Masami Teraoka is known for making funny, dextrous paintings on themes of bicultural imbalance. Done mostly with watercolors in a style evoking *ukiyo-e* woodblock prints, his burlesques work like certain *New Yorker* cartoons or the visual puzzles with captions that read, "What's wrong with this picture?" One might leave them at that, except for their ever more complicated esthetic, narrative, and moral fascinations, which recall the equally puzzling, oriental side of Pieter Brueghel. Even as quick hits, they're not trivial.

Ukiyo-e prints are small and square, their colors having been applied with water-based pigments mixed with rice paste. Teraoka's paintings tend toward bigness; the biggest are on canvas, the medium-sized ones on paper. None are square, and all are made *alla prima*, with few corrections showing. The earlier works comment mostly on discrepancies between ancient and modern; more specifically, between a homegrown tradition and the contemporary fast lane that respects no place in particular. In one example seen here, a rustic, leafy bamboo broom descends upon a Big Mac and its crumpled wrapper as if to reclaim the environment, which looks to be all atmosphere in various tan and blue tints. The inherent grace of the garden whisk and airheaded grossness of the burger bun make the triumph of simplicity over schlock appear like no contest.

A lot more is involved in Teraoka's new pictures, especially the ones dealing with AIDS and lust. In them, his conventional lapidary manner, with it unconventional inversion of techniques, retains its former crispness, but a coarser handling of shapes coincides with the subject matter. When Teraoka paints unencumbered sexual energy as an emollient surge and the AIDS panic as its imperative counterforce, he might as well be setting Shakespeare's "th' expence of spirit in a waste of shame" to pantomime. In *Hanauma Bay Series/Octopus and Woman at Sandy Beach*, 1988, a courtesan and sleepy-eyed giant squid tumble from the breakers in a coital sprawl. The glooming, polymorphous beast upon the dazed female is "lust in action"—a sort of Peaceable Kingdom version of the Rape of Europa.

Some of the same elements recur in the "AIDS Series," 1988, but there the erogenous surf has changed to a gruesome hell-mouth's lava flow in which exasperated women like crimped swans tear at condom wrappings with their teeth. *AIDS Series/Dody and Fox*, 1988, shows an upstream-straining nude encircled by snakes and a ratlike trickster fox. (Ambiguously, the fox's long salt-and-pepper mane resembles the one seen in the artist's numerous self-caricatures.) *Tale of a Thousand Condoms/Mates*, 1989— another, larger painting set in the back of a London taxi—expands upon two lovers' grotesque sexual postponement amid a maelstrom of protective devices and admonitions voiced in an Edo-Period script. Some of the lettering, of a kind traditionally used for stage directions in Kabuki theater, annotates the presence in the picture of "a spermicide for women, Anti-Pregnancy, Anti-AIDS. The product is transparent, water-soluble and comes 10 sheets to a package for £1.44." Such allegories are forceful enough—they're both packed-in and magnetized at every stroke—to satisfy their cautionary impulse while

bursting all preassigned topical seams. Image by image, Teraoka is creating what Edwin Denby, referring to Kabuki, called "the spell of a fabulously esthetic comic strip."

Artforum, Summer 1989

William Tucker

William Tucker's recent sculptures are stark, heavy, freestanding cast-bronze chunks, each with a mutable image. As you move around them, tracking successive profile views, their roughly modeled masses slip from one directional emphasis to another, from flexing, truncated anatomical hints to broadly sloping topographic sensation, and back again. Such perceptual episodes modify and hide on another. Meanwhile, the monolithic shape that is their integer stays unperturbed, though constantly elusive, and the big abstract scale is consistent throughout. Then there is the sculptures' gravitational pull, they way they compel you—imaginatively, bodily—to experience them up close. Their energies are not projective so much as contagious. Face to face with these things, you get an inkling of the sculptor's impetuousness, like that of a rock-climber, in scrambling together their plaster prototypes.

Writers on Tucker's work have regularly pointed out the similarity between his conversion from open Minimalist forms to these more traditional-seeming bronzes and Philip Guston's move, in his paintings of the late 60s, to a recognizable imagery. But Tucker's casts most resemble the ink drawings Guston was making in the early 60s, with their slow accumulations of line and their refusal (often by a saving twist of the quill) of any distinct mimesis. Like Guston, Tucker is a connoisseur of catastrophe. His densely encrusted objects are records—sites, really—of fundamental, differentiating urgencies. Like the pre-Olympian deities of unstable aspect from whom many of them derive their names, they make sense as the metaphoric evidence of forces in flux, gists of crude matter and desire rather than personifications of a fixed order of being.

Tucker locates the motions and tensions and voluble vortices—the sheer geologic incipience—implicit in the archaic creation myths. This is no mere archaicizing trick: he's not redoing Stonehenge or the Parthenon. The newest and smallest of his pieces shown here, *Daktyl III*, 1986-88, is also the most quintessential: a stumpy, twisty, beanlike outcropping that seems to hoist itself at one extreme in a barely achieved calisthenic flourish.

Rather than presenting an image of what it means to be human, Tucker's work is a stab at showing the formative states of physical matter that impinge on all of life, and for which the human body, with its self-consciousness, is a fair registration. In 1977, the artist wrote, "the statue is a thing set upright: it stands against gravity and against sight." By that definition, Tucker's figures assert a statuary compressed by its own isolate exposure and ever-unslackening battles over leverage and pitch. The biggest *Ouranos* and *Tethys*, both 1985, look most distinct at the sliced nether edges where their trunks stamp themselves inevitably flush to the gallery floor. (The smaller works placed on pedestal

cubes looked relatively stranded in their exertions.) All core and no appendages, these sculptures grind up the immediate space as if from below and within, like the first rumblings of a thunderclap, less a signal of pride than of necessitous volition.

Artforum, September 1989

Poe Dismuke

Fool-the-eye is the pictorial equivalent of sophisticated doggerel in verse; both play on memory's expectations, embarrassing the mind in its connective gullibility, its rote habits of belief. In the observer's mind, the intrusion on visual reality seems like child's play, no matter how painstakingly it has been accomplished by grown-up skill. Accordingly, once the trick is revealed, the observer either dismisses it as a paradox unworthy of an adult's attention, or submits to childlike wonder, transfixed.

Poe Dismuke's latest figment-ridden assemblages occasion both wonder and the reminiscence of it, as if wonder were integral with the objects of childhood. Actual-size pieces of rickety furniture—chairs, steamer trunks, a footlocker, an armoire, a tall parrot house—are, as Dismuke has said, "new things that look old." Their dysfunction as furniture points up their real function as syntactic sculptural forms. Fashioned out of wood and sheets of corrugated tin, they harbor among their details slipcast ceramic replicas of toys and ornamental bric-a-brac, thrift-shop Americana of the recent past—circa 1953, say, when Dismuke himself was born. The apparent salvage proclaims a mildewy desuetude. Almost every surface bears a faded primary color or some other patina of age. There are perfect renditions of wooden ducks, black plastic gorillas, a squeaky rubber pup, and a truckload of cowboy-and-Indian gear, complete with a tiny, rusted six-gun and a mound of crumpled boots. (Dismuke has colored the earthenware boots with boot polish.)

Dismuke's preservationist esthetic is fun and something more insidious than fun. It suggests the melancholy—the cruelty, even—implicit in nostalgia: the demand that objects associated with past time answer us in kind, in the dialect of enchantment we imagine they once shared with us. The realization that such a language, if we ever knew it, is irretrievable give a displaced feeling, like the perpetual ache of disappointment that is the leitmotif of so much of John Ashbery's poetry. Just as the discarded stuff at a landfill dump mounts and spreads to form new contours, the elements Dismuke works with seem to have worn their way into the world by default.

Of the nine assemblages here, the best was the plainest: *Resort Chair,* 1989, a straight-backed, asymmetrical suturing together of charred scraps, travel decals, and mismatched curlicues. (These last, as well as a row of Chinese figurines just under the seat, make up the clay contingent of the piece). Dismuke was originally inspired to make replicas by seeing the small ceramics Richard Shaw and Robert Hudson cast from found objects in the early 70s. His own constructions don't pronounce the high-gloss refinements or compulsive-cum-exquisite artifice that Shaw's porcelain sculptures do.

Like Shaw, however, Dismuke subsumes his virtuosity in delivering an objective imagery. His three colored-pencil drawings further exemplify this conceptual purposefulness. They look to be both work sketches and handsomely designed posters advertising the finished product. A handwritten note on one of them characterizes Dismuke's current fascination: "travel pieces….about journeys and vacations—memories"—memories, one might add, that have come theatrically alive.

Artforum, October 1989

Catherine Wagner

Catherine Wagner is a particularist whose black and white photographs discriminate, as she says, "more than the eye is used to seeing." This small show comprised prints chosen from the three main series she has completed over the past decade: "George Moscone Site," 1979-82, "The Louisiana World Exposition," 1984-85, and "American Classroom," 1982-87. As the titles suggest, her subjects have tended to be the purposeful spaces of public architecture and schools. The subjects have a reflexive pitch, as if Wagner's eye and her camera had set out to rediscover their own intentions through confronting the dense patterns of big-scale building construction and the bland machinery of education. Thus, the images themselves derive from slow, conscientious study through the viewfinder, and as compositions they are intricately, even grandly, engineered. Altogether, they propose an objective photographic grammar that is no less vibrant for being clear.

In the "Moscone" series, a burgeoning convention center's massive mess appears bound by an inherent rationale, like that of wading birds all facing the same way at dusk. Thatches of scaffoldings, rebars, planks, and pipes recall Robert Smithson's designating the late-industrial buildup along the Passaic River as "ruins in reverse." By contrast, the wall-to-wall systematizing devices common to just about every kind of schoolroom—from Sunday school to a high-tech science lab—look as specious, if not downright satanic, as the rubrics ("Transmission Theory," in an auto mechanics' school, is one) under which learning is advanced.

Wagner's pictures are long on discovery and sensation and reduced in regard to attitude. In framing her subjects, she exercises a gritty reticence along with a sharp feeling for surface-wide abstract organization and lapidary detail. She seems to read each space as a syntactic tissue in which every hair-breadth variant stands out. The images are rendered mostly from suspended standpoints, so that looking at them makes uncertain the observer's imaginary bodily relation to the scene. Wagner favors horizontal formats full of horizontal divisions, typically from edge to edge in the lower third of the frame. Tension and a concomitant, sometimes dizzying lushness spread across the print. Even the occasional blurs seem choreographed. Indeed, by way of lengthy exposures and adjustments within the depth of field, they rid the images of just those minutiae that would prove distracting: the lettering on a fairground flag against cloud contours, a newspaper layout across from a graffiti-infested desk chair. Contrariwise, in *University of*

Texas, Speech and Hearing Institute, Houston, Texas, 1985, each node of fabric in an oval braided rug has entered the wide lens to make its tactile point—and these modular thematic glimmers are answered in kind by the bricks in the wall and by rows of alternating happy and frown faces on the blackboard centered upon it. Given the protracted moment, the world with its various marching orders beams in.

A noninterfering, speculative classicism underlies the transparency and distance Wagner's approach allows. The social data are all there, loaded into her pictures, but the longer you look, the less instrumental in terms of social science they seem. Instead, the pictures broadcast the mystery that can accumulate about any profusion of closely rendered things, the enigmas that multiplicity in coincidence provides. Instead of a developed theory—of perception or culture, or both—they show the primacy of looking, with the emphasis that "theory," at its root, is tied to sight.

Artforum, November 1989

"10 + 10"

The round numbers in the title of this traveling anthology exhibition refer to equal sets of Soviet and American painters, all of whom are under 40, commingled in the show's ranks. The Soviets—Yurii Albert, Vladimir Mironenko, Yurii Petruk, Leonid Purygin, Andrei Roiter, Sergei Shutov, Alexei Sundukov, Vadim Zakharov, Anatolii Zhuravlev, and Konstantin Zvezdochetov—are all males living in Moscow (although some of them were born in such places as Lvov, Naro-Fominsk, Dushnabe and Tadzhikstan). The American male and female artists are David Bates, Ross Bleckner, Christopher Brown, April Gornik, Peter Halley, Annette Lemieux, Rebecca Purdum, David Salle, Donald Sultan, and Mark Tansey, all but two of whom live in New York.

Barely 3 years ago, it would not have been possible to discuss the work of young Soviet artists without having visited the studios and other informal venues of Moscow and Leningrad, at least. Now with glasnost and its mostly commercial repercussions in the West, the situation has changed. The current international art market identified wild-haired varieties of recent Soviet art as right up there in demand with Australian aborigine paintings. Thus, change has been mediated in accord with the jobber's rule: acquisition precedes communication.

Oddly enough, although this show by-passes all that sorry business with a minimum of curatorial channeling and geopolitical superscripts, its prime revelations occur by a sort of transcultural inversion, especially within the American sector. Bleckner and Halley each had a separate alcove gallery to himself, at the very beginning of the installation and at the midway mark, respectively. This situated Bleckner correctly as *hors de concours*, or anyhow ahead of the game. The most recent among his three pictures here, *Architecture of the Sky III*, 1988, is the singularly great painting qua painting in the show—a cosmogony viewed as if from inside a colander. On the other hand, the intermediate framing of Halley's work effectively raised it as the ideational fulcrum of almost

everything else to either side. Suddenly, like Bleckner, Halley zoomed forth as a venerable master painter in the company of others still working out their approaches. He also looked specifically "Russian" and immediate, subjective even, like a true heir of Malevich bringing gratuitous, noisy blasts of outright sensation to the Suprematist desert. In other words, his pictures looked more like pictures and less like his ideas.

Altogether, the surprises in "10 + 10" hinge on identity shifts—the Soviets appearing not retrograde but at once familiar and hip, like the resourceful children of old yet seldom-seen friends, and the Americans somewhat despondent but prismatically defamiliarized (or more properly, Soviet-ized). April Gornik's landscapes, for instance, possess distinctly Slavic or Tartarish complexions; her *Mojacar*, 1988, might be Irkutsk, her *Tropical Wilderness*, 1987, the recipient of a chill from near the Finnish border. Similarly with Tansey (that wayward Soviet Realist), Purdum (Rayonist frostbite), Bates (an Estonian's idea of the bayous as wildlife preserve) and Brown (Ilya Repin seduced toward Action Painting by way of Larry Rivers' revisionist excesses). Even Sultan's fruits and fire fighters emerge singed and glowering from a Dostoevskian murk. Of course, much of this shiftiness may be just evidence of how thoroughly the hard-won retrievals of early Russian modernism have affected both Soviet and American art since the early 60s.

The Americans make art explicitly intended for museum status, whereas the Russians have worked in an atmosphere promising next to nothing in the way of shows, much less curatorial sanctions. The Americans are nervy and suave, the Soviets nervy and (understandably) nervous, and where virtuosity shows up among them, it typically reflects sophistication about design. As Mironenko remarked in a panel discussion at the museum, the Soviets work "in the absence of European amusement, without American unexpectedness." All the same, the Russians are funny and histrionic. (Among the Americans, only Tansey and Salle equal their monstrous levity.) As with the Americans, nearly all the Russians are conceptual painters, and many of their works—including the most imposing and accessible-seeming among them, by Zakharov, Roiter, and Zhuravlev—exist either as parts of series or as residual of other activities. Even Purygin's exploded Slavic-style folk art seems homesick for its context, which may signal a defining virtue of folk art, generally. Then again, because Purygin and so many of the others use words emblematically in their images, we come up against a severely mortared version of the language barrier. Some translations would have helped; except for the titles and artists' statements, there are none in either the catalogue or the wall texts. Zhuravlev, at 26, the youngest of the painters here, makes the most normatively abstract art. His image-as-text oils and enamels on canvas, summarily reflective of linguistic confinement, are blocked out with a dandy's cursive dash. Likewise, the industrial greens and incisions (standing for radio speakers and air vents) of Roiter's *Unseen Voices* panels, 1988, communicate directly the drab look associated with everyday Soviet urban life.

To what extent do both the Russians and the Americans confine their work to the representation of current art ideas found more or less synchronized in magazines and books? And is "painting" the appropriate rubric for such a show when painting as such (despite its readiness to be shipped) is extraneous to the many non-media-specific intentions on both sides? In prompting and dealing with these questions, the Russians

have the advantage of pretty well knowing what the Americans are about; we are largely ignorant of the dimensions of Moscow Conceptualism. Perhaps we are blindly entering our own "period of esthetic starvation," identified in the East (by the poet Alexei Parshchikov) with Brezhnev and here with Bush and Helms. What will the prospective viewers in Moscow, Leningrad and Tbilisi (where the show will proceed after its American tour) think? They may recognize the monolithic concepts of "America" and "Russia" as two dystopian, labyrinthine voids within which the "10 + 10" artists are gathering their senses.

<div align="right">Artforum, December 1989</div>

The Museum of Jurassic Technology

The Museum of Jurassic Technology was founded two years ago by David Wilson, an artist who designs miniature special effects models for movies and TV. Normally housed on Venice Boulevard in Los Angeles, the collection comprises a bevy of eccentric artifacts—some redolent of the ultramundane but most of them chortling at the high end of speciousness. Excerpted here, the museum is a belated tribute to the batty logic of 19th-century empiricism, whose will to certainty was paralleled by a taste for the grossly unfounded. An introductory slide lecture encourages immediate identification with "the incongruity of the overzealous spirit in the face of unfathomable phenomena." Specimens are propped up and decisive scientific discoveries reenacted inside glass cases. Windows give onto tiny stage sets featuring stereographically projected *tableaus-vivants* of biblical scenes from 14th-century illuminated manuscripts. Each display is embellished with a supplementary wall-text or audio commentary. Some still "under construction" are nevertheless "explained" as if already visible.

Wilson's inventor's touch provides every convenience for delivering seemingly iron-clad bits of disinformation. So adept is he at maintaining his user-friendly museum illusion, you can see how an exhibit is rigged and still be baffled by the evidence. The discrepancy between historical explanation of science facts and the means by which their evidence greets the eye is gratifying: Johann Wilhelm Ritter's 1891 proof of plasmatic postvisualization—"the ability of vision in the extreme ultraviolet to reconstruct life forms from inanimate remains"—is conveyed by a compact video camera that, turning from the skeleton of a human hand to a bare twig, shows live tissue recuperated on each. Across the room, seen within the larynx of an encased fox head, resides a free-floating image of a man straining forward in a chair, snarling and yelping like a fox. (Here, too, rather than dampening the mystery, the fact that the performing man does dog voices for the movies deepens it.)

There are more skeletal specimens (the ringnot sloth and the European mole, among them) and habitat views (one for the African stink ant, *Meglaponera foetens,* whose brain is eaten by a fungus spore) and narrative displays. You see the block of lead that

trapped a Deprong Mori, the "piercing devil bat" whose X-ray powers permit it to fly through solid matter. You push a series of buttons to hear dead beetles foil their predators by imitating the languages of stones. The ultimate showpiece of all this benign stupefaction is an untitled tableau involving two ghastly reclining wax figures of a man and woman. A set of mini-stories is whispered on tape and communicated in sign language by hands that seem to hover in midair at the far end of a large vitrine. Nuzzling a pair of catoptric spectacles prompts both the taped monologue and the "hands" image to tell, for instance, how the narrator resuscitated his wife after her fatal automobile accident by sprinkling her body with his dried, opalescent sperm.

The title phrase "Jurassic Technology" is an oxymoron, of course. It implies either that the dinosaurs of the Jurassic Period were conscientious toolmakers or, conversely, that human technology as anything other than a form of rational amusement might usefully consign itself to the scrap heap of historically failed projects, along with dinosaurs and their brethren, the flying reptiles. Probably the latter thesis is what Wilson has in mind. In any case, this gentle artist-technocrat has invented an educational device that releases facts from their obligations to certainty and pulverizes even as it purifies our sense of museological time. On either side of the entryway were what seemed to stand as the museum's presiding metaphors: a scale model of Noah's Ark—mechanically rocking on a makeshift floodplain, the first natural history collection—and a wall of old prints depicting the Tower of Babel, humanity's first big technological non sequitur.

Artforum, January 1990

Henry Wessel

Everything in a photograph by Henry Wessel sits tonally clear and smooth across the sheet so that whatever seems to be the main subject—a sunbather, a suburban house or solitary tree—stands as just the pretext for seeing all else that is simply, and absurdly, there. By dint of being centered in the frame, the subject, like the unitary camera eye, ushers in a set of transforming binocular aftershocks. Wessel's black and white images are head-on but his comic conceptions reveal themselves obliquely; he lets both his and our attention wander enough to discover the multiplicity in any range of facts.

In *Richmond, California*, 1989, the frontal view of a two-story cottage looks normal enough to be mounted in a realtor's window, except that every inch of architecture and shrubbery has something uncanny or patently wrong about it. The nutty, smaller-than-life cottage, pitched against one of Wessel's cloudless aquatint skies, sings of some unconscious planning error. Its nuclear family of three disproportionate aluminum clapboard eaves poses stiffly atop cruddy flagstone walls that fritter around the respective jambs of an oak door and a garage. This domestic trifle comes across as off pitch and less humdrum than visionary. Someone had the bright idea to crop a cypress bush so it fits one corner of the garage entry to a T: did that person know that the sun at the appointed

hour would throw the bush's shadow moodily across the door slats to fill out the missing chunk? One might think that the photographer has made the whole thing up, that Wessel staged the view instead of making it out wittily for what it has become—an occasion of lifting from the midst of reality its affectionate if blunt self-caricature.

Wessel's pictures hold palpable light to a degree that few contemporary photographs do. Insensitivity to light is a fairly general photographic paradox and probably accounts for most of the diminution in what Peter Schjeldahl recently termed photography's "short esthetic track." Most art photography reduces observable light to a punctuation in the service of texture and contour; once its mechanical trick is done, light defers to a leftover graphic definition, the close-fisted markings of frozen pathos or satire. The blithe-looking light with which Wessel bathes his imagery is deliberate and stands for itself. It's the principle—the rational element, almost—by which Wessel finds his way to soak up the peculiarity of a scene. Supple, clear daylight or the immediacy of the photographer's flash reflected from a hard surface (for instance, the gleaming modular bath stall against which a naked, half-tanned boy tenses in *Nick, Cape Cod*, 1986) convinces you that things appear as they were when the shutter clicked, even though the sum total of this appearance is a mass of incongruities.

Wessel's bright epigrams teeter on symmetrical perfection: there's always something in the middle, but the composition keeps showing you its edges. The spread of tones—from a creamy, billowing white to spots of absolute, lacquered black, with a wealth of grays between—feels eventful. Elongated triangles, trapezoids, and other more irregular shapes at the sides of the prints jog the wide-angled views, so that the basic photographic rectangle seems to add on facets as you notice the spaces it contains. Spatially and conceptually, Wessel puts the emergent joke before your eyes without a clincher; repeatedly, a picture will lay out its anecdotal particulars to be read in a different conjugation—just as gently balanced, more baffling than before, indissoluble from the perceptual event.

Artforum, February 1990

Group Material, *AIDS Timeline*

In *AIDS Timeline*, 1989, the artists' collective Group Material helped to clarify what Paula A. Treichler has called elsewhere "an epidemiology of signification." Here were itemized samplings from the convergent swirls of nomenclature, image management, political ur-texts, and sheer numbers that continue to make a mess of people's perceptions of the AIDS crisis. About AIDS there can be no dispassionate informants. An artistic attitude, such as Group Material made operative in its installation, can take up accretions of topical data and straighten them out—handily, pointedly, albeit provisionally.

Group members Julie Ault, Doug Ashford, Felix Gonzalez-Torres, and Karen Ramspacher accomplished their mission by way of a tidy curatorial syntax. A thick, black, waist-high band sweeping along the gallery walls was accented by perpendicular date

markers for the decade beginning 1979—the year that American doctors began to notice a marked increase in "immunologically unusual patients" (twelve new cases, eleven deaths), and coincidentally the year that Group Material came together. Above and below the band, they aligned images, objects, and wall texts—altogether about a hundred items, including annual tabulations of recorded case and deaths, paintings, photographs, magazine tear sheets, posters, leaflets, a computer terminal (with Michael Tidmus' AIDS data base accessible), comparisons of public-health budgets with military spending, a pair of yellow rubber gloves like those the police in various cities have worn to arrest AIDS demonstrators, and brightly colored masks made in art therapy sessions. Just above the baseboards ran Steven Evans' *Selections from the Disco, Various BPM, 1979-1989,* 1989—bumper-sticker-like, pink-and-blue wall renderings of song titles, from "Got To Be Real" to "Never Can Say Goodbye." Across the room, under Group Material's and Lindell's official-looking bus banner reading "All People With AIDS Are Innocent," you could sit and watch a deliberate mix of rough-cut video documentaries of street demonstrations, educational programs, and art tapes.

In such a context, what is or isn't a certifiable artwork scarcely matters. Information and attitude matter, as does the will to provoke connections without overexplaining. At the end of the show, Robert Beck's *Safer Sex Preview Booth,* 1989, with its three-channel, optional views of gay, lesbian, and straight porn films, had a witty enclosure, like a phone booth with a dusky hard-edge paint job. But it was the time line's general graphic efficacy that counted. Most AIDS-active art seeks a quick sting, through a neighborhoodly adroitness of design; the genre is streetwise, low-tech halftone, guerrilla-wheatpaste. Right off, you could see how tyrannical the time line band was meant to feel—time waits for no culture to mend its inequities, it seemed to say—but only cumulatively did the surfeit of almost totally rectilinear information register as oppressive in itself. In Michael Jenkins' American-flag painting *June 30, 1986,* 1988, the compact, supposedly utilitarian rectangle was finally blown-up, broken, and literally voided. Jenkins stripped the flag down to nine stripes and a blank where the field of stars would be, to impugn the Supreme Court's upholding of Georgia's sodomy laws.

Arranging its display with pushpins, tape, and paste, Group Material maintained a rudimentary classroom history-project look so as to be campus-specific. In that regard, however, the installation inside the Recreational Sports Facility of a video monitor with continuous shows of agitprop tapes was more to the point—as, too, was the "Democracy Wall" of ten blue-and-gold panels on the museum façade with quotes from on-site respondents who were asked "How does AIDS affect you and your lifestyle?" or "How do you see the future in terms of AIDS?" The printed answers sufficed to indicate the urgency of intellectual effort the time line represents: at one end, the mind-splitting ignorance implied by one student's assertion, "AIDS doesn't affect me at all. I don't really sleep around"; at the other, the well-rehearsed clarity of a Student Health Services worker who said, "To fight and overcome AIDS we need compassion, sensitivity, anger, helping hands, vision."

Artforum, March 1990

Inez Storer

Inez Storer exhibited sumptuous mixed-media installments in what might be called her "Voyage of Self and Marriage" cycle. The paintings show male and female figures pitched against elemental vistas—predominantly, air and sea. The figures, with their sharply planed contours, have the individual, hieratic fixity of foot prints; the elements—bright, busy air, darkly tossing sea—are all a matter of flux, so that each scene unwinds with a natural-looking, tousled continuity. The overall approach is personal and operatic, with images that have washed up plush from the artist's soul.

Within a single canvas, Storer's juicy colors vary in thickness and texture. There are sun-dried whites, acidy and powder blues, incinerated grays, aching red smears, and a blushful pink as gritty as brick. Other variances include bits of collage—old chintz lengths and chromos of birds, flowers, and Victorian show folk, pressed and laminated so as to go seamlessly with the paint. Thrust forward in an expanding gravity puzzle, the human characters negotiate their fantasy situations like aerialists or gymnasts. The tangencies of water and weather are as specific in their blends and tensions as the relative position of one character to another, or what a single character finds in the way of a foothold—in *Goncharova,* for instance, the tip of a slender, upright plank for the toe of one blue shoe (just enough, it appears, for the bearer to maintain her sturdy, at-home look).

In the large diptych *Race*, one panel shows a white rabbit outlined in red leaping into the center of a mauve field, while a couple's disembodied heads bumble placidly in the distance; on the other panel is a dark, prismatic, virtuoso effulgence that might be three simultaneous landscapes interlace—or just a blanket signature of the artist's pleasure in her medium and its aptitude for jewellike color and elastic space. The light touch, stemming from reverie, achieves a wide-awake presence, a mood of the plainest pleasure—what else but shared observation segueing to a mutual sentiment?—recalled and keenly accounted for.

Contour in these paintings is like faith in the integrity of the self. A pair of integers converges repeatedly in a kind of barometric proximity, wearing fancy hats; the two connect and sometimes overlap, but refuse to melt. Storer's sense of activated spatial separateness and proportion in relationship is visionary. (And as contemporary views of the gender gap go, hers is spectacularly devoid of malice and rage.) It's a comic vision of married love as an improvisation of selves pressing outward in tandem; in each in-between space lurks a large, possible pratfall or maelstrom. This aspect of the human comedy comes clear in ways that recall Edwin Denby's line about classical ballet where "there's no quarrel, but there's fate."

Artforum, April 1990

Elmer Bischoff

Elmer Bischoff's paintings are those of a virtuoso who indulges his love of performance without egocentricity and therefore without stunts. In this, Bischoff resembles Hans Hofmann although Bischoff's work can be subtler, and cumulatively mysterious as Hofmann's never was. Bischoff trusts his paint to achieve an impassioned surge when worked up into interlocking scrubbings and flickers of color. Like Hofmann at his most orchestrally romantic, he shows innumerable transubstantiating things that color can do when handled in innumerable ways. The result, equally intense throughout, has the strength of prior experience committed to memory.

In this show of seventeen heretofore unexhibited paintings from Bischoff's 20-year (1952-1972) figurative period, virtually all of his favored motifs were represented: from vistas of land and water to slices of sun-shocked high-ceilinged rooms peopled with insecurely propped figures. Though color is the main event, the figurative scheme provides the synthetic compositional hook. A compact figure, a room, its furnishings, and a window view are hammered together so that the image breeds a right-angled inertia relieved by flushes of daylight at top and bottom. The figure here is fabulously decentralized; where it lodges, an otherwise buoyant surface admits a small sag. There is a well-known difficulty of knowing how to care about these figures; what one cares about finally is what the painter himself seems to have considered important, that the painting is allowed to go about its transcendent business, sparked, rather than impeded, by descriptive chat.

The typical paintings of this period parade immense horizons against which tonalities drift and plummet, like gulls feeding indiscriminately. The paint goes right to the edge, often finding its finest moments there. *In the Rain,* 1955, is a marvel of such willed brilliance: Two darkly bundled figures skirt the foreground while a third walks away with the weather in an orange coat. The painting—clearly a variation on David Park's epoch-making *Kids on Bikes* done 5 years earlier—sings in several registers at once, effecting a singular harmonic splash.

In a similar arrangement, *Boats,* 1965, two masses—a pair of rowboats on the left and a bush on the right—impinge from the margins. In between, the motley shore builds to a misted horizon and, further up, a heavily underscored sky. Here, the air seems chiseled, light a matter of vectors crisscrossed along some unseen superstructure. But the broadest light is that of the wide view in *Girl on Porch,* 1968, with its troweled-on burnt-caramel and mocha sunset. Pilings of deep, impacted color equal mood, and mood is feeling's ornamental residue. The scene is an unabashed latter-day Symbolist's reverie: all nostalgia for an infinitude of sentiment.

Artforum, Summer 1990

Yayoi Kusama

The Japanese artist Yayoi Kusama spent the years 1958-1973 in New York where she gained her first notoriety. During that period her work shared affinities with a nearly encyclopedic range of avant-garde practices. Her large "Net" paintings coincided with reductivist abstraction, her "Accumulations"—beginning around 1962, first with collage, then as environments with stuffed-fabric penises clustered on common household furnishings—anticipated the proliferation of strange erotic objects during the latter half of the decade and her nudist Happenings from the late 60s and early 70s were right in sync with the politicized exhibitionism of the Age of Aquarius.

Kusama returned to Japan in 1973 and has been voluntarily living and making her work in a Tokyo psychiatric hospital since 1977. This small retrospective showed her at her best and still left one curious to see more—especially of her recent assemblages, which look just as timely as her earlier work once did. The serial, nearly monochrome "Net" paintings (examples here were from 1959-61) still look superb. Their closely adjusted, shallow layers hold the surface and yet suggest a breathiness reminiscent of Jackson Pollock's *The Deep*, though slower and more elaborated. You have to peer very closely to see how these graceful and sophisticated pictures were made. Kusama's surfaces seem about to swirl madly out of focus, but the very arcs that suggest this motion also serve to stabilize the paint. Do the small flecks index the putatively scattered or inundated self? How literally interior are they? Alexandra Munroe, in her catalogue essay, likens them to capillaries and cells, but it's hard to see the paintings as the artist did, as images of the dissolving self, because the forward colors—especially the whites in *No. 2*, 1959, and *No. T.W.3.*, 1961—are like skin asserting a tender yet solid primacy.

All the same, Kusama's work can be read as an agon of self-possession, both instinctive and shrewdly mediated. Even her way of claiming its status as "psychosomatic art"—as therapy—may be a mediating device that asserts, even as it apologizes for, the authenticity of her meanings. Her conceit is that of a perpetual leave-taking (as in *Farewell Supper [2]*, 1981) that paradoxically shows signs of an ever more entrenched staying power. A wall-size cabinet assemblage, entitled *Leftover Snow in the Dream*, 1982, has terrific scale: several white podlike forms swell against the walls of fourteen abutted, upright bins. If a pinprick were applied, the whole ripe agglomerate might burst, spurting its juices clear across the room.

Kusama's art is fun—a fairly regular irony arising from work that derives from the more frazzled depths of the human psyche. This is not the "wonderfully dismal" quality that Robert Smithson found in Eva Hesse's sculptures. Kusama's compulsive reiterations are at least as specific and intricate as the weather. The work's strangeness is not remote—not *brut*—but part of its intimacy.

Artforum, Summer 1990

Dan Connally

Dan Connally, a 34-year-old painter from Georgia, came to Northern California in the early 80s as a graduate student and now lives in Santa Barbara. At a glance, the six medium-size paintings he showed here could be taken as luxuriant, though somewhat private, meditations on the pleasures and pressures of 20th-century style. Some consist of cubistic planar grids, reactivated and jumbled so as to suggest seismic distress. Or, where the grid bursts open in glowing shafts and forward clusters of pigment-as-surface-and-edge, what is recalled is that moment in the 40s when Abstract Expressionism emitted its earliest hybrids, budding bravely out from under the Euro-Modernist mulch.

Connally's pictures project a self-conscious heterodox incipience. Thus, their impetus isn't private or antique at all. They recapitulate the vibrancy of certain favored moments in art history when a new ripeness was ready to spill over—early Cubism, proto-Action Painting, and even the unfussed form and color associated with the Sienese quattrocento. Thus, their impetus isn't private or nostalgic at all. Connally is after an objective, ecological root language of painting and the sort of copious statement such a reinvention of first principles can help to deliver.

Each of the paintings declares it own temper: hectic, reckless, hilarious, stately, absurd, or affectionate. Finding his originality in an oblique, improvisatory classicism, Connally multiplies forms hand over fist. This gives the pictorial drama another measure of incipience, making for paintings full of brinks and tangents, close calls between darting and otherwise disjunct elements, and sudden extrusions from minor to major, from baffled middle distance to full-fledged close-up. Among the many strokes in a two-foot-high painting, every stroke counts. The merest swatch of green suggests a wood, and landscape regularly enfolds itself amid still-life accoutrements, on a cue most likely from Juan Gris. But then Connally tempers every strain of imagery with an overriding abstract possibility. Squiggly, low-rolling ocean waves in one painting, *Untitled 90.VI* congeal in the next *Untitled 90, VII* as scalloped architectural trimmings. There are micro/macro conundrums, such as the scattered bulbs, blooms, and starburst shapes in *Untitled 89.IV*, which look undersea, garden-variety, and intergalactic, all at once. Complementary symbols—the most persistent being an old-fashioned key and a keyhole—seem fated never to connect. Similarly, in *Untitled 89.III* a pair of jet-black curves that suggest compositional tethering devices twist loose from the matrix and hang suspended like a musical note or monogram.

Connally edits by daubing one thing over or next to another; instead of fracture and congestion, there is a sense of incantatory completion among separately incomplete thoughts. His stray shapes look slapped down without compunction or plan as to how they might fit. Because they do fit, the result is an airy profusion asserted where an all-too-fixed order (the fabled grid again) was once assumed.

Artforum, September 1990

Jim Barsness

Most of Jim Barsness's mixed-media paintings show real people striking attitudes that are both familiar and discrepant. We see the artist's wife and children in the nude, full-length and hieratic rather than intimate. Taken from memory, the poses are idealized beyond anecdote, as if, in the course of their domesticity, these people had collectively assumed a double life that their individual features reflect. Their nudity is functional, a way of making what the artist calls "indelible character." Looking at them the discrepancies one recognizes relate to art history (scads of quotes from Renaissance examples obtain), but more so to art's way of reminding us of how a pervasive grace may arise—and linger touchingly, illogically—in the most ordinary circumstances.

Barsness incises his figures' contours with dark ballpoint blues on unstretched cloth often partially covered with collaged sheets of his son's drawings or pages from discarded comic books. The dim brown tone and heft of rumpled canvas or tarp tacked to the wall is self-evident; less so the gravity of the figures depicted there. The paintings have a double aspect of size: the plain, wide expanse of the cloth and the heraldic scale of the image, often set off by an inner border of gold leaf. (For skin tones, Barsness uses burnished gold or silver leaf, or else white paint like scoured porcelain.) The zappy marker-pen drawings and irregularly divided comic-book pages bring texture, perspective, and bright colors to an otherwise pallid scrim. Another perspectival device is that of a recurring ellipse—the foreshortened oval of a goblet, saucer, or tabletop—affixed to a cushion of air.

The ballpoint's thin, reiterative contour strokes pool up slowly, a process that goes both with and against the nature of the tool. Ballpoint pens are designed for speed and fluency on paper, but Barsness pits them against the rough canvas weave ("I find that images respond to the physical difficulty of making them," he says). Then again, ballpoint ink oxidizes, leaving an iridescence like that of a grease puddle on a dirt road, a deep dazzle. If the blue ink sidles up to gold leaf in a sweet reprise of 14th-century spiritual glamor, it's no accident. Barsness is after exactly that passage from one human affirmation to the next.

Partly because the figures, like the surfaces they inhabit, are patchwork inventions, they can look interchangeably noble and a little dumb. Sometimes it's as if the compressions of Old-Master contour had sprouted a self-caricature at the extremities. There are clunky-cum-enigmatic hand gestures and smiles that verge on the intense inane. Barsness has chosen the far-flung masters of his ideal, and of the grotesque as well, carefully; a thick, tuberous nose memorized from Leonardo's *Madonna of the Rocks* turns up repeatedly transplanted onto each member of a family circle. Likewise, spread huge across *In Memory of the American Empire*'s laminated funny papers, an isolated woman's face wears an exaggerated Mona Lisa overbite. In *From 1 to 100*, a frieze of women and children takes on a sportive, bumptious case, like Pieter Brueghel's closely choreographed gnomes. Two other canvases hold paste-up accumulations of pure caricature: rows of torn paper sheets—one set from a book of art criticism, the other of coffeehouse tabs—

on which Barsness doodled heads while riding the New York subway; these represent a canny way of converting busywork to artistic generosity.

Colliding kinds of recycled representation intimate a world in which such normally disassociated modes are simultaneous revelations. Which sign is more accurate, the classically proportioned rendering or the juvenile smear? And how does Barsness's ennobling vision equate with boyhood themes bodied forth in a jack-o'-lantern, a castle, arithmetic, superheroes, firepower? The simultaneity slows the viewer's contemplation so as to heighten it; you see the layers of reality as they are—jumbled yet contiguous, and no less exalting for their commonplace deadpan quirks.

Artforum, October 1990

Francesc Torres

At the center of Francesc Torres' new installation, *Destiny, Entropy, and Junk*, 1990, a 10-minute, fuguelike videotape projection was beamed from above onto a nine-by-eighteen-foot patch of salt on the main gallery floor. Surrounding the highly reflective, makeshift screens sat seven luxury cars—a Jaguar, a Cadillac, a BMW, a Corvette, and so on—all exhibiting varying degrees of front-end collision damage. Torres borrowed the sedans from a local AAA garage for the duration of the show (fittingly, the Capp Street building is an ex-body shop). Next to the cars stood shiny steel showroom display markers framing head shots of the large German-culture-hero statues that line the Siegesallee (Avenue of Victory) in Berlin's Tiergarten from the 1880s until the later 1940s when, having been severely battered during World War II, the statues were removed and buried on the grounds of the Schloss Bellevue. These same recently exhumed cast-concrete figures emerge as major players in the videotape. With their stricken visages topping off an egregious heroicism, they supplied, as Torres put it in a gallery handout, "the visual record of a historical lesson."

Collision, or crash—with its ur-text of speed at all costs—was the central metaphor within this work. The videotape opens and closes with blurred and grainy zooms and pans of the hapless Siegesallee figures. In between occur bonfire-lit street scenes of Torres' native Barcelona during the summer-solstice celebration of St. John's Night, shots of intense proceedings on the floor of the New York Stock Exchanges, and correlative footage taken off network TV. There's telling sequence that begins with a couple of boxers breaking from a clinch, accompanied by a soundtrack of some obligatory Wagner overdubbed with car screeches: cut to a Wall Street trader hanging up the phone and bowing his head (whereupon the whole frame enacts a literal slump), Reagan speechifying, and a race care exploding. Finally, a 1981 news tape snippet of Reagan being shot freezes on the appearance of a gunman's hand (not John Hinkley's but a Secret Service agent's) at the edge of the frame. The whole sequence lasts little more than a minute and triggers several quick changes in tempo. A panicky, speeded-up overview of Wall Street segues into a set of slow, near-ecstatic, pastel-hued pixilations of

solstice fireworks, at which point the "victory" statues reappear and the tape goes blank on one long note of white noise.

Torres may be a kind of model intellectual artist. He doesn't fiddle around with ideas but goes straight to their everyday relevance. Viewing the installation at ground level, or, better, from the second-floor balcony, one could see how he orchestrated a tidy repertoire of analogous elements into a theoretical nexus of gists about how history does and doesn't work. Sensibly, the thesis was rigged so that, of the three terms in the title, entropy came out the winner. Torres assigns entropy the potential value of a spontaneous cleansing agent. A self-styled destiny, being coercive within any rationalized system (of which the destiny-acquisitive nation-state is one), ends in a shambles. If temporal powers fall apart by their own momentum, the resulting chaos can prepare for a new and more promising order, or, at any rate, a little humane loosening at the controls. If not, all that's left is junk—bashed-in remnants of the old, self-defeating control mechanisms ripe for retooling into another cycle of coercion.

Torres' way of connecting the dots among the displaced tenses of history is distinguished by its soulfulness. By invoking the popularly ritualized forms of chaos in an ancient Catalan carnival, he means to introduce a salutary glimmer of optimism into the infernal mix. There's as much pathos in that as in the drive of one superpower after another to end up on time's scrap heap. If anything is missing from Torres' vision, it's the crazed eroticism that J. G. Ballard, for one, has discerned within the fast-lane enchantments of contemporary life. Even the most sensuous moments of Torres' imagery are checked by a resolute spareness, which may signal a cautionary refusal to cross over into excess.

Artforum, November 1990

Lee Friedlander

Early on, in the late 60s, Lee Friedlander's photography was acclaimed for its skittish alienation effects and headlong artlessness. Looking at his pictures now, you realize how willfully their images have been managed, whether the compositions are helter-skelter or nominally empty. (That willfulness can be overbearing. Friedlander is also notorious for the stupefaction his monstrous puns and one-liners can induce; it's a chronic case of humor running afoul of its own logic.) Friedlander doesn't come off as alienated, as if the culture has pushed his sensibility aside; you sense that he has arrived on the scene from elsewhere as a designated observer, a live wire, an often haplessly disruptive goof out of step with, yet transfixed by, the ways of modern life. Such distancing (not just esthetic but at the core of his vision) might be innate or coolly devised for the peculiar, often spooky clarity Friedlander is after and usually gets. He shows the duress—a collective darkness in broad daylight—that vision comes up against in threading its way through the perplexities of present-day urban spaces. Typically, confronting one of his 60s cityscapes, you see the spread of detail but can't see what's happening in the mix. What John

Szarkowski calls Friedlander's "found Cubism" tends to be a cluster of un-right angles jiggling across the frame. The landscapes, gorgeous or bleak, are uninviting or anyway impassible. The New York views with their multiple reflections and occlusions (often one and the same) permit few avenues of either access or escape; most of the interiors and whatever people inhabit them look abandoned, and the rooms' contents are rendered not just untouched but unreachable. Such an intensely photographic world view is a corruption in the literal sense that Wallace Stevens intended when he wrote "Realism is a corruption of reality."

This 30-year retrospective at the Friends of Photography's Ansel Adams Center shows Friedlander's footloose range without digging deeply into his particularity. The choice of portraits, especially, seems to err on the sentimental or arty side: instead of the famously piquant shot of R.B. Kitaj with a woman's leg draped across his lap, we get a looming close-up of the sensitive painter nuzzling a cat. The two best portraits in the show, nonetheless, respectively demonstrate how powerfully plain and on target and, conversely, how suddenly complex and fraught Friedlander's vision can be. *Eric Friedlander, Florida, 1974* amounts to an emblem of tousled 70s teenhood (the bright, stand-up aspect of the same generation whose dark side Eric Fischl would portray a few years later), while a contemporaneous image of the boy's mother, entitled *Maria Friedlander, New York City, New York, 1976,* taken as she strides down the hall, wrapped in a bath towel and crisscrossed by light and shade, is shot through with affection tinged with the barest touch of domestic malice.

In the late 70s, while photographing factory valleys by day, Friedlander began taking nude portraits of women in their homes at night. The nudes are specific in fleshiness, character, and place. For the unsettling rightness of their realism, there is nothing like them in contemporary photography, or, for that matter, in painting. The closest parallel among painters would be Philip Pearlstein, who once wrote of treating the nude as a found object and whose paintings feature relations between bodies and furniture comparable to those in Friedlander's photographs. But, unlike Pearlstein's pictures, Friedlander's are not studio setups, and his women are less performers in a perceptual charade than actual people who look to have sat or stretched out prone for a session of down-to-earth, mutual self-revelation. The nudes are living subjects first and last, and objects of perceptual and formal contemplation somewhere in between. Friedlander's shadow, the photographer's perennial index of his art's built-in subjectivity, doesn't fall across their bodies—only one of the women in the pictures shown here even acknowledges him or his camera as another factor in the room—but you can feel his observant presence, and a kind of nutty sympathy, in the images' every angle and curve. Nudity here is grand-scale but so classically clear-eyed as to be incidental: from roughly the same period, a couple of photographs of adolescent girls in sandals and shorts at the seashore—*Naples, Italy, 1982* and *Galveston, Texas, 1975*, the latter recalling the torsions of Edward Weston's mid-30s beach nudes—belong in spirit to the same series.

Artforum, December 1990

Frank Lobdell

Frank Lobdell's recent pictures suggest narration the way Australian bark paintings do, by spreading and tilting bits of pictorial incident to give a sense of elastic time. The widely stacked, radiant colors—mostly trued-up swatches of blues, blacks, greens, and thunderous yellows—perform as syntactical compartments, paragraphs that interlock emotionally, whatever their rationale. Their hues are like the perfumes of colors you once thought there were precise names for. Each painting could be the story of a particular day, from sunrise to midnight, and the soul's mood swings within that span. To each localized color is fitted a specific linear sign—most prominently, a knobby, dark-contoured glyph that undergoes self-entanglement like a paroxysmal Tinker Toy. It's a psycho-spiritual progress articulated as a dance diagram, with the kinetic twists of a contortionist's tumbling act thrown in. Any catechism informing these mandalic episodes is strictly heterodox—or as they say, "intuitive."

The original aims of many Bay Area abstract painters in the 1950s—Lobdell among them—were grand and fuzzy. Their pictures bristled with yearnings for an uncosmetic, primally intuited iconography prompted by Clyfford Still's hard-won brand of beaux-arts mysticism. Lobdell, while having kept the faith, has never appeared clearer, more emphatic, or less dour. His characteristic involutions are all here, but they are broader and brighter, and delivered with variation in place of fuss, vivaciously.

The main thing is how thoroughly, even dashingly, *covered* the surfaces of these large, taut, complex pictures appear. Such surfaces invite close looking. Most of them appear to have been built up and out from the lower left, with the artist's basic, flatly colored forms holding (often as if in colloidal suspension) their airy plenitude of big and little markings. Beside humanoid and constellatory or molecular point-and-line glyphs, there are squiggly spirals and other, filigreed or concentrically raking abstract marks; pulsating discs with tiny flamelike centers pressed from the tube; an indigo "coffin" on a pale blue rug (an elegiac duo that moans out "Rothko!"). In both *Spring '89* and *Winter I* an exploding blob evokes the frontal birth throes of some cosmic egg. Such whopping ur-figures surge sensibly within the pictorial spread, but the overall tautness allows as well for miniature reveries: along the rim of a blocky silhouette will occur a microscopic Monument Valley, its flats and ridges limned to mouse-hole dimensions in seemingly direct homage to George Herriman or Saul Steinberg.

Who would have thought that Lobdell, long celebrated for his gritty rectitude, would let sheer buoyancy count for so much? This is an instance, much like that of Philip Guston in the later 60s, of a senior painter having pulled together all his resources into a heightened statement, for the likes of which his earlier work provided pungent clues but not completion. Also, as with Guston's later pictures, these recent Lobdells have the advantage of looking timely—peculiarly in sync with the newly limbered-up modes of emblematic abstract painting—without the artist's having guessed, much less worried, that such might be the case.

Artforum, January 1991

Jeffrey Beauchamp

Jeffrey Beauchamp is a 27-year-old painter from New Jersey. He started out as a graphic artist and film animator and turned to painting landscapes three years ago while an undergraduate at the San Francisco Art Institute. This was his first solo show. One thing his landscape pictures express is a fascination with a Euro-American art form that could be identified fondly as Old Brown Painting. That is, the pictures make you consider the odd assortment of epoch-making talent and specialty acts that dramatic, chiaroscuro-based nature painting has borne along its 500-year spillway since the High Renaissance—Leonardo together with Rembrandt, say, or Corot and Ryder, and then Arthur Rackham, Maxfield Parrish and (for the caramel gleams of their enchanted-forest sequences) the 1940s Disney animators.

Beauchamp, for his part, doesn't comment on this flow so much as dive in imagination-first to find his own fresh impetus within it. He's a natural painter, and thus his reliance so far is on his own instinct for the peculiarities that a developed genre's givens can convey: the mixture of dereliction and hope evoked by sunlight glimpsed through wrenching marine clouds (*The Hellespont*), or something pending at the edges of an otherwise restful glade (*The Decision*). His teeming skies and semideranged foliage may be, as he says, pulled from his head, but they also come from the objective repertory of painterly means outside him, and sometimes refer recognizably to the life of the California coast near Fairfax, where he lives.

Beauchamp is a naturalist for whom every twist of cloud or leaf is potentially magical. His images are spooked. Nature is a blandishing, sly impersonator, and all textures signify theatrically. The action, set mostly against summery heats and shades, radiates from the middle distance. There's a sense of some things turning to catch the light and of others cryptically burrowing (usually around the lower third of the canvas) to avoid it. Daylight is cast as a relief from chthonic tensions, but it's also a device for searching out those tensions amid the literal and metaphysical darkness of the pictures' other major forms.

It's hard to stay more than a couple of feet away from the surfaces of these medium-size paintings, so thoroughly does Beauchamp pack his spaces with clues to tease out the viewer's tolerance for anecdotal reverie. Under close inspection the merest daub can detain the eye into suspecting some untoward event, or at any rate, into noticing some unsettling instance of exotica tossed upon familiar ground. In *Chaleur Park*, two shade trees framing a gaseous incandescence have rough-hewn profiles the likes of which might be found in the famous monster grove at Bomarzo. Beauchamp's private grotesquerie carries more than a whiff of the sinister. The incredible roses in *Rose Portal* resemble giant, loosely bunched, mutant grapes; one of them, blown from the arbor to lie at the base of a megalithic throne, looks bloodied, like the skull hidden in the bushes of Brueghel's *Landscape with the Fall of Icarus* (the Brussels version). Among contemporaries, Beauchamp's nearest precedent would be Odd Nerdrum. They both work in a key of disturbance and enigma when lushly depicting bare reaches of the physical world. Yet Beauchamp isn't up for salvaging the epic dignities of humanism at large. He seems bent

instead on keeping alive the remaining fraction of consciousness that can read the imprints of nature as somehow needfully analogous to our purposes and fears. Though his places are ostensibly unpeopled, they bear the proof of being looked at with human eyes.

Art in America, January 1992

Rosemarie Trockel

At 39, Trockel is already a historic figure in her German homeland. Seeing her work's capaciousness articulated in this large traveling retrospective left one mulling the prospect of a pressurized intelligence that can take on a checklist of topically urgent, largely gender-sensitive themes, deal jauntily among the terms of each and still have plenty left to insinuate. At the start of the installation lay bronze casts of three dead animals—two dogs and a deer—strewn across the gallery carpet like institutional road kill. Throughout the show's continuum, aseptic Muzak is crosscut with similar organic noise.

Trockel's conceptual follow-through happens subtly apace, with a particularizing orderliness, so that, for the viewer, abrasive silences and manic laughter bubble up at intervals you think could be clocked. They can't; Trockel's like a Kafka or Kleist in that department: the disturbances that arise from inspecting her set pieces aren't telegraphed by the ways she's arranged them. Her typical display-case conceit implies hermetic discretion along with a lengthy pun about museological containment and window shopping. These melancholy facets of steel and glass, like the meal cubes and stretcher bars in other pieces, stake out a geometer's dreamscape.

Each vitrine houses one or more of Trockel's speculative-appliance kits, succinct as nursery rhymes and just as variously menacing or nonsensical: a parchment-dry pig bladder and brass wire funnel hung above a small dark hole in the base; a live spider cohabiting with a while shirt, a packing pin neatly transecting the breast; a set of five hellishly imprinted ski masks, all upright and empty, their bare slits suggestive of hand-puppet mouths. The symbolic raw edges of miscast (e.g. commodified or sexually pinpointed) identities languish or ricochet, are shattered, mourned, transmuted or fused. Beyond the constituent meanings—biological, economic or both—lie puzzles of extra intentions and transfinite depths. Where monumentality occurs, it is exact, not showy—a cenotaphic fullness.

Trockel's best-known works, the computerized knit paintings, have an additional fullness—the kind that repetition makes as if drumming over an abyss. The slight sags the fabrics take along their horizontals permit few precise straight lines, so their logo-riddled surfaces spread somewhat clownishly. Knitted or woven images are nothing new, but advancing them as conceptual objects is novel and effects a raid along the feminine/masculine divide. Untitled *(Please Do Nothing to Me, but Quickly)*, 1989, succeeds in deepening gender politics with an erotic charge. Ten, maybe 20 years ago, these paradoxically chill mural-samplers would have been called "seductive"; as it is, in thought

and presence they're voluptuous, which Trockel probably intended as part of their critical weight. As well as any of her more nettlesome productions the kits slyly address a baleful compression in our psycho-social climate, where taking care of business—the dusting off of a determined meaning, for instance—is just one step short of delirium.

Art in America, February 1992

Bruce Conner

During 1973-75, Bruce Conner collaborated with the photographer Edmund Shea on a series of photograms—one-of-a-kind imprints of the artist's body, or parts thereof, on scroll-like sheets of photographic paper—called "Angels." Of the twenty-nine originals in the set, twenty-seven are still extant, and this show had twenty-four of them. Encased in Plexiglas and arranged chronologically on the gray walls of a dimly lit, narrow gallery, the photograms marked a vertiginous narrative flow, like figures on a frieze to which light filtered by eons had just penetrated.

The "Angels" are Conner's most close-to-the-bone, literally autobiographical works, and also his most otherworldly. Turning 40, with over 15 years of painting, assemblage, collage and film-making behind him, Conner was beset by a sense of his accumulated artistic ego, what he called mere "heavy baggage, encrusted with all sorts of pleasant and unpleasant things." In that respect, the "Angels" can be read as self-portraits in a time of crisis—they take for subject matter the self's identification with the body. Looking at these images, we don't gain any feeling for who the real Bruce Conner is or was when the pictures were taken. Conner's own assessment of his role in taking them— "I supplied the body"—is no modest disclaimer but realistically indicates a point of removal; if anything, it's the choices made among a variety of poses, each calculated as to effect (they're often as weirdly contorted as modern-dance gestures), that give us clues about the personality at home in the work.

In these images, we seem to see luminous, androgyne shapes advancing from the dimensionless stretch of darkness. Conner and Shea worked them up in nightly sessions by draping lengths cut from mural-size rolls of photographic paper in Shea's San Francisco basement studio and exposing them to light from a slide projector. Against these sensitized backdrops, Conner perched himself nude on a wood box, interrupting the beams of light so as to cause his silhouette to emerge on the developed prints as a gaseous white and/or gray area in an otherwise slick black field. Varying exposure time and points of contact between body and sheet produced gradations of tone, texture and modeling. As the series progressed, Conner experimented, pressing an extremity or two (palms, fingers, lips) onto the paper and letting the rest of his body virtually disappear under prolonged flooding.

Thus, some of the later images show a full-length, "mummified" shape (swathed in watery striations induced during the chemical processing) with protruding white "wings," while the final, more abstract ones tend to register only disembodied flares

above the pyramidal wedge of Conner's makeshift pedestal. The uncanny "skin" of the photogram surface—the way its voluptuously extruded whites and marbled tonings really do imply a presence of both flesh and "other"—fits impeccably with Conner's self-distancing conception: the particular self is indexed as a shifting mass of particles, of which the only perceptible common denominator is a shade or astral flash, imposing and memorable as its energies may be.

Art in America, November 1992

Jay DeFeo

As it happens, soon after Bruce Conner began inventing his "Angels," Jay DeFeo made eleven of the thirteen photo-collages seen in this show. Defeo and Conner's friendship had followed from Conner's arrival in San Francisco in 1957 and continued until DeFeo's death, from cancer, at the age of 60, in 1989. In 1973 they were having quasi-daily telephone conversations—dialogue so intense that Defeo came to address Conner by the code name "Telephone." Like Conner, DeFeo was at an impasse in her work. *The Rose,* that immense albatross of an oil painting which took over most DeFeo's energies for 8 years, from 1958 to 1966, and which continued to haunt her long after, had been deposited on a wall at the San Francisco Art Institute, and Conner was furiously lobbying for its removal and conservation.

True to the call-and-response tradition of art making that grew up among her Bay Area peer group from the mid-1950s (beside Conner, others in that circle included Wallace Berman, George Herms, Wally Hedrick, Joan Brown and Jess), DeFeo's paste-up recombinings of homegrown photographic imagery were inspired both by Conner's initial progress with the "Angels" and his urging that she examine more closely the household motifs she had been more or less ruminatively "sketching" with a Hasselblad over the previous months. Different from her large-scale collages of the 50s—two of which, featuring loosely joined, whirligig arrangements of female nudes, animals and hand gestures cut from magazines, made up the balance of the show here—the 1973 pieces are tersely conceived and exquisite in their part-to-part layerings. If the order on the gallery walls followed anything like a chronology, they seem to have increased apace in density and expansiveness as DeFeo's confidence in their meanings became more distinct.

What DeFeo was after can be taken as the visionary flipside of Conner's project: instead of removing her self-view to an instant ethereal plane of light-and-dark flashes, DeFeo gathered a parallel self from whatever accoutrements of her day world caught her eye. An old-time upright telephone, patio furniture, flowers, a leaf after rain, a velvety cross-buckle shoe and, in some instances, sheer black photo paper, sliced at to produce elegantly meandering white ridges—such things are transformed in the collages into surrogate body organs, orifices, contours, skin. Generally, as one can see from her paintings, with their occasional stabs of red and incised blacks set against softer tonalities,

DeFeo was at home in the oneiric, detailed, halftone world that photography best proposes. Much as in the mixed-medium rendering of common objects that derived from in part from these collages, her contemplative vision operated by internalizing the natural forms, implements and accessories she observed about her and identifying their bodily correlatives, the better to conceive a personal place among them.

<div align="right">Art in America, November 1992</div>

Tom Field

Tom Field (1930-1995) was born in Fort Wayne, Indiana, where his parents ran a bar. Early on, he found for himself the pleasures of painting. In a 1986 interview with Christopher Wagstaff he recalled, "About the age of 5 I took a petunia and squashed it on some paper and discovered there is pigment in flowers...." From 1953 to 1956, after 3 years of art school in Fort Wayne and a couple more as an army surgery assistant in Korea, he attended Black Mountain College, where he readily absorbed the bravura modes of Franz Kline and Willem deKooning, along with the consolidating manners of their younger followers. Field's main teacher was the New York painter Joseph Fiore, but he also studied with John Chamberlain, Charles Olson and Robert Creeley, the last of whom published some of Field's poems in *The Black Mountain Review*.

The earliest picture in the present show of ten paintings from the 1950s and early 60s, *Bird in Flight*, 1954, is also the sparest and resembles Fiore's work of about the same time in its feeling for particulars pitted against the stress of large, general forces. On the other hand, *Deep Blues (The Party)* is more stable and announces Field's adeptness at chromatic splendor. Field described the picture as "a very deep-colored thing with lots of cobalt and reds and earth color. I liked to make my shapes the size of brush strokes...."

After his studies, Field came to San Francisco and developed the habit of alternating periods of intense concentration on painting with shipping out as a merchant seaman. The daily mixtures of drudgery and romance found at sea inspired at least one painting that has remained a local legend among the painters and poets who became Field's prime San Francisco audience. *Pacific Transport*, 1958, is an iconic arrangement predominantly in somber aluminum grays and three or four high-intensity blues. Based on the view (piles of crates and, over the railings, a choppy sea) from a cargo ship's wheel house, the painting locates the power of such a vessel through focusing on the sensation of being on board, rather than drawing one's attention to the trackless beyond.

Beginning around the time of *Pacific Transport* and for a year or two thereafter, Field's pictures build upward from a kind of proscenium apron or ramp over which teams of quasi-recognizable shapes parade. *Cluttered Roof* is a veritable bacchanal of such shapes. *Valencia* releases its energies (sprung from details as diverse as scribbles, bits of collage and a still life) in all directions at once with an ardor both fraught and firm. The view feels aerial and nocturnal; the title is one of those multipurpose proper nouns,

meaning a ship, a port of call and the oranges clustered in the canvas's lower right quadrant.

Field committed his repute as a painter to the periphery of a local art scene that he recognized as having next to no career-potential to begin with. Accordingly, he figures in none of the standard histories of modern California art, and no work of his was included in either the "San Francisco Abstract Expressionism" or the "Beat Culture and the New America" museum exhibitions that have circulated over the past year or two—an oversight that might well have passed unnoticed by the artist himself. "I usually shipped out again no matter what was going on," he told Wagstaff. "It never occurred to me to stop doing that. I just—I didn't think I'd ever make it big, really, and so I didn't feel I should devote a lifetime to painting." Be that as it may, a lifetime's worth of painting is what he left behind. This was the first gallery show to focus solely on his work in 32 years.

Art in America, February 1997

Henry Wessel

Twenty years ago, when he was in his 40s, Henry Wessel was asked in an interview about the phenomenal luminosity of his pictures. He responded that, for him, the photographer's task "is to describe the existing light…. Chances are, if you believe the light, you're going to believe that the things photographed existed in the world." Now Wessel is past sixty, and a retrospective of his work, including examples of his first bare-bones road studies in 1967, shows the splendor of his conviction.

By now, Wessel's lack of conceit, his objectivist discretion as a maker of images of outdoor social spaces, with or without people, should be legendary. You almost don't find him in the image-making process at all, and his resolve about keeping at bay every conceivable subtext—sociopolitical and otherwise—seems to have been firm from the get-go. Accordingly, what is most interesting about the early pictures is their forbearance, as if Wessel was initially content to render visible whatever there was in such spaces other than the spaces themselves and their directional markers, as if he was after nailing the core of some proverbial "middle of nowhere," which in turn might have pointed him toward becoming an abstract artist. However, it's clear that by 1973 the contemporary haphazardness of the perceptual world was exerting a contrary pull and, with that, the richness of Wessel's own sensibility began to manifest itself. The declarative candor of his work has remained pretty much consistent ever since.

Something funny happened in American photography of the late 1960s and early 70s, quite possibly reflective of the national culture as a whole: a kind of frozen slapstick, by dint of which everything in a picture misbehaves or appears irredeemably displaced. A worthy parallel to this occurs in Robert Altman's 1973 film *The Long Goodbye*, with the leitmotiv of the character Philip Marlowe (Elliot Gould), who, in the face of perpetual

disconnect, murmurs offhandedly: "It's OK with me." Inklings of what might be called an absurdist phenomenology of moment can be discerned early on in the work of Henri Cartier-Bresson and 1960s Lee Friedlander, and a core intensification of the mode can be found in William Eggleston's mid-70s picture *Memphis*, which shows a matron in sunglasses twisting to look behind her (did someone call?) as one foot slips off the sidewalk into ankle-deep grass and a monstrous fruit tree explodes at her back.

The flawed moment is recognizable as something from which no one is exempt (hence the chorus of amused snorts from every side). Like Eggleston, Wessel is no satirist, but many of his photographs could be held up as evidence of a kind of endemic stupefaction (as the poet Philip Whalen asked in 1969: "When did the dumb-bunny bomb first hit U.S.A.?"). To see even the nuttiest of Wessel's creations simply that way, as spoofs, would be to shrug off their (and our) abiding care for what we see in them, and the beauty that seems to emerge from such benign attentiveness as well. In this regard and others, Wessel's closest artistic kinship is with Harry Callahan.

In the early 1980s, although he had photographed women off and on previously, Wessel seems to have discovered them as a new kind of subject. Wessel is good with women, who tend to act in his photographs as foils to his penchant for inexorable, flat-out discrepancy. Where Wessel's men look uniformly clunky, ill at ease, or distracted, the women confront the camera directly with everything they've got: dynamic, distinctive, sometimes bristling, always unencumbered and alert. Oddly, the two genders rarely mix. Like the pictures, the women tend to sit in place unassumingly; they project an affect of long waiting (even though the swift click of the shutter says otherwise). The resulting document, so-called, is a matter less of an everyday phenomenon gone unremarked than of how Wessel's camera remarks upon it. Some purpose is in the air but you sense it only after the fact—the message, if there is one, chronically tied up in perceptual traffic.

Peer of the gods is that man who stands stock-still on a strip of patchy lawn, hands sunk in pants pockets, a flock of pigeons just sprung from around the palm-tree trunk before him. Identified simply as *Santa Barbara, 1977*, this image is a stunner. In another (not in this retrospective, but at the Charles Cowles Gallery in New York), a dog is seen trying to eat a tree. Back in San Francisco, there was the bonus coda of forty 1990s "house pictures"—succinct, frontal color portraits of rudimentary bungalow-type dwellings in Richmond, California, near where Wessel himself resides—in five rows of eight on the show's end wall, six by nine inches each. Whatever stories might be told of such views, their terms are self-evident and require no shuffling into coherent narrative. The photographer's coherence, a kind of unanticipated, angelic order, is plain: the head-on shot spaciously devised, a little symmetry (Wessel's basic default factor), egalitarian depth of field, and all rinsed in plenty of light—by turns exuberant and blithe, deeply humane, brimming across the sheet.

Aperture, Fall 2007

Gabriele Basilico

In April and May, 2007, Gabriele Basilico, at the invitation of the San Francisco Museum of Modern Art, set about photographing public spaces in San Francisco and the information-processing haunts southward, along the Peninsula, as far as San Jose. All the images in the resultant series "Silicon Valley, 07" are digital pigment prints, about a fifth of which are in color. Shown variously in large and medium formats, they are large scale and revelatory without pushing into the spectacular beaux-arts dimensions that have become normative for ambitious photographic projects.

A fairly large print format lets Basilico's prodigious scale extend itself, and with it, his largesse. That scale, with its massive sweeps and salutary frontal intimacies, is contiguous with a highly refined sense of projective light, so that the pictures leave no bare fact unturned and the least detail sits in utter vibrancy. (Such qualities put Basilico's pictures in striking relation to the heightened montage in Michelangelo Antonioni's 1960s films, *Eclipse* and *Red Desert.*) Basilico has trained his eye to find views where architecture can declare its singularity aside from any ostensible use. As happens in the mostly industrial or corporate spaces he visits, styles of architecture are gregarious, even when the people around and in them aren't. Elide or diminish the human element and everything else becomes sublimely noticeable (that "everything else" shows human intervention anyway is inescapable).

The life of a place is a continual allegory. It's as if Basilico, with his big view camera in tow, first catches a whiff of the whole of a particular situation, its larger meanings, and then ferrets out what's going on it. Intense contemplation of this order produces the sort of uninflected pause identified by the museum's press release as "eerie stillness," which is more probably the concentrated hum of Basilico's mode of expanded looking, transmitted across the scene. The point is to advance a stable image out of complexity, even where the scene is determinately out of whack or where, as Basilico puts it, "the urban environment has become so watered down that it has lost its way.

Is this what Late Capitalism looks like? An exhibition vitrine held two maps Basilico had marked for outings. Looking at what the pictures show one can point to the evidence of what has become of a particular place—or this is what is there, to work with, perhaps. Alfred North Whitehead wrote, "The animals enjoy structure, we only understand it"; it's clear that no one now understands management or planning, and the land just puts up with it. In his various aspects as European, former architecture student and an artist, Basilico presumably has a sense of history that befits his baseline culture. For Americans, however, conditions of imperturbable flux make for histories obfuscated or grossly ignored. History anywhere resides in the persistent identities— energies, even—of places that otherwise undergo changes of name and apparent function. (This is as true for, say, the site of San Clemente in Rome as it is for El Camino Real, stretching from South Francisco down the peninsula—once a trail for long-settled Ohlones, then a Gold-Rush trade route and now a lengthy business strip parallel to U.S. 101.)

Basilico is said to have especially liked the Bay Area's intensely variable light and skies, which in his black-and-white pictures appear blanched or else possessed of

graphite-like tonalities. Then, too, there is his wondrous range of sun-lit grays. The more long-range color views of San Francisco tend to show some fogbank in the distance, as well as (even with—or maybe thanks to—the tentative look of ink-jet printing) subtle shifts in registers of microclimate. A jet trail and some horsetail wisps accentuate the identity-in-difference of a pair of abutted Palo Alto homes; beneath an encroachment of frothy cloud cover, a four-way stop among Palo Alto hedges posits a structure of Arcadian ceremonial calm. (Generally, any kind of weather showing acts as a bonus.)

Basilico's attitude may be that whatever the circumstances, the sheer existence of made things counts as an opening to seeing in the human universe its inherent poignancies, beautiful as can be. He honors the optimism (and desperation, first and last) that put these things where they are in so many mixed-up ways. There are endless boarded-up, fenced-off places, neo-Baroque freeway ramps and other incidentals of orotund portentousness. A couple of doughy installations at the Mountain View NASA site literally take the cake. What we have here is documentary photography that does the job, with such magnanimity of purpose, its ultimate addressee is the human heart. The pictures are aglow with curiosity. They don't miss much, including the hugeness of what is usually hidden. Speaking of the ultimate opacity of his Silicon-Valley subjects Basilico says: *You see the architecture, the interiors, open spaces, areas for relaxation, the army of computers, in synthesis; this is everything, but you don't perceive the actual substance. The real content is invisible. It's as though we don't know what the persons working there are doing.*

Aperture, Fall 2008

American Figures

Alex Katz

The diverse large-scale truthfulness of Alex Katz's work extends from its spirited professional stance. He has labored at deciding for himself what is most admirable and ripe in the line of masterfully balanced, traditional oil painting—a tradition he confronts quite bluntly and has gone some lengths to enlarge. When one of his paintings is beautiful and right, you can see how succinctly he meant to bring about that completion. He would speak now (as in Rudy Burckhardt's lovely film about him) of masterpieces, so that the level of his aims is clear, and besides he has delivered—painted genuine ones, I mean—in a goodly number. As he says, "Irony is just an apology for not being able to lay it out there," by which "it" I believe he means a specific thing, each instance taken at its full extent. His recognizable style is objective, decorous, timely, and grand; also combative, and difficult even when most clear. His subjects are from life: personal, sociable, familiar, sometimes very funny and odd, and unexpectable (Nature). He has a narrative, rather than descriptive or lyric, sense of the occasion at hand. (Hence, the "History Painting" look of some of the group-figures, neo-classic like out of David; hence too, the range of strong, affectionate, often elegiac, feeling, as in Turgenev or the "pointless stories" of Charles Reznikoff, immediate and lately getting more explicit.) Looking at his pictures, you will either know where you stand or end up dazed in them. The color tones, which are fixed and decisive, register character and space, which spread, packing a wallop with their light-and-energy size.

People, as they are set forth, suggest a New Yorker's tact about distance: Eyes in groups meet or stare away or come straight for you; at close quarters elbows define a multiplicity of personal edge. Elsewhere, a single sitter's gaze widens, beyond any set contingency, to throw open the whole surface towards miraculous scope. Such large possible totals transmitted with paint out of dailiness are great sources of delight and instruction. The delicacy of Katz's new-found drawing style is a great thing too. His is an observant, willful art, asserting what is seen, articulated into graceful, renewable states. Take the immense painting called *December* in his latest New York show: We see the head and shoulders of a woman (a rather Japanese-looking Ada) in a soft brown hat, coat and muffler, wrapped, so to speak, against the elements, while the snow splotches about her. The look is slightly askance, she's just flashed an attitude, but it's utterly intense and furled. The entire space is pivotal, on the brink. The weather intensifies the sharpness of feeling, but the character being projective, appears impervious to the weather. She's absorbed in something else, serious and determined. She addresses herself to the second person, which may well be the viewer, or light. But, on the other hand, the character and its light are one.

April, 1980

Wayne's World

One of America's best-loved painters is Wayne Thiebaud, whose appearances in New York this month reveal him in the dual capacity of artist and connoisseur of painting's multifarious ways of conferring what he calls "a condition of specialness" on a recognizable image. A survey show of his work inaugurates the Allan Stone Gallery's new space in an abandoned Upper-Eastside firehouse while the National Academy of Design will mount his personal gleaning (for the second in that institution's ongoing series, "The Artist's Eye") of seventy-odd examples from its permanent collection of pictures by 19th- and 20th-century Americans, along with another, smaller array of still lifes, landscapes and portraits by Thiebaud himself, a member of the Academy since 1985. Thiebaud's choice for the Academy exhibition includes works by artists as various as Gertrude Fiske, Thomas P. Anschutz, George Tooker, Elmer Bischoff, Edwin Dickinson, Felice Wald Mixter, Jane Wilson and George De Forest Brush—a mixed bag of curios and marvels that gives a fair idea of the range of this eclecto-traditionalist's own hybrid procedures.

Thiebaud's success has been achieved without much hoopla from the critical establishment. He's an old-fashioned professional easel painter (his canvases rarely venture much beyond five feet in any dimension, and most are considerably more compact), a confirmed realist in a period when realism, despite its continued marketability, has at best a fringe currency among most art-world insiders. There's one way of seeing Thiebaud as an affable, bravura describer of sunny climes and the small pleasures of everyday life and another that focuses on his dark side, for which the sociability his pictures project provides a shrewd but quickly diminishing foil. Thiebaud paints his pleasure in scrutinizing the world but also the discrepant truths that such scrutiny reveals.

Since the early 60s, when he settled into a unique, brassy manner of rendering food displays and stiffly posed men and women in mostly blank, floodlit settings, the course of Thiebaud's art has been deliberate and steady—a centripetal, if sometimes capricious, gathering of motifs together with all the technical brio to make his peculiar vision of them strike home. He seems never to exhaust any particular subject, changing only his methods throughout multiple recapitulations. Thiebaud turned to painting full-time, after a decade-long career as a cartoonist, layout designer and illustrator, in 1949, just short of his thirtieth birthday. A year later, he moved northward from Southern California to Sacramento, where he has for the most part since remained. His first New York show, at the old Allan Stone Gallery in 1962, coincided with the Pop explosion, thereby easing a view of the West-Coast interloper's seemingly impersonal hot-dog and pastry-counter imagery as somehow affiliated with Warhol's soup cans and the other common-object stylings of Roy Lichtenstein, Tom Wesselman and James Rosenquist. But the coincidence was misleading. By training, Thiebaud was too thoroughly steeped in the methodologies of commercial art to stand outside and take the vernacular look, as Lichtenstein said the Pop artists did, for subject matter (and in that sense, as a kind of prefabricated "nature"). Nor was he interested in displacing, with a neutral glaze of demotic signage, painting's customary body heat. Instead, he amalgamated: a typical

Thiebaud, whether of the 60s or any time later, can be analyzed stylistically according to how closely the artist has aligned a graphic trope carried over from his designer days with brushed-up felicities that signal, among other things, an autodidact's infatuation with the more arcane codings of traditional painting. Thiebaud has repeatedly gone on record as disavowing any hierarchical distinctions between fine art and its numerous commercial cousins, all such doings being subsumed, in his view, under the rubric of "various visual enterprises."

Thiebaud's mode of self-presentation, upbeat and jaunty, with the finely tuned manners and eloquence of a town magistrate, can appear to wink out from a Norman Rockwell chromo. Just under six feet, with tousled hair, a high, creased brow and prominent chin above the habitual, conservatively patterned bowtie (Q: What's with the bowtie? A: "They're very practical. When I was a designer, I was always getting ink on my ties."), he draws himself up lithely so that people often carry an afterimage of him as taller than he is. He's a handsome man who, at 73, exudes a markedly beamish vigor. His two family homes—the primary one on a quiet suburban street in the venerable Land Park area of Sacramento and a turn-of-the-century Queen Anne cottage, acquired in 1973, on San Francisco's Potrero Hill—are each fitted out with a modestly appointed studio on the second floor and in the basement, respectively. (Daylight pours in from the front and back windows of both domiciles, wherein a spirited tidiness prevails.) Beside his non-stop prodigious output as a painter and a taste for travel to foreign lands (Mexico and France being the main countries of choice), Thiebaud keeps to a weekly regimen of amateur tennis in tandem with his wife of 35 years, the former Betty Jean Carr. "I play tennis on an average close to four times a week," he says, "or more when we play club tournaments. Betty Jean has her own partner for doubles; they were at one time number one in California in Women's 55s. Her highest national ranking in singles was, I think, number seven. My only ranking has been in Northern California. My highest there has been number eleven in Men's 65s and, later, in Men's 70s. Tennis, for me, is a kind of metaphor for dealing with the limitations and discipline of painting and trying to modify behavior in the confrontation, hopefully with a victorious result. A lot of the problems in painting are games. A game played well depends on bending the rules."

The self-styled "radio-announcer" voice Thiebaud emits has a midwestern tinge, a slight drawl and lilting crackle that, like his paintings, betrays sources deep in an archetypal family migratory pattern from the heartland to the Pacific Rim. This is how Thiebaud tells it: "My grandfather came from Switzerland. His last name was pronounced 'Kaybo.' He became superintendent of schools in Indiana where my father was born. After he retired from teaching, he came West, first to Arizona where he homesteaded some property, then, in the 20s, to a little place called Wintersburg in Orange County, black-earth country, where he had a two- or three-acre farm he liked to experiment with. He raised vegetables. I used to visit him there. He used to ask me how I was doing in school. I always hated to be specific because I was never a very good student, I was bored to death in school, but with him I had to pretend. He was experimenting with different varieties, like black-cat raspberries. He sold some of the first berry plants to Knott's Berry Farm. He was also interested in local politics and became the surrogate mayor for this little town of Wintersburg.

"My mother's family came from Arizona. That's where she and my father met. Her grandmother came West with a wagon train. My mother's family were Mormons. My father converted to Mormonism and became a bishop in the church. After I was born, when I was about 6 months old, we came to Long Beach, California. My father was an automobile mechanic, very interested in inventing. He held the first patent for six-wheel brakes for trucks, and he invented milk trucks which drove from the center. He went from being a mechanic to a mechanical administrator at Golden State Milk, with about eighty men under him, servicing and taking care of all the milk trucks. That was in the late 20s. When the Crash came, they gave him stock in the company, which proved worthless. That's when we moved again and bought a big ranch in southern Utah between Cedar City and St. George, and immediately went broke in the Depression. In some way, southern Utah is where I got my love of landscape, a landscape I still recall. It was a great time for me growing up. I was 12 or 13. I had a horse. I worked like crazy, growing vegetables. I thought that might be the way I'd end up, be a farmer.

"In 1933, my father went back to Long Beach. He got a WPA job cleaning up rubble. I stayed in school in St. George, living with my mother and sister. Then, ironically, my father got a job with Golden State delivering milk on the wholesale-milk run. Eventually, he worked his way back up and became the safety coordinator for the city of Long Beach. He was very resourceful man.

"I had nine uncles or more on my mother's side. One was a fisherman who took movie stars on hunting and fishing trips in Las Gallinas. Another was a salesman for Folgers Coffee, but he loved cartooning. He worked part-time on 'Happy Hooligan.' He used to come and draw for me. Uncle Lowell was a road engineer, a kind of a hellcat. He taught me to drive when I was 13. He gave me road-building toys. He talked to me about building roads, how there had to be a certain degree change on a road gradient."

Thiebaud delivers such facts with cracker-barrel readiness, intermittently pausing to brush one hand across his broad, set mouth, the ever-attentive eyes sparkling squintwise behind round-rimmed eyeglasses. His spoken paragraphs commingle amusement and earnestness in the unflappable manner of the trickster-pedagogue. The oracular wit with which his utterances are formulated can be traced back to a brief career as a student at Long Beach Junior College where his favorite class involved public speaking and debates. (By then, he had already established himself as a talented freelance cartoonist, having worked during his teens at Walt Disney Studios as an in-betweener on animated films.) What he wrote years ago in appreciation of Matisse could easily have served for a self-portrait: "He's a sly fox, and smart as a devil." Thiebaud's own cunning extends to his way of fending off flattery—of the sort that, no matter how well-intentioned, might trigger whatever reserves of vocational self-doubt still lurk within him—with a self-deprecating one-liner. When an interviewer sought to praise a still-life etching of the late 80s for its "Morandi-like character," Thiebaud cut her off sharply: "Don't insult Morandi," he growled.

Thiebaud's ambition towards mastering every intricacy of image making culture as he perceives it is anything but cool; indeed, his work has developed as a celebration of that cultural legacy, as if by reinventing its terms he might measure his own ranking within it. With a characteristic twinkle, Thiebaud himself once described his progress in

this direction as that of "a sign painter gone uppity." He has amassed a modest but telling collection of works by artists he admires—among them, Morandi, Willem deKooning, Matisse, Balthus, Picasso, George Herriman, Charles Burchfield (an unsigned watercolor snapped up serendipitously in a thrift shop), John Graham, Gottardo Piazzoni, David Park, and Thiebaud's adopted son, the landscapist Matt Butt—and what he says of them tends to reveal his standards more pointedly than any remark he might made about his own process. In conversation, he's apt to invoke household names like those of Chardin, Mondrian, or Cézanne alongside lesser-knowns like that of the 19th-century portrait painter and Utopian fantasist Erastus Salisbury Field. (For the visitor who draws a blank at the mention of this Vermont-based naïf, a postcard showing Field's 1865 extravaganza *The Garden of Eden* is plucked off a sideboard in the Potrero Hill dining room.) His connoisseurship of how painting works has been further informed by a tireless dedication to teaching. He has been on the faculty at the University of California at Davis for over 30 years and so far has shown no inclination to retire. Asked why he continues where many another successful artist would depart, he says: "The basic questions haven't been answered. The students are very good about that—their irony, their skepticism keep me intrigued. That's the fancy reason. The other reason is, it's a way of experimenting. Teaching substitutes for a laboratory. I see it as testing. The ways in which we learn about art are still very mysterious."

Last November, at San Francisco's Campbell-Thiebaud Gallery (where the artist's son, Paul, is a partner), Thiebaud showed a bevy of more than fifty elaborations—including large-scale paintings, watercolors, gouaches, monotypes, pastels and charcoal drawings—on the cityscape theme that has preoccupied him increasingly since the early 1970s. The city depicted in these rollicking views of frontal highrise slabs pitched alongside unnegotiably steep thoroughfares that often cut (in an illogical but no less accurate montage-effect near a frame edge) to bare, rolling hills and waterways is a composite, modified San Francisco, from whose gridded plots and copious open spaces he teases out large helpings of both chaos and splendor. Thiebaud's vision of that pretend city, noted for what the painter John Button once termed an indigenous "melancholy hedonism," is a perennial visitor's one, though available to any who recognize that its bumptious geometries, splayed over geologically youthful, tremblor-prone terrain, are themselves just visiting.

Thiebaud is interested in how San Francisco displays itself, coaxing its comforts under the jouncing, milky glare of Northern-California coastal light. He speaks of the way the city is "psychologically positioned. I'm a little troubled by how it can appear a little too toylike. But I'm fascinated by the dematerialization of the city, its ethereal character, the various ways of access and sense of elevation." Observing the sprawl from widely different vantage points—for years he used a telescope to study vistas at the rear of the Potrero house, until the device was taken, in the late 1980s, by a burglar—Thiebaud catches the basic mid-air look of its multiplicitous architecture and the paradoxically disconsolate mildness of its weather. The cityscapes argue spatial ambiguities in box-and-loop concatenations and abrupt forward occlusions that say, as Thiebaud would have it, "No trespassing." In fact, as far these illusionistic spaces are concerned, there is nowhere to go in them, only the hanging-on to see in greater detail what they are about. Because a

Thiebaud view has no destination, the eye scales the face of it, or darts about, grasping at fillips of ledge and curb—or, again, skating a switchback, plummets to where yet another byway bellies out only to dip into some nether zone where vision can't follow. The cloudless skies register pale blue for clear days, pink or peach for fog. ("I always have a lot of trouble with sky," Thiebaud confesses. "The reason clouds don't enter in so much is the need for planometric finalization. if the sky becomes too atmospheric, you get a kind of window in the picture.") The major portion of *Window Views*, 1989-1993, is a wild, skyward reckoning of towers and sundry civic conceits—a layer cake of a parking garage, a dumpling-chewy Federalist dome—presided over on either side by a wrecker's crane and a traffic island sprouting frazzled-looking palms. Gesturing at the absurd agglomerate, one longtime aficionado of Thiebaud's excesses summed it up in a word: "Shangri-la!" (And, true, this is not the only site, among the painter's many vertiginous fantasy mounds, to recall a piebald refuge perched above some preternatually lush Himalayan plateau.)

Thiebaud's recent pictures are richer than ever in detail, and more keyed-up as to color. The many whites, raw vermillions, acid yellow-greens, swamp browns, a deep orange next to a pale yellow blush—all are, he allows, "more contrasty," and promote, as well, "a kind of two-way opportunity for light: on the one hand, a replication of the condition of light, as light describes form, and on the other, using color as light. That's one thing I like so much about Degas' late pastels, their twofold light." Light is everywhere in Thiebaud's latest cityscape images, most piquantly in the smaller watercolors and gouaches where it comes in lapidary flashes or, for the occasional nocturne, in beadlike nodes (except that the "beads" smoulder like the "hot coals" Thiebaud once cited as the glory of Bonnard's palette). Thiebaud has long been a champion at the small, exquisite watercolor study. (His printmaking achievements, too, are competitive with those of any modern master.) Where the bigger paintings bulge with complexities, the swifter watercolors tend to leave all such engineering feats aside.

Another new twist, ushering in still further complications, is the intervention of figures set peripherally against aerial prospects in some of the cityscapes. As ever, like the sturdy homburg in a charcoal drawing tucked away within Campbell-Thiebaud's sole vitrine (so that it figured as a kind of mascot for the show), Thiebaud's figures are retrievals from memory, generic 1940s types whose lineaments may hark back to featured players in the movie posters he designed during his 20s. Cropped-off at the bottom of *Window Views*, for instance, is the tiny top half of a man leaning back from his drafting table; his hulking shadow, cast across a trapezoid of bronze-ish wall, resembles nothing so much as the upper body of Rodin's *Thinker*. Then there is the separate series of strangely fraught, narrative images in which two figures, a slightly less generic man and woman in formal attire, confront one other woozily (the woman's back is always to the viewer) in what could be a 1920s ballroom. However these stranded remnants of Jazz-Age psychodrama may have found their way into Thiebaud's repertoire, their appearance is at once erotic, hilarious and chilling.

For all the raffishness of Thiebaud's painterly approach, he's sensitive to how more overtly serious painters look askance at his "jokey" side. He likes to quote his late friend Richard Diebenkorn on the necessity of "crudities" to enliven any pictorial

surface. Humor ("a comic idea," as he told the philosopher Richard Wollheim recently, "placed next to the many ongoing human tragedies") is one aspect he enjoys pointing up in his pictures. "It's a dialogue between the silly and sublime, and how you orchestrate that. Humor is one of the most difficult things, so it's always a dangerous component." A far knottier component is "empathy," defined by Thiebaud as akin to what other painters, following a well-known remark of Cézanne's, would call "sensation." "Empathy," Thiebaud explains, "is physical transference into form, and body language. How do you arrive at tension visually? It's something, for instance, easy to miss in Cézanne—taking a turbulence flight—as opposed to a Rubens picture, which would be lyrical, gyroscopic. Physical participation in a picture is not only the way of receiving physical pleasure but also a humanistic jump that you make. Gloria Steinem says, 'The most revolutionary human emotion is empathy.' When you look at a painting you should feel your inward parts move. Painting is a charade, an empathetic experience, including feelings of disappointment—things you can't see around or through but want to."

1994/1996

The Elements of Drawing

> *A stage direction tells us of a chair in the sunlight.*
> —Richard Wilbur, Introduction to *Phaedra*

Height, width, depth—the more easily solved mysteries of solids—leaving the greater essentials, the energy of whatever's visible engraved in its portion of air and light, on hold. Indelible, even so, my adolescent pleasure in discovering, during otherwise alien geometry lessons, receding parallel lines that, if you extended them from any given rectangle and connected the strokes, line angled to line, would produce by sleight of hand a box, brick or room-like setting. Or, in a rapture of perpendicularity, stack box over box, add several parallelograms worth of doorways, and presto, a city, ancient or modern as you like, ready for occupancy. Or so it seemed, from sixth grade onward. "Mathematics is my nemesis," I told the admissions officer at my next school. As it was, despite failing computational skills, I had found for those secretly solitary moments at a school desk a literal elbow room; indeed, the importance of learning to draw simple shapes recalled in this way seems on a par with learning to dance or throw a ball clean through a hoop. Looking at it now, Thiebaud's lightly handled charcoal rendering of a coffee can in front of a radio-cassette player has that same primordial exactitude and lilt.

Of the drawings chosen for this exhibition, most began as procedural classroom setups, master-class demonstrations for student exercises. Although, going on 90, Thiebaud continues to teach, as he says, "on a volunteer basis," the works here are of that earlier vintage, the 1960s and early 70s, when his art and his teaching had together achieved their levels of mastery sustained every since. (Some were exhibited at Allan Stone's gallery in New York in the mid-60s but rarely, if at all, afterward.) Every sheet

shows two, three or a few, "various and sundry things," mostly commonplace items small- and/or medium-size as you tabulate, tick them off: comb, coffee pot, a cup, a can, a bowl, a pocket watch—the individual fact distinctly presented with what Thiebaud has called "an independent repose." A practice spilled over into pedagogy with guidelines at once principled and occasion-specific: "Forget about finding what's there but *making* what is there;" and further, "Focus, edit, change and modify."

Zeroing in, what is plain to the eye becomes complex in the viewer's articulation: surface defined by singularity delineated by line by edge, and inside of that, more edge. The various lines zip about, making forms that sit still but are never static. Every mark has equal value, and the paper, too, is a major player. The "work on paper," so-called, is itself object, space, paper as space, and across it all is light unfurled on and of the object so declared. Or (taking another spin) how drawing in its own terms can be such an unruly Global Positioning System, as when the shadow thrown by the MJB can indicates a light source different from that responsible for the wall tone behind the radio, which Thiebaud, with his characteristic musing chortle, identifies as "a contradiction—paradox."

As ever, the appeal of the inanimate is strictly metaphorical, determined by intimations of, if not exactly an inner life, a vitality belonging to that one thing seen as it is. In the setup, a thing's reduced function renders it somewhat hapless to begin with—just there to be looked at. Little to do but strike one's solitary chord as occupant, which in Thiebaud carries always an aura of somewhat cinematic arrival (it's our attention, after all, that rushes to the rescue). Likewise insistent is the suspense element murmuring in all that stillness. A deft ellipse, the watch looks warily at—or is it ogling?—the upstage pinch-waisted dancer figurine, both she and it having traveled far to create (right here, at almost 1:25 p.m.) their own Allegory of Persistence.

Warmth in the doing, slyly communicative—and how oddly contemporary these drawings-qua-drawings appear, now that drawing predominates among far younger urban image makers. It's all on paper here, straight in straightened perceiving: an efficient clarity that breeds exuberance every which way.

2010

Susan Hall

Most of my subject matter comes from-our Point Reyes. Sometimes it gets combined in odd juxtapositions. Like "Kite-Flying-at Night:" there was a man selling handmade kites at the Inverness Y just before the green bridge in Point Reyes three years ago. Every weekend I would look out from our house and see them fluttering against the sky. At the end the summer he was killed. A coffee can of flowers was put on the spot where he sold his wares.

Point Reyes peninsula—the place where Susan Hall grew up, and to which she returns each summer—is a grassy outreach of Northern California coast given over to broad sweeps of fog and lopes and sudden jounces of sunlight. The local paper, the Point Reyes *Light*, takes its name not from these phenomena but from the lighthouse at land's end, near which Hall's father worked as a radio-operator. (Both the lighthouse and the town proper served as settings for John Carpenter's movie, *The Fog.*) The rural topography is as disorienting as the loops around San Francisco Bay—a switchback coast where the afternoon sun appears from behind estuarial hills as readily as from flat-out at sea.

It's a geologically youthful, unstable landscape not quite inured to human traffic. Management occurs in the forms of dairy farming and a National Seashore Recreational Area; California Highway One takes a jog through the center of town, straightening northward a short block away from the garage where Hall sets up her summer studio.

In these environs, a visiting New York painter once complained of tired eyes after a day of trying to see contours in the dusty glare. Contrariwise, individual colors on foggy or overcast days appear struck at their most peculiar intensities. Similarly saturated and piercing, the orange of a two-piece swimsuit, the sudden iridescent aquas, violets and cobalts in Hall's recent waterscapes flare from their variously dusky or nocturnal surrounds. The tonal equivalence is exact without taking on local color.

Hall paints suspended moments, those parcels of the temporal self that elude consequence but score memory and reflection with an enigmatic clarity. The substance of each such moment increases it; it convinces by virtue of an actual sensation, that of colors arranged in tactile measures of light and dark. A woman stands on a floating dock tensed aimlessly as if posing for a snapshot. Backlighting tosses glints along the contours of arms and legs; a tumble of yellow hair. The view lifts with residual heat. You know the feeling: late-in-the-day stillness of air and water, air of midsummer in the country, 1980-something, a hillside stretch smudged against distant ripples like a dark, subtle, looming thought.

All this is compressed in Hall's special abstract way of tendering the motif across a prepared bas-relief surface—that underlying grit which serves as a foil for her watery themes. Washed over the textured gesso, a bright yellow ground tone remains to enclose the picture with a flourish, a nimbus within which the discriminated details stir forward and sing.

1989

Apparition as Knowledge

The first Roman to mention the report of the midnight sun disbelieved it. He was an educated man well aware of the necessities of nature. In this way, the necessities of nature can be exaggerated.

— Alfred North Whitehead, *Modes of Thought*

Deborah Oropallo's ample new studio near the Berkeley waterfront has all the daylight she requires for seeing what she's painted. She paints mostly in the afternoon and into evenings under floodlamps. Out the back loading door, along two sides of a paved impasse, there are tidy Italianate garden borders: olive tree; plots of sage, rosemary, lavender; black iris, black tulips; a small fish pond.

Here are a few more facts noted between detailed stares at particular canvases:

Among books banned recently by school boards in the southern U.S.: *Red Riding Hood*, Steinbeck's *Of Mice and Men*. Both books figure largely in Oropallo's new pictures, two or three canvases per theme.

She's been reading up on the psychology of Grimms' tales in Bruno Bettelheim's *The Uses of Enchantment*. ("I guess I should read it." "Oh, don't bother.") "Red's story can be thought of as a classic instance of child abuse and/or abduction, or, as British psychologists have claimed, cosmology: Red makes the westward journey of the sun, and the wolf who gulps her down in the woods is darkness.

For the many stavelike, sometimes steely bands that now fortify the surfaces, and for much else besides, she uses print rollers from which narrow strips are extracted with a razor blade. "I cover my tracks. The brushwork is there, but erased. I want different rates of speed in these paintings." She smears over a cleanly rendered cloak with rollers and rags and takes a squeegee to create a stammering "aura" effect for folds reduplicated in midair. Some found items—the police firing-range target on *The Wolf*, the crown in *Encountering Mary*—she applies flat-out with silkscreen.

A note from a previous visit reads, "Confidence in her process: 'As thoughts change the painting does. These paintings contain a lot of buried information.'"

One version of Red Riding Hood looks to be a white-paper-cutout-with-black-text silhouette repeated in maybe six rows at least thirty-six times, allowing for scarlet smear-overs and wholesale blottings-out; in a couple of others, the little one is a capable, brunette pre-teen in a mantilla fit for a Goya seductress (except, of course, the "mantilla" is part of a parade-dress ensemble in red, white and blue).

The "Virgin Mary" images derive from prayer cards. Recent "Mary" sightings: in a tree in Watsonville; in a Marlboro, New Jersey, backyard; in Oropallo (souvenirs of a Catholic girlhood). All of her paintings have an ex-voto reach, suitable for private reliquary or as processional standards to be carried through the streets.

Sixty-seven handcuffs in *Escape Artist*—most are whited over to become double-jowled cloud puffs.

Hurricanes Named Grace: The Weather Service keeps a six-year list of names for possible storms. Disasters once exclusively feminine now are designated Earl, Henry, Oscar, Emile....

Stray facts proceed directly to the void. The void is omnipresent, and indispensable. Oropallo has it covered. As against painting's consequentiality of "moves," the void offers itself as already endlessly complete to excess (in its own entropic flows)—it can be animated only by factoring in a further fullness of edges. Edge, or surface, mirrors the blankness inhering at any juncture between image and the mind that thinks to know "things." Thus image conquers void by immersion.

Oropallo's images are prefigured by an interest in history and how memories occur and connect, a life of partial meanings sustained on emotional frequencies. She transcribes without quotation marks—her texts have been read relentlessly, as it were, into the bedrock, but then she envisions them to a fresh prime. There's an aspect of investigative reportage in all this—Oropallo following up on a lead raids the agency archives, antique as well as current manuals, *The Book of Wonders*, the photo morgue, her own back pages, forms of heraldry, typefaces.

"There's something that isn't learned or even known yet. The best obfuscation bewilders old meanings while reflecting or imitating or creating a structure of a beauty that we know.... (There's always the danger of making a statement.)" (Bernadette Mayer) It's as if Oropallo's images have coasted hither on slowly swelling mental tides. Or (back to one of childhood's gambits): flip the Magic 8 Ball's smooth black sphere to enquire of its bottom portal, that toilsome sibyl at whose mouth the white letters bobbing in gray fluid spell "Outlook Not So Good," "Reply Hazy / Try Again," "It Is Decidedly So."

Dove sta memoria...(Guido Cavalcanti, 1250-1300). Where is the seat of memory?—which is also the place, as Cavalcanti says, for affect to gather forms like a dusk. Isolate veers and fragmentations of the mental ur-text conspire to bar us from a communal present. An ideal history would tell how the present has been built that we might live in it. It's no small wonder how consistently graced, guileless—though beguiling, yes—and even-tempered Oropallo's memory theatrics feel. The less clear image, as she says, "allows something to happen." The focus is less on things than on the mind's comminglings. The recognitions her pictures provoke are entirely psychological—peering at the coat of paint, the viewer comes up against a fair analog for consciousness whose "contents" are sealed in any number of specialists' codes. She personalizes official history while exteriorizing (finding outer, public semblance of) her own. This gives her work a bonus clarity, that of chords struck from particular connections: paint to paint, appearance to emotional tug, elegance to veracity.

The main thing is still to make a painting of substantial, resistant surface, even if out of several splintered impulses. This surface can proffer the sleek, firm, subtly nuanced look of wax, ice, some varnished murk one could nonetheless skate upon. But the particular images sit back a ways, imminent yet consigned to a perpetual deferral. What looks like retreat is really memory's reticence about ever making its terms physically apprehensible. Our afterimages, however we carry them, can't be grasped. Oropallo

shows vision, either inner or outward, in the guise of a finely tuned argument, concealment made coextensive with revelation.

<div align="right">1993</div>

Questions of Moment: Rupert Garcia

Over nearly three decades as an image maker, Rupert Garcia has been progressing in high gear, toting up mileage across a sizable territory of existential/artistic concerns. He has gone from a raw beginner with an instinct for close-to-the-bone public imagery, through a headlong (and highly visible) flourishing in the context of broadly defined social issues in the late 1960s, and further, to a complicated maturity in which an inclusive, and arguably grander, world view is posited with deliberate finesse and a stepped-up curiosity about a variety of techniques. The present exhibition finds him on a verge. Having redefined his pictorial scope via an outsize use of pastels, he now brings it forward with the full-bodied and of oil paint. The graphic wiz has evolved into a solid, no less audacious painter with his own keen sense of the turnings in the neighborhood of human event.

Like most evolutions, Garcia has been partly in the nature of a continual recycling of accumulated strengths and skills. He had started out as a teenager making paintings inspired by whatever closest at hand seemed most pertinent. Of this output there exist a Walt Kuhn-ish clown, liturgical images residual of a Mexican-Catholic upbringing, portrait studies of movie stars and musicians, together with recapitulations of the various styles in force in mid-century modern painting. The naturalness of these youthful entrances strikes the eye: the clear recognition in 1959, for instance, of James Dean neither as an exotic or especially tragic representative of a culture massively "out there," nor a brooding solipsist's idol—but as simply belonging to one's own spiritual company, an icon from the neighborhood, so to speak, with character writ large in the ethos of the time. Getting the young actor's profile down on paper in sharp graphite strokes against a soft cerulean that doubles as "shirt" and "sky" is a way of bringing the relationship home, brightening it with incidental meditative chat. (Dean had totaled fatefully in his Porsche near Paso Robles only two years previous.)

Garcia devised the boldest, most succinct silkscreen images in the Third World poster movement of the late 60s and early 70s. He did so by amplifying his pre-established bent for dramatic form and color (or, as he has said of the Mexican murals of the 30s, "moving colors and dynamic shapes"). In the process—besides educating himself, as it were, "under fire"—he absorbed and put to work some of the period's most strategically bland and/or ironic styles in an area requiring complete sincerity, a sincerity that had to be both deep rooted and stylized to make its point. The period styles are there (first Rosenquist, then Warhol—and you can see traces as well of Wesselman, Indiana, Ellsworth Kelly, and Larry Rivers) but adjusted to be instantly communicable to any passerby. Given the social pressures that occasioned Garcia's political screen prints,

sizing them up stylistically may seem beside the point until you realize how unlikely it would have been, without a cogent style, to do the job well and truly. Garcia put into more direct and outgoing terms the brilliance of fabulously self-referential, reductive modern styles. The terms are situation-sensitive; as Peter Selz has remarked, the posters "do what posters are meant to do." And, no mistake, the prime requirement in them is truth.

Fast, precise, efficacious—the posters and prints exhort a gut-grabbing alertness to specific social facts. They avoid both cliché and the discrepant syllogisms of a too finely rationalized politics. Remaking images from the official print media into vivid social emblems, they accomplish purposeful transformations within the quick-shot limits of the stencil-and-squeegee look. Where words occur—as in *Attica Is Fascismo*—their message is as clear-cut, compelling, and singular as the image. If the images are declamatory, what they declaim is the primacy of individual visible fact. The fact of Angela Davis's hair and facial features swept frontally across multiple sheets of poster stock is a powerful reminder of the complex of issues and intentions the actual woman has come to symbolize. The authority of such an image is personal; the idea or message is an extension of person and not the other way around. The objective message—consistent in Garcia's images then and amplified more recently—is human dignity, which needs no ideological buttressing. Garcia's human images exemplify dignity and thereby position it in the face of (and with staying power, beyond) immediate political duress. Where dignity is to no avail (in *Fuera de Indochina!,* for example) the alternative is an outright, space-engulfing, surface-shattering scream.

With his mid-70s shift to pastels, Garcia's work picked up scale and density. Begun in his screenprinting phase, a series of adaptations from images of the faces of past masters (Orozco, Frida Kahlo, Picasso, van Gogh, Léger, Goya, Siqueiros, and Berthold Brecht, among them) persisted as a way of pondering the conscionable stances of the citizen-artist in the contemporary world. In a sense, Garcia was woodshedding in public—working out problems, looking to his artistic forebears, as well as to the materials literally at hand, for archetypal critical guidance. In Kahlo's steady look, in the multicolored glints around Orozco's bespectacled stare, or the sheer rock face of Picasso, we may find the requisite evidence of how to see and live with total attention and a modicum of grace.

Layers of pastel chalk dust—which Garcia says is "ninety-nine-percent pigment, with less binding medium" (the chalk is dry and porous or, lately, soaked in a medium of linseed oil to yield a raw, pliant paste)—provided the seedbed for a mature efflorescence of image combinations and conceptions. Long considered an intimist's subtle dream medium, pastel's range and its advantages as a carrier of large-scale color sensations have been shunted into the contemporary technical oubliette. One thinks first of Redon's exquisite glow in his reveries and flower pieces, and only afterward of the rawness and furor of Degas, or the grandeur of Chardin's late color explorations, in the same material. Garcia's pastel tones match lushness with horror, or redouble them separately. *In Aflame Man and Orange Horse*, the hobbyhorse's manic grin bristles with a ferocity as intense as the desolation of the burning figure. From a similar horse—Garcia's by-now reliable stand-in for human alertness and will—the counter-ceremonious flagburning in *What Is*

This? elicits a quizzical expression in an adjacent maze of ornamental white and blue shadings. *Hermana a Hermana* aligns the "sister" images of a slain South African woman and the bouquet borne by the black servant from Manet's *Olympia*. The back of the servant's hand is rotated to a ward-off position, as if to deflect any advance—or assault—on the scene, and at that angle the snowy clump of peonies comes to resemble a patchwork skull.

Now "touch" enters as direct fingering—a reiterative kinetics of smudges and glancing strokes which, instead of signifying the artist's presence (his hand, per se), gives each image its proper character, speed, and atmosphere. In the pastels and recent oils on canvas, Garcia has amassed a lexicon of multipurpose fingerstrokes. Such touches—black and gray swirls, whisks, tendrils, fumelike wisps, vapor trails, spikes, dots, darts and dashes and squiggles—inflect and sustain the surface fields across abutments and add to the ominous aspects of dark or smoldering, fuzzed silhouettes.

Dividing his pictures with two- and threefold composite imagery, Garcia opens them to a rush of multiple meanings, making them more volatile to the understanding as well as more palpable to the eye. The edges of two or more images within the same picture coruscate like states conjoining on a map. The images vary greatly and derive from a wide range of sources: newspapers, photodocumentaries, artbook reproductions, calendar art. How they fit, abut, and intermingle as to their meanings are three different things. The distinction between the area occupied by one image and that of another may be sharp or just a shade difference or just a difference in shade or texture, or a change in texture, and the transition in color—in *Manet-Fire*, for example, from woolish green triangle to crimson blaze—often seems more thermal than topographic.

The latest paintings both continue and diverge from the ambiguous concatenizings of the pastel panel works. (And as the oil paintings get more expansive and fiery, the pastels of the last year or so breathe a new air of delicacy and mildness.) Garcia has closed his, and our, distance from his material. High or wide, rhetorical vistas of war and conflagration hover and rage in blacks, reds, and cobalt blues amid a range of dirty or acid cadmiums. The central images unfold from low horizontal baselines--the watery blue in *Burning Building on a Pier*, the troweled-on rocks underfoot in Yankees--telling gravity stories at variance with the pictures' frenetic upward drifts. (The earth itself seems somehow "up" for disaster.) Garcia's palette probes and illuminates the spectral nature (in memory) of historical calamity.

Largest and most pungent of these new works is the diptych *Ominous Omen*, in which the fearsome silhouette of a war plane exudes an acrid dirge, redolent of petrochemical exhaust, for all manner of military-industrial hubris. Like some mutant insect declaring sovereignty over a bare black wash of land, this blunt spectacle seems literally to seep into focus. Contrariwise, the warriors in *Yankees* and *Reds Against the Nazis* are like zoom shots cropped and shredded by the battlefield's screeching turbulence. Silhouettes usually function as patently flat, static elements, but Garcia now sets them in motion. Running and jumping, embroiled, streaming force lines in the bloody smear, the giganticized yet ghostly action figures play out their fates oblivious of the sky that lifts as ulterior witness to such violent exertions.

Like his skies, Garcia may well be asking whether, since violence is inherent in nature, we are bound irrevocably to manifest its codes despite everything else we may think to know. The elemental fact of fire, a favored motif in Garcia's work, testifies to this paradox. Garcia's predilection for fire admits complicity with the urge to decimate whatever is "other" at the same time as proclaiming an innocent fascination with splendor. *Later Than We Think?* shows a tree—an immense black oak—in a swarm of flames against a fairy-tale blue backdrop. The blast of *Burning Building on a Pier* sends up a black cloud thick as roof tar. The cloud, with intermittent yellow flecks, evokes the presence of a human head, just as the upper part of *Burning Building* suggests a head-and-shoulders figure gesticulating. (Interestingly, both paintings also veer as close to painterly abstraction as Garcia appears inclined to go.) Disaster, Garcia seems to be saying, is never elsewhere; its ever-present threat is synchronous with—and can't be reckoned outside of—our perception of its transfixing elegance.

A picture that mediates between the terms of such questions, *The Secret's Out* displays in equal measure the plausibilities of coercion and wonder implicit in the interweavings of human history with the forces of nature. One half of the painting shows a jubilantly colored version of the latest photographic computer scan of binding energies among atoms on a solid surface; in the other half, a figure swaddled in a red tunic (based on another newspaper photo of a captive American flier in Vietnam) curves in profile across the panel, just touching the partition line with his forehead. The situation of the figure is uncertain: is he slumping in defeat or acknowledging ceremoniously a revealed truth? Then again, is the actual truth of those brightly dancing particles so removed from our cultural entanglements as to be beyond apprehension? Do the thick blues that surround the figure, and in the darker pool, of which he seems half-immersed, represent a quandary in which we're stuck? The big questions themselves may be mislaid, but Garcia engages and clarifies them, reminding us that they are the only ones left worth asking.

Haggin Art Museum, 1988

Paul Harris, Secret Agent

To be taken seriously, sculpture requires a sense of gravity just as painting requires an internal light. Gravity in Paul Harris's bronze sculptures is primary and emphatic in ways that nothing else about them is. How the object sits, lays, stands, or leans—the general position that orients you to it as a three-dimensional image in the space of a room—makes the first impression. Once oriented, you notice a conundrum: the weighty, tactile presence thus deposited has a resonance and scale not there to be grasped at all, an elusiveness suspended among the familiar shapes borne to view.

That the bronzes are often not as weighty as they look adds to the general bafflement, but the semblance of weight, in any case, yields a quick apprehension of their power. Then there is the sculptural skin, which in the figure pieces comes close to real

human skin without being literal about it. The bronze retains the surface smoothness of the wax (or sometimes clay) prototype. The thick bronze skins perform feats of memory to which all the visible handiwork (including closely calibrated lustres of patination and the traces of scorings and crosshatches from Harris's serrated modeling tool) runs counter.

Harris came to California in the early 1960s by way of New Mexico, New York, Jamaica, and Chile, and before all that, Florida (he was born in Orlando in 1925). He isn't properly a Californian and neither does his art convey an especially California flavor. The playfulness he shares with other (mostly younger) California sculptors was pretty well established by the time he had his first New York show, at Poindexter in 1958. (His first bronze cast, from a plaster original, was made slightly later, in 1960.) In the local context, Harris's playfulness is distinguished by intensity and bite. It's both checked and augmented by a will to simplicity, a classical reticence: no "aw shucks" impulse touches, no gewgaws or gimcracks, always a dark undertone.

Look at *Anna In Love*: the outer shell of the recumbent woman is plain as day, but what an insidious plainness. You can see it, walk around it, even touch it, but you can't get next to the body ostensibly at hand. The form is there, but the female figure is elsewhere, "other" in time. The figment shows you everything and nothing; in fact it's truncated at both ends and hollow like a bell tolling the barest remnant of desire—a desire that remains open-ended, and endlessly self-mocked. What to do about those massive thighs but run one's mind along them, until the mind itself empties out with uncertain laughter.

Harris's female figures have distinct characters, as distinct from his men who tend to be faceless and shadowy. "Men are agents," Harris once remarked, and quickly added, agents of what, he didn't know. The two genders rarely appear together in his work. An implied commingling occurs in *Hat*, where an unusually schematic studio nude reclines along the brim of a relatively upscale fedora. But the knotted couple in *Earl One Morning* is something else: an oneiric window tableau holds the wanton lovers' different anatomies in sharp focus—and from that nexus, the scene billows affectively with intimations of light and air. Commenting on this piece, the sculptor made its ambience specific though no less arcane: it is, he said, "like a June morning in Baltimore."

Harris's sculptures are unapologetic fetishes: a nasty word in contemporary kulchurspeak, but what's wrong with a fetish if it works! For that matter, what other than a fetish can a representational sculpture pretend to be? As surrogates for the figures and objects of memory and dreams, or for pinpoint flashes of meaning in everyday life, the shapes wedge their way into your consciousness like witty after-thoughts, melancholy alarms. The arrays of household items extending from commodious, neutral slabs— actual-size or on their way to being gargantuan—comprise place settings for a psychic feast. Such domestic ceremonies flourish from subtle tangencies: a biomorph teapot's spout whispering into a cup, the curved end of a spoon handle athwart the rim of a saucer like fingering a single, fraught note on a toy piano. Or else, where things don't touch, they congregate in choral groups or orate separately. A series of discrete, tabula-rasa shaving mirrors are typecast at various tilts ("for seeing the future"). Transmitted out of their functional capacities, ordinary objects serve as the stand-up characters of Harris's

oracular shadow play. With suitable mock imperiousness, they savor those grey areas in which identity confronts its outer limits. Where each posture has only tragicomic options (at one extreme lies madness, at the other, dissolution), they brave it out broadly, standing their ground in a scale commensurate with imagination at its most circumspect, most ripe.

<div align="right">1989</div>

Among the Poets

Joan Mitchell liked to protest that she was "a visual painter," ergo one emphatically not expected to issue pithy statements about her work. Be that as it may, Mitchell was a heavy-duty talker, armed with a literate wit, a tigress of the well-appointed tirade. She grew up and spent a lot of her adult life with poetry and poets. Her mother, Marion Strobel, was a poet and coeditor with Harriet Monroe of *Poetry: A Magazine of Verse*. From Joan's early readings—and for her paintings, in their mode of exultant landscape abstraction—Wordsworth became a secure point of reference. Among her peers, she numbered as close friends such poets as Frank O'Hara, James Schuyler, Samuel Beckett and John Ashbery. (Of Ashbery's disjunct epic in 111 sections, "Europe," she once remarked "God, how I worked over that poem!"). She collaborated directly with Schuyler; with both Ashbery and the younger poet, art critic (and editor, eventually, of Schuyler's diaries) Nathan Kernan she created elegant *livres d'artiste*. Another young friend, J.J. Mitchell (1940–1986) came into her orbit by way of O'Hara and his longtime apartment-mate Joe LeSueur. Poetry was not J.J.'s first calling, but for his limber occasional lines Joan found an affinity and visual purpose. Between them, more than in any of the other collaborations, you get a sense of mutual fun.

Did the violet-rimmed blue of *Blue* precede and occasion the J.J. Mitchell poem that seems so promptly to respond to it? What O'Hara called "the appropriate sense of space" is both working premise and outcome of the majority of Mitchell's works with poets. For all her fabled contrariness of person, her "color abstracts," as she called such drawings, are intensely sympathetic—they mean to grace the shared pursuit to the utmost. Thus, the J.J. poems become more forceful when closely read in the light of Mitchell's pastels, and contact with them points up a delicacy with which the painter's marks and masses aren't generally credited. Similarly, where a typical Schuyler poem finds its lead character in the day that holds the poet's observations, Mitchell sets a large, general weather (goldenrod in one, mauve in another) for poem and day as one—at the base of which incidentals ("grass....more than green," "streaked white by birch") may be glimpsed to lay or skitter.

<div align="right">2002</div>

The Mysterious Albert York

The scant biographical data on Albert York could be expected to clinch the air of mystery about his art, but neither the data nor the mystery work quite that way. The ascertainable facts of York's life don't signify the stuff of legend; they are as plain-seeming as the unforced, just-so acuities of his pictures. Nor do the pictures suggest that a peek at the artist's intimate files would bring any deeper meanings to their already fully revelatory surfaces: fascinating as such inside dope might prove to be, York's small, perfect paintings ultimately have detached themselves from whatever bizarre personal impulses engendered them. A backroad-classicist's detachment and candor are precisely those qualities around which the works' mysteries gather and are confirmed. York is that special kind of obsessive artist at pains to communicate his vision cleanly, with a pragmatic touch that suggests the equanimity of fate.

The bare facts are these: York was born in Detroit in 1928 and has lived, since the early 1960s, on the South Fork of eastern Long Island. Shortly before the Second World War, he went to live in Canada with an uncle and aunt. While in his late teens, he attended art schools in Ontario and Detroit, and then, after a decade of which little is known, he appeared in New York, where he briefly sat in on Raphael Soyer's figure-drawing classes. During his early 30s, he trained and worked in Manhattan as a water gilder with the framer and still-life painter Robert Kulicke in Kulicke's frame shop, which was frequented at the time by painters of the New York School. Kulicke brought York's paintings to the attention of Leroy Davis, at whose small townhouse gallery (now Davis & Langdale) he has shown ever since. York now lives in Water Mill. Removed from the New York art world and independent even of its extensions in the Hamptons (of which Water Mill is a part), he has delivered his works to his dealers intermittently over the past eleven years in plain brown wrappers, unsigned, untitled, without dates or frames. Some 335 panel paintings, watercolors, woodcuts, and drawings are documented to date in the Davis & Langdale file. (There are rumors of additional pictures, many left unfinished, others missing or destroyed, a small number done especially for friends.) Pressed for further accountings of the man, York's artist neighbors—those few who know him socially—mention his solitary temperament and slow, meticulous work habits. He is, they say, disinclined to talk about painting, preferring instead such topics as history, literature and local politics.

York's outdoor scenes catch the high skies, the flatness (closely alleviated by hillocks, hedgerows and dunes) and often hazy yet no less brilliant light of the South Fork moraine. Reviewing York's first show in 1963, Lawrence Campbell pointed up a range of subject matter that has changed little in the intervening years: "fields, trees, ponds, a bird, a bull, a face or two, a figure in front of a wood." There are also cut flowers—zinnias, carnations, impatiens, roses, begonias, tulips, anemones, to name a few—put into tomato tins or jars; a long, fat snake that sometimes seems a stand-in for the artist's signature; and dogs. (York is probably the greatest dog portraitist of this century after Bonnard.) Hovering in size around one foot in either dimension, a typical scene may recall deKooning's enthusiasm at seeing "that sky is blue, that earth is earth,"

as well as his remark about Cézanne that he was "always trembling but very precisely." There are views that blend apparition with observed fact—prospects evacuated or sparsely populated by figures out of daydreams or past art, or both. (One of York's favorite daydreaming pastimes, I'm told, is "looking at picture books.") There are no extras, no asides, in these mirage-like settings. York so mixes the actual and the allegorical that while the one loosens its bonds with circumstance to breathe as metaphor, the other is stamped as blatantly perceptible as a footfall in a thicket. The mystery emanating from such undemonstrative surfaces is keyed to the discreet measure of catastrophe murmuringly available in each.

A patch of ground holds strange expectancy. The story it might tell is unknown but the remnants—interstices, really—are parceled out by frames. Time and light are the terms by which York's emblematic images become legible. It's as if York were surveying the sweeps time makes in slow motion across the visual field and at such close quarters that light shakes off its temporality to become a fixative. Thus, his clearings seem momentarily enchanted, or of an enchantment momentarily revealed. Nothing explosive happens, and yet the odd tensions intimate disturbance built in stroke by stroke.

At his most refined, York can get light, air, contour and bulk all in a single stroke. It's normal for his figures to look as though they've torn, or been beamed, through the landscape scrim. In *Three Red Tulips in a Landscape with a Horse and Rider*, the distant equestrian is dwarfed by a frontal monstrosity of stems and petals (there are three flowers but four stems) breaking from otherwise desolate loam. A chill across the scene—even in full sunlight, York's landscapes seem never to heat up—may have to do with the South Fork's glaciological past or else with the persistently rumpled mid-Atlantic climate. Strong colors occur only in the middle distance. Almost everything in a composition has a way of looking squared off. The tonal niceties regularly stack up under cloud cover, so that an overall low-key impression makes an emotional set, a register of appearances taking stock, pitched between events.

York's impartiality about his characters can be seen as a reaction to his own amazement at their entering his line of sight. The landscape, having produced these figures, hands them over unaffectedly, with that "secret passivity and stillness" that Paul Rosenfeld remarked in Ryder. There are epigrams amounting to primary lessons in light and gravity: the way sunlight pauses on a shoulder, or a cow invents a lateral earthboundness to which the airy trees, with their hardly rooted or disproportionately slim trunks, are oblivious. The trees are floating modifiers of earth and sky; they indicate voids that might be filled by the viewer as one more imaginary saunterer.

If there's such a thing as an American classicism, its major texts would be drawn less from Virgil or Hesiod than from Whitman, Stevens, Williams Carlos Williams and more recently, the particularists James Schuyler and Larry Eigner. Its common sense is that things are signs of the life that is there but not delimited by material life. Williams once observed that American art history begins with the image of a giant cat with a bird in its mouth; the colonial painters responsible for such images were "eminently objective, their paintings remained always things." York himself seems aware of this tract. History enters his plots dressed as stock characters who, while unhinged from chronology, seem

always specific to those haunts as we see them. They are luminaries of place; just standing there, they condition the topography into a kind of memory theater.

York depicts the American scene as it once was and as it remains in ever-diminishing pockets of rural survival. His occasional trappings of handlebar mustaches, Stetsons, parasols and sunbonnets evoke that period after the Civil War when America was becoming at once hyperaware of itself and nostalgic for its own best chances. The American 19th century (the last third belonging to Ryder), along with its French artistic counterpart, is in his grasses, but it's not as if York conveys a yearning for those times of boom and lost innocence—rather that he's absorbed them: they're as real to him as his own front yard. His work, with its peculiar stability, seems ever on time. Its pertinence for the present moment may lie in how he has taken up the desultory art of genre painting and returned to it its original powers as a symbolic form.

<div align="right">1993</div>

Note: Thanks to the perseverance of Calvin Tompkins, who interviewed the artist for a *New Yorker* profile that appeared three years after this catalogue note accompanying the Albert York exhibition I curated at Mills, much of the mystery of Albert York's biography has been solved. Even so, the sources of his art and its mysterious powers remain unfathomed.

Presenting Surface: Judith Foosaner

To identify Judith Foosaner's charcoal and graphite works on paper as "drawings" is not to suggest anything secondary about them in relation to her oil paintings. No sketchiness is implied, nor are distinctions in scale an issue: the large, bravura charcoal spreads verge on the mural proportions of the biggest oils, and the intimate graphite drawings carry that fullness of suggestion which the best small works in any medium can persuade us is no less than what the eye might ever seek for its gratifications.

Above all, these drawings present us with a prismatic surface existence, confounding as sunlight glimpsed through branches and clear as the branches and light seen as one thing, an event. "The piece of imagery," Foosaner says, "is mostly a matter of movement and light."

In painting and drawing generally, we are given to see an imaginary surface where particular energies gather as suspended fact. Foosaner puts forth the appearance of such gatherings candidly, letting her improvised lines—including those force-field arcs and atmospheric jolts produced by erasures—follow through and seek each other out. The fictive "where" of her art is other than, though it subsumes, with whatever measures of transmutation, the actual surface of the worked-on support. (What, for example, looks like an underlying, carefully plotted grid across the square containment of *Andante* turns out to be the result of charcoal pressures against a corrugated board nailed to the wall upon which the drawing paper was worked.)

"I watch the piece, search the thicket. I find a place to enter…. Subtraction begins. I rub, wipe, erase…." A sheet initially soiled by progressive scrapings and

rubbings is "entered" by alternately marking the field with different consistencies of charcoal and crosscutting with eraser strokes. "I find the pulse, set the pace, stretch and pare it down." The erasures take on meaty insistence; here and there, a piercing greyish white sensation peeks through. Repeated scourings recall the inflections left on a gritty plane across which wooden matches have been struck.

Airiness of *Courante*, maximal density in *Adagio*, keen edges zipping among the wiry loops of *Andante*—these are but some of many variables. Different papers allow "white" a spectrum of its own; what is constant is the requisite strength of paper stock that "stands up to the assault." The big charcoals are exhibited push-pinned to the wall, an intimacy of pictorial invention with its literal place setting.

Variety is telling in the smaller graphites, too, where blurry connectives bear meanings as strong as those of individuated, tumbled shapes and intervals. The shapes piled up or delicately tethered appear chosen—or perhaps second-natured—from Abstract Expressionism's polyglot lexicon of biomorphs (*Disappearing Act*), still-life (*Fast Company*), landscape (*An Inside Job*) and figuration (*Emergency Clause, Private Mileage*). Foosaner's vibrant lines are rooted in memory and long practice, the better to catch what James Schuyler once called "the flying splendor of change."

<div align="right">1995</div>

Inez Storer's Identity Opera

Over the past decade or so, each of Inez Storer's paintings has tended to take the form of a response to a set theme. She assigns herself a subject and completes a painting accordingly, allowing for leaps of faith in her own opulent imagination. The pictures— like discrete flash-card scenes in an extended opera about identity, history and gender positionings—are both fanciful and distinct. The overall approach is personal, with images that have washed up plush from the artist's soul. Stirrings of emergent occasion, once grasped, become transposed to dramatic incident, emblematic in the paint. Procedurally, this wasn't always the case: looking over an array of new work in her Point Reyes studio, Storer said, "I used to start by just making marks and let the painting take me along, but now I have an agenda."

The amalgams in Storer's family background satisfy the prerequisites for a richly blended autobiographical art: a glitter-factory childhood in Santa Monica with "highly European-Catholic" overtones presided over by her dancer-actress mother and her father, a Franco-Austro-Hungarian count and erstwhile aviator, who, after quitting Germany in the late 1920s, worked as an art director for Paramount (his assignments included several Billy Wilder projects and the King Vidor version of *War and Peace*). Her kindergarten contemporaries included Kenneth Anger—later famed for underground films and the seamyside history *Hollywood Babylon*—along with a number of movie-colony progeny. Having been encouraged as a child in her artistic leanings, she zigzagged during the early 50s through various educational facilities in and around Los Angeles and San

Francisco, finding mentors as she went (at the Pasadena Art Center, Lorser Feitelson, Helen Lundberg and the photographer Ed Kaminsky; at the California School of Fine Arts, Nathan Oliveira). In 1955, she moved permanently to the Bay Area, where she has since remained.

"Paint," for Storer, may comprise, beside her regular meld of oils and glazes on top of a starter layer of Golden Acrylics, an admixture of collage—patches of old chromos and sheet music, for instance, or chintz lengths for drapery. Within a single canvas, her juicy colors may vary in thickness or texture. There are sun-dried whites, acid and powder blues, incinerated grays, aching red smears, and a blushful pink as gritty as broken brick. Standard formats are verticals and squares; horizontals seem to be reserved for large, impersonal themes—the creation myth cum directory of global place names in the recent *And so goes the world*, for instance. Some canvases are left unstretched—originally a contingency measure against high costs of shipping crated works to Russia for a show in the early 1990s. Then, while in Petersburg, she studied turn-of-the-century dropcloth paintings of the kind that sometimes doubled as domestic winter carpeting and were later used by the Constructivists to drape revolutionary slogans from buildings along the city's public squares.

The household male and female figures in Storer's pictures are lifted from domesticity into other, plausibly mythic circumstances. Cast in luminously smudged abstract spaces, they step or swim forward into view. Old-masterish *sfumato* finds gainful employment as an anti-gravity device for floating a scene in uncertain weather. Contour here is like faith in the integrity of the self. A pair of integers converges repeatedly in a kind of barometric proximity, wearing fancy hats; the two connect and sometimes overlap, but refuse to melt. Storer's sense of activated spatial separateness and proportion in relationship is visionary. (And as contemporary views of the gender gap go, hers is spectacularly devoid of malice and rage.) It's a comic vision of married life as an improvisation of selves pressing on and outward in tandem; beyond every toehold lurks a large, possible pratfall, or worse.

Storer has spoken of her aerial vistas as having "no perspective, no beginning or end." Even so, seeing what happens within them, the viewer knows the size and distance appropriate to any detail, and the scale of the territory at large. Props—a ladder, a dinghy, a family of chairs, a cap a monkey dropped on a Parisian thoroughfare—lend leverage, both graphic and psychological. That fabulations so thoroughly nuanced can come across as declarative throughout, so all-there at a glance, is a measure of Storer's commitment. Poise, the work invites us to think, amid the indignities of human self-awareness, is no soulless window dressing, but a wonder regained by turns.

1992/2003

True to Type: About Willard Dixon

Thinking about Willard Dixon's pictures, one first thinks of how unfenced the range of possibility in non-reactionary American landscape painting continues to be despite the

many assumptions—by critics and curators of the forced-march-of-time persuasion, especially—to the contrary. Beside Dixon, the likes of Robert Bechtle, Rackstraw Downes, Alex Katz, Jane Freilicher, Neil Welliver, Susan Shatter, Rudy Burckhardt, Yvonne Jacquette, Wayne Thiebaud and Susan Hall have all produced work within the past couple of years that forcefully testify to the genre's persistent viability. Dixon himself has been painting directly from the Northern California coastal landscape—open-space motifs within easy driving distance from his Marin County home and studio—since just after the time he turned 30, in the early 1970s. He was quick to get a handle on the basic elements of the type of perceptual image making he opted for, but slower to come to terms with the historical role it cast him in (the problem put plainly is "how to reconcile being a corny, old-fashioned painter with modernism"). The present array shows him branching out, taking on subjects of more emotional as well as topographical variety than before. (Though not included here, the spare yet mellifluous still lifes he's painted also over the past six years are further evidence of a pleasure taken in doing more and different things.)

A typical Dixon begins with drawing "a composite, possible scene" in charcoal on a large, horizontally oriented canvas, using slide projections as well as details (atmospheric conditions, a cow or two or extra telephone pole) interpolated as authentic to the particular, usually panoramic motif. What is sought from this delicate tracery is a big painting either simplified or complex. Where complexity occurs it is often mediated by the noblest and handiest of pastoral devices: to one side, a backlit Claudean coulisse; at top, a frontal awning of zenithward, deep blue sky; and midfield, the right blend of tones and lighting "to create a door into the space"—any or all of which may likewise subdue the not always convenient tyranny of landscape's most regular, regulating feature, the horizon line. It is usually well past noon in Dixon's universe, time for all vivid things to extend themselves in contemplative light. Sometimes the effect is other than calm: In *Near Olema (Golden)*, for example, the eponymous-colored illumination pouring in from the right sends a clump of trees into a dithery froth.

Especially magical and endearing among Dixon's new pictures is the visual hymn situated near land's end at end of day, *Ocean Beach I*. Here, a little to the right of center— her feet at the tidal edge, her plumbline seconded by that of the landmark Cliff House crowning the headland beyond—a woman in slacks and aqua pullover stands in profile facing approximately due west. More vectors extend deeper into the picture space by way of a dozen or so other beach strollers, all of them seemingly heading upstage, away from her. The moment-become-memento has a lived-in, durable poignance. "Transfixed by the sun" is how Dixon says he sees the figural group. But the sun's departure is visible only by the effect of its diffusion on the one person directly viewing it and regally unaware of how stained by its hues she appears. Reflection-deep, "she is the sunset," as Dixon remarks.

The fixity and spacing of the figures Dixon sets within his scenes may be partly photography's yield, but their vibrancy is due to Dixon's sympathetic way with broad pictorial light. (In this, his acknowledged mentors are Morandi, Sargent, Velasquez and more noticeable of late, Balthus.) In *Potrero Hill*, note how the rather abstract details, amounting to a largely silent vignette, are cradled by the central sidewalk ledge, how the

many (five-plus?) blues convene in a literal crescendo on the one white wall, how the painter has succeeded in painting a true contemporary cityscape without delving into architectural gridlock. Typically, every detail put where it belongs surprises by belonging so succinctly where it is, both nuance and scruple, an ad hoc verity.

1998

Working with Joe

While working on his open-ended prose masterpiece *I Remember,* Joe Brainard commented: "I feel that I am not really writing it but that it is because of me that it is being written. I also feel that it is about everybody else as much as it is about me. I feel like I am everybody." One great truth about style or character in art is that it is not so much to be pursued or cultivated so much as to be allowed or tolerated as that aspect of the work that can't be avoided. Thus viewed, personality, style, even so-called "meaning" register as inexorable elements, not necessarily the main order of business at all. A certain hankering after anonymity—or generality, anyway—rules the greatest art. As Carter Ratcliff once wrote of Brainard, "His hand has its own, immediately recognizable way of trying to be anonymous."

All art is collaboration. You collaborate with your culture, your language, your reading. Kenneth Koch called Frank O'Hara's poem "Choses Passagères," written in O'Hara's limited French but inspired by a French dictionary, O'Hara's "collaboration with the French language." When Bernadette Mayer says of her writing, "It's as if the language wants to say this," she acknowledges the proper relation of matter to genius. Or, as Brainard again put it, giving advice to a collage maker: "Do not try to 'arrange' your objects; let them help you formulate." As an artist, you collaborate with history, the past, the art—poetry, paintings, dance, whatever—that you admire. You don't so much control as work with your materials, which inevitably include yourself, whatever may be your most intimate facts. You collaborate with your peers, either directly (that is, you write works together) or not (that is, by parallel creations you form the work that comes to be recognized as that of a period style, the art of your time). Competitiveness is a form of collaboration. Addressing an audience—conceiving an addressee, a reader or viewer, for the work—you collaborate with that shifting phantasmagoria. Such sociability is what puts the work in the world.

Artistic collaboration between one or more poets, or between poets and other artists (be they dancers, painters, musicians or theatre folk), is often a spontaneous extension of social life. If your friends are other artists, the inclination to make something is likely to become salient in the midst of the most casual occasion. The writing pad gets passed across the room. Some nights in the late 1960s the drop-in work force in George Schneemann's studio was George plus four to six poets deep. There are, of course, more formal, institutionalized projects—but those are usually *livres d'artiste,* where the text is the starting point for, and eventually incidental to, the creation of a beautiful luxury item, a

book of illustrated verse. Artists have illustrated poetry perhaps since poetry was first written down. Image-and-text work certainly goes back at least as far as the Mayans. Botticelli's drawings for a folio edition of Dante's *Divine Comedy,* Manet's responses to Poe and Mallarmé, Picasso's drawings on poets as various as Ovid and Pierre Reverdy— the tradition stretches to the present with Joe Brainard's settings of images to John Ashbery's *Vermont Journal* and to Kenward Elmslie's *Album* and *The Champ,* and more. But the more hands-on variety of such works, by now so familiar, has a much shorter history. "Poem-paintings" and "poem-pictures" or just "collaborations" are some of the terms for the kinds of image-and-text combinations painters and poets together and separately have invented in this century. Foreshadowings of these modes may be found among the group inventions of the Surrealists—Exquisite Corpses made in the 1920s by poets, painters and others, where revelation rather than virtuoso handicraft was the charge. Collage and readymades in a sense had already insinuated a kind of a collaborative spirit into modern art. (Ernst's collage novels such as *Semaine de Bonté* enlisted the tacit collaboration of 19th-century dime-novel illustrators.)

In 1957 Larry Rivers and Frank O'Hara were invited to produce a portfolio of lithographs in collaboration for Tanya Grossman of Universal Limited Art Editions. Working together over the next two years in Rivers's Second Avenue studio, they made a set of twelve prints called *Stones.* Rivers recalled the process a few years later in these terms:

> *I did something, whatever I could, related in some way to the title of the stone and [Frank] either commented on what I had done or took it somewhere else in any way he felt like. If something in the drawing embarrassed him he could alter the quality by the quality of his words or vice versa....with these image....and his words we were at once remarking about some subject and decorating the stone.*
>
> *We were fully aware...that Frank with his limited means was almost as important as myself in the overall visual force of the print.... Frank without realizing it was being called upon to think about things outside of poetry. Besides what they seemed to mean he was using his words as a visual element. The size of his letters, the density of the color brought on by how hard or soft he pressed on the crayon, where it went on the stone (which many times was left up to him) were not things that remained separated from my scratches and smudges.*

O'Hara went on to do other, less formally proposed, collaborations with Norman Bluhm, Michael Goldberg, Jasper Johns and, eventually, Joe Brainard. With Rivers, Kenneth Koch soon followed suit. The 50s and 60s were the prime decades of such wildcat improvisation, the working principles of which, in retrospect, could be set down as three:

• Two or more people working on one or more surface at a time in the same room.
• Given a degree of impersonal 'otherness' (or what William Burroughs more arcanely called "The Third Mind")—simply put, more, and more varied, information goes into the mix.
• Participants have no expectations—there's a tacit agreement that the result may be a desultory mess—but there is a strong sense of obligation, again sociable, to

keep one's end up. (Brutal undercutting, rash obliteration and every other form of one-up-manship—each has its place.)

Commenting on the 1950s poetry-and-jazz collaborations, Frank O'Hara wrote to Gregory Corso (March 20, 1958): "I don't really get their jazz stimulus but it is probably what I get from painting... that is, one can't be inside all the time, it gets too boring and you can't afford to be bored with poetry so you take a secondary enthusiasm as the symbol of the first...." O'Hara collaborated with other poets, with painters, composers, theatre producers and directors and actors; the results were poem-paintings, collage comics, lithographs, songs, a musical comedy, numerous plays, and two films with Alfred Leslie. In 1960-1, O'Hara and I wrote a series of poems together that Larry Fagin later published as the *Hymns of St. Bridget* in a small edition with a cover by Larry Rivers. Some of the poems read to me today like instances of a very young poet (me) tagging along after an older poet in full possession of his genius. Yes, but what "Third Mind" was responsible for this choice item?:

Song Heard around St. Bridget's

When you're in love the whole world's Polish
and your heart's in a gold-stripped frame
you only eat cabbage and yogurt
and when you sign you don't sign you own name

If it's above you want and you know it
and the parting you want's in your hair
the yogurt gets creamy and seamy
and the poles that you climb aren't there

To think, poor St. Bridget, that you never got
 to see an Ingmar Bergman movie
because you were forbidden our modern times
but you're not as old as all that, you're not a mummy
you saw the Armory Show and Louis Jouvet
and Mary of Scotland and ANCHORS AWEIGH

 and we're sure
that you've caught up with La Vie et Esprit poetically pure
and indeed quite contemporary and just as extraordinary
as ice cubes and STONES and dinosaur bones and manure

When you're in love the whole world's a steeple
and the moss is peculiarly green
you may not be liked or like people
but you know your love's on your team

When you're shaving your face is a snow bank
and your eyes are particularly blue
and your feelings may be fading and grow blank
but the soap is happy it's you!

Joe Brainard's collage-comic collaborations with O'Hara occurred in much the same way, except that Joe apparently had the courage to suggest collaborating, and the terms of doing it, himself. Like myself, Joe was a 20-something interloper emboldened by O'Hara's keen eye for talent at the get-go stage of its development. (Actually, by the mid-60s when these collage comics were done, Joe had already refined *his* talent more than had any poet his own age.) Writing on O'Hara, Joe defines the in-tandem, hand-over-hand improvisational method in comparison with another, intermediate, call-and-response kind:

> *Actually, in the strict sense of the word, Frank and I never collaborated. (Alas) never on the spot, starting together from scratch. Giving and taking. And bouncing off each other. What we did do was that I'd do something (a collage or cartoon) incorporating spaces for words, which I'd then give to Frank to "fill in." Usually he would do so right away, with seemingly little effort....*

What Joe does in that little paragraph is detail his two basic ways of collaborating, except that the comics more often than not were delivered to poets for text-production through the mail, and filled in with considerably less spontaneity than was normal for O'Hara. Comics were very natural. We had a feeling for how they worked. They were our first art and, in many respects, our first literature.

Intrinsically, criticism is a form of collaboration, another form of call-and-response. It can, as Saint-Beuve observed, transform "half-poets who become and appear whole poets in criticism: all they need is an external fulcrum and a stimulus." Think of the great critics and reporters who are neither artists nor poets—Whitney Balliett on music, Herbert Muschamp on architecture—and you see that Saint-Beuve was right. But then again occasionally a poet who is "whole" to begin with maintains that same wholeness across the board. In poetry and prose, James Schuyler wrote about what was really there, and loved to trace out the details that appealed to him. (Schuyler said that he even used to write his art reviews out in verse lines first and then "turn" them into prose.) In 1967 Schuyler wrote on Brainard for an issue of *ARTnews* that featured a picture of Joe's on the cover. Schuyler's text reads in part:

> *Also a painting of a ribbon tied in a bow: "I don't know what I'm going to do with it." He is a painting ecologist whose work draws the things it needs to it, in the interest of completeness and balance, of evident but usually imperceived truths. He is like Darwin deducing why there is more red clover where old maids live: they keep cats that catch the field mice that eat the clover.*
>
> *Also a Prell "shrine." A dozen bottles of Prell—that insidious green—terrible green roses and grapes, glass dangles like emeralds, long strings of green glass beads, a couple of strands looped up. Under glass, in the center, a blue-green pieta, sweating an acid yellow. The whole thing cascades from an upraised hand at top: drops and stops like an express elevator. It is a cultivated essence of shop-window shrines and Pentecostal Chapels (John Wesley with*

Tambourines, lugubrious and off-pitch). Its own particular harsh pure green is raised and re-enforced until it becomes an architecture. It is to green what a snowball is to white, an impactment.

> *A violet-blue, the border of the glass over the pieta, emerges as an echo, as though if you squeezed a leaf hard enough a little sky blue would ooze out. The whole thing has the musical look of a clock.*

Criticism made by artists, which is sometimes formal, in the art magazines, but mostly spoken or otherwise off-the-cuff, is valuable mainly for its forthrightness. Brainard wrote to Schuyler: "One thing I like about Hans Hofmann is that he is hard to like." Then again, Schuyler quoting another painter on Brainard's acumen as a colorist: "He just puts down a color, and it's *right*." (Most professional art critics would spend twenty pages getting around to such a conclusion.)

Then, too, there is *self*-criticism, the unacknowledged type of criticism that makes good art good in the best way—it is good *on purpose*. Joe meant his work to be good. He wrote (this again from Schuyler's endlessly informative text) in July, 1965:

> *Working on a new construction that I am a bit suspicious of: it is practically floating together. (As though I am not really needed.) I do love it though: each object is crystal clear, but equally so, so they all seem to belong together very much. It is constructed in the simplest possible way: one thing on top of another. It has no theme except color: emerald green, royal blue, cherry red and black. It is not all gooky, which I am glad of. Also there is purple, and stripes of clear rhinestones. It is very geometrical. And of course very dramatic. Sometimes what I do is to purify objects. That is what I have done in this construction.*

The fullness of Joe's art is augmented by the fact that he was a wonderful writer—so philosophically adroit, and as good as any artist you can name (and that includes some very big names—Leonardo, Delacroix, van Gogh, Picasso, de Chirico and deKooning, among others). For a while, it seemed that his literary masterwork *I Remember* would outstrip his assemblages and collages in the immortality sweepstakes. Historically, it's important to realize that Joe began writing *I Remember* in 1969 at what may have been the exact mid-point in his artistic career. (Ron Padgett says that he had been reading Gertrude Stein at the time.) All of the major assemblages and a good many of the great collages, including the "gardens" series, were already behind him, and at least 10 more years of marvelous invention lay ahead.

Joe was a such a brilliant writer that he could even write his "visual" works in prose, viz. the series of piquant *Imaginary Still Lifes*, written in the 1970s, one of which reads:

> *I close my eyes. I see a white statue (say 10" high) of David. Alabaster. And pink rose petals sprinkled upon a black velvet drape. This is a sissy still life. Silly, but pretty. And in a certain way almost religious. "Eastern" religious. This still life is secretly smiling.*

Another example: Joe the expert portraitist manifested his acuity in both words and pictures. Here is his word portrait of James Schuyler:

James Schuyler: A Portrait

Let me be a painter, and close my eyes. I see brown. (Tweed.) And blue. (Shirt.) And—
surprise—yellow socks. The body sits in a chair, a king on a throne, feet glued to floor. The
face is hard to picture, until— (click!)— I hear a chuckle. And the voice of distant thunder.

Poets and painters collaborate partly for the same reasons that painters make portraits of people they know—it's another way of spending time with that person, and the artistic aspect lends an extra, more surreptitious, intensity to the get-together. Usually, my collaborations with Joe were done at Joe's invitation—either he sent a comic in the mail for me to fill in the text, or, as we sat around in his studio or in Kenward's house in Vermont, he would quietly ask if I felt like doing "some works." Collaborating in person with Joe was a gas. He was usually quiet, purposeful, always encouraging, quietly amused. My favorite instance with him was an afternoon in his Sixth Avenue loft in 1973—Joe was in his "blue" period, and we did I forget how many collages all in blue with blue lettering, the title for which was a line I contributed from the Humphrey Bogart/Lizbeth Scott movie *Dead Reckoning:* "It's a Blue World."

Alex Katz's recent statement about collaborating with Robert Creeley reads in its entirety: "Working with Bob makes me feel bright." Working with Joe was bright, sweet, demanding, mysterious (how to please Joe in this process was both mysterious and demanding, as well) and silly. Somewhere beneath the scornful shrug of "silly" sits the etymological mother lode of "soulful." Avoidance of pretence is a prime stratagem of the pursuit of beauty and truth; hence Joe's love of the dime store frames and slightly more expensive but just plain Kulicke plastic passe-partouts he somewhat casually slid his drawings and collages into. Kenneth Koch has remarked on O'Hara's "feeling that the silliest idea actually in his head was better than the most profound idea actually in someone's else's head." Smart or idiotic but never dull. (Ron Padgett recalls poems we wrote in groups of anywhere from two to ten in the late 60s as making him laugh so hard his stomach hurt.) Collaboration thrives on the nerve of putting shamelessness at the service of mutual respect and the will to be interesting no matter what. In 1978—in an interview reprinted in the present exhibition catalogue—Anne Waldman asked Joe "What about collaborations?" and Joe summed it up for her (and for us today) like so:

It's fun. It's very arduous. You have to compromise a lot. You have to be willing to totally fail
and not be embarrassed by it. That's the main thing, which is very good for you.

2002

Empathy in Daylight: Edward Hopper and John Register

We sanded the floors
and invited the ocean in.
　　　　—John Ashbery, "Gladys Palmer"

John Register gathers evidence of the material world around him like a private eye on a case where human presence has lapsed almost beside the point, so thoroughly have furnishings, light and weather—in short, the environment—absorbed its capacities for mythic import. The polished surfaces and sprawling, sunstruck angularities that fill Register's pictures can be read as contradictory signals of high expectation and abandoned purpose. They display a soulful lustre like that of distant stars, compelling though uninhabitable except by a wild leap of empathy. The leap must be instantaneous, of its own moment; this eternity of recognizable particulars brooks no nostalgia. Perhaps this is why there isn't in fact very much weather in sight in Register's views, although the upper tier of a picture-window prospect will have "sky" things going on in it. Many of the inside-outside vistas suggest, in the artist's phrase, "waiting rooms for the beyond"— the built environment's more or less coherent mesh of functions caught in a slow, entropic skid. The impending vacancy feels already flooded with recall.

Register's typical image is an equivalent of the establishing shot in narrative film. Our awareness that for this picture there is no next frame lends urgency to the occasion: the bare setting, together with our contemplation of it, tells all. A standard motif is the single chair positioned in light and shade near a window and seen at an angle from above. One chair alone in a room equals a character study. A set of them indicates a micro-culture, middle-management, say, or tourist class. Sameness of texture constitutes an order of being, just as orientation, being more temporal, implies attitude. Such modern humdrum surfaces find redemption in how they take and modify available light. You imagine yourself entering these spaces with your eyes wide open—the constant daylight sees to that—and then negotiating them according to directions inscribed in whatever textures and facets the architecture and its contents present.

The most obvious precedents for many of these aspects of Register's art are Edward Hopper's images, from the 1920s on into the 60s, of architectural settings with and without people. (Recalling his early days as a commercial illustrator, Hopper said, "I was always interested in architecture, but the editors wanted people waving their arms.") Like Hopper, Register packs the bulk of a possible story (and the story of a possible life) into one suspended moment, and, also like Hopper, he uses the look of sunlight thrown across inanimate surfaces to create suspense as well as to point up psychological discrepancy in his characters. Hopper wanted his art to be a record of his emotions. Register, no less committed to emotion, is more speculative, perhaps because the spaces he finds about him—the spaces of a world far later than Hopper's, and later even than the tally of years would suggest—are more abstract. As Register told Barnaby Conrad, "With Hopper you witness someone else's isolation; in my pictures the viewer becomes the isolated one."

As it happened, Register came of age as a painter at just that point in the mid-70s when what Peter Schjeldahl has called "the Hopperesque" (Hopper himself having died in 1967) gained a new and deeper cultural pertinence. "The Hopperesque," writes Schjeldahl, "pertains to a glimpse that burns into memory like a branding iron. Anyone who has done much living knows situations in which mood and moment produce a spark, and some utterly neutral thing is permanently charged." The sudden spark annihilates on contact Pascal's famous caution against painting's siren call to linger over images of things of no apparent consequence. In Register's pictures, the sensation of momentous fact comes alloyed with a piquant foretaste of afterlife: whoever sees this is fated to see it both forever and nevermore. Without distortion, the pictures record actuality sublimated as a ghost or dream.

1996

Linda Fleming: The Scale of Experience

When discussing her sculpture, Linda Fleming speaks readily of "building" a particular work and then of how a series of works will "grow" toward "collective identity." As to shapes, she's especially aware of "cores and exteriors," some of which she likens to Johannes Kepler's drawings of nested planetary forms. The reference to the German astronomer is consistent: To a sculpture group she made in France during the summer of 1991 Fleming assigned the title *Some Models for the Universe*; lately she commented wryly that the conceptual aspects of her recent work could he seen as analogous to "a chimpanzee trying to puzzle out astrophysics." Mention the buoyancy projected by one of Fleming's massive salvaged-timber constructions, how blithe seems its point of contact with the floor, and she'll confide, "What is 'down' in the shape isn't where the piece started."

Fleming's 90s sculptures pour out three-dimensionality as a sign of the energy spread through matter generally, though the physical dimensions in each instance are specific, as are the materials, which affirm their own individual histories and character. It's as if Fleming wants to show her materials in their raw state while unleashing their capacities for transformation into imagery. Likewise, the articulations of solid planks and beams in the large pieces tend to stretch across and distinguish, rather than command; bits and blocks of space, blanketing some and leaving others. Commingling blunt physicality and complex notions of the appearance of things (as Fleming puts it) "between identities," the undertow of these paradoxical structures draws you in.

The present installation of eight variously sized sculptures together with three thrift-shop-Victorian chairs makes both a set of forms and a situation. The chairs—upholstered amenities chosen for looking "old and touched"—double as viewing devices (you can sit and scan the installation from ringside) and near-sculpture of another, more intimate, if blander, order. The look of the arrangement, as well as the countenance of each sculpture, changes as you weave through and circle around, and so, too, does your

understanding of the intentions at work. The whole array proclaims the esthetic hardiness and malleability of the hybrid.

To alert viewers to "the varying ways of seeing" she was after, Fleming hit upon the overall title *Wilderness. Study. Area.* This piece of found language hauled menially from parklands in the Sangre de Cristo Mountains of southern Colorado (where the artist spends four months a year) retains its function at the Sculpture Court as an advisory glyph. Willfully parsed and punctuated—and notably ironic in view of the institutional, urban setting—it conceptualizes tensions and ambiguities implicit in the assembly of shapes unfolding this way and that within the large, glassed-in City Center space.

"To *study wilderness,*" Fleming remarks, "must be some kind of oxymoron." In the same vein "area" suggests a predictability of space at odds with the scale of lived experience, including the ever-unscheduled extensions of the imagination. The realization of what it is to be "between identities" as a sculptural idea may come into focus as a twenty-foot eggbeater or a toppled Sequoia. A correlative of the contradictions involved is plain in Fleming's relatively miniature assemblage of a weathered tree root uneasily shouldering the aluminum cast of a toy tree silhouette; the abstract smoothness of the latter object renders the actual, clunky remnant of vegetable matter absurdly alien.

Structure "distinguishes," the sculptor reminds us, but in Fleming's physical conjurings even the most intransigent-seeming mass retains the option to evanesce or, at any rate, to become gently sociable: turn to the "back" of the biggest of two tilted, tapelike sculptures to find that, from that view, the interlocking beams comprise two shady niches inviting entry. Such comfort zones (each a "scallop shell of quiet," in Walter Raleigh's phrase) exemplify the non-intimidation pact, rare for large-scale sculpture, that Fleming's monumental leanings make with the viewer. Porous to light and air as well as to our feelings about them, her sculptures suggest that "life-size" is indeed as variable as liveliness.

<div align="right">1995</div>

About Bill Scott

> *Perhaps the roses really want to grow,*
> *The vision seriously intends to stay;*
> *If I could tell you I would let you know.*
> —W. H. Auden

Bill Scott is a confessed "mannerist" aesthete who tends to declare his considerable ambition as a painter by way of such terms as "serenity" and "gravity-free" (the latter in reference to a particularly admired Berthe Morisot, of a hollyhock garden). Recently, he wrote: "Freedom, or playfulness, certainly helps me in the painting of the painting. Most of all, I want my work to feel alive—it may not be doing cartwheels, but at least it has a

pulse." His impetuses are many and varied. One comes from children's art: when visiting Northern California last winter, he stumbled upon a group of children's drawings done in a "doggie drawing" class; these he rated "inspiring—even more than someone like Bonnard."

Among painters of historical record, Morisot, Joan Mitchell and Jane Piper are three whose names crop up regularly in discussions of Scott's work. "All three were great colorists and used white in similar ways," he says. A selection of Morisot's art Scott co-curated had a three-museum run, beginning at the National Gallery of Art, in 1987-88. Through Piper, a fellow Philadelphian who had studied with Arthur B. Carles and had absorbed Cézanne and Matisse on her own terms, he made his most intimate link with Philadelphia's version of vintage modernism. (Scott was born in Bryn Mawr in 1956 and met Piper in 1972.) From Mitchell, some of whose pictures (the late "chords" series, especially) Scott's work obviously resembles, he gathered both the general belief "that painting can still be a terribly important thing to do" and a specific trust in the medium's capacity to transmit sensation.

Mitchell's type of painting worked from residual feeling towards a kind of trace imagery of occasions from which such feeling might have sprung. Mitchell's profusions are plainly abstract; Scott's only incidentally so. All the same, the eponymous, recognizable hollyhocks or dandelions in one of Scott's paintings may be entirely metaphorical, like the sea of flowers suggested to Bernard Berenson by faces jumbled together in a Sienese street.

Scott's florals come usually long-stemmed, "all melt and fume" (as James Schuyler once wrote of an early Matisse *Dahlias*), each in a stable economy of stroke and daub. What may have been perceived in either memory or actuality as the ripest bloom now appears as a yellow ellipse in the loop of which some bit of background white or washed-on ocher or black has been grasped. Scott's strongly assertive brush keeps contrasting color, mass, and interval pretty well constantly aloft and frontal. The envisioned, vivid moment appears articulated at exact luminosity, a surge contained by his painting's requisite tautness and suspension. Squads of intense, separate, liquid color scale smartly upward—the diva's high note held fast—and, as apprehended, arrive there in a flash. The eyes, thus tumbled and refreshed, find believable bliss.

Q: What sets Scott apart? A: Boldness conjoined with courtesy—plus rarest, undiluted faith.

1997

Chaos Dancer

The surfaces of Keith Morrison's paintings give onto a big, broad world of teeming event. That world is both outside and in—memory and observed happenstance, symbol and material fact, self and not-self. The breadth is related to Morrison's own cultural bearings, accumulated by him—some willingly, some not—from near and far. Morrison

hails from Jamaica and has lived since 1959 in American cities—Chicago, Nashville, Washington and, lately, San Francisco. Not least of all, Morrison carries with him a composite, and purposefully selective, painting culture that in itself symbolizes his overall, piquant sense of identity as mixture. In the paintings, all such discontinuous matters are ordered by way of syntactic views that permit abrupt shifts in space and scale. They show imaginary land- or cityscapes—and, occasionally, still-life arrangements—within which each thing sensibly, if uneasily, finds its place in relation to others.

Morrison began as a painter of reductivist abstractions. He looked for ways to, as he has said, "condense messages into pure shapes." Clear, flat shapes, the *lingua franca* of the 1960s, he soon realized, couldn't carry the density of message he was after, so he proceeded to flesh them out. How far Morrison has come from the containments of minimalism may be signaled by the simple fact that all the works in the present show are oil paintings, and whatever else may go into them, Morrison handles oil paint ecstatically. The ecstasy is contagious: in sheer body heat, the "whatever else"—even the most outright satire or cautionary tale—is tricked out like a bacchanal.

Ecstasy thrives at the rim of chaos. Or, better, reverse those terms: a chaos bred of cultural confusions has become so familiar that Morrison's sensibility can dance within it, dervish-fashion. All that exists here is on dangerous, or anyway shaky, ground. Posed along an incline plane, shapes—a regular repertory company of slave dolls, Nigerian *ibeji* figures, and assorted land and sea animals—register that any second the floor might slip away from under them. There is in fact very little "floor" as such; most of Morrison's feverish tableaux are set on, or include, bodies of water or else the juices in which all manner of stuff gets stirred, provisionally held in place by the universal pot or skillet. Where solid footing does occur it is likely to be that of an alleyway or, as in the audacious zap of *Red Sea,* boundless sand. (Around the stewpots, of course, stretch only miles of burning coals.)

It is always either high noon or nighttime in Morrison's places; shadows, when they are cast, tend to lie flat and squat below. This wide-open lighting system in the pictures is what aligns their narratives with those of the so-called Magic Realism of Gabriel Garcia Marquez and other contemporary Central American writers: it proclaims suprarational occurrence as the norm within persuasive fictive space. Practically, however, the pictures' light owes its existence and continuity to the choices and moves of an expert colorist. (Watch how, in the overall glare of "CyberCity," Morrison's reverberant secondaries—orange, green and violet—make with edgy, optical pops and clicks.) A spangled snake will wind across a color area—hideous and enchanting in its languor. A parrot presides at the center of disjunct creation, a self-appointed cosmic orator. If, as Morrison says, actual human figures would be "too literal" here, the dolls and figurines are so invested with secrets they permit no ordinary social contact. Like the places they inhabit, they are plainly psychic emanations—to be approached warily.

1996

About Ernie Gehr

Ernie Gehr's films fascinate by the continual sense in them of probing—a seeking out, looking for the angle, the way in. It's like watching someone nervously insisting on arriving at an intimacy with the fabric of appearances, including the appearance of a film as Gehr himself puts it together. Perceptual art is often not so much about vision as such, but about human information, which leads us to consider how people know one another, how character is revealed—matters of empathy as much as of optical sensation.

History, the manifest of facts in time, is, so to speak, a human element. Gehr shows, among other things, buildings and traffic, which have, as he would say, abstract patterns. But he doesn't show abstract patterns; instead, we see the creases on the back of an old man's neck, or among many drab or muted details, the bright red paint of a butcher shop wall. Something else comes across: a kind of sympathetic resonance transmitted obliquely. The vantage point is sometimes a close-up intervention, getting into the thick of serendipitous detail: a pointed finger, a stroke on the back, how a woman fills her own shoes. The mystery is in the transmitting. In certain filmmakers the most unstyled, seemingly pointless cinematography permits a distinct attitude towards human existence to be felt. Gehr's films carry their loads of intentionality lightly. It's not as if we don't see what he means to make visible in any one film; there's always a signal. But given all the moves—turning the camera this way or that, flipping the frames, a sort of relentless, often very witty, editing—the perceptual part seems objective, and subjectivity seems reached through the showing of the film, a "projection" in every sense. The continual manipulation, Gehr's purposefulness, affects the viewer's orientation. (The mind reels.)

Two materials of film are light and gravity, two unsolved riddles of the universe. Light through celluloid striking a white screen, and the pull of each frame vertically through the projector gate. Consider the moment in *Shift* when the edge of a truck, seen from above as a parallelogram in motion, sweeps and "erases" the white traffic line on the street. Gehr's way of eliding directional—or directorial—guidelines lets us experience paradox as a humorous yet essential jolt, a necessary glitch in the perceptual cosmos.

1995

From the Land of Drawers

Around Christmastime 1967, construction was completed on Philip Guston's new cinder-block studio a few feet from his house in Woodstock, New York. During that year and for another eight or nine months Guston did no painting but drew constantly. Among my notes from a summer 1968 visit to Woodstock I find:

> *All ink and brush or compressed charcoal. Some of these not-to-be-labeled images look as though they were thrown there or shot. Others turn to shapes around the studio—bottles, cans,*

an occasional head. The moving Hand-in-Space touches no oil (and no acrylic either). It is all perfection there in the land of drawers.

Eventually when, in the fall of 1968, Guston began painting again, shapes that had been lurking in earlier pictures became explicit, and with them, a third major phase in Guston's life as a painter. How continuous have been the lives of those shapes can readily be seen by observing a "hand" or "shoe" in a painting like *Evidence* at the San Francisco Museum of Modern Art and then similarly contoured forms in two other, much earlier paintings in the same collection, *The Tormentors* and *For M.*

During the late 60s and early 70s, when he had absented himself from the New York art world and vice versa, it fell to a group of disparate young poets, beginning with Clark Coolidge and myself, to be the core audience for Guston's work. He in turn became an "Ideal Reader" for our poems—providing drawings for the books and magazines in which they appeared, and sometimes copying them out with a quill pen and adding images around bold, cleanly spaced lettering. Considering what he had done, Guston wrote of "words and images feeding off each other in unpredictable ways. Naturally, there is no 'illustration' of text, yet I am fascinated by how text *and* image bounce into and off each other."

1997

From the Guston Papers

For a long time I did not hardly sleep at nights, but dreamed all the time about colors and forms, and often, nearly always they were crazinesses in their queerness....How I suffered in my doubting and would change again, make a fine drawing and rub weak sickly color on it, and if they told me it was better, it most drove me crazy, and again I would go back to my old instinct and make frightful work again. It made me doubt of myself, of my intelligence, of everything, and yet I thought things looked so beautiful and clear that I need not be mistaken. I think I tried every road possible....What a relief to me when I saw everything falling into place, as I always had an instinct that it would if I could ever get my bearings all correct at once...
　　—Thomas Eakins

A note from 1966: It is as if Guston had been trying to paint over a solitary shadow falling across the canvas—impossible because it shifted with every move he made.

Steps, shoe prints, or dashes in dance-step diagrams (Andy Warhol?), make a kind of map. Call it locomotion, or "chronography"?

Dagwood's Inferno.

Guston's not-gesture of "put" paint in place. Caricature: *caricare*, to load. "Cliff Sterritt did the best furniture." Loaded semblances.

The coated figure in *Back View* with his burden of "steps," shoe-ins, plods of experience, identity. Kafka in his diary wrote, "They know me by my coat."

Pyramid and Shoe, skidoo! (To speak of stopping "when the emotion runs out.")

Interesting to consider the sources of "place": exterior places reflected, as well as where the pictures come to reside. Larry Fagin claims he could reconstruct a certain downtown L.A. neighborhood where both he and Guston lived at different times from one of those images of hoods in a car. I thought I caught a glimpse in Iowa City: a big clock on an old brick building flat against pale blue sky. No matter, nowhere as specific as the sites those paintings propose.

You don't need a lot of features to have a face.

Two black strokes make eyes for a hood. No mouths. Black marks say eyes. (We have an "eye" habit.) You're not about to ask how they smoke those cigars with hoods on, are you? When one smokes, the mouth isn't working. The one mouth that appears spits out forms.

Ears: one to a head, almost identical to a cup handle, a semi-circle completed by abutting. Wonder what Guston construes as the sound space for his paintings. In a letter once I took the chance and asked him was I right that there wasn't any music in his house, much less in the studio—no phonograph, radio, etc. Got no answer, silence. Now I read that in his younger days he played the mandolin.

Titles: *Painting*, 1954, etc. Who else does that? Like calling a poem "Poem," and not *Number 2, 1950*. Other Guston (later) titles resemble framed titles of silent films: *Bad Habits, Edge of Town*.

Words in (or on) a book are vertical marks, like "stand-up" words, like eyes. Guston fixity and/or atmospherics parallel deKooning's "wind" where the pages are ever flipped. Under the book is a table, just a slab really. You can easily imagine a text under the book. The book is entitled *Matter*. Another drawing, called *Water*, is 24 squiggles, all vertical— on a windowpane? In painting, rain falls diagonally, everyone knows that. (A rainy window by van Gogh, streaked on the vertical, is the exception.)

Likewise, the caricature portraits Guston made of his fellow artists in the 1950s, head shots all: O'Hara's angel turning in sleep, Cage like some strange rootstock, Harold Rosenberg blurting in his bristles, Kunitz's eager rodent, the workaday deKooning in his knit cap, Landes Lewitin apprehended as a distraught yam.

Journal 3/11/61: "It's like the fable of some last judgment. You want to say this is what I've done, good and bad, do you get it? But the line is so long you'll never get to be judged anyway." (P.G.) A visit to Philip Guston's studio: weight in the air—different from the buzz or frenetic space of other painter's lofts, and not exactly business-like as others' beside, not oppressive either—the feeling you could talk there and, hearing what you'd say, be surprised. INTEGRITY—in big block letters.

"What's wrong with feeling bad?" (P.G.)

A Contrarian Digression: Legends of the 1970 opening at Marlborough.
1. Alex Katz descending: "He blew it. They're not going to go for it." True about the art world in general; wrong about artists, the younger ones, anyway, like Susan Rothenberg, Elizabeth Murray, Neil Jenny, and scads of the then-unacknowledged European imagists (Baselitz is one), for whom Guston's work now becomes not influence, but confirmation.
2. The great solace taken in deKooning's greeting "We know what this is about, Phil! Freedom!"— versus deKooning's private assessment ten years later: "I dunno why he started doin' all those shoes and clocks—he vass doin' alright with dat abstract stuff!" Or it means the same anyway, e.g., feel "free" to fall flat on your face if that's what you want? (Plus what was deKooning's own late "stuff" up to in that regard?)

"It may be that poetry makes life's nebulous events tangible to me and restores their detail; or conversely that poetry brings forth the intangible quality of incidents that are all too concrete and circumstantial. Or each on specific occasions, or both all the time."— Frank O'Hara

The scale of what art requires of us and what we believe to be real in it. In Guston, substance, the vernacular, can range from bricks and bubbles to a smear. Well, difficult as it is to arrive at a "smear" in words, that graphic show has always spelled a confirmation for me as a writer: I really do conceive of "putting" words, like bricks, in some order in a poem.

His "substitute world, which comes from the world" stepped out of the shadows, as it were. But the dark pictures of 1960s don't "predict" the later ones; they state duress as a condition of things seen that way. Shadows are expressive of objects grounded in light.

Defaults of abstract art: Guston was as ill at ease with abstraction as an operative principle as Pollock was. And if there exists any parallel, or kin, to Guston's multiplicity it would be Pollock's black and whites of 1950-51. (Though the connection is clearest in the drawings of each throughout.)

More on the 60s: Scouring strokes sometimes at gale force, others at a bog. "I'm suffused with the day / Even though the day may destroy me." (John Wieners) And the different ways these things come to be: vortex, float, settled (as layers), tear from fabric, fracture, hunch....Paint pushed, not drawn. Soldered, as if brush were torch. In drawing,

filaments.

In Guston, substance, the vernacular, can range from bricks and bubbles to a smear. Shadows are expressive of objects grounded in unblinking light.

The scale of what art requires of us and what we believe to be real in it.

A cache of circumstances. Composition need not apply.

You feel the spatial position has been inflicted as much as "won." "The weight of the familiar," seen but not touched, perilous to logic.

Yet again: "Sometimes all you remember from an event is the look in one eye."

1994/2009

Jackson Pollock: The Colored Paper Drawings

> But [Pollock's] work is not about sight. It is about seeing and what can be seen.
> —Frank O'Hara

> In his drawings and works on paper, which were an integral part of his working life, Pollock used a wide variety of media: pencil, crayon, colored pencil, ink, gouache, tempera, watercolor, pastel, chalk, and enamel, alone and in combination. He worked on sketchbook sheets; textured, lined, and colored paper; Japanese paper; and other fine handmade papers.
> —Elizabeth Frank

The colored papers exhibited here bear the marks of Pollock's imagistic probings in the five or so years on either side of his 1947-50 drip paintings. The basic materials themselves range from ordinary schoolroom construction paper to the exquisite, dense, unsized rag papers woven and pressed by the Long Island craftsman Douglass Howell. Some pages Pollock tore or clipped in ways that suggest editing or salvage, but a ragged margin here and there may also have delighted him by recalling the irregular formats of petroglyphs.

Pollock often chose to work on surfaces prepared with one evenly saturated color. The colors of these sheets don't become local to the mostly inked-on images but rather provide ground tone, a continuum extensive as surface, air or light, or sometimes all of these. Given a red, gray, light or dark blue, pink, brown or purple tone, the stage is set. Literally grounded or aswim in color, Pollock's fancy wanders. The viewer's imagination, too, is set loose among the resultant, accumulated conjuring.

The drawings can be seen as instances of a vast storyboard. In them, from year to year, Pollock tests certain marks and motifs—among them, the more or less generic sigils and props that constituted a kind of second nature to him. In his earliest maturity, around 1943, Pollock began distributing these all-purpose signs in ever more diverse formations. Sometimes the disparate parts look inconsequential, even weak, but the fabric to which they contribute, unpredictable as it is (and full of that "nervous legibility" O'Hara pointed to as a defining attribute of Pollock's line), is specific and tight. As usual, the figure/ground shifts are drastic. It looks like aimless doodling until you catch onto the sequencing, the syntax. Perhaps therein lie the fundamentals of Pollock's genius: a high tolerance for the notionally unintelligible backed by extraordinary deftness at pattern recognition. There are no semaphores. The graceful interstices add up in clusters, articulated.

There are curiosities: an elephant lifts its ears skyward, absurdly; a retina doubles as a showerhead emitting a fizzy spray; another eyeball is cradled on a crescent moon; one of Pollock's famously enigmatic equations murmurs, "61 = 00'4"; plus-and-minus signs bunch up like gravemarkers; three horizontal scrolls from the 50s posit three contradictory theorems of pictorial space (one, a frieze of abbreviated standing figures, terminates at the far left with closing credits: "FIN"). In one line drawing over thick red gouache a three-legged burlesque queen performs a high kick over the footlights. There are other unusual traceries of women alone, and men and women together, in kinds of everyday, affectionate guises that Pollock's otherwise myth-bending canvases would never admit. There are also the usual, even classic Pollock forms—for example, the straight or meandering line that ends in a set of curlicues that could signify "petals" or "fist"—as well as the continual pressure to jolt these (or let them drift, like smoke rings) to new permeability, other ways of being seen. One aspect of a figure may sneak into another without the pen having been lifted from the page. The line that makes an edge may proceed to define a recognizable shape but will also refuse closure so as not to define too much. Most curious of all is a tan-tinted "desert" panorama studded every which way with animal figures: the central, rather melancholy, pan-sexual human figure seems to be both embedded in and generating (from its exposed vertebrae perhaps) the landscape, which lopes away across shadowy folds toward a far-off ridge.

A great, if somewhat harrowing, pleasure in looking at these drawings involves glimpsing yet again that aspect of Pollock himself as an image maker committed to the roiling flux of his creations. What Elizabeth Frank calls "the interconversion of form" and Rosalind Krauss "an imagery which is conceived of as fundamentally unstable" amount to the same thing. Across a single spread may unfold a sensuous diary entry recounting the several adventures of a biomorph or just how many ways a flick of the wrist can make a black stain turn—all in a day's work, so to speak. The endlessness of Pollock's entanglement occurs not in unchecked infinitude but within each discrete site of the tangle itself, the surface Pollock made with whatever medium he took up. The support for such a fictive surface—in this case, some piece of paper—retains in every dimension the plainness of its boundaries. Thus, the interval between image and surface closes.

1999

The Abstract Bischoff

For most historians and critics, the Elmer Bischoff story begins and ends with his prominence for twenty-some years as one of the Big Three (David Park and Richard Diebenkorn were the others) among Bay Area Figuratives. But Bischoff's schooling and the works of his earliest maturity were in abstraction and he likewise spent the last fifteen years of his life painting abstractly in a manner radically different from that of his youth. Commenting in *ARTnews* on Bischoff's first New York show, at the Staempfli Gallery in 1960, Fairfield Porter began by calling him "the most magnificent performer of all the Californians seen in this city who have given up abstraction in favor of realism." Accordingly, Bischoff's contributions to the initial surge of Abstract Expressionism during the 1940s and early 50s have been largely ignored, and, despite the admiration of other, mostly younger painters, the audacities of his late work tend to be looked at askance.

Born in 1916, Bischoff belonged to the generation of painters who made abstraction the dominant mid-20th-century genre. His most telling pictures, whether figurative or abstract, succeed by dint of his passion for color. They are full of tensions between an epicure's delight in the material, protean facts of painting and his oft-stated ambition to create pictures that would sweep all such facts aside, to arrive at what Bischoff himself called "totality," a wholly encompassing vision capable of striking chords deep in the viewer's consciousness. Anything less was too limiting. Students who took his classes at the University of California, Berkeley, recall Bischoff as "a twinkling Buddha" extolling the virtues of "vague" as opposed to a too-clear partiality of image; above the attainable, "stamped-out" product, he favored the more arduous, open-ended personal search.

Many of Bischoff's early abstractions might just as well be seen as very limber variants of still life or landscape, exfoliate in paint. The important thing was to cover the canvas surface with more surface and to make that overlying surface sing. His virtuoso figure paintings harbor non-descriptive areas where, as John Ashbery said of Bonnard's pictures, "shapes dissolve and outlines swoon." As with David Park's Golden-Age-ish nudes, Bischoff's way of piling on raw effect by the primeval brush load signals a romantic yearning to get beyond what he called "the customary self," to let each picture supply its own discrete Arcadia. It's as if only in such circumstances could the kind of sublimation occur that would cast a direct line from visual fiction to inner life.

Bischoff's abstract works have little of the troubled look or portentousness of his figure paintings. The earliest ones date from when Bischoff, aged 30 and just out of the Air Force, came under the spell first of Mark Rothko (in the latter's "mythopoeic" period) and subsequently (though less bindingly) of Clyfford Still. For all their ingenious cropping and sportive graphic devices, these paintings feel less like full-fledged performances than workouts in a generalized idiom -- the local "open-form" manner soon to devolve listlessly toward what Lawrence Ferlinghetti in 1955 would call "the final Asia of the Abstract." The "twirling, strutting and flying forms" that Alfred Frankenstein observed in 1946 can be spotted in many of the artist's late paintings, but with

considerably more elbow room to make their motions felt. The more distinctive pictures dating from a couple of years later are lyric fragments, intimate and inward leaning, with staked-out, taut patches of cloisonné color. Their colors tend to glower or blush. Hypersensitive tangencies and unruly tilts push the scale of each picture up and out, and the ones with the greatest scale put all hesitancy aside and kick into a soft-shoe kind of humor. The tautness Bischoff sustained well into the 1950s required some slackening: you can see how, eventually, figuration freed up Bischoff's color as well as his feelings for masses within the physical expanse of the surface until around 1970 when the energy of that intermediate pursuit ran out and Bischoff declared it "too much of a one-way street."

Bischoff literally went out in a blaze. The shaggy symmetries and incantatory brilliance that are the glories of the late pictures are suggestive of some cosmic instigator feverishly shooting the works. (In the 70s, Bischoff, ever fascinated by esoterica, had been reading up on Gnostic creation myths.) Here paint is more choreographed than put; incandescence—reticulated, comparable in its deviousness to the "unpredictable light" Bischoff admired in El Greco—rules. There are quadrilateral pockets that echo with tick-tock nonchalance the ninety-degree angles at the corners. Played against the steady no-dynamics of the square or near-square formats Bischoff favored throughout his career, what the painter and Bischoff's one-time Berkeley colleague Christopher Brown calls "the look of noise" is panoramic and extrovert. The coalesced glyphs parade or tumble across celebratory surfaces—acrylic ribbons, slashes, scrapes and scrubbings; rubato hatchings, darts, cartoonist force lines, charcoal and chalk addenda and silhouettes with odd, jagged contours that may have been tracings of objects held against the canvas (a partial list, only, of the many incidental marks involved). Convulsive in the sometimes audible cackling of a plain-painter-gone-visionary exultation, they all fit.

<div align="right">2002</div>

Join the Aminals

Tom Neely has a day job as an animator on the Disney website. With little or no break in continuity, he is also a committed painter and the creator of "i will destroy you" comics, which include black and white versions of some of the same imagery as his paintings. Just as the comics are fairly conventional in narrative syntax, the paintings are forthright about their distinctly pictorial ambitions. Though slight in format, in terms of esthetic probity and optimal, sometimes giddy enchantment, they mean business.

It is a recognizable universe, and Neely is a correspondent. *Sad Bird* stares out at a world not of his (or our) making. Because comics are a form both Neely and his normative viewer know, the viewer understands the complete situation at a glance. Neely concentrates on the mild end of character peregrinations. Memory, easily perked, strains

after the name for a familiar shape. Ignorance of circumstances is practically a prerequisite for the ensuing empathy.

Recognizables among Neely's "aminals" (his term for the diverse fauna inhabiting his pictures) are the near-generic in old-master chromos: Van Gogh's bedroom; Rembrandt's Dr. Tuyp, arch wielder of dusky forceps; the Vermeer "Pearl Girl" turned abruptly kittenish, her turban swapped for streetwise cap of elastic polyester knit. (Neely's form of parody is an undercutting force in love with what it subjects to direst mutation: in an earlier turnabout, Caravaggio's *Conversion of St. Paul* provided the basic choreography for the oil on panel *Giant Tick-Monster Attacks*.)

One of his sources, I learned, is the painter and printmaker L.S. Lowry (1887-1976), known mostly for his industrial townscapes populated by near-zero-dimensional "matchstick people." The Edwardian little master prided himself on his exclusive palette of ivory black, vermilion, flake white, Prussian blue and yellow ocher—tints that occur, or find their more highly saturated equivalents, in Neely's own imaginative realm.

A few years ago, in a rare artist's statement, Neely wrote that his paintings are "about life, love and the fear of monsters under the bed." There are no unfriendly monsters in these new works; rather the fate of each rather forlorn figure is a monstrosity pulverized and spread thin throughout the enveloping atmosphere. (A typical Neely canvas is a thermometer in reverse.) Abjection is common ground. Neely's shapes endure. The pleasures of recognizing what the mind believes it knows relax you to the point at which the actual painting can go about its work—dark, quizzical or brightening, as the case may be.

2001

George Schneeman's Italian Hours

Distinct in atmosphere, thin clouds blown by the wind, forms bathed in and defined by light.
—John-Pope Hennessey on Sassetta's predella for *Madonna of the Snows*.

Over the past 40 years or more, George Schneeman's art has comprised portraits of his family and friends on canvas and in portable frescoes on cinder blocks, collages and paintings based on collages, painted ceramics, and countless cover designs and drawings for books of poetry and little magazines. (He has also devoted considerable studio time to hands-on collaborations with poets in various media.) Bracketing these segments of work, and sometimes intercutting among them, have been the Italian landscapes begun during the time Schneeman first lived in Tuscany from 1958 to 1966 and resumed in the 1990s after he started revisiting the Tuscan countryside, having spent the intervening decades solidly in New York. (He and his wife Katie now divide their year between apartments on Saint Marks Place and in the commune of San Giovanni d'Asso, southeast of Siena.)

The recent landscapes are tempera on carefully gessoed plywood panels. Practicalities— storage and portability, especially—argue for settling upon a reduced size, without stinting on a picture's energy requirements. Averaging twelve by nine inches, done on location in half-hour sittings, the panels exemplify, Schneeman says, "the struggle between miniature and landscape"—which links the question of the size at which a landscape painting can register across a room to the thornier one of how in a compact two-dimensional space depth and surface will compare notes so that all that is visible can be both actual and clear.

An allegorist by disposition, Schneeman brings out the characteristic drama of each scene, keeping it from being merely a view or *bella vista*, and projecting more of what he calls "spatial sentiment." By Tuscan standards, these views are as ordinary as their place names—Il Moro, Castelletto, Poggio di Val di Rigo, and so on—are plainly functional. Formed in a fissured slope or where a couple of rumpled, vivid gray and brown rises meet, a crotch of ground fills up lustily with thatched greens. There are subtler moments, as well, mostly little details daubed along the ridges: a dark vertical sliver says "distant cypress"; a cuticle of brick red makes an isolated farmhouse roof. Further off, exquisite incidentals of buildings cluster together amid trees, making some sought-after shade. Still higher, the necessity arises "to invent something in the sky that relates it to the land."

Is spatial sentiment a more far-reaching, iconic version of Cézanne's "little sensation," more keyed to the bigger sweep of what the persistent observer takes in? The answer may be found in the painter's process as Schneeman tells of it:

> I don't forget the brushes or the water or the palette or the board to paint. And I have to take advantage of the clear days, because sometimes a haziness will set in for a week or more. We've already had one spell of that: and it's hard to paint clearly when the landscape is clogged. But even now I haven't had those beautiful clouds to work on. Clouds always make it clearer that there's a heaven and earth. And space between them.

2003

George's House of Mozart

I seem to have the distinction of being the only collaborator George Schneeman ever invited to join in on one of his series of yearly, limited-edition silkscreen calendars. One night toward the end of 1969, we went to work in George's studio; at the end of a single session we had finished. I remember thinking that the 1970 calendar's message should be complex rather than a single flash to be simply glanced at intermittently—something to chew on, sort out over the year. Perhaps the seeming complexities of silkscreen—new to me, anyway—had something to do with this. Or perhaps it had to do with the fact that I was just then turning 30.

In the upper middle, George has placed a fire chief's helmet, the largest element in the picture. The helmet commands the stratosphere, edging upon a cloud that looks to have been sprinkled, or "seeded," with black specks. Off toward the lower right a silver quarter rolls and, below it, the little mustachioed man from the Monopoly board scratches his head, top hat tumbling, as he reels away from his reeling-away mirror image. The mirror is yellow, the fire hat bright red with a silver blazon. The coin is shiny silver, too, as are some of the letters strewn across the rectangle—"Pete," for instance, and the "o"s in "No Go" which encircle the periods in "N. G." (although the same yellow "N" is also the start of "Nice" and "Nose," and "G" is for guy, gay, gag, gig, goy, goon….). The biggest words are in black and say "Easy onto Edna." In smaller script are "melting," "pregnant" and "pause." At the bottom, running below the Monopoly figure, is the adage "It is true-r than true." Fifty copies: two for me, two for George, and the rest went to friends.

I first met George in Spoleto, Italy, in the summer of 1965. George had driven down from Asciano on his Vespa with Peter Schjeldahl. Peter introduced us in the midst of the hubbub at the opening of a contemporary American landscape painting show that Frank O'Hara had curated as the Museum of Modern Art's contribution to that year's Festival of Two Worlds. The inclusive range of the show was timely: next to realists like Alex Katz and Robert Dash were Allan D'Arcangelo and Roy Lichtenstein. I recall nothing that George and I may have said to each other that day, or whether, beyond acknowledging Peter's introduction, we said anything at all. I remember him as bearded, which now seems unlikely and may not have been the case. George remembers John Ashbery directing his attention onwards from the Katzes by saying, "Let's go see what's on the dash board…."

Late nights at the Schneemans' at the end of the 1960s, the wall-to-wall conviviality drifted from cozily appointed living room through an interim, compact bed alcove to the broadly lit studio, at the near end of which was a long worktable with Rapidograph pen, ink, gouaches, brushes, glue and poster (or "composition") board and stacks of collage possibilities at the ready. Over these materials and their uses George presided gently. Perhaps due to my hazy recollection, my sense is that our collaborations proceeded, with participants sometimes as numerous as three or four at time, as if in a trance. The trance tended to favor the momentary punster—or at any rate one who will take the lid off word or phrase and transcribe the static-y emanations that accrue. Verbal doodling indulged, it fell to George to unify the often contentious elements. White paint and black ink camouflage a multitude of bloopers.

George's cover for *Recent Visitors* (1973) is based on a photo-booth strip of my daughter Chou-Chou and me in a New York arcade. Among the drawings in the book, one shows a billfold hovering spatially; the angular opening reveals empty plastic casings for credit cards and (oh, folklore-exotic!) five slots for coins. Others incorporate phrases I had sent George as goads for possible images. "Your guess is as good as a Mayan's" seems to have evoked a chubby fellow of indeterminate age contending with a runaway Ouija board.

About the same time as *Recent Visitors*, George sent two sets of start-up sheets to Bolinas, where Tom Clark and I added words and images. For one of these sets,

George's part was distinguished by a thematic consistency: to each page begun by Tom and me George added a faceless female nude drawn with crayon and fleshed-out in creamy tans and pinks. Thus, one of George's particularly luscious "girlies" overlays tracings of illustrations in R. L. Gregory's *The Intelligent Eye*, above which Tom had floated a couple of thought balloons with the words "thought" and "weightless." Mailing these sheets back and forth added a dimension—the post-office dimension, call it—to our procedures.

A favorite image of George's back then, the little Old Dutch Cleanser lady in full stride appears so purposeful we imagine a neat set of orthogonals for her—edges of kitchen tiles, cupboards, counters, a broom closet maybe—but it's just bare white her clogs stomp away on. White in Schneeman's pictorial universe has the sanctity of medieval gold leaf. A taste for mild, yet no less revelatory explosions—force lines and rose-colored zigzags shooting through myriad rings and disks, car tires, out of open doorways, windows, drawers, funnels. Such things smack of the well-documented Schneeman love of old church art. (Think Expulsion, Annunciation, Descent into Limbo and such like, in the hands of Giotto, Fra Angelico, the Lorenzetti brothers et alia.)

In a few quick sentences Ron Padgett has nailed most of the terms under which Schneeman's art can be discussed: "It is beautiful—mild, balanced, well-drawn, firm, straightforward, and sometimes serene. It is also light, modern, attractive, clear and likeable. It is not outrageous, declamatory, shocking, sneering, trendy, bizarre or shrill. It is good. Sometimes it is affectionate." To me, this would serve as well for a fair description of the music of Mozart, another constant presence, along with old-time Italianate civility and the surehanded art that manifests it, in the Schneeman household. Strictly Mozartean is the way George accommodates the airy, the rude, the idiotic, the transcendent—sometimes, incredibly, across the same, insouciant surface.

<div align="right">2004</div>

A New Luminist

We join the animals
not when we fuck
 or shit
not when a tear falls

but when
 staring into light
 we think
 —Frank O'Hara, "Heroic Sculpture"

Inaccuracies are mostly what there are to discuss light.
 —Tim Davis

The photographic prints in Tim Davis's *Permanent Collection* series are more or less, as they say, actual size and neither glazed nor set off from the frame edge with mats, thereby avoiding any reduplication of lighting effect and/or lessening of the insistently partial character of each image. They look, as Davis says, "somewhat confusable with paintings."

Davis is a sort of new-fangled Luminist, attuned to visuality in our current variant of the frenetic urbane. Luminism starts from an initial wonder: What is it about objects that lets us see them? Art objects as they are shown in Davis's pictures are slices of life as much as any contemporary experience, and seeing them in their stark material aspects, all varnished ridges, striations and cracklings, enhances their poignancy, so that more, rather than less, meaning leaks into the mix. The incidental glares in the photographs are entirely local, no flash employed. You sense the photographer's responsive physical activity in taking them, too. The encounter with the intimate lineaments of a thing—a rare type of photographic fool-the-eye—is complex, as funny as it is annoying. The perfect, unobstructed view is a mirage by which we flatter our ever-eager sense of sight. Faced with the pictures' intrinsic disorientations, you foolishly shift your center of gravity from side to side; as the fixed image refuses to respond—you cannot see the picture better—the Decisive Moment becomes a vain perceptual joke.

What Davis has gone after for the most part are the wizened textures of "old brown painting"—which is to say, the bulk of Euro-style imagemaking from roughly 1500 to the mid-1800s. The contemporary exception here is Gerhard Richter's *Betty*, itself a photorealist commentary on old-master grandeur and luminosity, and the book's final image is of an early-modern classic, Walker Evans's *Church Window*—a photograph of a photograph, oddly, under glass. Dispersals and contractions of ambient light, whether artificial or from the sun, bespeak intentions neither museological nor documentarian; what's at issue is consummately pictorial. Davis's is a world filled in every respect with light. The projective, residual light of a painting is peculiar to its skin. But light on paint is another story. In Davis's photographs light narrates itself—the light of photographs

unusually sensitive to the qualities of light they hold—as well as the commensurately physical stuff it encounters and reports on. Observable light is recorded as a color—white. Where in the paintings do the depicted light source and the actual one collide? In contained chaos, molestations of contingency rough up our sense of esthetic exemption: an alien flash cast across aged bumps and puckers of oil paint could be a slapstick catastrophe or obliteration, or else a love song or lament.

Among photographers, Davis's personal exemplars include Evans and, more recently, Abe Morrell, as well as, I would guess, Rudy Burckhardt. In contemporary terms, his taste for elegant straightness is both anomalous and refreshing. His voids are properly forlorn, his momentary beauties devotional. Thrown from the upper left of one of Martin Johnson Heade's magnolia paintings, an annunciate light rinses off the surface, exposing weaves and wrinkles of facture; such precise "noise" from outside augments the drama of the lone flower's sensational white presence.

Most photographic color, even when substantial and "in" the picture, is either self-consciously applied or overly enraptured by photography's natural facility with detail. Davis's colors are alive with the sense that what he shows us has those colors, and in that sense the colors of his pictures ring true. A whole image as well as its various details can be altogether sumptuous and wonderfully plain to see. That color is an issue of reflected light is never obvious. Davis's photographic version of hard yet exuberant looking reinforces the prodigious mystery of that fact.

2005

Visionary Babcock

Jo Babcock is an artist-inventor of the old stripe. He tinkers with objects, blithely transforming them into receptacles of images of other objects and/or vistas in their path. Everything is handiwork, with the result that what you see is no-sweat, a finely achieved, intentional conundrum.

The artist-inventor is a recurrent mainstay character in the American pantheon—primarily in photography and sculpture, the two arts with which Babcock is identified. (Are his cannily modified discards—all those hapless pots, cans, boxes, suitcases—anything but sculpture of the "assisted readymade" variety? "Sometimes the cameras are enough in themselves," he has said.) Resolutely low-tech but conceptually adroit, the images he produces have a raw, antique, sometimes "terrible" beauty. Rawness bespeaks actuality. The evidence here is of the fact of something's having been photographed, sans any pretense that what we see is an exact graphic replica. Process and product both intimate how strange photographic mimesis ultimately is.

Babcock with his unobtrusive—albeit highly discriminate—sensibility acts mainly as the registrar of whatever appearances he encounters. He takes care throughout. The camera, compact or huge (he's made at least one each out of a van and an RV), is the visionary subject within the terms of which whatever available appearances make their

impressions. Hospitable to all manner of leakage from ambient fact, the pinhole esthetic is the archaic mode *par excellence* of "point-and-shoot." The tiny apertures afford scope and sublimity. The views are both sociable and socially alert; they speak plainly, with a vulnerable, rooted grandeur. Occasionally, especially when the surface tones turn sour or decayed, the effect is cenotaphic—having "captured" its perceptual prey, the print stands as commemorative slab. A modern adage has it that "light brings us the news of the universe." That darkness into which the light of the observable world enters may be a fair analogy of anyone's consciousness. Visuality takes it from there.

<div align="right">2005</div>

Ultramodern Park

In 1952 David Park wrote: "I like to paint subjects that I know and care about....in commonly seen attitudes. It is exciting to me to try to get some of the subject's qualities, whether warmth, vitality, harshness, tenderness, solemnness, or gaiety into a picture." Park by then was in his early 40s and had just recently arrived at the generously lathered naturalism on which his fame now rests, but he had been painting the same subject matter since at least the 1930s, and quite possibly back into the early 20s, when he was in his teens. The attendant "qualities" Park enumerates were there all along, too, though never so thoroughly declared as when helped by being, as he would say, "extravagant with paint." Most likely, it was the palpable muting of affect in his four-year dalliance with abstraction in the mid-to-late 40s that finally prompted him to break ranks with his Action-Painting friends. The few surviving examples from that phase show that, even at his most reductive, Park allowed considerable residues of figuration to stay put in his repertory of forms.

Park's naturalism was aided by a prodigious memory for intimacies of pattern, facet and mood. His figures and their settings have been absorbed so thoroughly over time as to appear quintessentially imaginary. New ones appear and are handily absorbed, subject to his overall attentiveness and magnanimity. As he developed in the 1950s, for instance, Park became a first-rate portraitist, though even the features of those within his close circle of family and friends were recollected, as it were, in tranquility. In light of the essential unities of his work, the remark Paul Mills made apropos the 50s pictures, that Park "could digest the forms of a face, a chair, a car without so much as disturbing the flow of conversation and use them in a painting a week or so later," seems limited only by dint of its short-term accounting: the image done at about age 12 of a girl beside a woodland stream finds its full-blown recapitulation thirty years later in a series of standing river bathers; likewise, the violinists and other musicians, and figure groups involved in sports—more or less anonymous folk absorbed in everyday activities—all are constants, touchstones in Park's world view.

Park developed a passion for drawing before the age of ten and was exhibiting his paintings in museum shows at fourteen. Acknowledging his long-cultivated "sketchbook habit," the elder of his two daughters, Natalie Park Schutz, is also quick to suggest that motifs such as the mother-and-child variations of the early 30s, when she and her sister Helen were born, should be seen as "confirmation of something he was conscious of" rather than on-the-spot renderings of things observed. Similarly, Helen Park Bigelow sees in some of the paintings from 1936-41—the years of Park's return to the vicinity of his childhood to teach at the Winsor School in Boston—"a diffuse wash of blue, that film of color" correlative of the glow cast from a skylight above the stairwell in the family home on Marlborough Street. "He bled that color into those 30s paintings," she told me.

It is interesting to consider, too, what afterimages of art might have stayed with Park from his earliest years. According to his friend Richard Diebenkorn, "the influence of paintings on David Park had occurred before he came to the West Coast." Park's paternal aunt Edith Truesdell was a painter with strong modernist leanings who sent Park west at age 17 to study and realize himself as an artist. (His only formal training occurred in Los Angeles at Otis Art Institute, possibly under the Czech-American painter Vaclav Vylacil who was just then fresh from his own studies with Hans Hofmann in Munich.) Puvis de Chavannes' frescos in the Boston Public Library and the Piero *Hercules* in the Gardner Museum would have initiated Park to the sort of large-scale Arcadian vision that is basic to his art. The somewhat mythologized city of saunterers, lounging couples and boating scenes of his mature work could be an updated version of Maurice Prendergast's (the Prendergast of the *Boston Public Gardens Sketchbook*), without parasols, with girls in cotton dresses, the men often stripped to the waist or in bathing shorts. (As Lawrence Campbell wrote of Prendergast, "He made Paradise a city park.")

The mid-30s pictures show Park stepping away from the social commentary of WPA mural projects that had occupied him earlier in that decade and into trying out ways of working associated with the general amplification of high-modern styles perhaps best classified as Ultramodern. In terms of the lissome brightening and broadening of Ultramodern sensibility that, as the filmmaker Nathaniel Dorsky once put it, "let the sunniness of Classicism shine on modern art," the remarks Park made to an interviewer in 1935 are telling: "Contrary to many of my colleagues, I don't think easel painting is doomed. In the long run art is not functional, at least in our society.... I do know that the isolated picture on the wall is as fitting to our day as any medium of artistic expression." For Park and others of similar persuasion (Philip Guston is one who comes to mind), easel painting's chances of survival were augmented by the Renaissance-inspired muralists' lessons in prerequisite scale.

Large, simplified forms are everywhere in Park's vintage 30s experiments. If the series of allegorical panels he made around 1936 for Mills College (now in the collection of San Francisco's De Young Museum) exemplifies a retrenchment in "commonly seen attitudes" cast in supernal spaciousness, *Woman at Table*, a scaled-up portrait of Park's wife Lydia (not so large a woman, but recognizable here by her signature bangs), appears as a kind of hinge painting of this period. It's a cubist reverie, complete with comical redoubling along the sight line of the obligatory "kidney"-shaped silhouette, fortified by the stabilizing bulk and solidity Park had learned in his time as a public muralist and

stonecutter; and it's prophetic, too, of the intensity he would project in the more assured, iconic pictures of the last decade of his life.

The applied Cubism practiced by Americans beginning with Stuart Davis and Alexander Calder was predominantly a design style—softened, full of felicities and cheers, and prone to caricature and parody. Cubist-type design provided a lively surface syntax by which to integrate local experiences otherwise resistant to high-art structure. Paradoxically, the compressed, boxy proscenium into which Park packed his figures off and on, in drawings and paintings starting about 1933 and through most of his Winsor years, helped to bring the specifics of his subject matter into sharper focus and at the same time radically freed up his feeling for color. You can see how, given one type or another of conceptual perspective, his sincerity impinges on the adopted style; sentiment intrudes on form, pragmatically. Such determined waywardness is attractive and one imagines how it kept Park himself guessing until well into his 30s.

Park's relation to Picasso in particular recalls Edwin Denby's comment regarding the pictures Arshile Gorky and Willem deKooning were doing in New York around the same time: "Downtown everyone loved Picasso then, and why not. But what they painted made no sense as an imitation of him." On top of the rudimentary, stylized dissection, there is an insistent, dramatizing specificity. Rhythms bounce off structures; streamlined silhouettes search for mooring in lyric space. Colors, for their part, are emphatic as emanations of what is seen or imagined, more so than the contours, which Park tries dutifully to generalize. Park was a natural particularist: the facial features, a musician's demonic frown or new mother's adoring smile, are giveaways in this respect. Often enough, amid the daring colors, reminiscent of the Sienese trecento—segments from the citrus range next to earth tones and the gentle, pervasive blues—something ecstatic looks ready to burst through. In both *The Violinist* and *Woman at Table*, it very nearly does.

Toward the end of his abstract-expressionist phase, in a statement for a 1949 group show at the San Francisco Museum of Art, Park wrote: "To me a painting is a record of a state of being. An exuberant state of being naturally is reflected in an exuberant painting. It would be fine to be exuberant often and natural always." His personal myth was founded on a capacity for registering quickly what was there around him and connecting it to both the patterns in his experience and larger ones for which only his intuition knew the key. The trajectory between eternity and circumstance, the domestic and idyllic, looks seamless; there is no break in the procession of event, of memory—which is how Park, in his eminently civilized way, must have seen his life and those around him. The world view in his pictures is a markedly enlightened one: clear, direct, sensuous, trusting, measured and somewhat quixotic—brimful of a condition defined by Virgil Thomson as "alive with affection." The pictures, like the commonplace experiences projected in them, are renewable pleasures.

2006

Adelie Landis Bischoff

My first Adelie Landis Bischoff painting showed a pink woman's leg extended, reaching matter-of-factly across fairly luridly conceived, loosely defined, mostly red horizontal space. Around 1988, the picture held pride of place just inside the entrance of Adrienne Fish's 871 Gallery in San Francisco. That single leg with its high-heeled appendage was deeply funny, tantalizing, sharp, more Lombard than Dietrich; the paint was bright, saturated and clear, and the scale was way up, which helped draw openhearted laughter all around. The synecdochical leg turns out not to have been a one-off image: the leg, or a pair of them, unconnected, plays a big part in Landis Bischoff's imagistic repertory. Open to vicissitudes of emotional tenor—from sexual rapture to bodily distress or the stress of war (viz. *The March* and *Men with Guns*, both from the early 1990s)—it's a symbol seemingly at ease in a whirl of infinitely expandable meanings.

Openness is strength. Landis Bischoff's early pictures show her trying out almost everything—whether in the way of abstraction (both geometric and what was then called "open-form") or of expressive figuration—mostly in the intimately nuanced, murky tones prevalent in Bay Area painting during her student days. Of each instance of contemporary style she seems to have known where to find the more vivid aspect. Nowadays she keeps going where impulse takes her, not so much trying as taking up the task as if on assignment, though the assignment comes from her sensibility alone and signals a stepped-up ambition to speak her piece on the world stage. (An on-the-mark series of commentaries on war in the Middle East is her clearest declaration of such urgency so far.)

Landis Bischoff's touch, practiced over years, matches the personal with the professional. Private traits made visible include both tenderness and skepticism; in practice, the professionalism is muted by a healthy looking-askance at how or why the business end of the art world (including the nonsensical business of critical assessment) works—or works so hard, so self-importantly. Technically, Landis Bischoff's touch tends to quiver at the edges and then to dig in, deepening into song. Fidelity to the image that demands unveiling supersedes consistency of manner, although certain preferred markings can be seen to facilitate clarity.

Abstraction often represents just the far side of caricature. A black mark streeling across the ground tone of wintry pallor may end up delineating only itself—a "gesture," so to speak, put forth for feeling—but carrying with it the reminder of other supporting roles: as wisps of hair, perhaps, a storybook imp's contour, the edge of a mourner's robe. For all the looseness of such glyphs, the intensity of the pictures is astonishing; built of concomitant resistance (where handling meets, and becomes, surface), it can fulminate or embrace, by turns. Landis Bischoff's themes are romantic; among the many varieties are fairy-tale scary or *Goyesca* somber, a crepuscular eroticism, poignant shifts in landscape and weather, and, in the face of war, an encompassing sense of light-shocked futility and loss. Her scope, refined and broadened over time, is remarkable.

2006

Seeing with Bechtle

Done over the past 15 or so years, the examples of Robert Bechtle's work in watercolors selected for the present exhibition tend to be, as Bechtle says, "quick, simple, direct and without stylistic anchor." All are outdoor views, accounts of particular landscapes visited and what there was to see. The warm, open light in most of them evokes pleasures of summer travel to places where the sun shines brightly.

Watercolor painting is one of the unacknowledged glories of pictorial art. There are more great drawings than paintings—probably because a drawing can claim an unselfconscious scrappiness thus relieved of all burden of proof (e.g., the heat is off). Watercolors, being "on paper," are an adjunct category. Aside from its early application in fresco painting, watercolor began to take hold in Western art in the 17th century. It's said that Claude Lorrain's dazzling wash renderings of the Roman Campagna heralded the rush. The great European watercolorists that followed were Turner, Constable, Cézanne and eventually, at his least finicky, Paul Klee. The ranking Americans are Winslow Homer, Sargent, Marin and Hopper, and in the later 20th century, Fairfield Porter, Nell Blaine and John Button. Traditionally, as this highly selective roster implies, the medium's major subject has been landscape taken as a mode of seizing sensibility on the wing. Curiously, despite copious works on paper as well as an overriding taste for extreme fluidity in whatever form, the output of Abstract-Expressionism generally eschewed watercolor as such, the main exceptions being Mark Rothko and after him, Helen Frankenthaler. Bechtle himself, who early on aspired to a figuration that adapted the surface excitements of Action Painting to recognizable subject matter, has worked with watercolor both in and out of the more restrained Photorealist style he invented for himself beginning in the mid-1960s. The one close-to-home prospect here—of Lake Merced lightly reflecting the dense greenery of an adjacent sward—was made on an outing with his watercolor students from nearby San Francisco State University, where Bechtle taught for over 30 years.

A model instance of the pragmatist as American Mandarin, Bechtle in his art goes for quiet, unassuming places. But in these he has, as Henry James said of Winslow Homer, "the great merit that he naturally sees everything at one with its envelope of light and air." Now in his mid-70s, he was born in San Francisco and grew up in and around the Bay Area. His painting's usual sightlines are those of the Potrero Hill neighborhood where he lives, a fairly sunny, bustle-free zone of tidy stucco-fronted box houses set upright on their tilted lots, overlooking the feckless urban vortices below. Any intervening human presence in such views is likely to be consistent with the general stillness. Bechtle's may be a "cool simplicity" like that attributed by Roger Fry to Claude but his sense of the immediate environment is imbued with a wariness akin to Vuillard's. There is the much-remarked feeling of something not quite right that violates our comfort at any Bechtle scene—a sort of lurking criminality shared among phenomena, occult as that might be, perhaps. Or the more or less contrary—and more likely— intimation that all function, even that of a street sign or parked car, has been set aside in favor of something "other," the fact that momentarily all things are simply there, a

sudden case of primordial self-possession which only the picture itself will ever fully grasp.

Visually, of course, the stillness in Bechtle's oil paintings is made emphatic by the *a priori* fixity of the photographic images from which they are literally drawn. The recent watercolors, painted directly and without photography, have no such fixity, and the vistas—characteristically nondescript, or, as Bechtle says, "do-able"—tend to be broader. An oil painting for him can take as much as three months, an on-site watercolor rarely more than a couple of hours. (The impression of layers, endemic to watercolor, is, however surreptitiously, part of what happens in Bechtle's elaborate oil-painting process.) Even at their least picturesque, the watercolors are also dramatic and experimental in ways that the paintings are at pains not to admit—mostly due to climate, the bits of weather manifest in skies. Photography doesn't do skies. The sky immediately observed in *Paros (5/30/96)* is loaded with weather concomitantly slumped downward onto wide ridges and flanks of hills beneath; further down, where the land is flat and the day clearer, trees and houses make swift white darts and clusters, suspended in the moment's massive repose.

It is in the nature of watercolor that every dab or flick of the brush makes a kind of limpid silhouette. Without being particularly lapidary, Bechtle's images are true to their individual actualities, including those of the accretions of runny color as such. Light and pigmentation are barely distinguishable—so the light in each picture is not incidental but intrinsic. Occasionally, the grit of heavy, absorbent paper surface itself joins in to modify the visual field, at once solidifying and refractive like the mica in Aegean air. In *Off Shore Rocks, Sakonnet Point Road (7/20/94)*, the grit jibes with the pervasive exhalation of mist to create a staining luminescence that ranks as one of life's fecund mysteries.

Here and elsewhere, you can see Bechtle letting his sensibility relax and begin to enjoy itself. Paradoxically, or maybe not, this leaves the pictures themselves emotionally calmer (they really are "just looking," after all), with no let-up on exactitude in the bargain. Take *Lake Catchacoma, Ontario (7/23/98)*, its precipitous light culminating on the deck of a funny-face skiff pulled up to shore. Nothing in sight is imaginary yet something fantastic insists: aligned with the gusto of tree and rock and gently inflected water's edge, the boat, obviously no stranger to the scene, nevertheless projects an oddly helpless countenance. It seems to shrug, abstractly, for no discernible reason. For Bechtle, such oddity may register as commonplace, or conversely, the result of an art so dedicated that it exists as if only to let you see, without arguing the case, how things are.

2007

Dewey Crumpler's Metamorphoses

Standing in the cramped studio, looking at some of the changes his images go through, Dewey Crumpler told me, "The head has got to see itself in Hell and transform out of there."

Transformation, a.k.a. metamorphosis, is something painting has always been especially good at. A purposefully colored surface manifests, seemingly of its own volition, a palpable cosmogony of forms slipping and sliding between available identities. The space of changes comes with the territory—surface upon surface, fluidity as parent to invention (or back up some steps to find the bare canvas a voluptuous body *pro tem*), countenances as talking pictures of creation. Recent clues to the persistence of the art's virtuosity in this regard have been the big show at the Met of Nicolas Poussin's landscape pictures and the traveling survey of Philip Guston's works on paper. That Poussin emerges as a passionate visualizer of both mutability and catastrophe brings him unexpectedly within range of Crumpler's cause, which takes the latter as a culturally intimate given and the former as both eternal process and dire need. For his part, Guston once traced the physics at hand: "You're painting a shoe; you start painting the sole, and it turns into a moon; you start painting the moon, and it turns into a piece of bread."

In similar terms, Crumpler posits a ceremonial dance-accoutrement-turned-slave-shackle (and surveillance-device, with rattles) or the tulip writ large, an emblem of far-flung Empire, as a shifter. Trace the inside rim of a wristband in its brute iron transposition, you find a face, or faces, residual on your sheet, demanding recognition—as if, when the shackle was pulled off, an interrupted identity stared out.

Things jump. Genes jump from row to row, so the ethnobotanist Barbara McClintock tried telling her colleagues in the early 1950s; later, after receiving the Nobel Prize in 1983, she explained the absence of academic protocol in her maize discoveries: "I just listened to the corn." Even Poussin's non-tempestuous landscapes celebrate the pleasure and terror of tumbled identifications: *The Triumph of Flora*, for instance, shows an *omnium gatherum* of beings—Daphne, Hyacinthus, Crocus, Narcissus and so on—who, as characters in Ovid's poem, have changed into plants. Ovid's premise, inherited from earlier antiquity at its fullest, is that life prompts its constituent elements to exist as aspects of one another, spun from the same fullness. It's in the stars, so to speak—a constellation of the sort Homer was conversant with, and palpable. For Crumpler, the "listening" is attentiveness likewise to multiple shifts in connotation, the energetic guises of what's to see—how the tulip, sporting a pullover, shakes its hips, turns to a drip or exclamation mark; how the collar's mouth puckers in minstrelsy (disgrace) or wails outright (bootless—is Heaven really deaf?) or tangles in a Sargasso Sea (lost in thought) of its own reduplications—and all stops between. (In our conversations, Crumpler alluded to how, in African-American circles, "listening" is now more apt to be *looking* as the cultural center of gravity—and, with it, the action—moves from music to image making, with poetry, one assumes, as constant and mediating a force as ever.)

Painting's advantage lies in the capacity, which Crumpler deploys maximally, of holding contingency in suspension, so that a shape's multiple possibilities are fused visibly into the all-at-once reality of pictorial surface. Just as paint goes across canvas ("making discriminations," as Alex Katz once said), a form's idea of itself turns inside out, returns meanings to the conversation *among* meanings, slips further along the possibility chain in the samplings of shape after momentous shape.

Catastrophe, literally the downturn or denouement, is where the scene changes sharply and energy discloses its disdain for any semblance of *status quo*. The "Hell"

Crumpler speaks of is existential, not limited by circumstances definable as either history or politics, although categorization as such, the deep freeze of syntax and/or logic, may be the infernal agent *par excellence*. (What we hold these things to fly in the face of.) Dante starts in Hell and ends in ineffable light. Crumpler works his way through one achingly particular department, close by that actuality where, as Amiri Baraka wrote, "we remember w/ love those things bathed in soft black light."

The idea may be to lighten existence—its "head," as Crumpler might have it—if only to lift us from humiliation on all sides. So the essence of our urgency may be just shape (or appearance) wrestling with itself. Hence, the home-made tapes (recently issued on a double CD as *The Transformer*) of Thelonious Monk's beautiful turning, over three months of 1957, of the Ned Washington standard "I'm Getting Sentimental Over You" into high drama; hence, as well (to put a ribbon on it), Lorenzo Thomas's sense of an indeterminate, yet piquant and lordly company in his poem "God Sends Love Disguised as Ordinary People":

> *In other words,*
> * we were not brutes for lack of feeling*
> *Nor sorrowful in spiteful isolation*
> *Nor lonely yet*
> *But damaged by avoiding touch*
> *Being only smart enough to trust*
> *That there's some*
> * gifted outcast family*
>
> *Somewhere a troop of djalis*
> *That still performs the music that we need*
> *To reconnect our feet to dirt*
> *To fling our arms like windmills*
> *Spinning in dusted twilight....*

2009

Introducing Nathaniel Dorsky

Ways of getting at the particularity of Nathaniel Dorsky's films seem fairly endless. I've introduced two or three such showings and used words like "classical," "pleasure," "primordial," "civilized," "affection"—all rather unfashionable words, all of which still apply in the newer films we'll see tonight.

What is there to be seen is maybe harder to talk about, maybe because you can't be too sure you've seen it, which is strange, because the films show so much. One term for the way they engage the observable world and then transmit a sense of it to the viewer is *extreme seeing*. Your sensibility finds itself pitched very discreetly—gently, even— at the threshold of recognizing what's there, at (as I think Nick once said to me) "the

beginning and end of language." The slippery part, the uncertainty, is real, but so is the release of being allowed to look without anyone's agenda intruding.

More concretely, you are seeing quite candidly aspects of, for the most part, where we all now are—San Francisco (where Dorsky, originally from New Jersey and then New York, has lived since the early 1970s)—aspects you probably never saw before and, although there they are, just as likely you won't notice them again, and certainly not that way. The technique, the shooting and assembling of the films, is little remarked upon—how Nick goes out for walks and regularly brings his Bolex camera with him, how he points and prods the camera, crawls into unlikely spaces, inspects things, people, weather, streets, sky, plant life, and qualities of light in places like the Arboretum in Golden Gate Park, Chinatown, the Avenues, and other city neighborhoods, most of them within walking distance of his home. (In the new films you get an increased kinetic relay of the physicality involved.)

The films have what Edwin Denby called "a passion for the lost chord," the perfectly plain secret our ever-obstructed view contains, like a node of utmost beauty that once glimpsed bursts high and wide and then, flooding, stays. Nick makes it the job of his otherwise dumb recording devices, the camera and film stock—on through the projector and across the screen—to find, reveal, or simply make this happen, not just nice moments of footage but with a sustained sweep that makes twenty minutes of your life coherent, mysterious, melodious and surprisingly sane.

2009

Dean Smith in Action

Brain waves undermine cliffs of thought.
—Robert Smithson

Imagine *Ode to Joy* in pencil on paper.

Once art was abstract. Antiquity had myth. Now recognition in some respects is readymade, if not stealthily yanking at our coats. Sensation bypassed, forgotten or shunned—we know (are thought to know all about) an image when we see one and have learned to duck when we know too much.

If form and substance are one, the greater the expanse across which either can be discussed.

For lack of any discernible story thread—modernity having paved over whole neighborhoods where tradition enjoyed itself, modern art moved toward revelation, clairvoyance. Annie Wood Besant and C.W. Leadbeater's gospel of "thought forms in action" went into large circulation. Theosophical investigations were the norm in the

California avant-garde of the thirties and forties; the New York equivalent, typically sans spiritualist trimmings, was D'Arcy Wentworth Thompson's *On Growth and Form.*

Analogies to music bred what Kandinsky called "a visual Esperanto"—or haul out the player piano: a convincing yet ineffable argument advanced without sanction of any discernible program—loop and tangle, edges impinging where contours reduplicate, drifting glyphs, wall-size frontal blanks.

The original impetus for abstraction is normally forgotten. Mistaken as a game for connoisseurs and/or some default vehicle for blankness—"the final Asia of the Abstract" Ferlinghetti dubbed it in the early 1950s—Significant Form hung in there with a durable imagery, partly because always available to conjecture. For Roger Fry, the erotics of Indian sandstone sculpture distracted from the deliciousness of its forms. But Besant saw spirit graphs and pendulum vibration figures arriving as "forms clothed in the light of other worlds," while listening to Wagner produced "a marvelous mountain range." Confronted by André Breton's dogma, Mondrian allowed as how his was the authentic surrealism. Speaking at the San Francisco Art Institute in the 1990s, Gary Stephan said, "If you are a painter and when you look at a Jackson Pollock you see spaghetti, you are obligated to go home and paint spaghetti." The Color Field abstractionists spoke of "color feeling"; Jules Olitski thought his essential picture would be the sprayed paint as it hung in air before hitting the canvas. For years, variants of one classic Cedar Bar joke made the rounds: *Rothko pulled down the shade, Reinhardt turned off the lights, as the elevator doors come together, Barnett Newman stands in the aperture, winking.*

"A thought undergoing metamorphosis" is how Dean Smith anticipates the tentative finality his metaphysical forms arrive at. "These will be drawn in line work only without shading or filling in of the constituent areas as in seen in previous thought forms."

Aliases pulsate on the desktop: "Save." "Don't save." "Cancel." Excitations along a magnetic ridge; salient mutabilities; thoughts viral, spongiform or bristling, immune. In an abundance of lines, the sudden juggernaut of towering, glowering mass. A more or less secret thought breathes heavily in the seam between crates.

To render the life of the mind—whoever thought this was anyone's cloud-cuckoo affair? Aspirations hover *en masse*. A culture without singularity versus "solid objects that are obstinately there." Communal, meditative, conversational, evolutionary: "But that's a" "Yes, sphincter."

Here form makes a picture, radiating, neither historicized nor tactical, but necessary.

As these pictures give the eyes small chance to rest, shape shifts thought into icon; this performed succinctly without blurs. The white field, not a void, is plasma. In it Smith sets slices of meaning, open and dancing like on the head of a pin.

<div align="right">2009</div>

Word on the Street
Critics and History

What Becomes a Legend

Tracking the Marvelous: A Life in the New York Art World by John Bernard Myers, Random House, 1984. *A Not-So-Still Life* by Jimmy Ernst, St. Martin's/Marek, 1984.

Both John Myers and Jimmy Ernst have constructed their autobiographies out of backlogs of spirited material about the recent past. After beginning earlier and elsewhere, each settles into a first-hand account of the New York art scene of the 1940s onward. Jimmy Ernst perforce deals as well with the Dada/Surrealist years in Cologne and Paris and the disastrous effects of the Nazi terror immediate to his family and himself. Myers and Ernst are roughly the same age—or were, since Jimmy Ernst died at age 64, soon after his book appeared last spring. Both life stories seem prompted by necessity: Ernst wrote his, one can feel, out of deep personal need, while Myers may have felt that a memoir was expected of him, culturally, by his milieu.

Each book is in some way incomplete. Myers has opted to tell almost exclusively of his life in the art world, with only passing mention of his Buffalo childhood, in the "provincial circumstances" of which he developed a lifelong passion for marionettes as well as a precocious involvement with modern art and literature—but how or why we're not told. He plays down his historical visibility, arguably much higher than that commanded by his art dealings, as publisher and theatrical producer for the poetry annex of the New York School. Ernst's is a family story—haunted and horrifying, with great human interest and a number of unresolved dilemmas, aside from the art-historical, star-studded incidentals. Ernst has the more prodigious memory, but he too leaves out much about a part of his life that would seem to deserve fuller coverage—namely, his own achievements as a painter.

It makes sense that someone with John Myers's credentials should be expected to write a definitive life-and-times account of the period in which he made his mark. As it is, his narrative moves across the still scantily told-of watershed years of New York culture, from the early 40s, when Myers made his entrance straight from the Queen City of the Lakes to become managing editor of *View,* through the ripe 50s (during which the de Nagy gallery; the important little magazine *Semicolon*; gallery editions of first books by O'Hara, Ashbery and Koch; and the Artists Theater all came to fruition under Myers's hand), and on through the 60s, when the directions and manners of the art world eventually turned counter to Myers's own. Even with his peculiar biases, which anyway he's at pains to modulate, Myers seems eminently suited to tell the tale. It is something no single artist, and no critic, collector or pure dilettante could do. But an ex-dealer of the small-scale, high-style, personalized type, with unlimited access and alertness to the larger world outside studio and showroom, could.

Basically an autodidact, Myers is altogether street-wise and a believer in glory above other, more immediate returns. He is cultivated, brave, hyperactive, witty, outrageous, impossible—everything in fact that spells "1940s-50s" in the survivors' collective memory kit. If the book doesn't fulfill the aforementioned expectations, it's more due to unsteadiness of tone than lack of pith. The book has less character than its

author—a not uncommon pothole in the memoir-writing field—and in this instance it looks to be a case of too much circumspection (or what Myers calls "the governessy aspect" of his character) aforethought.

The publication data for *Tracking the Marvelous* lists the book's contents as "Anecdotes, facetiae, satire, etc." Myers himself writes at the outset that this is "an account of what it was like to be an art dealer of little fame but not much fortune, who managed to make a dent in the New York art world. It is also the story of a person who had to invent a self from nobody and then become a plausible somebody without the aid of money, social connections or even a credible education."

Actually, the incidental makings of Myers's "plausible somebody," and those of others he has been privy to, have been, as he confides elsewhere, "boiled down," and so has a great deal of his personal storytelling style. The latter reduction is unfortunate because Myers is an exciting, headlong talker given to flamboyance in a manner interpreted (and parodied) by him out of the lineage of dandified early French modern (he once went to a costume ball as Alfred de Musset). Where precision fails, he makes up the difference in brilliant outlays of gush. There are touches of this manner in the book, but not enough for a unified impact. Instead, we find a parade of tones, arranged more or less according to period: his account of the 40s is starry-eyed, giddy, yet observant; his 50s, inexplicably perfunctory and sober; his 60s, rueful, fatalistic; while, for his sections on the 70s and 80s, he adopts a manner that is by turn elegiac and (apropos of the Rothko case) indignant.

Myers says his "approach to art comes from poetry and history." "Glory" is his long-term measure for success of which "the Marvelous"—his espoused Boileau-ism ranking just short of *le sublime* in esthetic satisfaction—is the interim marker. He recalls beginning to publish *Semicolon* in 1954 with the intention of combining "seriousness with frivolity….. Someone remarked I had a real talent for ephemera. Considering the lugubriousness…. of the accepted literature of the day, I accepted that as a compliment." Obviously the price of promoting glory *per se* is to risk being adjudged conspicuously silly. But Myers's "talent for ephemera" has proven paradigmatic. Whatever grand manner New York art sustains has been bolstered traditionally by the locals calling upon reserves of ephemera just as the towers of self-seriousness start getting top-heavy. John Ashbery's remark that "art is already serious enough; there is no point making it seem even more serious by taking it too seriously" may stand likewise as a primary lesson in the quintessential New York ethos.

Volume I, number 1 of *Semicolon* led off with a collaborative poem by Koch and O'Hara (composed aloud while walking) that went:

> *Sky*
> *woof! woof!*
> *Harp*

As John Myers reminds us, "This stanza was repeated twelve times without variations."

Another feat Myers has managed is the bridging of the "uptown/downtown" gap in New York art life. "For me both spoke the same language—uptown liked millionaires and duchesses; downtown admired Trotsky and Dorothy Day—but the

snobbism was equal." Among principal characters in both neighborhoods—from Jackson Pollock to Tchelitchew, from Cecil Beaton to Jane Freilicher and Larry Rivers—Myers's equalizing Marvelous is true to life, and a relief too. If "the tiny art world of the 1940s existed ahead of the general public and was divorced from it," it is also true that "the 'art world' exists side by side with many groups of creative people. In the 1940s there was a give-and-take between the artists and the intellectuals, the poets and entrepreneurs that seems hardly to exist today" (1961). The latter regretted confluence is shown off extravagantly in the first third of Myers's text by pagefuls of names sporadically occurring, such as these (a sampling from page 29): Barry Ulanov, Charlie Parker, Thelonious Monk, Pearl Bailey, Stuff Smith—a jazz benefit for *View* is in the offing—Charles Henri Ford, Peggy Guggenheim, Esteban Frances, Helena Rubinstein, Mrs. Huddleston Rogers, Charles James, Mrs. Robert Sarnoff "(electronics)," the Princess Zalstem-Zalesky "(Johnson bandages)," Alexander Calder, Marcel Duchamp, Aaron Copland, Monroe Wheeler, Glenway Wescott, Stark Young, Georgia O'Keeffe, Carl Van Vechten, Vern Zorina, Tamara Toumanova, Lionel Abel, Lautréamont, Gypsy Rose Lee....

Myers's best full-length portraits are those of his early friend, the engaging grouch and poetaster Waldemar Hansen; Fairfield Porter; the gazelle-esthete Edelgey Dinshaw; the young Alfred Leslie (at 18 crowned Mr. Bronx for body-building), and Joseph Cornell, who is also seen in Ernst Beadle's photograph pushing back a boulder in Central Park so as to "rescue" a pint-size doll. Robert Goodnough, of those in the de Nagy stable, is "the artist I considered the best." But "the only major painter America has produced is Pollock." Of an art world gone bananas the most telling image Myers conveys is from a report on the Ben Hellers' farewell party for Pollock's *Blue Poles*, sold by them for big bucks to Australia: "The center-piece was....a large cake whose frosting was a replica of *Blue Poles*."

Myers's ruminations on the Rothko case take up the whole last fifth of his book. About the verifiable facts behind the mumbo-jumbo of the case, I, like most people, remain almost completely uninformed. It seems pretty obvious that the litigations failed to affect any of the real qualities of Rothko's paintings, and the rest is strictly family business and/or merchandising. (Merchandising is merchandising whether you're handling liquid valuables or prospective glory.) If John Myers wants to exonerate certain of the principals (Reis, Stamos, Lloyd) and cast doubt on the intentions of others (Kate Rothko especially), that's his privilege. As he says, the case was "tried in the press," and it probably will continue to be, to nobody's satisfaction and the dwindling entertainment of all. The burden of Myers's complaint is that the intricacies of the real world of the art market, including the care and feeding of artists' reputations, was testified to inaccurately and ultimately misjudged by a bevy of incompetents. He makes his case handily enough, and manages to vent some spleen and bear down in writing as not before. His estimate of Rothko as a minor artist is as much baloney as others' testimonies to Rothko's greatness—in its relevance to the case, I mean, which was about expectations of sales and ownership and finally not about Rothko's reputation or the value of his paintings as art. So, in that respect, Myers is right about the case having been misheard. And he's also right in seeing the whole *megillah* as exemplary of a big shift in manners accompanying the

massive influx into the art world of all sorts of creepy, lowdown token-energies, and the demise withal of the genteel profession of art dealing for love and *la gloire*.

By Surrealism neither Myers nor Jimmy Ernst was apt to be dazzled for very long, and their final estimates agree with Edwin Denby's earlier one that "in the presence of New York....the paranoia of Surrealism looked parlor-sized or arch." In that context, André Breton's apparent urge to be acknowledged as a legislator of all conduct, according to a program increasingly of his own unilateral devising, nonplussed even those most likely to have played along. But his authenticity caught everybody's eye. Here is Jimmy Ernst's version of him, based on impressions at age 9:

> *I cannot compare him to any other man in the aura of dignity that was his at all times. Handsome, so erect in stature as to make him appear larger, he was the ideal of what one could imagine as the perfect blending of poet-philosopher royalty. His mien never seemed receptive to inconsequential thought. When he spoke, one listened, not as an act of obeisance but out of deep respect. The proud carriage of his head and profile never suggested a pose. It was that of an elder and sage angel, but nevertheless an angel who now and then would carefully look over his shoulder in apprehension that some dust motes might have settled on his wings.*

In 1920 when Jimmy Ernst was born, Max Ernst was 29 and at the center of Cologne Dada. Lou Straus-Ernst, Max's first wife and Jimmy's mother, was a woman of wide culture, a scholar of medieval art, a critic, and a *collagiste* who exhibited under the name "Armanda Geduldgedalzen." The infant Jimmy (né Hans-Ulrich) was diapered by Paul Klee, indulged by Arp and Tzara, and hailed by his father as *Dadafex minimus, le plus grand Anti-Philosophe du Monde*. Much of *A Not-So-Still Life* is about personal freedom and resilience in the face of an almost inconceivable array of distress. On April 2, 1976, when Max's ashes were deposited in the columbarium, Jimmy, having lived for nearly 40 years in New York and with his eventual identity as a painter intact, was among the eight people invited to witness that finality. Meanwhile, Lou Straus-Ernst had died on an unspecified date after being transported on the next-to-last train from Drancy to Auschwitz, July 30, 1944.

"My mother was a Jew and my father created forbidden pictures.... Get out." Such is Jimmy Ernst's assessment of his birthright as a German citizen in 1937. In retrospect, he says his mother "provided a humanist armor that enabled me to find a world of my own making, the existence of which she had sensed to be on the other side of her mountain....Her murder, finally, was terminal evidence that I never belonged to what I had left behind." Be that as it may, one question Jimmy Ernst asked himself, prompted by seeing Brueghel's *Icarus* in Paris when he was 13, was: "Should a son make use of wings fashioned by his father?" Another, more complicated one arose later: by what arrangement of the spheres did his mother die, and what, if anything more, could have been done to save her from dying as she did?

The first question was partially answered by an epiphany of equal force before *Guernica* when he saw it at the Trocadero in 1937: Picasso's painting unveiled for him, he said, both the "elusive miracle" of the whole activity of art and by implication his natural affinity for his father's imagery in paint. (Even so, it took him another 20 years to shake off the residue of *that* imagery and jump off into his own.) The second question, under-

standably, was never fully resolved and is efficient cause for the particular urgency of the book.

The New York parts of Ernst's story are graced by a keen visual memory and a good sense of how different people talk. We learn of Jimmy's entrance into "the family business" as secretary at the Art of This Century Gallery for the duration of Max's liaison with Peggy Guggenheim; of Mondrian's generosity in transforming one of Breton's catechism sessions into a hymn to the openness of art and of his instructing a puzzled Peggy Guggenheim on the probable virtues of Pollock's burgeoning work; of Jimmy's friendships inside the family circle with Duchamp and Kiesler, and outside it with Baziotes, Paul and Jane Bowles, John LaTouche and Joseph Cornell. (Mention of relations with those of his own generation, and all but the most cursory reference to his home life with wife and children, are strangely missing.) He gives an eloquent account of Philip Guston at work on the mural for the Queensborough Housing Project: "There was an air of melancholia in both the man and the images…. Guston's own face, particularly around the eyes, could have come out of a Romanesque mosaic. He expressed anxiety and impatience with the work in progress. His face could light up in a wide smile, but then only as if the sun knew it was about to lose a battle with the clouds…." And another of Zero Mostel in his capacity as a docent at the Museum of Modern Art circa 1939, cajoling visiting schoolchildren: "This picture is called *Girl Before A Mirror*….ever seen anything like it? Shut up…you're not supposed to watch your sister undressed, you're too young. Your old man shoulda hit you in the head…. Anyway….this is a girl in front of a mirror. But listen, is that a girl or isn't that a girl…. Look at her. Look what she's got…. More than one of everything…."

In art circles, *A Not-So-Still Life* is likely to be approached mainly for its gossip value, which is actually quite slight. It should however be read more assiduously for its content, which is profound and comparable in detail to Nadezhda Mandelstam's two memoirs of similarly sad circumstances and the spiritual stamina of people in them. Ernst isn't gloomy about this or any aspect of his experience. In fact, he remains remarkably levelheaded and fair throughout. *A Not-So-Still Life* is a heartening book.

1984

Critical Manners

The Critical Writings of Adrian Stokes, edited by Lawrence Gowing, Thames and Hudson, 1978.

It was Philip Guston who first suggested reading Adrian Stokes for his apt descriptions of certain painters—necessary ones like Piero della Francesca. Cézanne and Vermeer—and as a guide to the natural habitats of early Renaissance in Italy. Guston probably felt at home with Stokes's "Quattro Cento" conception of turned-out placement, a crystallizing "in terms of position of objects related by space." And Stokes's view of Piero stands "brotherly" to Guston's detecting (in *The Flagellation*) "the presence of a necessary and

generous law." Stokes says, "Piero reveals the family of things. His art does not suggest a leaning from the house of the mind. He shows, on the contrary, the mind be-calmed, exemplified in the guise of the separateness of ordered outer things; he shows man's life as the outward stale to which all activity aspires." It is Stokes's way to be companionable while looking at or remembering art; his close concentration enfolds a stately awareness of how all the incidentals matter: "Indeed, the ideal way to experience painting in Italy is first to examine olive terraces and their farms, then fine streets of the plain houses, before entering a gallery. As for as the streets are concerned a similar procedure can be recommended for Holland in preparation for Rembrandt and Vermeer."

Stokes considered himself an esthete. His style is less plush and really not so self-conscious as the word suggests. His rage for theory makes him more like an esthetician in practice. He was not a professional explainer. His scholarly researches (on Mediterranean limestone, color phenomena, and the lives and works of Michelangelo, Turner, Giorgione and Cézanne) were at the service of a bigger contemplation. "Art invites recognition of more than it ostensibly shows." I read him primarily as a writer with a great practical grace. His style is personal and sincere, nervous, sudden, rarely ironic but sometimes, seemingly ahead of his intentions, absurd. He loves the subject matter and knows why. "In adult life," he says, "my models have been things rather than persons." From his childhood he recalls tantrums, yelling "I want it put right." About his later, more dense analytical writings he would say, "I have sought the clean sweep. I have had an absurd faith in the efficacy of generalization and, at times, a neurotic subservience to the behest of an apparent logic." But where logic may sail past you in a blur, his observations (no less wild) stick: "Another image comes to us in terms of the heads of hair of walnut and stained oak." He's discussing Cézanne's *Bathers* in the National Gallery, London. "It speaks to us of the strength of the trees in those women and of the tawny arena on which the bodies lie and, by contrast, it includes the circumambient blue, the knife-blue day that these nudes have crowded to inhabit. They feed on the blue, on the distance at which the seal-women exclaims. The close, clumsy, yet heroic flesh sips the sky. These nudes are blue-consuming objects and blue is the only color almost entirely absent from all varieties of nourishment.... The sky too is faceted, spread thick like butter."

Stokes was English; he was born in 1902 "in Radnor Place, Bayswater" and wrote roughly between the years 1925-1972. He first visited Italy (Venice) in 1921 and returned there to live apparently whenever he could. In 1926 in Rapallo he met Ezra Pound; they became tennis partners (Stokes was an expert tennis player) and discovered a mutual passion for the Tempio Malatestiano at Rimini. Through Pound, Stokes's essays on the Tempio and the "Quattro Cento" theme were first serialized in *The Criterion* (T.S. Eliot, ed.), then issued as books by Faber and Faber in the early 30s. Meanwhile, Stokes returned to England and entered a long-term psychoanalysis with Melanie Klein, which partly resulted in his becoming a psychoanalytic theorist in his own right.

During the 30s he wrote art and ballet reviews and began to paint. It is difficult to find examples, even in reproduction, of his paintings—there seems to have been no catalogue, for instance, of the 1972 memorial exhibition at the Tate—but his personal note on them suggests something in the vein of Morandi. "It would be ridiculous of me to pretend that my fuzzy paintings of bottles, olive trees and nudes, dim as blotting

paper, project an armature of the architectural effects that mean everything to me....But I have to confess that my interest as a painter...is in an interpretation of volume that is without menace in slow and flattened progression as of the lowest relief...a status of mutual recognition, as it were, between objects and their spaces wherein there is nothing monumental, no rigidity, no flourish, no acuteness, no pointedness, no drama. What's left? It seems a fluidity, but this too I find anathema, I mean for me. I fully admire all these qualities, but in the act of painting I don't aspire to them."

His local artists were Henry Moore, Barbara Hepworth, Ben Nicholson, Matthew Smith and William Coldstream. His essays include excellent brief appreciations of de Chirico, Giacometti, Mondrian, David Smith, Pollock, Bonnard, Picasso, and, more ambivalently, of Matisse. (His short review of a Picasso/Matisse drawing show in 1933 is a gem.)

Gowing's introduction to the present edition says "the three volumes make available Adrian Stokes's major critical work on the fine arts." Collected thus, they form an architecture that is in every way monumental. Stokes's guiding image came from architecture, "the inescapable mother of the arts." His real innovation as a critic was to look harder at the overall surfaces of art works, including the materials they're made of, to see ("image in form," as he put it) the deepest meanings there and not elsewhere. The ballet criticism, which is formidable, Gowing says "lies outside the limits." But classical ballet, "largely judging from experience of Russian ballet in London," served Stokes early on "in the perfect outwardness of its stylized forms." Classical ballet, like his "Quattro Cento," is no one-shot expression, and never (as in "some German forms") "too particular and too intense." It is outward and a thing, and that, reasonably enough, is the first principle of Stokes's esthetic.

Is art a form of nourishment? Stokes proposes that it is, psychologically speaking. Later on he finds that this is true of even art that is less than ideal—as Piero and the Tempio are ideal and Monet and Turner aren't. Only one's attitude about the proposition matters. Carter Ratcliff has pointed out that Robert Smithson may have been negatively disposed towards "humanist solace" but the plotting of *The Spiral Jetty* was remedial in terms of human scope. Stokes sees Renaissance, its scope—with "Quattro Cento" as its prime embodiment—as literally, even autobiographically, "sense of rebirth," ongoing and generative against a circumstantial sense of loss. "Quattro Cento" is not Renaissance in the blaring programmatic fact but an "emblem" spread previous and beyond the humanist formula. Technically, "an introjection of the carver's fancy into the modeler's aims, owing to love of stone"—or in Piero's case, love of perspective. Every which way, Stokes is fascinated by dualities; it's quite a parade of mirror images—carving/modeling, color/tone, self-sufficient/enveloping, smooth/rough, etc.—that all end up getting resolved as complementaries of one another. His idealism wants the right one to come out ahead; his sense of fair play is conciliatory. "Giorgione, Piero, Vermeer, Chardin, Brueghel and Cézanne"—and no one, I think, with the possible exception of Roberto Longhi, has pointed to such an exact and mysterious "tradition" of thing-oriented masters—"are the painters who really interest us the most." Later Picasso, Georges de La Tour, and Seurat would complete that list. But he admires Michelangelo, Rembrandt, Monet and Turner for other reasons entirely.

Colour and Form (1937), Venice (1945) and *Art and Science* (1949) are triumphs early-and-middle among the essays. In *Color and Form* he sees how (in Piero again) "things have their own light; they seem less lit from the sky." In *Venice*, he is wonderfully pertinent:

> *Giorgione had no axe to grind: but he was foremost of originators in art. He broke down all systems of insulation. There has never been an art less mannered, at the same time less formalized. Accent was superfluous. The* Tempesta *is dramatic in the want of tension, it is lyrical, supremely by this lack of tension, by what the Italians call* ozio *or ease. Tension of some sort has otherwise always existed in art: and art will need it again immediately. For all other times an art without some tightness in organization, or even some looseness as the tightening bond, has not been art at all. Since Giorgione's time Western art is often skirting an abyss.*

Nourishment against circumstance is a matter of gradations in the later writings. They are heavier going. I get a queasy feeling reading of a Vermeer interior, for example, taken as model for "adult integration of the ego" Not that it might not incidentally be true. "We ourselves don't work as valued art," Stokes says; but "valued art" does tell us cohesion and grown-up love are practicable, and about this Stokes is ever sincere. His use of specialty-terms from psychoanalysis is brave—it disrupts his style but it's supposed to exemplify a desired cultural integration—and it doesn't work, partly because the terms— "good breast," "bad breast," "paranoid-schizoid," etc.—are clinkers, neither "rooted" nor desperate enough; and one feels a greater, more imaginative physics is missing. Be that as it may, Stokes kept his imagination of the image-making process amazingly surefooted and tireless Of Cézanne, for instance: "He transmuted his strength, pushed it further away from himself than has any living artist, into a living-dead thing, into a Cézanne-become-landscape.... His was the most direct homage ever paid to the infinite coherence of the visual world."

Stokes's "homage" is beautiful and coherent too. I like the sense of him, that, together with writing these essays, and painting, and leading an alert domestic life, he began at age 65 to write poems. Those were collected in a little Penguin Modern Poets edition (#23, long out of print). They are contemplative, serious and direct, with interesting opacities of phrase. Here is "Private View":

> *These faces known*
> *Some spoken into*
> *Over forty years.*
>
> *Thereby ageing them a little more*
> *Paintings look back*
> *Add customary weight*
> *Of new experience*
>
> *The clear-cut artist*
> *Or is he here?—it makes no difference—*
> *Speaks more candidly*

Than we have done to one another
Whose voice will not cease to grope
Or flourish an impertinence
We ourselves don't work as valued art.
So each year gaps occur upon the wall of fame
Thefts calmly viewed as if by sharp custodians.

1981

Dutch Details

Artists and Artisans in Delft by John Michael Montias, Princeton University Press. 1982.

"The intense archival work I have done....yielded generally reliable and detailed information about small and disparate fragments of a total reality.... Many of these facts are adduced here for the sake of completeness or because they just seemed interesting to me." John Michael Montias's *Artists and Artisans in Delft* elucidates a special history. It's a documentary version from a social-science perspective of the goings-on in the official artistic life of a medium-size Dutch town. Of course, it's also the very town where Vermeer, the one great artist who was actually born in Delft and who unlike most did not leave for brighter prospects elsewhere, painted his "deeds of light," the same place that could boast briefly "a veritable Pleiades of artists" in addition to Vermeer—Carel Fabritius, Pieter de Hooch, Emanuel de Witte, Leonart Bramer, Daniel Vosmaer, and other glimmers less known to the general watcher of Dutch skies. But Montias doesn't limit his study to the stars of the Delft painting scene as such; what he describes is the economic fabric of the local arts-and crafts community as a whole, how it was put together and how it prospered and failed.

"It was not long after I had begun my project that I realized Delft was of an ideal size and importance for a comprehensive survey. With its populations of twenty-five to thirty thousand inhabitants in the middle of the seventeenth century, Delft was large enough to host a significant school of painting....it had a thriving faience industry with hundreds of apprentices and journeymen whose economic status could be statistically compared to that of the masters of the guild; yet it was not so large that its archival materials could not be exploited within a reasonable period of time in a period of five years of intermittent research. I was able to go through most of the notarial archives at least once (about half of them twice) and to scan the estate papers left by the overwhelming majority of burghers." A standard thoroughness perhaps but one can't help wondering at Montias's affinity for such work. He is a professor of economics and head of the Institution for Social and Policy Studies at Yale. His main academic work is in comparative systems. (He lectured last December before the American Historical

Society in San Francisco on "current East European indebtedness.") A footnote by him in the present book values "a less uptight, antipuritancial approach to economics" that should probably extend to social studies generally including the study of art. Montias subtitles his book, "A Socio-Economic Study of the Seventeenth Century." The manner of his delivery is unique, so far as I know, and should impress anyone in or out of the academic community.

In his dedicatory note, Montias avows a personal "interest in art"; and the later disclaimer of being "only an eavesdropper on the profession" of art history appears unduly modest in view of his obvious familiarity with actual works, including the unusual examples he has chosen to reproduce. Another clue to the extent of his involvement is his style, which is penetrating and decorous. For all the circumspection and benchwork statistics, Montias's interest must run deep. Most of the information he gives is new, and so are his conjectures.

"All those earning their living with the art of paints, be it with fine brushes or otherwise, in oil or watercolors; glassmakers; glass sellers; dish bakers; tapestry makers; embroiders; engravers; sculptors working in wood, stone or other substance; scabbard makers; art printers; booksellers; sellers of prints and paintings, of whatever kind they may be...."—these together constituted the professionals belonging to and/or regulated by the Guild of St. Luke under the ordinance of 1611. (Within the next 90 years, tapestry makers would be excluded, the scabbard makers phased out, and bookprinters and faience sellers would be added to the master lists.) The Delft guild in the 1600s was a survivor; for its compact membership (ninety-four members in 1613), the rules could be enforced with some degree of consistency. (Delft *in toto* was relatively underpopulated; as Montias points out, the 1622 headcount of 22,769 made it the fourth largest in Holland after Amsterdam, Leyden and Haarlem.) Business-as-usual for the membership meant making finely crafted items for décor and household use, and with them, "working the market."

Trading was brisk in a "competitive, diversified" market. The Protestant "alteration"—and its literal iconoclasms—had put an end to Church commissions, and Delft artists never found any steadily consoling high-class public or private patronage. Instead, there were sporadic contracts and commissions, private clients for sales from stock, regular art dealers and secondhand dealers (Vermeer's father was one of the former, his paternal grandmother one of the latter), weekly auctions, fairs, lotteries (in which a single artist could raffle off "a few pieces of painting"), all sorts of barter as well as bets. Montias is provocative on the subject of paintings' liquidity: of transactions "in paintings and other works of art that involved no middlemen of any kind," he says, "one conclusion that...can be drawn from the frequent references to these...is that paintings were relatively liquid valuables at the time, perhaps because standards of quality were fairly uniform among large groups of people, at least among people of the same social class.... The illiquidity of works of art in today's world is a reflection of the wide disparity of tastes even among individuals in a given income group, and of the difficulty of locating the rare customer willing to pay the highest price."

What standards of quality obtained? "This lively market....operated with a minimum of collateral information: exhibits were in their infancy; there was virtually no

literature to guide customers' tastes—no catalogues or books about artists, no advertising, nothing that would have helped, objectively or otherwise, to establish or puff up an artist's reputation. In the early years of the 17th century most paintings were judged by their visual impression alone, much like silverware or furniture. Later, the names of artists began to matter more: attributions….appeared with increasing frequency in inventories. By the mid-century point, artists' signatures were accepted by a wide circle of consumers as a signal of quality."

Similarly, assuming some "quality" that leads us to want to know more, it is only from "visual impressions" that anyone now can begin to guess what the various Delft artist-painters' own standards and procedures were, or what, maybe more specifically, they had in mind. (Which is not to say that "integrating ideas" like Svetlana Alpers' notions of a "visual culture" pervading Holland at the time, and studies like Montias's of the basic layout of art networks aren't enormously useful.) In any case, the scatter of Delft art works obviates all hope of a full-range, site-specific study; Montias estimates that of "as many as forty to fifty thousand paintings in the city's four-thousand-odd houses" circa 1650 (a large percentage of them by local artists), it's doubtful whether a hundred remain in Delft today.

Altogether, 116 artist-painters were registered in the guild between 1613 and 1680. Most of them came and went, including the likes of Geeart Houckgeest, Willem van Aeist, and Paulus Potter. Most were by turn in the money and then out of it. (A general "rise in apparent wealth until mid-career and the decline thereafter" is noted.) Contrary to stereotype, most "either were from families who could afford the relatively high cost of the six-year training or were themselves the sons of painters." And another contrary finding, reasonably argued: "The great majority of the paintings that hung on the walls of Delft citizens were copies and other 'work by the dozen.'…. Most of the [high-style] paintings that were once in Delft and hang in museums today….were owned by rentiers, merchants, professionals, and perhaps a few of the more successful craft masters." The market changed significantly in the 1650s "when Vermeer in Delft and Frans van Mieris in Leyden, following the earlier lead of Gerard Dou, developed a clientele for minutely painted, highly expensive pictures." The scene as a whole, however, with the exception of the very-booming Delftware industry, had already diminished: "The artists' colony in Delft began its numerical decline even before the school of original painting for which the town is best known…reached its maturity…. When Vermeer became headman of the guild in 1662, he had little left to preside over."

Artists and Artisans abounds in paradoxes like this one. Montias's weave of data is tight; few of the facts are stray, and most, if excerpted away from their counterparts, would make for distortion. Montias is more readily sampled in his conjectural mood, for instance, when he guesses "that early training in painting 'histories' allowed painters to switch fairly easily from one type of painting to another, whereas painters who began their career by specializing in more mundane subjects were tethered to their specialty." Or when he raises necessary questions: "How did Vermeer…acquire the expertise necessary to testify on the authenticity of Italian paintings, as he did when he was called to The Hague….?" And likewise, if the art of drawing was "the common denominator of all these fine crafts….what are we to make of the fact that so few drawings of the best-

known Delft masters….have survived?" These are matters on which the notarial archives offer only blanks.

I wanted to read this book in order to know more about Vermeer, even though no documentation uncovered so far about his life seems in any way pertinent to the scope and accomplishment of his work. Anyone struck by the electrifying sublimities of Vermeer's best paintings is inevitably drawn to the apparently irrelevant but ultimately consuming background facts, which now appear to be suddenly proliferating. Montias gives many fresh details about Vermeer and his connections both in his book and in two important articles in the Dutch magazine *Oud Holland.* (The articles, in fact, are devoted exclusively to archival mentions of the artist.) Interestingly, Montias seems to have started with just a general curiosity about seventeenth-century Dutch artists and the guild system—and to have zeroed in from there.

<div align="right">1984</div>

What People Do All Day: A Memoir of New York Styles 1959-65

I begin with a digression. In the beginning was the brushstroke—well, not the beginning but where I began to know the story of art, along with the sense that the fact of put-on paint meant something, signaled a purpose, and made an analogy with other parts of the world. DeKooning's "paint in front of the picture" (seeing the "how" of the paint as equivalent to the "what" was painted) spoke of purpose *and* abandon, character (the openhanded gesture) *and* impersonal grandeur.

Followers of deKooning had this confidence in the analogy—that nature (sensibility) could meet the traces of nature (sense objects) fairly directly in the paint. Stroke equals sensation, whether in Mitchell, Mondrian, Cézanne or Monet.

The materiality of paint—the dumb, sticky gravitational fact of it—could be signaled in other ways—maybe even more definitively by *not* stroking, but by spilling (as in Pollock) or heaping on (as in Joan Brown). This was part of the general hypermaterialization of art that gathered momentum in the 50s and 60s, from Abstract-Expressionism through to post-minimalism's arrays of matter until the fabled "dematerialization" of conceptual art set in circa 1970.

"Hyper" was kin to Action Painting, a critical strategem devised by Harold Rosenberg as a trick to add intelligibility to Abstract-Expressionism's otherwise open-ended surface attractions. In the popular view, "Action" was identified with the look of spontaneous creation—either the deKooningesque loaded-brush attack on more or less conventionally sized canvasses or Pollock's performative engagement with spilled paint on mural-sized surfaces laid out on the floor—or both. In Rosenberg's original definition—seldom invoked by later historians—Action Painting promised a backdoor version of Albertian *istoria*—the depiction of ageless, noble characters and events, which was the art's best hope of big-time cultural respectability brought back home, as it were, through the service entrance. True, the hypostatizing means of delivery was the

relentlessly purposeful artisanal mark—"good strokes," as deKooning liked to say, or what Rosenberg neatly called "changing a surface with paint." In the "dialectical tension" between paint-as-paint and whatever image emerged, the once-sanctioned semblances of mythic figures gesticulating before eternity found their true 20th-century analog. Such improvisational acting-out of events on canvas was a virtual History Painting. According to Rosenberg, the fictive surface formed of accumulated marks achieved probity as "an extension of the artist's total effort to make over [her] experience." Pointedly—in the scandalously nationalistic mood of the time (though no one here appeared one bit scandalized)—the full title of Rosenberg's essay was "The American Action Painters," even though "Action" as an art term was an import from those vectors of literally war-torn European and Asian practice that had left the old-time cares of fine-art production to the furniture dealers.

Meanwhile, the clichés of painterly paint—spontaneity, accident, uniqueness, automatic authenticity—required....Rauschenberg. What is a cliché but a truth whose intentions are lost, or overly codified; you can't, as Al Held would say of deKooning's pictorial idiom, write your own sentences with it. In this sense Pollock as both idea and fact, or where the idea was separated from the fact, the idea of the process from the fact of the pictures, was an un-generative cliché. Rauschenberg was fabulously anti-cliché, *and* generative. In 1956, Rauschenberg made two works—*Factum I* and *Factum II*—side by side: same colors, same details, nearly same drips. In 1960 (somewhat redundantly, it seems to me), he made *Summer Rental I-IV*, same difference. This is how Rauschenberg described it:

> *A friend of mine had tried to rent a place for the summer. He saw the desirability, the equal desirability, of all these places that were extremely different—yet the same for his purposes. There are four Summer Rentals. I painted them all at the same time. They are all made up of the same ingredients, say, approximately one brush load of yellow is used in all of them. I couldn't use anything, any material. I couldn't get four quantities of. I was interested to see what difference it would make.*

> *When you finish a picture and someone likes it, they say it just couldn't be any different, or that it's just perfect, or that's the way a real artist sees it. I think that's a lot of bull, because it could, obviously it could be some other way. I mean that, for instance, a few minutes after it starts drying it's already some other way, it doesn't look the same, I thought four pictures would be a fair minimum.*

> *It was an incentive. I consider that, to answer that other question. I consider that a subject. I had to figure out a way to stop and that's the only difference in the pictures. I added the one more color to each one progressively.*

Rauschenberg isn't joking but he is being ironic; to an ironist, as Auden remarked, "the limitations of a situation loom larger than the situation itself." A couple of years later, speaking of *Ace*, Rauschenberg amplified along similar lines:

> *When an object you're using does not stand out but yields its presence to what you're doing, it collaborates, so to speak—it implies a kind of harmony.... I don't like the idea that [the work so unified] is none of its components. I would like my pictures to be able to be taken apart as*

easily as they're put together—so you can recognize the object when you're looking at it. Oil painting really does look like oil paint even in the most photographic painting.

In that sense, the paint is, as Duchamp was first to assert, a kind of found object, the painting an assisted readymade.

In Rauschenberg, and even more in Jasper Johns, paint and paint handling are two elements among others, and style is taken as a portable given, a thing: "Take an object, do something to it, do something else...."

But to assert the materiality of a thing as "one thing and not another"—to begin with that—the situation had to be leaner, or as Frank Stella put it, "lean enough"—the point of contact was getting the paint to be (Stella said) "as good as it was in the can." Stella was 32 years younger than deKooning, 10 years younger than Johns; he belonged to the first generation of artists for whom abstract art was the norm.

And for Andy Warhol, crossing over from commercial illustration to fine art, the loaded, dripping brushstroke—what Clement Greenberg referred as to Ab-Ex "loosening up of the painted surface"—was like a calling card that said "Art." Andy wanted Art, to be taken as a serious artist. The syllogism is quite astounding: Serious art looks like brushy paint with drippings—that's why it took him two years to let go of it (and even so, he returned to it now and then).

So: it was the fateful idea of the thing, the representation of this endearing object, the brushstroke *as image*, that Roy Lichtenstein sealed in 1965—just the right year; because that's where this lecture's story ends.

By then, irony and other necessary correctives had done their work. The brushstroke got chastened somewhat. Faith is shaken. But, among possibilities in art, nothing, once it is in play, can be pronounced dead.

End of digression.

> *The revolution is accomplished*
> *noble has been changed*
> > *to no bull*
> —William Carlos Williams

Nothing dies. Be that as it may, the late 50s and early 60s harbored what may have been art's last fling at being genuinely silly and beautiful and pertinent, all in the same fond leap. The early 60s were an extended initiation for me into the facts and mysteries of hometown New York art. To begin with, painting, which I first met in the spring of 1959 in the form of deKooning's landscape abstractions at the Janis Gallery. I was 19. Before that, art had meant the Egyptians and the armor display at the Met (down the street from where I grew up), and color slides of Raphael and of Gorky and Mondrian in college. Little more than a year later, a college dropout, confirmed in my resolve to write poetry, I was working as a kind of glorified copy boy at *ARTnews*, the long-gone version of that magazine which, with Tom Hess as editor, was the venue for criticism that one way or

another celebrated the New York School—and much of that criticism was written by poets, so in a sense I'd come home.

When poetry meets painting, one begins to wonder about art. The signal gesture then was deKooning's expansiveness and speed, which suggested spatially the kind of surface excitement poetry was getting at, as well. The continuance of the New York School in those years was fast and furious. What Frank O'Hara referred to as "a splendid state of confusion" was partly due to the residue of so much heroism in the air, though it was also becoming millions-in-business-as-usual. The city where artists had gathered found itself the center of a general cosmopolitan alert that lasted about ten years. Recalling the beginnings of that alert in the 1950s, the composer Morton Feldman wrote: "What was great about the 50s is that for one brief moment—maybe, say, six weeks—nobody understood art. That's why it happened. Because for a short while these people were left alone. Six weeks is all it takes to get started. But there's no place now where you can hide out for six weeks in this town."

Feldman was writing from the vantage point of 1968, by which time, thanks mostly to the emergence of Pop art, the art scene had changed from a tiny "downtown" enclave of maybe 300 artists, poets, dancers, musicians and others to a multi-tiered Art World (aligned somewhat on the Parisian model) with High Fashion and Café Society: Style was Meaning enough, and no one was interested in being left alone. 1959 had also been the year of Frank Stella's black stripe paintings, of Harold Rosenberg's book *The Tradition of the New* (which contained "The American Action Painters," written in 1952); of the book version of Robert Frank's series of photographs, *The Americans*; of the Stable Gallery's "School of New York" show that featured Rauschenberg's assemblage "Monogram"; of the first serious study, by Robert Lebel, of Marcel Duchamp; of John Cage's "Lecture on Nothing" and "Indeterminacy," as well as of Rauschenberg's statement for Dorothy Miller's great MoMA show *Sixteen Americans*: "Painting relates to both art and life. Both are impure situations. Neither can be made. I try to act in that gap between the two."

In the early 60s almost all the artists I knew were at least ten years older than me. (Except for Frank Stella and Ed Ruscha, artists of my own generation—roughly anyone born between 1935 and the end of World War II—waited until the mid- or late 60s to appear.) Mature artists, whether born in the 1920s or before, had the 30s in common, which meant for the oldest among them a soured politics, and for the others, some basic, often fearful, residue of the Depression years. It was a history I had no grasp of. For them, it was a reference point from the perspective of 30 years later, just like looking back on the 60s is now for me.

The 50s art scene and the rest of the world existed in markedly different time zones. In the larger world, abstract painting as such—and most of modern art with it—was still a hoax or commie plot. In September 1959, the *New York Times* critic John Canaday attacked Abstract-Expressionism as a style foist on the general public by a cartel of critics, museums and charlatan artists. He continued to attack Ab-Ex well into the early 60s: Ab-Ex's supporters fought back, signed petitions, and eventually got Canaday fired. That was 1962, the year Ab-Ex supposed died, put out of its misery by Pop art. A history like that is all very pointless. As a style, Ab-Ex had arrived by 1950 (deKooning,

Pollack, Rothko, and others—by the mid-40s); in 1958, it was exported as an accomplished historical fact in the New American Painting exhibition touring Europe and Japan. (For all its individualism, Ab-Ex remains the hardest style to pinpoint since the full range of the Baroque. As Arthur Danto said recently, "Each of [the Ab-Ex artists] exemplifies the essence of Ab-Ex, but always in the artist's own particular way, so much so that had deKooning (for example) not existed, it would be impossible to imagine his paintings on the basis of the work of his peers." (whereas the same might not be true for, say, Pissarro or Mary Cassatt.

By 1951, Pollock, deKooning, Rothko and others had achieved old-master status in the downtown New York scene, newly populated as it was by a larger contingent of dazzlingly talented emerging artists—the second-generation New York School, so-called, which included people like Frankenthaler, Mitchell, Rauschenberg, and Larry Rivers. For the younger artists, there was a sense of making discoveries right alongside, rather than after, the older ones like deKooning and Pollock. There was what Franz Kline called "the Dream"—transmitted across generations as a matter of conviction. There was also the broader generational mix: Picasso, after all, never irrelevant, was still astonishing, going strong, though seemingly farther and farther away. By contrast, Duchamp was a neighbor; by 1959, the year Johns and Rauschenberg met him, he had been living in New York for 20 years and could be seen pursing his lips, attentive at Happenings.

Hans Hofmann, eldest of the first-generation, closed his school in 1958. Together with his own sort of overreaching stylelessness and utter belief in the mission of modern painting, his open curriculum made it so that his students pursued vastly different modes, few of them abstract: Mitchell, Freilicher, Kaprow, Segal, Rivers.... Abstract art takes a particular turn of mind. Figurative artists took off from Ab-Ex with the ambition to make a representational painting that had the surface energy that abstract art had. Frankenthaler was one of the very few touched by Hofmann's teachings who stayed with outright abstraction. Frankenthaler didn't actually take classes with him as Joan Mitchell did. To Mitchell and Frankenthaler in fact fell the task of authentically adding something vital to Ab-Ex with what might be called a second-generation sensibility.

"Modernism" was not then a term in common usage among the artists I knew; that came later, as a reaction generated mainly by social historians and critics. Circa 1960, modern art still had an adventurous ring to it. The general conception of the "modern" since the Renaissance is one of artists making new kinds of art—of progressive styles, isms, of novelty as such, or questionings of convention; of the revolutionary artist. A new artist invents a new art, or advances an old one. This is very peculiar to European-centered art (the West), because other cultures have had absolutely no such conception. Chinese art for centuries rested on a stable set of conventions; the new artist arrived at his uniqueness by copying ancient models. Since about 1400, novelty *is* the Western convention: the Tradition of the New, or as it turned out, the Inertia of the New.

If you believe in a linear progression in time (history), you say X's work went further forward, is or was "avant-garde" (or "ahead of its time"). Or a more traditional artist *continues* the development of a form. If you see history (and art) as a field where

people wander or explore, you simply say X went elsewhere—somewhere previously unexplored—or else re-occupied a position that had been forgotten or ignored.

An artist's entrance or intervention—Picasso is a good example—can appear *both* avant-garde and reactionary: to 50s eyes—for those who had pledged themselves definitively to the abstract-expressionist ethos—Stella and Warhol appeared that way. The 60s had an almost incredible case of avant-garde-itis—a new "ism" every 6 months, "a sort of Darwinism on amphetamine," as Peter Schjeldahl has said. New attitudes of hip and cool pronounced a new type of culture hero (called "Larry" or "Andy")—and "the artist as a man of the world." A tolerance for "blank gorgeous art" was implicit amid the flickers of the new prosperity pictures.

In recalling my own process of understanding art in the early 60s, a few moments stand out, and one night in particular, in 1961, the opening of the "Assemblage" show at the Museum of Modern Art. Threading my way through galleries full of Cornells, Duchamps, Conners, I came to this—*Canyon*. Some moments alone, then a voice to my right: "Pretty good, huh?" "I was just thinking so, myself." "And it's *no joke*, either." I never thought it was. But "neo-Dada" and "anti-art" were the terms by which Rauschenberg, Johns, Niki de Saint-Phalle and others were still being explained. Afterwards in the King Cole Bar, Jasper Johns said that, as far as he was concerned, Duchamp was as "important as Picasso." We had seen Duchamp outside MoMA, hailing a cab as we were going in. I went home with a changed century in mind.

In November 1962 the Sidney Janis Gallery in New York mounted an exhibition of European & American artists, most of whose works dealt in one way or another with common objects and media imagery. The show was called "The New Realists." It had a catalog introduction by John Ashbery. The same month, Andy Warhol's first New York show—of paintings of Campbell's soup cans—opened, and a group of Ab-Ex artists (Guston, Rothko and others) left Janis in protest of the New Realist show. The New Realists included Warhol, Wesselman, Oldenburg, Segal, Jim Dine, Rosenquist, Lichtenstein, and the French artists Arman, Yves Klein, Daniel Spoerri and Martial Raysse.

When one says "Realism" what's usually understood is an image resembling or representing an aspect of the observable world—*and* something that people in that world, given a shared culture, can recognize as such. "The paint moves across the canvas making discriminations." Realist painting is a matter of including aspects of the observable world among those discriminations. Obviously, realism has to account for what is real. A "new" realism constitutes a restyling of pictorial codes of recognition in terms of changes in cultural appearances. (Warhol responded to the look of the culture he was in, rather than reacting—as Rothko and Newman had done—*away* from it, in fact refusing to look for the horror they saw there. In 1964, Roy Lichtenstein said: "Commercial art is not our art, it is our subject matter and in that sense it is nature." He saw the necessity of art's entering into what he called "competition with the visual objects of modern life." (e.g., billboards, cinemascope, freeways, and television, not to mention rock 'n' roll).

Alex Katz says, "Wayne Thiebaud paints social symbols." The story goes that early on Thiebaud was mistaken for a Pop artist, but that was mere coincidence. Pop was

a catchy term as misnomers go; but New Realism, a name that came to New York from France and lasted about a month, was better. Had it persisted, New Realism would have accounted more penetratingly for Jim Dine and Red Grooms as well as for Warhol and Rosenquist; it could have encompassed Oldenburg and Segal (the only "realist" sculptors—the first sculptors to make portraits of things), and it would have let Jasper ("I am not a Pop artist!") Johns out of the bag sooner and thrown sooner into question the relation of Roy Lichtenstein's vehemence to the cheeriness of the general Pop scene. (As it was, Lichtenstein and Warhol were the only pure Pop artists). It would have made a more comprehensive space, too, for Thiebaud and Katz, and possibly for Philip Pearlstein at one pole and Ed Ruscha at another.

All these artists foregrounded the symbiosis of commercial and serious art as Courbet had done in the 1840s. They dealt with culturally enforced habits of seeing and desire. In one way or another, their works involve a syntactical fit of found design a familiar mid-century subject matter, which often amount to the same thing: a kind of obviousness to be enlarged upon or battered so that esthetic immediacy—the feeling that someone's at home in the work—comes seeping through. They exemplify art as a mode of applied looking, set anew (though with a melancholy that has long been typically American) in the flow of recognitions that commercial design seeks to regulate. As a form of image management, a Warhol or Ruscha graphic spread locates the ubiquitous motif within a recognizable, but outsize, "second nature" of design. The sizable mutation brings home an intangible image in a suspension of meanings. It shows the haphazard process of recognition at face value.

American art is traditionally grounded in design. Few significant artists from the 1850s to the 1960s art-school glut received strictly fine arts training. Winslow Homer, Maurice Prendergast, John Sloan, Edward Hopper, Stuart Davis and more recently Warhol, Rosenquist and Alex Katz were schooled or apprenticed in commercial art. DeKooning's applied-art training at the Rotterdam Academy is well documented, but Guston's, David Smith's and Franz Kline's early sources in cartooning are usually taken as ancillary biographical oddments. Wayne Thiebaud had an entire career as a cartoonist, illustrator and display designer until he changed to a full-time painter at age 40. I'd hazard a guest that most artists born between 1900 and 1945 (which easily encompasses the artists in the Whitney loan show) began their art educations with correspondence courses in caricature or basic figure drawing ("Can You Draw This Dog?"). The fabled toughmindedness of much mid-century art was due as much to the demystifying technique (you *can* draw this dog) engendered by commercial practice as to Outside skepticism about both academic and modernist esthetics. Alex Katz says that, while he was learning to draw from plaster casts in high school, he had no aspiration to fine art: "The only art form I knew at that time was dancing."

One can say that in the period 1959-65, modes of recognition became the content of art. (In terms of what Michael Baxandall calls "cognitive style," this has always been the case, but the extent to which imagery filled up the observable world at this time made the issue more pressing.) Note that the same years (1958-65) also saw, concurrently: 1) the rise of the professional art critic; 2) the codifying of formalism, the discipline of discussing art in strictly formal terms; 3) the proliferation of art magazines

(*Artforum, Arts, Art International*—all got their start in this period) and of reproductions via the 4-color separation process (colorplates, slides, postcards, etc.); 4) the art-school boom, and the development throughout the U.S. and Europe of the contemporary art museum; 5) the emergence of the U.S. contemporary-art market, and with it, of the "art star" (with a movie-star name like "Larry" or "Andy") and the transcribed, tape-recorded interview as the prime form of written criticism; and 6) the establishment of abstract art as a cultural norm.

And right there many of the distinctions between abstract and representational art collapsed. In a culture of received (because relentlessly delivered) images, painting—from say Rauschenberg, Johns and Warhol to Gerhard Richter, David Salle and Ellen Gallagher—takes on another purpose as the site of interpretation (rather than invention) of imagery. "The allover churning of immense image fragments—chunks of the inert presences, the ad and movie and news picture, that clog our emotional atmosphere."—Carter Ratcliff's words about Rosenquists's source materials indicate the urgency of purpose involved. How we live now conditions the purposes of art—that's what Warhol saw so plainly.

Pop as a subcategory of Minimal Art—both are reductive. Pop uses techniques of commercial art, just as minimal uses forms and methods of modern industry, as "nature." The single (or synoptic) image, the non-art look, concentration of surface and demotion of "craft" or skill, work in series, repetitions, inert structures (squares—boredom). The big difference was that Minimalism's curiosity about the situation—object and perceiver together in a place and time (what Robert Storr calls "bodies comparable to other bodies")—was only occasionally implied by Pop.

An image is nothing but surface. It can go deep or shallow, can refer to deep or shallow areas of consciousness—but it is first of all there on the surface, cosmetic, externalized. The 60s shifted attention from the internal to external self (the acculturated self made up from the outside in): "If you want to know all about Andy Warhol, just look at the surface of my painting and films and me, and there I am. There's nothing behind it." Nothing behind it, I might add, but plenty in it.

It is interesting that 1965, the year that Clement Greenberg's "Modernist Painting" achieved its first wide circulation, is now often taken as the absolute end-date of Modernism, and that, if that is true, Greenberg's definition spelled its doom. In 1965, Ad Reinhardt was in the process of painting the last of what he had already called "the last paintings." 1965 was also the year the National Endowment for the Arts was founded and, incidentally, the year I started for the first time writing reviews on a regular basis for *Arts*. In 1949, as the New York School was emerging, there were ninety galleries interested in showing contemporary American art; in 1965, there 197, but the number of contemporary art exhibitions per year in New York had jumped from 300 to 1,200. It seems almost amazing to me that in 1966, after all the battering my critical senses had already taken in the preceding seven years, I had eyes for a work like Eva Hesse's *Hang Up*, which—happily, I now think—I wrote about as part of a review of the "Abstract Inflationism/Stuffed Expressionism" show that year. (It was the only work in the show I liked.)

A culture hastily mobilized upward to the point of liftoff mirrored itself in an art with mingled messages of aimlessly airborne imagery and virtually lost horizons. Glamorous and deathly it was, and is. But when the artists of that time removed the rapture from distress, they brought distress into focus as part of the furniture. Schooled in the discrepancies of modern life, these new realists elevated a hard-bitten, native irony to primacy among all of art's modes; they gave irony the ring and compelling scale of plausible truth. With a shrewdness that has long since compounded itself, their art alleviated shame by declaring an exquisite disposability, reserving contempt for the regularity with which images that posit our second-guessed desires keep coming, washed in on tides across the encrypted void.

A reminder, though: *Nothing dies*; once something is a fact, it tends to persist. There is no moral to be drawn from this, but it's enough to keep critics—and a few artists—awake nights.

1994/2010

Factum Fidei: A Walk-Thru Apropos the Late 50s

> *The common tragedy is to have suffered without having appeared.*
> —Mina Loy

Unofficial cultural history is full of glorious walk-ons and disappearing acts. Some of the best art of any decade gets lost in the shuffle of styles, sales, and curatorial records. It wasn't artists but the scorekeepers who missed out by forgetting that modernity's greatness was measured by variety and inclusion, by there being more to do rather than less. Thirty years ago, criticism's doctrine of the purity of the separate arts seemed like a joke just as it does now. It became a bad joke for a while in between. As for the 1950s, it fell to the composer Morton Feldman to provide the most telling definition: "What was great about the 50s," he wrote, "is that for one brief moment—maybe, say, six weeks—nobody understood art."

"First came Patchen, then Ferlinghetti": This line from a recent poem by Ron Padgett crystallizes for me the initial excitement of discovering for oneself, as a very young, beginning poet, the vitality of contemporary poetry and art in the late 50s. For those who, like Padgett and myself, were born during the early years of World War II, there was the shock that poetry of moment was possible in what before had seemed an encirclement of dullness. On such a "first-came-X" basis, a neophyte could proceed to invent his own culture as the elements accrued. What did I know? First Thelonious Monk, then Ornette Coleman; first deKooning and Pollock, then Rivers, Rauschenberg and Johns; after Patchen and Ferlinghetti, Ginsberg, Kerouac, Corso, O'Hara, Ashbery, Wieners.... Soon enough, I found, too, that these enthusiasms were shared by other, companionable writers of my own age, and the culture clicked.

The dreary regimens of official magazines and anthologies had become dismissible, merely out to lunch. In that respect, the Year of Wonders was 1957, which saw the publication of *On The Road*, the *Howl* obscenity trial, and the "San Francisco Scene" issue of *Evergreen Review*. I went from high school to college (and from tweeds and khakis to blue jeans and fatigues). Monk was at the Five Spot; deKooning embarked on his series of landscape abstractions; the tingling Balanchine/Stravinsky *Agon* was premiered by young New York City Ballet dancers at the City Center. Among the other great artistic events of 1957 were Robert Frank's *The Americans*, Wallace Berman's first show at Ferus in LA, and the early stirrings of underground film. Over the next three or four years, there would be Donald M. Allen's *New American Poetry* anthology, the first mimeo magazines (the Spicer circle's *J* in 1959, Diane Di Prima's and Leroi Jones's *The Floating Bear* in 1961), and the emergence of the poetry reading (beyond North Beach where it had already taken root) as a lively cabaret form.

The core group of Beat Generation writers were based in New York, but the ethos had become identified with San Francisco. During the Thanksgiving break in 1958, I visited San Francisco ostensibly to secure a summer job on a local newspaper but really to seek out the writers I thought would be there. North Beach was jammed with tour busses. I stood dumbfounded in the crush at The Place, the Coffee Gallery, the Co-Existence Bagel Shop. The only poet I saw plain was pointed out to me after the bars closed: Jack Spicer huddled alone in the 2 a.m. fog on the traffic island at Broadway and Columbus.

Years later, Ted Berrigan told me that he decided to go to New York instead of San Francisco because New York's literary atmosphere was open and not didactic and he could step in and out of the company of older, more accomplished poets without becoming absorbed by their auras. By comparison, until the late 60s San Francisco poetry was an island colonized by small factions, each with a ruling poetics embodied by at least one resident master. The temperaments were different and paradoxical. In a letter written during his stay in New York and Boston in the mid-50s, Jack Spicer complained especially that New Yorkers, as he encountered them, lacked a sense of humor. Years after Spicer had died, I asked a poet of that immediate circle what Spicer was like; he answered bluntly, "Jack was the most serious man I've ever known."

In both San Francisco and New York, relations between the arts get established by esthetic stance and commonality of reference. James Schuyler described the New York art world of the 50s as "a painter's world; writers and musicians are in the boat, but they don't steer." In San Francisco during the same period the reverse was the case. No visual artist had achieved a prominence outside the Bay Area equal to that of the Beats and some of the original Berkeley-San Francisco Renaissance group. Poets roughly the same age as Wally Hedrick, Jay DeFeo, and Jess included Spicer, Robert Duncan, Ferlinghetti, Philip Lamantia, and Philip Whalen—all born between 1919 and 1927. Somewhat younger ones like Gary Snyder, Michael McClure, John Wieners, and David Meltzer belong, as do Bruce Conner and George Herms, to the generation born in the early 30s. Interestingly, the presiding figure of Rebecca Solnit's cultural history, Wallace Berman, was born the same year as Allen Ginsberg, 1926.

The late 50s and early 60s were an extended initiation for me into the facts and mysteries of hometown New York art. The continuance of the New York School in those days was fast and furious. What Frank O'Hara called a "splendid state of confusion" was due partly to so much residual heroicism in the air, though it was also becoming millions-in-business-as-usual. In terms of visual art, I was discovering my own backyard. No one that I remember mentioned California unless they happened to have come from there. The local perception was that San Francisco painting was based on Skira plates of Bonnard, Matisse and later the New York School: the colors were mud and the scale diminutive.

When I first saw Bruce Conner's assemblages at the Alan Gallery around 1960 I didn't associate them with California; instead, they reflected the general culture I'd grown up with. What made Conner different from the New York assemblage makers was his dark, specific content that registered from behind musty surfaces, close to the bone. California art, being traditionally more private, tends to dissolve surface in atmospheres that yield intimate meanings.

The age-old distinctions between California and New York are those between sincerity and style, purity of intent and mediation, singlemindedness and ironic multiplicity, surface and atmosphere. Style trusts to surface as the relevant point of contact between the artist's meanings and the (anticipated) public. In retrospect, California assemblage of that time seems closer to the then-innovative European concoctions—the works of Yves Klein, Martial Raysse and others of the School of Nice and their cohorts, Daniel Spoerri, Niki de Saint-Phalle and Mimmo Rotella, in what came to be called the New Realism.

Californians emphasize that California is where they are, whereas a New Yorker wears the city on his nervous system as if any other place were out of the question. New York artists, who recognize their unfair city as irredeemably hellish but vital, view California art (whenever they see it) as too healthy in a self-congratulatory way. Conceived in puzzlement and a modicum of envy, myths about lotus eaters in Cloud Cuckoo Land persist. Al Held told me that during the 50s he stared for weeks at the Bay from a spacious studio on Telegraph Hill, exasperated. Eventually, he made a deal with a poets/printers collective in the basement: "I spent the rest of my time in San Francisco painting in a corner with a bare light bulb." To the hubris-ridden non-objectivist, the offerings of paradise are rife with constraints.

Coming to live in California in 1970, by way of a car trip across America for the first time, I realized how tiny, how parochial even, my New York perspective had been. But I also knew I wasn't going to lose my Manhattan attitude. Nineteen years later, my point of view has broadened, but I never converted.

It seems to me that what Rebecca Solnit is getting at is more than a redressing of East-Coast historians' blindspots; instead, she wants to advance the primacy of the direct, the hybrid—of the intervention in art by what Rauschenberg once called "the lively impure." This reminds me of an important exhibition organized by Gene Swenson in 1966 at the Institute of Contemporary Art in Philadelphia, *The Other Tradition*, which included works by Schwitters, Duchamp, Ernst and Miró alongside those of young artists such as George Brecht, Rosenquist, Ray Johnson, and Oldenburg. As Swenson wrote in

his catalogue essay, "the images of the *other* tradition possess artistic qualities beyond those which formalist critics have found in them—percipient and psychical qualities." And elsewhere in the piece: "After learning habits of abstraction, we often thought the subject matter of much painting of earlier centuries inappropriate to and incompatible with current interests and beliefs.... It was the formal elements which seemed most closely related to our own feelings; we even began to experience and feel 'abstractly.' Then artists....forced us to change our angle of vision; we began to reactivate our sense of the world around us. Advertising, to which we had deadened our senses in order to avoid kitsch-siren calls and conspicuous consumption, could be seen and looked at again...." Salubrious as Swenson's "other" was (or should have been—the show and essay came and went without making much of a dent in the formalist climate), its argument was vitiated by being strictly an art-historical one. Unlike their forebears, artists who started out in the 50s, like the ones both Swenson and Solnit discuss, dealt with media images because such images were a kind of second nature to them, dominant parts of the their landscape.

Today art is nobody's big secret the way it was a poets-and-artists secret then. If art has been helped along by a more general, if not exactly more wised-up and decorous, audience, poetry has pretty much kept the same small readership or else slipped. The first printing of *Howl* was 1500 copies, twice as large as the typical run for a small-press poetry book now. Donald Kuspit suggested recently that the art of the 90s will be "chamber music" compared to the noisy, cajoling, operatic 80s modes. Poetry, except where it has infiltrated the performance circuit, is ordinarily a chamber form. "The art world" now means a pecking order of power groups—collectors first, then dealers, the glossy magazines and their critics, and lastly, the artists. Everyone understands art at the level of day-to-day tuning of reputations and overview trends. This is very different from the connotations of "art world" in the 50s and early 60s when the artists themselves were the first to know what was happening and what it meant. The 50s were a glorious time for art as art for an intellectual audience.

Forward to Secret Exhibition *by Rebecca Solnit,* 1990

Reliquary Days

Think of six artists—Jay DeFeo, Wallace Berman, George Herms, Wally Hedrick, Bruce Conner and Jess—so associated in their multifarious, hybrid practices, and by now in the annals that comprise a 40-year history, but each with a markedly distinct originality. What they share is not a style but a world view and ways of asserting peculiar sensibility within it—how, literally, to make a life with thoroughgoing artistic attentiveness at the core, a larger fact than the maintenance levels of either art or everyday life would ordinarily admit. Attitude thereby is the key.

Style never seems to have occurred to any of these artists as a mediating factor. Rather, there are rudimentary, even neutral, principles of arrangement, blunt as puns: everything has its place; many things fill a given design (or grid) or make a jumble across the board; a few hang or stick crosswise; a single object held up for contemplation goes (where else but?) smack in the middle of the accommodatingly roomy, bare support. Cruciform armatures and other simple symmetries have long supplied the majority of these artificers with practical devices that also figure as emblems of spiritual intent. (Only Jess, whose work can be seen as neighborly to the others' but not of the immediate household, has regularly been concerned with composition as a setting for intricate special teeters and twists.) Herms's comment on his own procedure is exemplary: "Some of the works I do are like a tossed salad, and others are like dart boards."

The discrepancy between a cross as emblem of organized belief and the wayward stuff hung upon it is less a matter of irony than of mindful ardor: The world needs us to give credence to its dynamics of scrap and unheralded epiphany. The pressures—up, down, sideways—are radically devotional. Michael McClure has remarked on how, seeing Herms's works, "one thinks that they are by someone who is near-saintly in his care for the objects that are put together." If Herms is the archaeologist-conservator of this reliquarian tendency, then Jess is the illuminator, Conner the seraphic trickster, Hedrick the astronomer, and Berman and DeFeo the psychopomp and geomancer, respectively. Nary a work by one can be mistaken for that of another, but see how swimmingly they converse. The symbiosis is life-affirming, specific and hardly obscure: in the 50s, while no one else was looking, these Californians formed a daisy chain of mutual permissiveness for intervening along the edges of art, as well as for a general refurbishing of what civilized living in mid-20th-century "hobohemian" fashion might entail. Taking one another as prime audience, they became collaborators in a call-and-response species of art making that, not so incidentally, deepened their crisscrossing affections. Imaginative portraiture—often in freestanding, tabletop constructions—of an uncannily precise, allusion-packed inscape variety has been one of the main avenues of communication among friends.

The family album of this extended microculture was *Semina*, the serial anthology of texts and images that Berman produced on small hand presses from 1957 to 1964 (now newly issued by L.A. Louver in a limited facsimile edition supervised by George Herms, with the poems reprinted by Alistair Johnston). A sample packet with its modified, plain-brown commercial envelope might contain poems by John Wieners, David Meltzer, Bob Kaufman or "Pantale Xantos" (Berman's *nom de plume*) shuffled next to others by John Keats or Antonin Artaud; draw from the bottom and you might find an opium phantom pirated from Jean Cocteau or a photocollage of Lenny Bruce attacked in a crown of leaves and butterfly wings. Fittingly, in this year of Hollywood's and other re-rakings of smoldering conspiracy theory, we get to take yet one more hard look at the image (slightly altered by Berman) of Jack Ruby dispatching Lee Harvey Oswald: this photograph, accompanied by McClure's "Dallas Poem" on the inside, decorated the wrapper for *Semina Nine*, the last issue of the magazine.

1992

True Guston

Philip Guston by Robert Storr, Abbeville Press, 1986.

Philip Guston's work has regularly bred critical prose remarkable for its pithiness. The bibliography of the Guston literature is impressive, yet oddly, though there have been many long, significant texts, there is no big picture book. Exhibition catalogues appear and then disappear quickly; likewise, the earliest monograph and the compendious critical study *Yes, But....*, both done by Dore Ashton, have come and gone. Now Robert Storr has written the first comprehensive posthumous account of Guston's progress, and it has fallen to him to do it in the standardized format of Abbeville's "Modern Masters" series. This format allows for a goodly number of illustrations (upward of a hundred, many in half- or over-baked color), the usual semi-informative biographical outline, a sampling of "Artist's Statements," and the obligatory (though always provocative) "Notes on Technique."

Most writing on Guston has been conceptual or literary—or anyhow not keyed to direct experience of his pictures' physicality. (The main exception is Leo Steinberg's short review in *Arts*, June 1956, which Storr acknowledges, and which remains the most penetrating so far; a close second would be Ross Feld's essay in *Arts*, April 1978, on a single 1976 painting, *Wharf.*) Critics have tended to "read" Guston instead of seeing his paint, and this literary-cum-metaphysical bias needs redressing because, even though Guston shared that bias to an extent, his paintings are preeminently physical arrangements whose surfaces bear watching for what he called "the whole story" embedded there. Guston's paint is supremely "put," so that the rhetoric connecting an image with its verbal equivalent is neither more nor less than coextensive with the image's fact as an inveterate, palpable array of smears and gobs.

Storr sees the "dichotomous nature" of "fundamental meanings" in Guston's work; of the principle advanced in his early abstract pictures, Storr says: "The object of painting was not to find a solution to the problem of art's persistent antagonism to or ongoing compromises with reality but rather to find a provisional wholeness within the context of them." And, in the same vein, he says of the later work:

> *Though he had often said that art was a product of the mind, Guston had, in fact, become a painter of the body, a body at the mercy of the other alien bodies that seemed to inhabit it. Thus, despite his concern for facts and the apparent realism of his new imagery, Guston's imaginative world was subject to constant, urgent metamorphosis, and the state of any image represented but one possible incarnation of its basic form.*

Storr is a painter in his mid-30s who writes clearly and attentively about other people's art. His criticism has no special axe to grind, and the prose style he uses for it is functional, mostly subordinated to the onus of conveying information rather than impressions. His sentences have an impersonal, dutiful tone; you never feel him ready to chat with the reader, or to put his perceptions, via an occasional headlong verbal construct, out on a limb. I would guess there is something circumspect in his not

speaking out more confidently as a fellow painter when he writes on painting. However, there's a nice passage early in the book where Storr describes Guston's color as "built up and subtly polluted, while the tonal field over which he worked is a constantly varying fabric of glowing grey tints alternatively oil rich and mineral dry"—and that's the kind of observation one prays for from an artist-critic, the kind generally unavailable from any other source.

In discussing Guston's work, Storr has the other advantage of having had no direct acquaintance with Guston himself—hence of not being swayed one way or another by Guston's personal ethos, his erudition, or his genuine (and genuinely romantic) schema of "doubt." Storr has looked long and hard at the pictures and thought about them; and although he "hears" Guston in the air around them (there are many interesting passages quoted from lectures and unpublished letters of the later years), he is his own man when it comes to sizing up the turns in Guston's career and their significance. Between identifying Guston's "conception of painting as residue" and his 50-year "cycle of expansions and contractions, departures and returns," Storr provides a good description of method made visible:

> Guston's brush....patiently explored the canvas, establishing a network of short, discontinuous strokes that charted the exact dimensions of the painting's format and located its center of gravity. His gesture was not that of the hand that grasps a tool while the arm sweeps but that of an arm that extends a groping hand. It was as if Guston, with eyes half-closed, was feeling his way along a wall, noting all of its changes in surface while waiting for an opening.

Storr has other good moments in which he nails exact perceptions with verbal felicity. "Abraded geometry," for instance, is perfect for one aspect of Guston's lyrical pink clusters of the early 50s, as is "the circumference of the moment" for the concatenating image-verge of a work like *Dial* (1956). "Burlesque brutality" may not ring true for the later work (nor does "ponderous phantasms of an adult insomniac"), but he is right on target in speaking of the fresh kind of "conflated" genre painting that one finds in the still life/landscape/narrative of *Pyramid and Shoe* (1977). Storr sees the important relationship of Guston's work to Giacometti's, and his balancing relation with Mondrian; and he sees the importance, also, of the mid-60s "erasure" paintings, which too regularly have been lost in the shuffle while Guston's other phases have undergone reassessment.

Guston established no legend about his identity aside from its connection to his work. At the expense of history, personal and otherwise, he was engaged with truth. Many artists are interested in truth as a kind of sideline to their practice, but few are so obsessed, so nagged by its crystalline dislocations as to find it central to their art. There are many interesting (and many sad) facts in the Guston story—for instance, that as a teenager he drew "secluded in a large closet illuminated by a single hanging light bulb"— but even such facts show him acting upon his work (living it, he would say) from the inside. Storr advances a view of him as "the consummate insider" improvising a recital of the inclusive life of painting as a public human history cut loose from chronological bounds.

Proponents of the "three-careers" theory—in which Guston is seen switching styles, first from Symbolic Realism, then from Action Painting, to arrive at a sudden

proto-New Imagist effulgence—have missed the thoroughgoing discourse of which all Guston's pictures partake. Storr correctly says that the late paintings "embody the constants of Guston's sensibility" rather than diverge from them. The late work has everything (an awful and triumphant everything) because Guston so conflated his own history that nothing had to be left out. Exactly half of Storr's book is taken up with discussing this phase not as a denial of what Guston had done before but as an aggregate revelation, the summa of previous impulses and modes. Storr doesn't penetrate the mysteries of this revelation, or of Guston's truth generally—for that we need a field guide instead of a chronicle—but he has given us the necessary, basic text.

<div align="right">1987</div>

The Pollock Effect

The Fate of a Gesture: Jackson Pollock and Postwar American Art by Carter Ratcliff, Farrar, Straus, Giroux, 1996.

At an odd moment during the opening-titles montage for Robert Hughes's *American Visions* there suddenly spreads in closeup across the screen a transparent reproduction of a Jasper Johns "Target" painting through which can be seen another image, that of Jackson Pollock in motion against a pale blue sky. Traversing the innermost ring of Johns's picture, Pollock lets fly from a small paintbrush in his hand a drop of dark paint, which then cascades as if through some cosmic retinal port towards us and onward into space. The well-known image of Pollock (seen from below, distributing pigment, wire mesh and pebbles on a large sheet of glass) is a clip from Hans Namuth and Paul Falkenberg's 1951 film of the artist, frames of which also serve as a border on the dust jacket of Carter Ratcliff's new book, *The Fate of a Gesture: Jackson Pollock and Postwar American Art*.

Hughes himself has nothing to say on the Pollock-Johns connection. Ratcliff, on the other hand, seems to have pledged himself Galahad-fashion to the thorny sort of connective theorizing that Hughes blithely avoids. Ratcliff writes that Johns, along with many other artists from the 1950s on, "devised a variant on Pollock's infinite. To Pollock's 'nature,' Johns....replied with 'culture.'" Within the weave of Ratcliff's argument, these remarks are by way of clearing a place for Andy Warhol, because, as Ratcliff next tells us, "In place of culture, Warhol put society," and he thereby, not unlike Johns, "unfurled an image of America as boundless as Pollock's." Thus is artistic succession recounted as a kind of spinning song.

Ratcliff has committed to a conceit. In the introduction he writes that his book is "not a survey of postwar American art. *The Fate of a Gesture* concerns artists driven by the unreasonable belief that to be American is to inherit an infinite." Behind this dovetailing of initial disclaimer with declaration of major motif (trumpeted also as "the

American infinite" and maybe more plausibly, "gesture as world") you can hear the rumble of approaching heavy rhetorical machinery, which happily, to Ratcliff's credit, never arrives. Over some 300 pages covering more than fifty years of polymorphous local (i.e., strictly New York) art history, Ratcliff keeps calling into play his term of willful, isolate infinitude. Seen according to plan, some infinity equivalent to the type Ratcliff finds implicit in Pollock is detectible in whatever other art can be said to verge upon limitlessness. (About Johns, for instance, Pollock-esque infinitude appears but faintly audible in "the elusive but somehow always dependable hum of solitude.") With Pollock on top, the ensuing inventory links together the raw megalomania of Clyfford Still, just about anything "Johnsian," a multiplex cube by Sol Lewitt, virtually anybody's scatter pieces, an earthwork by Robert Smithson ("the anti-Pollock"), a Hans Haacke questionnaire, the "cinematic excess" of Robert Longo, and so on—each, Ratcliff keeps saying, "implies the infinite." Such bare insistence eventually feels so nutty and dizzying that it's alright to simply let it pass. There's a lot more to *The Fate of a Gesture* than meets the infinite.

Ratcliff's conceit, though not valueless, may be grossly overused, but he's no dictatorial theorist or crank, and he knows better than to try rearranging history to suit some idea he has about it. Reading him you sense a writer who sees through the artifices he employs to the need that prompted them—the need to tell how complex art and our responses to it happen within the continuum of experience—at the same time as being alert to the likelihood of never fully answering that need. Ratcliff is a thoughtful, sometimes sharp, mostly wry, commentator, a sophisticated insider who has maintained something of a novice's fascination with the celestial mechanics of contemporary high art. At street level, he sees interesting foibles where others more fretful see cabals. His book is, if not a survey, at least a near-survey, benign and beautifully particularized, of the New York art world from Pollock's time to ours.

Some of the best moments in the book happen when Ratcliff, having gotten too caught up in making a case out of loose threads, just steps free and resumes his spritely chronicle. The narrative especially glows whenever it touches upon the late 1960s, that time when Ratcliff himself made his entrance as a young poet writing reviews for *ARTnews* and when many artists roused themselves into action with odd-sounding tunes about how to, as Ratcliff puts it, "bear art into a proper future." (As it turned out, samplings of those same tunes—as sung by the likes of Robert Morris, Joseph Kosuth and Sol Lewitt—would form the bases for much of the art being made today.) There are eloquent descriptions of work by Willem deKooning, Warhol, Frank Stella, Lynda Benglis, Brice Marden, Pat Steir, Claes Oldenburg and Pollock himself, and good, brisk personality portraits, such as the one of Harold Rosenberg that begins:

> Rosenberg was tall—well over six feet—with a barrel chest and a large, angular face sectioned off by thick eyebrows and a mustache. He delivered quips in a voice at once querulous and imperious; falling silent for a moment, he would glower. Quickly the quips would resume, with their impatient edge. His conversation was always a kind of chiding....

Of course Ratcliff is not the first to take up the notion of some kind of infinitude in Pollock's drip paintings. As early as 1958 Allan Kaprow noted that many people had

already remarked how Pollock's art gave "the impression of going on forever—a true insight." For Ratcliff, such impressions failed to generate an intense enough vision of what is at stake in the spaces Pollock made manifest. As he sees it,

> *An infinite can only be implied because it cannot, of course, be pictured. The poured images do not picture anything. That is why members of the New York art world call them paintings or canvases. They are objects bearing traces of a self-absorbed drama: not merely a journey to the infinite but a transformation. Pollock becomes the infinite: his feeling of helpless exposure vanishes as his presence expands to fill the space that in less exalted moments would bear in on him unendurably.*

This is a sympathetic reading, though how "images" that, as Ratcliff writes elsewhere, "stir up surges of light and weather" can be anything other than pictures is anybody's guess.

"It all ties together," Ratcliff quotes Pollock as saying about his paintings. Ratcliff's conceit extends to flinging himself as narrator into Pollock's energy field by making the history or "fate" of the work analogous to the work itself. Although Pollock's infinite shares coordinates with no one else's, there are resemblances, and these tend to intersect and spill over one another in patterns like those Pollock made when he was "in" his paintings. Ratcliff's text purposefully mimes how the contagion of the critical vocabulary attached to Pollock's art has spread. Pollock's paintings sprawl and so, by nature, as it were, does much that follows—for example, "the progeny of anti-form, the sprawling family of new mediums which includes video art at one extreme and the texts of hardcore conceptualism at the other." Similarly, Johns's followers "form a large and tangled lineage." (Enhanced details along the tangle: if you are Keith Sonnier, you produce "a variant of the Johnsian mood"; if you are a 1970s New Image painter named Susan Rothenberg, you get to be "a Johnsian waif.")

Negotiating the turns—not all, but many—taken by artists in New York after Pollock's death, Ratcliff recognizes enough patterns to give his story both vista and the feeling of forward motion. This is facilitated by the existence of what has long been obvious as the Pollock Effect. Pollock in the 40s and 50s was seen as avant-garde; his painting went as far as painting could go, maybe even to the end of the line. That became part of the image of Pollock himself, which obscured the actual work. Pollock's death at the age of 44 helped to cement the image and keep it in front of the work. (Ratcliff, in the roughly one third of his book devoted to telling Pollock's story, places the character "Jackson Pollock" by turns within and alongside the paintings, admirably.) On arrival, Pollock's paintings gathered a mass of contradictory responses: different viewers found the same image to be either exquisite or gauche, emotionally charged (or spent) or as unexpressive as necktie designs, projective of either impersonal grandeur or romantic self-allure. That some of the paintings could arguably be seen as all or most of those things became an instant problem for criticism.

For about 20 years, until the mid 1970s, the drip paintings were cited as an impetus behind just about every new twist in contemporary art: from the various types of abstract painting (minimalist, color-field, monochrome and beyond) all the way to proto-installation "environments," performance and/or process-oriented work. One design

element of Pollock's paintings that had a large general effect was the all-over, single image; another was the articulated literalness of the materials—paint on canvas—as a strong aspect of a no less relentlessly fructifying, spatially ambiguous image. As the Effect sank in, there developed what Ratcliff identifies as "Pollock jokes" —assorted parodies and travesties, most notably, the designer-Pollock detailings in Claes Oldenburg's 1963 *Bedroom Ensemble*—to be followed by something more attenuated called "the Pollock option" ("Mike Bidlo's exercise of the Pollock option made him an art-world equivalent of an Elvis impersonator").

Pollock's "paint slinging," says Ratcliff, "generated a power that overwhelms understanding." My own experience of the work is that it is precisely when most engaged with a Pollock painting's terrific specificity that one "understands" it; only in retrospect, in the confused afterimage, does such understanding become elusive, largely because the specifics of Pollock's paint—including those wide prospects where an infinitude of sensation merges impressively with material tautness—are no longer there to guide and refresh one's thought. Ratcliff, too, knows this. In an account of the vicissitudes in confronting a picture like *Autumn Rhythm*, he writes:

> Sometimes vision sinks helplessly into a pool of color. The image congeals and the force of Pollock's gesture fades. Metaphor weakens. Emerging from a murky pool, the eye feels stymied by flurries of drips and drops and spatters—the effluvia of Pollock's method. At these moments, it's tempting to turn away, though the eye that lingers with patience always finds a path into the painting's dense tangle. It reopens, more grandly than before....

Such palpability of terms keeps Pollock from being understood as just another developer of unimproved acreage within the limits of official art history. As Ratcliff says, "Always honored by the New York art world, Pollock was never entirely assimilated. His brilliance had a primordial feel." Perhaps what Pollock accomplished is so mightily available to other artists, even if only as an "option," because it's so feckless as an idea. Conceptual schemes about Pollock's art tend to reduce it to a fairly intelligible graphic image, a cartoon of its creational method. Meanwhile, whenever scrutinized, the paintings keep fibrillating, heaving, slipping away and coming back into focus—bewildering as dreams and yet as images of actuality as plain, exact and tirelessly signifying as vision itself. Taken together, Pollock's work remains uncertain in principle, its fate confirmed in its mutability.

1997

Poet and Painter Coda

New York poets, except I suppose the color blind, are affected most by the floods of paint in whose crashing surf we all scramble.

—James Schuyler, "Poet and Painter Overture," 1959

In his lecture on "The Relations between Poetry and Painting," Wallace Stevens said: "No poet can have failed to recognize how often a detail, a propos or a remark, in respect to painting, applies also to poetry. The truth is that there seems to exist a corpus of remarks in respect to painting, most often the remarks of painters themselves, which are as significant to poets as to painters." As it happened, the site where Stevens delivered his talk was the Museum of Modern Art and the year, 1951, just when the local "corpus" in respect to poetry and painting together was gathering under the always-tentative classification of the New York School. Although Stevens made frequent New York gallery visits from his Hartford lair, he seems to have had no real contact with the new painting; his tastes, after passions for Klee and Braque, ran to latter-day Parisian delicacies like those of Tal Coat and the winsome beachscapes of Maurice Brianchon. Nevertheless, it was to Stevens that Harold Rosenberg turned for an epigraph to his "American Action Painters" published the following year. At 72, already revered as a modern master, Stevens was only slightly older than Hans Hofmann, who eventually would come to stand as the putative hero of Rosenberg's thesis.

Because the true history of any epoch would be a medley of cross-references, one can go on pointing up, and connecting, such chronological dots. 1951 saw the first appearance in print of the "school" in its first phase as a variation played on "the School of Paris." In the catalogue preface for "The School of New York" exhibition that opened that January at the Frank Perls Gallery in Beverly Hills, Robert Motherwell advanced the term as "not geographical but denoting a direction." (He had used the term earlier, in 1949, in a lecture setting.) Events of 1951 included the publications of both Motherwell's seminal *The Dada Painters and Poets* anthology and Thomas B. Hess's groundwork history, *Abstract Painting: Background and American Phase*, as well as the artists'-cooperative Ninth Street Show, which grouped members of the first generation next to what Irving Sandler calls "the first wave" of second-generation painters and sculptors, many of them fresh from Hofmann's classes in New York and Provincetown. In another part of the same cultural neighborhood, Black Mountain College continued to foster the sort of hybrid activities—proto-happenings and the like—that would become regular practice ten years later: the faculty there at various points during the early 50s included John Cage, Charles Olson, Robert Creeley, Merce Cunningham, Clement Greenberg and Franz Kline.

In 1951 Willem deKooning, who gave a talk on "What Abstract Art Means to Me" at MOMA that February, was in the thick of his "Woman" series; Jack Kerouac wrote *On the Road* in a Chelsea loft; Fairfield Porter began reviewing for *ARTnews*; and Robert Rauschenberg painted his first White Painting. That fall, Frank O'Hara, having settled permanently in New York, secured a job minding the membership desk at the Museum of Modern Art. Within the next few months, O'Hara began participating in

panel discussions at the Club and in May 1952 gave his first public reading there. The other participants in this "New Poets" symposium were John Ashbery, Barbara Guest and James Schuyler, with Larry Rivers as moderator. (Kenneth Koch, who would have made a fifth among the readers, was in California at the time.) The short-term focus on poetry in the Club's proceedings was instigated by deKooning who later spoke of the "good-omen feeling" about O'Hara in particular when he arrived on the scene.

If 1950 had marked (as April Kingsley's recent book asserts) "the turning point" for first-generation artists, the remainder of the decade went on wildly spinning. Clement Greenberg pointed long ago to 1950 as the year that Abstract-Expressionism "jelled as a general manifestation." A case could be made for an uninterrupted succession of *anni mirabiles* up to about 1966. (From then on, things slowed under the counter pressures of increasing institutionalization, the baleful results of which we have all about us nearly thirty years later.) By 1951, Pollock, deKooning, Kline, Rothko and the rest achieved virtual Old-Master status in the eyes of the still smallish downtown art world, newly populated as it was by a larger contingent of dazzlingly talented emerging artists; but the fact of the elders' achievement was still disputed, or aggressively ignored, elsewhere. It's intriguing to think of young poets entering that world simultaneously intent on making a momentous poetry but with even fewer prospects, for all that, of recognition in the general culture.

> *The painters who went to the Cedar had more or less coined the phrase "New York School" in opposition to the School of Paris....So the poets adopted the expression...out of homage to the people who had deprovincialized American painting. It's a complicated double-joke. It wasn't a question of New York subject matter but just as Paris broke through in opposition to, say, the School of Florence, New York was where it was happening and it was these people living in New York who said 'That's what we want to do'.....Later, everyone's forgotten all that—the original joke.*

> —Anne Waldman, "Paraphrase of Edwin Denby Speaking on 'The New York School,'" 1974

In retrospect, it seems to have been no one's intention that "the original joke" get lost. Part of the joke, surely, is that none of the disclaimers by those to whom the term has been applied has succeeded in drowning out the rumor that some such tendency as "the New York School" exists, or did, if only by default. For the poets no other designation (except the weaker one of "New York poets") has ever been suggested. All the same, the name didn't gain credence in a literary context until well into the 1960s when a few younger poets took it on as a point of speculation. (Ted Berrigan, for one, was given to holding forth, only half-jokingly, on "action poetry.") Before that, John Bernard Myers used it unilaterally to argue for a cohesion—in Myers's mind, with roots in French Surrealism—among the poets he published under the Tibor de Nagy Gallery Editions imprint. Myers, who spoke of himself as having "three passions: poetry, puppets and painting," proclaimed the School's arrival with characteristic flamboyance and mirth.

"The New York School" indicates ultimately where a number of artists lived and met—clearly not *all* the artists; and not all of those who lived in New York during the same era were so connected. It was logical in 1950 for deKooning to insist "It is disastrous to name ourselves" because the painters by then had some expectation of a growing public for their work, whereas 10 years later the poets still had none. The very conception of "School" forestalls that of "movement" and with it the implication of a set of binding rules and proscriptions. As Harold Rosenberg said of the Action Painters, "What they think in common is represented only by what they do separately." Without that same caution, the name as applied to poets rings false—as false, say, as any concomitant notion that, because they were sometimes inspired by the ways of painters, their poems can be construed as "painterly." The poems of Ashbery and O'Hara, complementary as they are to one another, share no "look" the way, for instance, Kline's and deKooning's broadly marked paintings of the late fifties do. What the poets and painters developed together was synergy, the solitary pursuit made sociable by friendship and other allegiances that deepened according to attitude or esthetic stance. How that sodality worked is clarified by Schuyler's "Poet and Painter Overture," the second half of which is strict in its particularities:

> Harold Rosenberg's Action Painting article is as much a statement for what is best about a lot of New York poetry as it is for New York painting. "It's not that, It's not that...." Poets face the same challenge, and painting shows the way, or possible ways. "Writing like painting" has nothing to do with it. For instance, a long poem like Frank O'Hara's Second Avenue: it's probably true to deduce that he'd read the Cantos and Whitman (he had); also Breton, and looked at deKoonings and Duchamp's great Dada installation at the Janis Gallery. Or to put it another way: Rrose Selavy speaking out in Robert Motherwell's great Dada document anthology has more to do with poetry written by the poets I know than that Empress of Tapioca, The White Goddess: the Tondalayo of the Doubleday Bookshops.
>
> Kenneth Koch writes about Jane Freilicher and her paintings; Barbara Guest is a collagiste and exhibits; Frank O'Hara decided to be an artist when he saw Assyrian sculpture in Boston; John Ashbery sometimes tried to emulate Leger; and so on.
>
> Of course the father of poetry is poetry, and everybody goes to concerts when there are any: but if you try to derive a strictly literary ancestry for New York poetry, the main connection gets missed.

Beginning around 1950, the charter members among the poets—O'Hara, Ashbery, Guest, Koch, and Schuyler—were all in their 20s, or roughly the same age as the second-generation painters with whom they would be intimately aligned. Unlike many of the young painters, none of the poets were native New Yorkers. O'Hara, Koch and Ashbery—from Massachusetts, Ohio and western New York State, respectively—had met as undergraduates at Harvard. Edwin Denby, a senior poet who figured benignly in successive phases of Manhattan's mid-century artistic life from the 30s until his death at the age of 80 in 1983, had his highest public profile as a dance critic; the importance of his poetry was recognized in the fifties mainly by O'Hara and Schuyler and, earlier, by painter friends like Willem and Elaine deKooning. Recalling the milieu of the early 50s, O'Hara told how he and the others

divided our time between the literary bar, the San Remo, and the artists' bar, the Cedar Tavern. In the San Remo we argued and gossiped; in the Cedar we often wrote poems while listening to the painters argue and gossip. So far as I know nobody painted in the San Remo while they listened to the writers argue. An interesting sidelight of these social activities was that for most of us non-academic, and indeed non-literary poets in the sense of the American scene at the time, the painters were the only generous audience for our poetry, and most of us read first publicly in art galleries or at The Club. The literary establishment cared about as much for our work as the Frick cared for Pollock and de Kooning, not that we cared anymore for establishments than they did, all of the disinterested parties being honorable men.

Then there was great respect for anyone who did anything marvelous: when Larry introduced me to de Kooning I nearly got sick, as I almost did when I met Auden; if Jackson Pollock tore the door off the men's room in the Cedar it was something he just did and was interesting, not an annoyance. You couldn't see into it anyway, and beside there was then a sense of genius. Or what Kline used to call "the dream."

One of O'Hara's early poems begins "Picasso made me tough and quick, and the world." There is a sense in him of inheriting modernity—and modern art in particular—as an expanding ethos. The adventure was of such openendedness that there was typically more to be done. (A catch of endlessly anticipated novelty was signaled by Rosenberg's doomsday title "The Tradition of the New.") The "sense of genius" carried with it an envisioning of art as an intensified form of social behavior no more special than any other intensification. Attitude mattered, not as the stuff of manifestos but as something extending from what Baudelaire would call "temperament"—an everyday presence manifest in the work.

Schuyler described the New York artists' world of the 50s as "a painters world; writers and musicians are in the boat, but they don't steer." As the convivial site for painters to air their thoughts, the Club opened horizons for poets to whom most official literary channels were closed. O'Hara's handwritten notes for his part in the "New Poets" session show him dealing retroactively with the doldrums of American poetics since the thirties and ending with a checklist of possible alternatives under the heading *Now*: "The varieties of technique/The ideal of High Art/The liberation of language as a motive...." "Language as a motive" would be "a frontal assault" to satisfy his "high-art" ideal, which was prompted partly by his love of painting and music. Likewise, a graphic conception of poem as workable shape courses through "Design etc.," the talk O'Hara delivered as part of a panel discussion a month earlier, in April: "As the poem is being written, air comes in, and light, the form is loosened here and there, remarks join the perhaps too consistently felt images....All these things help the poem to mean only what it itself means, become its own poem, so to speak...."

According to Paul Totah (who in turn credits his list of qualities to Kathleen Fraser's classes at San Francisco State University): "New York poetry can be described as urban in theme, playful, non-traditional in form, demonstrative of the writing process, concerned with the texture of language, anti-symbolic and anti-hierarchical." Allowing for

variances—Ashbery's continual reinvention of traditional forms, for instance—this is as fair a description of the agglomerated poetics in question as one is likely to get. Density and richness of surface—the prime qualities associated with New York School painting and poetry—argue for an enlarged, less extricable (or as O'Hara put it, "less immediately apprehensible") range of meanings. Density makes a poem appear larger as you read it, and also later when you think of it. Surface may be deep or shallow, opaque or relatively transparent; there may be "nothing behind it" but much in it. Playfulness is both enjoyment of possibilities and *sprezzatura*, rigor the more rigorous for disguising itself as ease. Or else consider John Ashbery's remark "that art is already serious enough; there is no point in making it seem even more serious by taking it too seriously." Non-traditional forms are both urged and solidified by (O'Hara again) "a clearheaded, poetry respecting objectivity." "Urban in theme" probably has O'Hara in mind, since many of Schuyler's and Guest's poems have rural or suburban settings and the landscapes in Ashbery and Koch tend to be imaginary, either surreal or idyllic. At any rate, there is an urbane affection for the face value of everyday things.

Of course the agglomerate breaks down into the distinct ways of the poets themselves. Koch is fantastical and hilarious, though recently his poems have taken more autobiographical, and occasionally elegiac, turns. O'Hara and Schuyler were realists to the extent that O'Hara could say, "What is happening to me....goes into my poems," and Schuyler proposed "merely to say, to see and say, what is there." (To call Schuyler an "intimist" is to link him with the two figurative painters whom he and Ashbery most instinctively favored, Porter and Jane Freilicher.) Although both Schuyler and Ashbery are contemplative, Ashbery's poems devise what is for him "an autonomous world." Schuyler is descriptive, a sensibility poet: "All things are real / no one a symbol."

The arts establish general relations among themselves by esthetic stance and commonality of reference. Underlying the more or less specifically technical activities peculiar to any single art—words on paper, paint on canvas—there is a turn of mind (expressive of what Stevens called "a universal poetry") which by attitude, stance, or world view becomes conversational; it's the pivot at which artists of various stripes talk to one another. The impetus to enter upon such a turn is accompanied by "no sure proof," as Ashbery says, that history will follow:

> To experiment was to have the feeling that one was poised on some outermost brink....A painter like Pollock for instance was gambling everything on the fact that he was *the greatest painter in America*, for if he wasn't, he was nothing, and the drips would turn out to be random splashes from the brush of a careless housepainter. It must often have occurred to Pollock that he wasn't an artist at all, that he had spent his life "toiling up the wrong road to art," as Flaubert said of Zola. But this very real possibility is paradoxically just what makes the tremendous excitement in his work. It is a gamble against terrific odds. Most reckless things are beautiful in some way, and recklessness is what makes experimental art beautiful, just as religions are beautiful because of the strong possibility that they are founded on nothing....

David Shapiro supposes that "the smudges and smears of deKooning aided [O'Hara's] sense of a windblown poetry." Fairfield Porter's perception that O'Hara's "emotion is at

a constant level: it begins and lets off, but does not rise and fall" invokes reciprocity—it suggests a good way to think of certain pictures by deKooning or Kline, or, for that matter, Pollock. Perhaps the "inclusiveness" that Elaine deKooning cited in Kline's art can best be understood as regulated, in both poetry and painting, by, in O'Hara's phrase, "guarding it from mess and measure." O'Hara's personal poems—among the astounding variety of kinds of poems he wrote—are attentive to ordinary details and yet abstract in their overall emphasis. Ashbery's abstract emotion, the pathos and exaltations of an ambiguous character "whose disappointment broke into a rainbow of tears," grounds itself in the impersonal opacity of his syntax.

If, as Ashbery says, "poets when they write about other artists always tend to write about themselves," then Ashbery's remarks on Fairfield Porter's paintings readily place Ashbery's poems in a similar light: "They are intellectual in the classic American tradition....because they have no ideas in them, that is, no ideas that can be separated from the rest." Ashbery quotes Porter's belief that "reality is everything. It is not only the best part. It is not an essence. Everything includes the pigment as much as the canvas as much as the subject." This "everything" principle announces, with no less "classic American" pragmatism, that facts are signs of the life that is there and not delimited by material life. This is part of deKooning's enthusiasm "just to see that sky is blue; that earth is earth...." The peculiar fascination with sheer fact—whether of a day's weather, a swathe of blue paint, or the word "blue" summarily connected—includes an appeal to immanence. Schuyler's "The Morning of the Poem" makes a poetic of willful adherence to fact:

> *So many lousy poets*
> *So few good ones*
> *What's the problem?*
> *No innate love of*
> *Words, no sense of*
> *How the thing said*
> *Is in the words, how*
> *The words are themselves*
> *The thing said: love,*
> *Mistake, promise, auto*
> *Crack-up, color, petal,*
> *The color in the petal*
> *Is merely light*
> *And that's refraction:*
> *A word, that's the poem.*
> *A blackish-red nasturtium....*

When Poetry meets Painting we begin to wonder about Art. We enjoy the adaptability of ideas beyond the circumstances that may have occasioned them. The working premises of different arts reflect each other and define the separateness of the particulars with which they work. Poetry and painting conjoin because artists find it necessary to take their ideas out for a walk. Commenting on the then-current poetry-and-jazz collaborations, O'Hara

wrote to Gregory Corso (March 20, 1958): "I don't really get their jazz stimulus but it is probably what I get from painting....that is, one can't be inside all the time it gets too boring and you can't afford to be bored with poetry so you take a secondary enthusiasm as the symbol of the first...."

O'Hara's poem "Why I Am Not a Painter" advances this artistic parallelism in the manner of a diptych; it tells of two discrete instances—a Michael Goldberg painting and O'Hara's prose-poem sequence *Oranges*—how they happen (*Oranges* in fact preceded Goldberg's painting *Sardines* by six years) and the procedural dialectic they share. The force of O'Hara's analogy sweeps aside minor distinctions between the two art forms, while leaving their real dissimilarities intact:

> *But me? One day I am thinking of*
> *a color: orange. Pretty soon it is a*
> *whole page of words, not lines.*
> *Then another page. There should be*
> *so much more, not of orange, of*
> *words, of how terrible orange is*
> *and life. Days go by. It is even in*
> *prose. I am a real poet. My poem*
> *is finished and I haven't mentioned*
> *orange yet. It's twelve poems, I call*
> *it ORANGES. And one day in a gallery*
> *I see Mike's painting, called SARDINES.*

It may be because poetry and painting are less comparable to each other than to the other arts that their affinity is sealed. Such affinity is at the heart of O'Hara's dramatic monologue "Franz Kline Talking." That extraordinary document, an array of mutually generated probes and piths, reads as an instance of near-collaboration—Kline's impromptu eloquence amplified by the poet's reportorial verve—in the tradition of Gertrude Stein's poem-portraits. But as an interview from the pre-pocket-recorder days it is also fairly straight. In a single draft dated "7/20/58" O'Hara recollected, seemingly without notes, what Kline had said on a summer's day at the poet's apartment on University Place. "Since the painter felt that set questions were too stilted for him, the agreement was that he 'would just start talking.'" The Kline that talks in the text is the self-same conversationalist O'Hara later described as "a serious Bohemian" in love with "paradoxes and theatrics" who "personally held at bay all possibilities of self-importance, pomposity, mysticism and cant which might have otherwise interfered with the very direct and personal relation he had to his paintings and their content."

Kline's ruminations explain much about the common denominators of his work and the New York School sensibility generally. Near the beginning, he says: "In Braque and Gris, they seemed to have an idea of organization beforehand in mind. With Bonnard, he is organizing in front of you.... You see it in Barney Newman too, that he knows what a painting should be. He paints as he thinks *painting* should be, which is pretty heroic." Organizing visibly—in fact, inviting the viewer to confront imaginatively the working mesh of decisions entire—had by then become a standard trope in poetry

and painting alike. Insofar as the image of such activity involved an assertion about the world—or at any rate about art *in* the world (its being, as Kline says, "part of the noise")—anxieties over decorum, or rightness, dog every gesture. You can just about hear Kline and O'Hara in unison issuing the parting shot: "To be right is the most terrific personal state that nobody is interested in."

To see Kline as O'Hara did, as "the Action Painter *par excellence*," meant ascribing to the painter's "action" something beyond Harold Rosenberg's initial telling. It fell to the poets to make sense of Rosenberg's phrase in ways that Rosenberg himself couldn't have predicted. "Action Painting" was never of use to historians and connoisseurs, much less to positivist critics who made plain their hostility to its shamelessly unverifiable premises from the start. Even Thomas Hess, who published the article in *ARTnews*, disowned its eponymous thrust: "I never thought…Action Painting meant a hell of a lot, because it referred to an idea of the painting in the process of being painted…. It could not account for the art." But to the poets many of Rosenberg's paragraphs must have seemed to be covering familiar ground, albeit in a conveniently non-literary context. (A healthy irony prevailed: O'Hara at one point signed off a letter to Larry Rivers with a jaunty "Yours in Action art.") Rosenberg had, after all, only recently come to art criticism from a short career as a poet, and, whether he knew it or not, his vision of the painter's canvas as "an arena in which to act" had at least one antecedent in William Carlos Williams' lecture of 1948, "The Poem as a Field of Action." Process—the act of writing as writing (writ large)—was largely what the poets saw. Thus, Robert Creeley quotes Robert Duncan as pointing to O'Hara's "attempt 'to keep the *demand* on the language as *operative*, so that something was at issue all the time…. We think of art as *doing something*, taking hold of it as a *process*….'" In Schuyler's retrospective appreciation of Kline, a fluency in poetry's endemic way of happening guides the poet's empathy towards better seeing what the painting's "tissue of spontaneities" actually shows:

> *What was wanted was to cause something to happen. Not to stage an event, not to reenact one in a kind of psychodrama, but, having begun to act, to keep at it until a transfer of power occurred. The painting is not a laborious contrivance aping energy as expressed at a significant moment….nor is it a stabilized summary, a what-remains, the ploughed-up field after the battle. It is energy, both random energy and the energy of intention, in an inseparable contiguity. The painting is 'in essence (to wrench Marc Bloch's meaning a little) a continuum. It is also perpetual change.' Kline's pictures occur on the surface, but the overpainting of white on black, the optical shifts of white next to black and of dull and shiny, make a penetrable surface. Like a day when total fog presses on the window, and yet one's gaze goes into it a distance. His paint has that tone of air to it.*

We were grown up but we wanted to taste that special lollipop Picasso, Matisse, Miro, Apollinaire, Eluard and Aragon had tasted and find out what it was like. What *lollipop?*
 —Larry Rivers, "Life Among the Stones," 1963

The quip in *It Is,* that "artists read paintings and look at books," could only have been made in full cognizance of how much erudition went into the making of New York painting. The legends alongside the pictures remind us that most good artists are shrewdly literate, that Rothko knew his Aeschylus, that part of what is pertinent in Pollock came from his reading Melville, or in deKooning from Faulkner, in Guston from Isaac Babel and Kafka, and so on. If, as Betsy Zogbaum says, Kline was "not much of a reader," his fascination with Wagner and with Beckett's plays gave him a foothold when the talk turned literary. Fielding Dawson remembers Kline's language as "historical, dramatic and musical," and that he was "half a poet" in the way he spoke.

Conversely, Gertrude Stein said that she was hopeless when it came to drawing objects; she saw no relation between the piece of paper and the object she wanted to draw. The physical surface luxury in painting inevitably strikes poets as festive. Both poetry and painting have surface, but with poetry the location is harder to point out. It might be defined as a kind of ur-syntax, the elusive parcel of contiguity among various elements. One cannot literally, as painters say they do with paint, "push" words around to have them behave as the work at hand requires. Coming from the rather purposeless-looking scatter of a desk, the poet visiting a painter's studio is stunned by the inherent mysteriousness of an orderly apparatus in plain view.

The poet in the studio is a subset of the "Poet Among Painters" syndrome that had its first modern efflorescence in Paris (from Baudelaire to Surrealism, so to speak) but is recorded at least as far back as Dante's friendship with Giotto. In or out of the workplace, a poet could be, as Koch has said O'Hara was, the painter's "wings of language"—supplying titles or merely mulling associatively over a scumbled patch of green—and at the same time perform as a willing helpmate or stand-in for subject matter. Portraits of O'Hara by the likes of Rivers, Freilicher, Guston, Alice Neel, Porter, Alex Katz and Elaine deKooning probably outnumber those of any other figure of his time. Elaine deKooning once told how O'Hara could pose non-stop for hours in her loft "but then he said he was writing poems during the time."

Considerations of esthetic merit aside (although there is a lot of intrinsic merit in any two serious artists seeing what they can pull off together), the poet-painter collaborations of the mid-50s and 60s stand as emblems of those meetings of mutually inspired creativities which otherwise occurred in private or anyhow without ceremony. Very few were true collaborations in the sense of two people working together on the spot; the best of those done literally from scratch are the Rivers/O'Hara suite of lithographs, *Stones,* and the poem-paintings done by Rivers with Kenneth Koch and by O'Hara with Norman Bluhm. The more usual procedure—whereby the poet provides the painter with a text to which the painter then separately adds an image, or (but less frequently) vice versa—was followed in the portfolio of *21 Etchings and Poems* printed in 1955-58 and issued by the Morris Gallery in 1960, which included Kline's response to a

handwritten O'Hara poem beginning and ending with the line "I will always love you." In the introduction, James Johnson Sweeney called the images accompanying the poems "translations" and announced: "The portfolio serves to revive the attitude that poetry and engraving are married, in the Blakean sense." Kline's contribution was unique among the others in the set for being a photo-etching from an already extant drawing. There is none of O'Hara's "blueness" in it but both the lower and upper blacks work as ledges against which white, like the poem's eventual "snow blown in a window," takes hold. The sharp angles of Kline's ink complement beautifully the loopings of O'Hara's Palmer-method script. O'Hara's love poem, addressed to "a boy smelling faintly of heather," argues the same urgency he saw in Kline's pictures, "the power to move and to be moved," and the drawing redoubles this connection in its play of tangencies, pointed and zooming, by turns.

> *Our best contemporary art critics are preoccupied with assessing, surveying, tallying and rating—with history and with the history of painters, less with the achievements of the paintings themselves and our response to them.*
> —Frank O'Hara, "Nature and New Painting," 1954

Poets who write about art, like the artists themselves, tend piquantly to express the awareness that written criticism of the kind that appears in art magazines is but one kind of entry, and not necessarily the most telling, in the perennial discussion of what art is and can be, as well as of the kinds of expectations it can satisfy. O'Hara wrote in praise of Edwin Denby's ballet criticism that it "penetrates the meaning of our response to a work of art as well as the achievement of the work.... And perhaps the latter is truly secondary, for the achievement of a work of art changes but our response to it is a precise instant in the accumulation of its meanings and benefits from clarification. We do not respond often, really, and when we do, it is as if a flashbulb went off." Kline speaks of reading reviews "because they are a facet of someone's mind which has been brought to bear on the work. Although if someone's against it, they act as though the guy had spent his life doing something worthless." All things not being equal, the best negative review is often a one-liner constituting a passing shrug of disgust: Once, when asked why he refused to go on at length about something he didn't like, O'Hara replied, "It'll slip into oblivion without any help from me."

Kline says, "Criticism must come from those who are around it, who are not shocked that someone should be doing it at all." The so-called "unemployed poets" who wrote regularly for *ARTnews* during the 50s and 60s were encouraged to do so by the editorial graces of Thomas Hess, who let them write reviews and articles their way without imposing a homogenous house style. Himself a sophisticated onlooker—in reviewing Kline's 1956 show at Janis, he quoted Delacroix: "The poet saves himself by a succession of images, the painter, by their simultaneity"—Hess set copy-editing standards that allowed for the idiosyncrasies of "real writers" (e.g. O'Hara, Schuyler and Guest) whose manuscripts were to be less tampered with than those of contributors who, although trained as connoisseurs in or out of the art-history curriculum, had no feeling

for writing as such. When asked by a beginning reviewer for a clear sense of how to proceed, Hess would suggest that the best way would be to tell what you had seen as if in a letter to an intelligent and sensitive friend, thus bypassing the abyss proposed to art writers far and wide as "the general reader."

One facet of the short-review prose block in *ARTnews* as the look changed in the late 50s was its resemblance in format to the shape on a page of a Shakespeare sonnet. James Schuyler told Carl Little: "Every month you had a sheet with twenty-some shows to see. I mean some of them you could dismiss in one line. *ARTnews* had this thing about covering every show in New York.... But I liked very much writing about the Abstract Expressionists, and if I liked the show, I tried to describe it, to say what it was like in a fairly brief space." Writing whenever they can about the art they admire, the poets keep their criticism, like their poetry, unsystematized and lively. Each stays succinctly in character: Schuyler the sharp particularist; Ashbery the (seemingly) disinterested stylist; and O'Hara the rhapsodic insider and occasional slam-bang wit (for whose sense of show-business grandeur MoMA, where he eventually became associate curator, achieved a composite status of the Salons of the *ancien regime* and the 1930s Warners lot). Carter Ratcliff recently described the stance behind the "brilliant buzz" of Ashbery's critical writings in terms that could apply to O'Hara and Schuyler as well: the poet, Ratcliff writes, "wants to be fascinated by the illusions of art and....trusts himself not to be taken in by them." Here are a few samples of each at speed, idiosyncratically chosen:

O'Hara on early Twombly: "A bird seems to have passed through the impasto with cream-colored screams and bitter clawmarks."

Ashbery from Paris: "The super-colossal, lumbering, omnium gatherum art exhibition may one day suffer the fate of the brontosaurus, but it shows no signs of decline in Paris, its preferred habitat since prehistoric times...."

Schuyler on Joe Brainard: "Also a Prell 'shrine.' A dozen bottles of Prell—that insidious green—terrible green roses and grapes, glass dangles like emeralds, long strings of green glass beads, a couple of stands looped up. Under glass, in the center, a blue-green pieta, sweating an acid yellow. The whole thing cascades from an upraised hand at top: drops and stops like an express elevator. It is a cultivated essence of shop-window shrines and Pentecostal Chapels (John Wesley with Tambourines, lugubrious and off-pitch). Its own particular harsh pure green is raised and reinforced until it becomes an architecture. It is to green what a snowball is to white, an impactment."

Ashbery on Josef Albers' squares: "They advance smilingly and surely toward you like a disarming angel.... Albers has succeeded in creating paintings that are impossible to look at in a deep, as well as in the obvious sense, and this perhaps an aspect of the austere goal he seems to have set for himself. For his work invokes a high purity, the gift of coming away empty-handed."

O'Hara at the Guggenheim: "But the Bonnard....did not suffer from the light and the position, as so often remarked, it is simply a property of Bonnard's mature work to look what every sophisticated person let alone artist wants to look: a little 'down,' a little effortless and helpless. He was never a powerful painter, per se."

O'Hara's uncollected short reviews, his piece on Larry Rivers in *The School of New York*, and the three Art Chronicles for the little magazine *Kulchur* in the early 60s are the best of his art writing. The more official occasions daunted him, I suspect, because he was unsure of the audience for them (he had no concept of a general public, and no careerist stake in art history as such, to both of which a museum catalogue is expected to appeal). In those instances, his prose stiffened, and he became self-consciously oratorical. (The introduction for the catalogue accompanying the Kline retrospective that toured Europe in 1964 was an exception.)

Art criticism is, as it should be, a non-profession; yet there are professional critics. Fairfield Porter asks, "Who likes to read art criticism?" and quotes Ben Shahn in reply: "One likes to read it if it is worth reading." The rise in numbers circa 1962 of professional art critics—in the persons of young art historians who took to contemporary art as a province not yet annexed by the academic monograph industry—paralleled the rise of a spectacular art market; the proliferation of glossy art magazines, color slides and postcards; the art-school boom; and the construction of contemporary art museums in municipalities eager for big-time cultural status. Be that as it may, the best art writers of the second half of the 60s were the artists Donald Judd and Robert Smithson, each of them with a distinct, non-institutional prose style and point of view. They were followed in the 70s by the poet-critics Peter Schjeldahl and Carter Ratcliff, both of whom, though more thoroughly engaged in the debates of a codified art world, write as contemporary dandies influenced in their different ways by both O'Hara and Ashbery. (Schjeldahl takes the stance of the impassioned, properly frazzled, frontline commentator, while Ratcliff saunters more at the edge of the crowd, a slyly speculative provocateur.) Other "writerly" critics who emerged later, in the 80s, include Eileen Myles, Edit DeAk and the wonderfully obstreperous Rene Ricard.

In a 1963 account for *Art International* of the Rothko exhibition at the Musée d'Art Moderne in Paris, we find Ashbery performing a feat of more-than-routine critical housecleaning. He may be reacting to the clatter of self-important rhetoric in the art press, or simply keeping to his own distaste for too-overt explication, but having commented on the installation of the show and the Parisians' apathy toward American painting in general, he abruptly breaks off, backtracks, and proceeds to return resolutely face-to-face with the blank grandeur of Rothko's art in near perfect silence:

> I had originally gone on to describe the Rothkos, slightly hampered by the fact that most readers of Art International *know what they look like, and I had produced a text containing the words "shades snapped down against the day," "Rembrandt," "Dominican," "poverty," "Spinoza," and "the all-importance of fine distinctions." After having put this paper aside for a few days and come back to it I was infuriated by the inadequacy and silliness of what I had written. Rothko, like Still and Newman, seems to eliminate criticism. I cannot*

recall reading anything that added to the intense pleasure I get from these painters, although the work of others such as Pollock seems to foster, and profit by, a kind of poetic criticism. But Rothko's lack of intention, his openness, leaves the critic with little to do once he has remarked on it. I do not believe that his paintings allow the imagination any hold, that they are mirrors, screens, doors or any of the other things they have been called, even though the painter may have intended them as such. This is also the feeling of a painter-friend of mine who has been deeply influenced by Rothko, and with whom I have just been discussing his paintings. "Well, what would you call them?" I asked, and he answered, "I guess I'd just call them paintings." This may not say very much, but in my opinion it says enough.

1994

Occasional Pieces

The Art of the 80s

Peter Schjeldahl and I agreed that he would handle the business end of our topic—collecting—and I would assume the position of the more or less forlorn esthete. Although shoptalk is hard to avoid, I gladly tumble to this. I'm "in" art for the pleasure of it, and as far as the practice of criticism goes, I commit myself to that for the pleasure of giving my verbal attention to things that absorb it and pretty much stay put long enough to allow my impressions of them to add up. The critic/esthete proceeds, or stumbles, along the lines of articulated sensation, cultivating a shifting horde of passions, tolerances, grimaces and contempt that are only the temporary side-effects of what keeps promising to be a civilized habit. The esthete knows there is nothing lily-white in this conception of art as a mode of civilized behavior—that eventually he, too, must get his hands dirty. By nature, his attitude toward sensation is no less acquisitive than that of the most rabid collector of objects. Nevertheless, he finds it convenient to ignore that the cherished beauty and grandeur that drew him to art in the first place must have a price tag. The price of glory, even, he must acknowledge, is specific on the floor of the exchange.

The 80s: The glory of the 80s—unless I'm confusing the titular decade with my own middle age (I'm turning 50)—is that it has spelled out the price tags. As Gertrude Stein would have it, "The envelopes are on all the fruit trees." The numbers are up on the gallery walls. Everybody's cards are on the table, face up.

The conception of the 80s is to get on with it—the job, the show, the world that is precisely of our own making, whatever—in spite of everything we know. There is a noticeable—and not, completely healthy—dearth of silliness. To one who, as I did, began to know about art in the early 60s, the retrospect is sobering. The 60s harbored what may have been art's last fling at being genuinely silly and beautiful and pertinent in equal measures. That period inherited the premises of art as perhaps the only activity open to sensible individuals, something a grown-up could do without feeling ashamed. This was a happy story with a lot of built-in despair. Of course, the story began with despair. By now—the 80s—despair is trite, and heroism resides in recognizing art not as part of the solution but as The Problem, the outer limits of an egregious shadow play. 80s criticism has wasted the majority of time—thousands of pages—in post-mortem self-definition, trying to validate the red herring "Postmodern," in the process creating a considerable industry for academics and free-lancers of various stripes to show their stuff.

A few years ago, stuck in midtown traffic, a New York cabdriver turned to me, apropos nothing in particular, and said "You know what's wrong with this town? There's *too many artists*!" After a pause, he added, "And too many *art lovers*!" Are you an artist? I asked him. "Nah," he said, "I just drive cab."

Thinking towards this discussion, I've seen my flash cards turn up in sets of three, a healthy number. I'm going to try to spin each set like a little waltz, melancholy and haywire by turns.

Death, Rigor Mortis, Paralysis. This set constitutes the prime-time conceit of the 80s. (Doom & Gloom & Boom.) Subhead: Painting. The San Francisco Museum of

Modern Art will soon launch its "Elegiac Painting" show, accurately celebrating the ongoing death of painting as well as many, more terrible deaths. Forms die, but a dead form keeps coming out of living necessity, an insistence like "yes, we have no bananas." Since painting is my first love, and as a writer I will probably follow it to every possible demise, I work the critic's graveyard shift. More accurately, painting, like the sun, is *dying*. Like Greta Garbo, painting says, "I am in mourning for my life." Glorious assumption, or maybe just covering its bets.

But actually *all* physical forms are implicated in this death principle: Sculpture is said to be alive and kicking. (The "kicking" image is literal if you think of Joel Shapiro, Bruce Nauman and even some of Jeff Koons that way.) But sculpture is inherently a tomb. Photography is a cenotaph. Video, a funeral procession. The art film, according to its erstwhile champion critics, has dreamed its last little dream, except for a few sleepwalking necrophiliacs in San Francisco. Hybrids, on the other hand, are thriving, though short-lived.

Meanwhile, Conceptualism knuckles down, diagramming a general paralysis. Having no body (I don't knock it), it is spared every bodily indignity. John Baldessari, who had a hand in shaping Conceptual Art practice, told me of his dismay at what he may have wrought: his students, he said, "do theory—nothing physical about it." Theory is interesting—if only the students would read a wider range of books.

Idealism, Conceit, And The Test Of Faith. An interesting reversal: the audience has more faith than the artist. The audience's conceit is that the artist is better than they are at making sense of this life—of producing "meaning," as they say in the trade. Every season has its test of faith administered by at least one artist who might just be delivering the goods: beauty and grandeur and big upsetting ideas. Anselm Kiefer and the Raiders of the Lost Ark. Jeff Koons as Luke Skywalker. Religious art is hot. This past December in New York, conversations identified the awesome threesome of Courbet, Degas and then Jeff Koons—which made perfect sense in contemporary terms: Courbet the nervy interloper (who, like Julian Schnabel, could paint both real and terrible paintings that told more than he ever knew), Degas who made a nearly perfect art representing some of the worst-case scenarios of bourgeois life (self-absorbed men, tortured women, children in straightjackets); and Koons who portrayed the ultimate conundrum of to what lengths we are willing to go to see: our theology made visible. Koons is perfect. The critical discrepancies around that show were perfect: The talk on the street loved it, the proper critics berated it, Peter Schjeldahl saw it for what it was (I admire and couldn't begin to encapsulate his argument). One magazine editor refused to allow the Koons show to be reviewed at all; she said it represented "the bottom." But, as we know, all bottoms are false.

My last triad is *Power, Pessimism & Impulse Buying.* I'll encroach on the top of acquisitions to this extent. The 80s is a Dark Time, pessimistic in promising darker times to come. The artist, the critic, the corporate manager—they all know it, feel it; it goes with the territory. What's amazing is how professional everyone is at playing out the darkness, the feverishness inside. Contemporary poetry accommodates the language of the marketplace (and not just for satire). Management speaks of entering "the era of paradox." The executive artist has his headaches, too. Corporate powers, I believe, go for

the art that accounts for, and answers to some extent, their anxieties. Like art, money has to go *somewhere*. Critics want to have fun. Impulse buying—really the only way anyone buys art—assuages our very real feelings of helplessness and futility. The white flag fades, van Gogh's irises peel. The contrary figure of the Machiavellian artist (Koons as the Prince of Darkness) is such small potatoes in the general economy, and yet it could be that only a very cunning practice (such as his) upon the most unpromising materials will do the trick—give us the art we demand.

Manners change: I remember a wonderful New York painter arriving in San Francisco from L.A. and behaving in the most arrogant manner for hours until finally he said: "You'll have to forgive me—I've just been to Joan Collins's house!"

One thing I'm tired of in criticism is how expert we've become at getting the goods on art and artists. How easy it is to be right, to detect shrewdness in even the most hapless, supernumerary quarters. But the issue of art must be both larger and more specific than current critical vocabulary can allow. Philip Guston wrote in a notebook: "Human consciousness moves but it is only one inch…. You can go way out and then you have to come back—to see if you can move that inch." More to the point than all the so-called "discourses" seeing into and expressing how things work is the perennial requirement to account for the inkling of what got me into this mess in the first place— that, elusive as it may be, art represents a truth beyond our conceptions, beyond our expectations. If as a critic I remain relatively unprincipled, an amateur at heart, it's because my pleasure in art almost always comes from works that outstrip anybody's principles, and at which point everyone, the artist included, *should* feel amateurish, a bit humble. I like this age for what it doesn't promise, its art for being (as ever) analogous to the way we live: the present character is akin to a twenty-story swimming pool from which we hang by our thumbs.

1987

"What Are We Celebrating?"

Mark Van Proyen noted earlier today that he and I, the only two critics on these panels, are also the only two "white boys." And he followed with the logical question: where are the critics of color who ought to be here? I must admit that I repeatedly tried to shy away from this occasion. What do you need me for? What have I got to do with the questions Carlos Villa has posed? My troubles begin with the first question, *where are we?* How specific is that *we?* In this instance, Carlos's *we* prompts what I feel to be an all-too-circumstantial crisis of self-identification. Where are my call letters, my credentials, and, oh God, my excuses?

It is the privilege of the members of a dominant culture group to appear as generalized as that culture pretends to be. "I'm an ordinary person," goes the song, with a modicum of relief. I am reminded of W. H. Auden saying that it took him 50 years to realize that he belonged to exactly the same class as his parents. I myself, turning 50, am

no boy. I am a spin-off of the uptown, urban middle-class who happens to live in a kind of Brigadoon-by-the-Sea in Northern California. When I publish my art writing, I am conveniently identified as a "poet who writes about art," or a "poet and critic who lives in Northern California." It is not hard to imagine another version in other circumstances: "Bill Berkson is a *white* poet and critic who lives in Northern California."

What Are We Celebrating? Indeed. I wonder at the hint of self-congratulation in this question. My original take on it was that we are living in a Dark Time, so we must be celebrating social, economic and metaphysical darkness. In the past 15 years, many dreams have collapsed to form a very dense, seemingly immobile mass that is the present piece of cake. A tiny percentile of the human crowd that has gravitated thereto gets a nibble. Death and paralysis have been the major conceits of the Euro-American art of the 1980s. Last night when I told a critic friend, Peter Schjeldahl, that I was doing this panel, he said that I was cast as the sacrificial "white liberal." But that is not true either. I am not a liberal. In effect, there are not any *white* liberals anymore; liberalism as far as the dominant culture is concerned, has collapsed. In that respect, we need a new idea.

I am sure all this has something to do with art, which has something to do with the order of things. The art of the 1980s has been identified as one of "doom and gloom and boom." There are signs that now for the 1990s, we are emerging from an egregious pessimism. Maybe that is the agenda of *we*. Actually, the optimist in me always reverts to another, more obvious agenda, another sense of "dominant" culture, which says, simply, "Everybody knows better." In his 1959 poem "Ode: Salute to the French Negro Poets," Frank O'Hara put it this way: "The only truth is face to face / that dying in black and white / we fight for what we love, not are."

The silence of the art world I know regarding the issues this symposium means to discuss is dumbfounding. The art world can handle esthetic diversity, not the proposal of literal, specific *differences*. Of course, there is something irresponsible in that, especially at the level of public institutions; but demographics are demeaning—a kind of multicultural bingo—and fairness has nothing to do with taste.

"The only truth is face to face" supersedes all kind of cherished notions of race—including racial pride, otherness, doubleness and so on. The agenda for art and artists of color for the 1990s is to do what any artist does—decide what you want to see and make it visible; decide who should see it and show it to them; decide what the relationship of your art should be to whatever number of people and do what you can, in and out of the work, to make that happen.

I will edge out on one last limb for the sake of thickening the plot and maybe eventually clearing the air. The statement made earlier, "People of color in this country are by tradition, if not nature, in tune with higher sources" with ears "tuned for….important utterance" is one of the most self-defeating propositions an artist can make. It is disastrous, reverse snobbism; and, worse, it smacks of tourism within the artist's own given self. You can wear a very deep rut for yourself and your art by that kind of thinking. It is fascinating that, within the art world I know, issues involving people of color have been lately and most noticeable dealt with by white artists. I am thinking of Sue Coe's work on South Africa and Malcolm X, and Michael Tracy's *Santuarios* for the Mexican *mojádos* and the people of El Salvador and Nicaragua. When

Sue Coe was here at the Art Institute, she pointed up an interesting distinction: that, as far as she could tell, high art in official circles means art that doesn't mean anything, and that art that means something is propaganda. She was happy to identify her art as propaganda. Be that as it may, her art has the power and the access. I assume that *access* is what is most being discussed here, or do I presume?

As someone who looks at art and writes about it with a sense of necessity, not to mention immense pleasure, I refuse to be a tourist in either my own or anyone else's aesthetic neighborhood. I am hardly an official character, so I do not feel in the position to validate; nor am I a propagandist for anything but my own impressions. A lot of art does not speak to me, and I generally assume that those works do not really have me in mind, which is OK. As for the other forms of access, the corporate use of art, which now includes the usage of major museums as showcases, has prompted an art that serves as a very high-profile form of exchange, as complicated as money. It is unlikely that much specifically ethnically-based—or regional or neighborhood art—will find a place in that scheme of things; it is unlikely that such art would want to.

Good luck to us all.

Over-40 Panel, San Francisco Art Institute, 1989

For the Ordinary Artist

"Quality" is not a word I find readily in my critical vocabulary. In fact, I can't remember ever having used it in either talk or writing about art, though, thanks to Clement Greenberg, I remember reading about it and marveling at the authority with which Greenberg himself could employ the word. In print, "quality" is a heraldic device of evaluative criticism; everyone knows it's sheer rhetorical bluff, whatever complex of deep feeling may lie behind its usage. Feelings are for real. Validation stickers expire. Opinion and taste, especially when divisive, are tedious. Unless a moral is drawn among differing views, who's to care if you like something and I don't?

I take things in art as they come, attuned to my sensations and a few mental faculties. Therefore, I have no idea of quality out front, no a priori judgment. But I do have a sense of how art should be, and I demand that anyone's art show me the artist's idea of how it should be, what the artist wants to see, even if that "what" is not quite there. Artists divide and mingle along the lines of idealism and conceit. Idealism implies some important reason for becoming an artist and sticking with it. Conceit is just about everything that leads an artist away from the prime objective. Conceit is often idealism swallowing itself, and often there is really nothing to see.

Quality may be the last thing I see. I wait for art to show me its quality but I don't expect it. I can be interested without seeing whether a work is any good or not—interested, that is, in what it's doing in its allotted space, in what it tells of, in what might have occasioned it. Almost any work has certain qualities—identifying marks and characteristics—and those are what one's after in describing what is there, in criticism.

I've had people say to me about particular reviews, "That was an interesting piece of writing but I couldn't tell whether you liked the work or not." Honestly, liking it or not was not the point: engaging the work in terms of its being in the world, as a particular kind of human behavior—and then perhaps responding to it according to one's passions—is the point.

Just as in the world one looks to see people behave so as to fill out their peculiar frames—to be themselves to that outward extent—in art, one delights in a diversity of orders. You want everything to be great in its way. Juan Gris said of his work: "My painting may be bad painting, but at least it is *great* bad painting!" That's the general idea. Greatness isn't sacred. And nobody's circumstances, condition or materials are all that sacred either. They are ordinary parts of the conversation that art allows and should be recognized as such.

An important figure in my mythology of art making is the Ordinary Artist. The Ordinary Artist is the one who just does the job. No sweat. The Ordinary Artist does whatever comes to hand along with an everyday will to art. A few months ago I read of a poll of women in New York City designed to find out what sort of men they liked to be with. They said poets were very low on the scale—even, as one woman said, "if they rhyme." On the other hand, artists rated very high; they were typified as "sensitive, soulful, and they draw your portrait on a napkin"—which I think of as a terrific way to conceive of artists.

The Ordinary Artist is akin to the Hometown Artist—a painter, say, who can plant a tree, paint your portrait, decorate the facade of the grocery store, design local ceremonies or ballet sets, join the fire department, teach the kids, run for mayor, or just be somebody alone muttering in a room. Your basic artist. It seems, however, that both the big-time art-world artist and the multicultural artist (in or out of the big time) are denied this role. The burden of the Big-Time Artist is to maintain professional, even institutional, consistency—to protect the self-styled logo she has devised as currency for whatever her art wants to put across. The burden of the ethnically defined or multicultural artist is to foreground what Greg Tate calls "cultural confidence" and to make that take on institutional validity—whether matter-of-factly or defiantly or, as happens more often these days, ironically (thus critique-ing both sides of the coin).

A plausible description of the Ordinary Artist's work—by Ron Padgett, of George Schneeman's paintings—runs like so: "It is beautiful—mild, balanced, well-drawn, firm, straightforward, and sometimes serene. It is also light, modern, attractive, clear and likeable. It is not outrageous, declamatory, shocking, sneering, trendy, bizarre or shrill. It is good. Sometimes it is affectionate."

Provisionally, I am committed to living in this volatile and multiplicitous culture that I accept in some of its parts as my own. I respond to a lot of art as being within the scope of that culture—my scope. I have to think more than twice to see things otherwise. The main thing in art is curiosity: something is there, what is it, and then what can be said of that fact? Ezra Pound—a poet not given enough, one might say, to a multicultural understanding—uttered the truth that when a writer loses his curiosity he's dead. A critic's education continues—not out of a sense of duty, not even because he cares about

being right—but because his critical scope is commensurate with being alive in the world, including being more than a punch card of pre-engineered cultural reflexes.

A Challenge to Institutions, San Francisco Art Institute, 1990

Does Timelessness Count?

"Timelessness," which strictly denotes a condition of being without beginning and end, serves as a misnomer for two kinds of esthetic duration. That these two can intersect is implied by Philip Guston's remark (apropos two very different artists, Rembrandt and Piero della Francesca): "Certain artists do something and new emotion is brought into the world; its real meaning lies outside history and the chains of causality."

The first kind is staying power, a work's capacity to survive—or even gloriously, to transcend—the historical moment in which it is made, not just physically (or in some cases, not at all physically) but esthetically and conceptually. Anyone familiar with art knows the intensity—or what Whitehead called "the throbs of pulsation"—with which particular works can compel other-than-archaeological attention over a century or more. Ever more complex returns of attention here are the key. Implicated sporadically in all this attention getting is esthetic pleasure, which, as Kenneth Clark once observed, has the duration of the pleasure in smelling an orange.

The second kind of "timelessness" is the flash or drift or barest ripple of esthetic transport in the face of a single work—the epiphanic moment that yanks you out of your shoes or, conversely, so fixates that a time shift occurs, and a sense of open-ended revelation. Such revelation often has as its instrument on both sides an intuited disposition of mind—or attitude. The meeting of attitudes is akin to a two-way direct address across time. But before you can recognize that this meeting has occurred, the event has soared, and you with it.

"Timelessness" generally has a strange, false ring of permanence. Tied to the canon of "great works" and the oracular rhetorics that support it is a notion of permanence as a pedagogical device prized for its convenience especially within entrenched but otherwise unstable cultures (our own, for one). A poem is timeless as long as it stays in the schoolbooks, or a painting so long as it isn't de-accessioned from the sites (exhibition wall or postcard rack) of official memory. That anything gets past the security checks — into the general culture, as it were—often seems a stroke of luck. We can easily imagine the art museum in its decrepitude housing a surplus of time: a checklist of specimens divested of the varying degrees of importance that had once been assigned to them.

Whatever exists must first appear in some circumstantial relation. And, obviously, whatever is timeless must first be timely. Timelessness is very thin. An idea of it in terms of unalterable values would now seem farcical, if not egregious. Every artist's

15 minutes of fame argues for a "posterity" equivalent to an art mover's van stalled at the next traffic light. Value, we tend to think, has moved on.

In the panels for his 1986 "Seasons" paintings Jasper Johns shows an agglomerated fullness of artistic and everyday life—or the life of images as ideas of material things—abutting to a void depicted within the contours of a front-view, full-length human figure. The panels are busy with information—weather, recollections, affectionate personal asides, stuff mixed and matched (the matching occurs often as puns). The human image and its chill gray interior just stand there, a nudity of sorts and an upright blank, having just made a lurching entrance. For the template, Johns had a friend trace his, Johns's, shadow on a large paper sheet. Standing back from the pictures, I was struck by their timeliness, how they matched the shades, tones and stances of the gallery crowd. They did this with a just-so consistency that could only be called "classic," not a tick on the fashion clock at all. Contrariwise, across the street at Mary Boone's gallery, Ross Bleckner's stripe paintings looked nervously geared to fashion. No less serious or elegant—and no less blank in the right places—they were limited only in *wanting* to ingratiate the moment that Johns had already absorbed and carried off. The younger artist was wooing history; the older one had somehow met its demands as integral with those of his own continuity.

DeKooning's backdrop for a dance performance (*Labyrinth*, 1946), seen lately at the De Young, has an impact beyond both its original stage use and the history of deKooning's art. It is a ragged, large, mysterious, funny, scary, walloping picture. It was also lost for while, rolled up in the choreographer's loft, presumed not to exist. Now we have it, and it doesn't fit anywhere, except that when you confront you are amazed. DeKooning as an artist has, according to varying points of view, survived or outlived his moment: he is gloriously out of it—the greatest living painter is *all* he is. A few years ago, in a talk at the Art Institute, Alex Katz remarked: "After a certain time painting seems an old man's business. You're out of it, and you just paint masterpieces." Katz's sense of "masterpiece" is professional and precise: it focuses on artistic activity in a condition of impersonal mastery, not on the object itself as having any value other than as evidence of that condition. DeKooning shows what art can be. But, as Peter Schjeldahl put it, we appreciate in deKooning "the imagined possession of a perfect instrument with no proper function." DeKooning's mastery, even as early as 1946 (when he was in his 40s), has more than a craft aspect; his ultimate instrument is attitude. As history goes, attitude becomes a vague glimmer; but in the painting as we look at it, the attitude stays palpable across time.

Historical validations expire, but one has epiphanies. Somewhere between appearance and fatigue, any work negotiates its peculiar measures of provisionality and rightness, intermittence and impasse, transcendence and fact. What Guston called "a new emotion" may be an astonishing aperture giving onto the bedrock necessities of consciousness (or, as Guston also put it, "a necessary and generous law"). Circumstances provide the code, but the necessity lies elsewhere and outlasts them. You spend the rest of your life replaying and sorting out the ineffable as if to regain a practicable equilibrium. To that extent, one's long love for particular works is inductive and intellectual, because one wants to *know* them. The constancy involved is less a matter of wooing history or

eternity than of how inexhaustible the thing may be in its various aspects and completions. Inexhaustibility—that one is never done with seeing whatever has come to spell some vivid edge of sense or amplitude—is as close to an actual definition of timelessness as I would think to get.

<div align="right">1990</div>

The Salon at Mission and Third

There was a healthful porousness about "In Out of the Cold," the inaugural show at the Center for the Arts in San Francisco's new Yerba Buena Gardens. This salutary effect followed partly from the ample breathing spaces of Fumihiko Maki's building, empathetic to local drifts of light and scale, and partly from the way the presentation of the show itself, which was about duress and empathy on a global scale, by turns acceded to and smartly modified the givens of Maki's largesse. Playing fast and loose with sociopolitical myths and positionings of the past half-century (and in some cases, more), the show gathered to its complex theme an amalgam of contemporary art works and historically charged non-art oddments. One could, for instance, turn from the ironic gauds in Ralfa Valentin Gonzalez's depiction of mariachi *conjuntos* in heaven and hell to the earnest pallor of a plaster replica of Tiananmen Square's Goddess of Democracy made in San Francisco by Chinese political refugees and feel ever more happily inclined toward what the show's accompanying catalogue text calls "the refusal of dualisms."

Permeability was the message of the two most visually bountiful set pieces on view—beekeeper-artist Mark Thompson's funerary vault of translucent, beeswax-coated Plexiglas blocks and Gregory Barsamian's strobe-animated spin cycle of helicopters turning into angels and back again. These two works also happened to bracket everything else by dint of appearing respectively first and last in the main body of the exhibition. Thompson built his chamber floor-to-ceiling within a specially partitioned, windowless anteroom at the top of which one of Maki's many skylights provided both a light source and a point of passage for the comings and goings of 30,000-odd constituents of a beehive nestled in the rib cage of a waxed-over bull skeleton reclining on the floor. The interior tableau, inspired by an ancient Egyptian rite of symbiosis and renewal, was visible through narrow apertures lined with wire mesh at about waist level. Approaching this sanctuary by way of a slight jog just inside the first main gallery, you immediately caught a seductive whiff of raw honey. A tape of Yugoslav peasant farmers' vocalese, imitating bird and bee sounds, augmented the feeling of murmurous aspiration Thompson set into play as the exhibition's keynote.

No less literally highminded was Barsamian's imagery of airborne metamorphosis in the final gallery upstairs—even if it was all an illusion produced by a series of small clay sculptures tilted out on wires attached to a motorized disk hung from the ceiling. (There were in fact just one helicopter and one angel, plus a dozen or so transitional shapes between. But the intervening elements whizzed by so quickly that you

<div align="right">221</div>

saw them as contiguous phases in a single time-lapse unfolding.) Perpetually whirling and flickering in the otherwise dim room, Barsamian's spectacle put a cap on the restorative intimations of Thompson's piece, both morphologically and in terms of prolonged delight.

As it was, "In Out of the Cold" arrived relatively unheralded amid the more general buzz accompanying the public unveiling of the Yerba Buena architectural complex as a whole, which had been fitfully in the works since 1980. (The plan for some such complex dates back to 1964, when the immediate neighborhood, long known for its dim bars, X-rated theaters and pensioner hotels, discomfitingly near to the financial district, was slated for large-scale cosmetic overhaul.) Sheathed with corrugated aluminum and affording glass-wall views of the world outdoors, Maki's sleek, low-slung shed sits on one corner of the redevelopment expanse, at the busy intersection of Mission and Third streets.

Because Yerba Buena and its environs continue to be linked to the downside of human vicissitude (a short walk still gets you to the epicenter of desolation midtown, at Mission and Sixth), it's fitting that the Center be geared to become an arena of debate over what most pertinently constitutes serious contemporary-arts expression in the city. The San Francisco Museum of Modern Art's imposing new building, directly across Third Street, is scheduled to open next January. Already speculation is rife as to what this face-off between two major visual-arts institutions with sharply divergent curatorial agendas will mean. The museum has so far acted, with impeccable logic, as a showcase for institutionally manageable museum-type art—granted that the type comes now in ever more variously recognizable configurations and shades. Contrariwise, in the words of Yerba Buena's Renny Pritikin who, as artistic director for visual arts, masterminded "In Out of the Cold," the plan at the Center is "to balance the availability of institutional authority to groups that have in recent decades begun overcoming inequities on the political level." Since Pritikin came to his present position from 13 years as a director of New Langton Arts, arguably the most vivacious of the Bay Area's many enduring alternative venues, it's assumed that his balancing act will entail greater civic prominence for the often rag-tag and/or overtly political kinds of art to which he's been committed by long practice. Certainly, nothing in the present show was inconsistent with that assumption. The question hangs as to the makeup and numbers of whatever more general audiences Pritikin's normally attitudinal, avant-garde-ish offerings will draw. (During its first, admission-free week, the Center had some 50,000 visitors: thereafter, the attendance figures tapered off, though remaining respectable, thanks in part to large numbers of senior citizens dropping in from the immediate neighborhood.)

The rationale and, ultimately, the prevailing meta-esthetic for "In Out of the Cold" was Pritikin's. The title satisfied the need for a heading pliable enough to cover an awesomely comprehensive thematic premise (mainly, a hither-thither sifting through the manifold cultural implications of the Cold War and the seemingly irremediable chaos that has followed) as well as to get a grip, pincer-fashion, on the quasi-encyclopedic range of things Pritikin and his assistant, Rene de Guzman, chose to exemplify it. To claim, as did one of the promotional brochures, that this range amounted to "a snapshot of....diversity" seemed both true and overly modest. But a certain modesty was one of

the show's overall strengths. The selection reflected the ambition to be world-class while holding to a predominantly local-artists base. Roughly sixty percent of the thirty-five artists involved live in the San Francisco Bay Area, the remainder having been pretty well drawn from far and wide. There were, as the critic Jeff Kelley put it, "immigrants, a drag queen, a twin, a Native American Vietnam veteran quadriplegic, famous artists and lesser known, old and young, a Christian artist, and the spouse of a descendant of the Romanoff family line."

Contending with the twenty-five-foot ceilings of the galleries on the first floor, Pritikin stacked a number of his mixed-media wall groupings from the baseboards upward, suggestive of a latter-day salon. In order to adjust the scale of the architecture to suit that of its contents, he also built into the main hall's vastness a central cube of contrastingly compact proportions with doorways for entering four separate ethno-specific installations by Betye Saar, Hilda Shum, Carmen Lomas Garza and Lyle Ashton Harris. Elsewhere in the same hall, in a headlong surge of presentational glee, Pritikin made a wall of wonders, led off at one end by Andrei Roiter's sculptural glosses on the shabby production values of Soviet surveillance and propaganda systems and terminating forty-four feet away with George Legrady's interactive CD-ROM archive of his family's life in Hungary under Soviet occupation. In between, the eye was set free to bumble among the tilts and gibes of Jerome Caja's exquisitely tacky, bite-size, nail-polish-and-eyeliner paintings and the multilingual plaster hand signals of Thet Shein Win's *Urban Mudra*, or else to zoom aloft to one of Manuel Ocampo's enormous retablos (this one declaring "Adios" to Church, State and the recently deceased TV actor Herve "Tattoo" Villachaise, as well). Immersed in the overall array, you could feel at every point the onward tug of a big idea being put forth swimmingly. The resolute curatorial focus had the virtue of calling other, even bigger contexts to mind; thus, a feeling for what or who was missing—kinds of art, artists and the issues they would raise—was implicit in what was there.

"Cold" in Pritikin's terms meant, to begin with, the Cold War, understood in retrospect as an infernal centering device issuing forth, from either side of the superpower divide, a tundralike glaze of cultural uniformity. The ideological succinctness in Cold War alignments, together with the maniacal excesses of the arms race, was tidily sent up by Paul Kos's 1990-vintage row of fourteen gray-painted cuckoo clocks (retroactively prophetic, with their hammer-and-sickle pendulums, of the dissolution of the 14-member Eastern Bloc) and Chris Burden's grid of 50,000 nickels topped with matchsticks, constituting *The Reason for the Neutron Bomb* (a nickel and match for every Warsaw Pact tank aimed westward in 1979, when Burden made the piece). Tellingly, Kos's and Burden's by-the-numbers orderings shared the first gallery with a vitrine bearing irregularly shaped relics of recent history: shards, one each, from the Berlin Wall, Muammar Qaddafi's bombed-out home, and a camera shop set ablaze in the 1992 Los Angeles uprising. From there, in the seepage from militant dualities and their no-less-anxious aftermath, Pritikin envisioned the eponymous chill extending readily over fringe areas of what he calls "dislocation, diaspora and exile," to which are consigned those who don't fit any mainstream cultural scenario, whether of the latest overriding nationalism or the countless splinter ideologies we're left with as old-time allegiances flake apart.

The world Pritikin describes in his catalogue preface is a fearful mess in which "identity....is problematic, at worst fractured, impure, imposed, constructed of signs, and at best mobile, hybrid, multilayered and complex." Signs of displacement—habitual to the art world and to the streets around the Center alike (in the 1970s Pritikin himself lived close by what is now the Yerba Buena site)—are alluded to briskly in the catalogue, but in the exhibition proper they appeared in force, pointedly in Elaine Badgley-Arnoux's collaboration with people living on the South-of-Market streets to produce a wagon-train circle of shopping carts, each covered with paint-spattered canvas and holding a placard inscribed with a personal tale of survival against heavy odds. (Despite official policy to the contrary, San Francisco police had begun confiscating carts from the homeless in early October, just before the show opened.)

Pritikin's thesis, with its glimmer of promise, was neither heavyhandedly put forth nor, finally, as half-baked as it might have seemed. (During the latter half of the 1980s, for instance, anyone could have noted the synchronicity between the developments of perestroika/glasnost and American institutions' embracing, however haltingly, of art works characterized as "oppositional" along with, eventually, their "multicultural" equivalents.) If the title's prepositional phrase "In Out of" was meant to suggest that some assuasive power might be at hand, Pritikin made a stab at describing at least the mental conditions that could qualify for a more survival-apt future. He writes of a political world "now better understood as a complex and ever-changing ecology of interdependencies" and follows through, speaking to his own purposes: "This exhibition....presents work that addresses a reformulation of political and cultural boundaries without employing outmoded models...." To replace the "outmoded," Pritikin fixed on the sculptural mold as "the epitome of mischievousness.... simultaneously a positive image, a negative image and a third thing...the unexpected alternative." As it happened, this ethos of "the mold itself" could be seen as the guiding principle for Pritikin's curatorial handling throughout. The felicity of Pritikin's own curatorial handling showed in subtle blendings-cum-recapitulations of typology and theme, as well as in occasionally shrewd softenings of standard institutional framings. There were in fact many molds, literal and implied, whichever way one looked, from Cherie Raciti's hydrocal body-part casts to the glove forms Betye Saar used to represent the migratory spirits of the African Diaspora and the surgical trays and cast-urethane antlers of the Korean-American conceptualist Michael Joo.

Given the regulating pressure of a historicist theme, the show's miscellany kept a fairly constant momentum. Within a multiplex of rhymes and cross-references, each work "read" well enough into the next that there was no opportunity for any single piece to assume exceptional importance. The word on the street was that, even if you didn't have a taste for this kind of theme exhibition, the Barsamian and Thompson pieces were worth inspecting. Further plaudits went to Legrady, the Korean-American conceptualist Michael Joo and Alfred J. Quiroz (whose *Novus Ordo*, a map-mural caricaturing just about every identifiable head of state, served implicitly as a logo for the entire show). Beyond those, David Hammons's *Black Star Line*, a massive painted-plywood star connected by a green-tinged hawser to a cleat, exerted an outright *force majeure* that was otherwise absent (presumably because unwanted) in the art on hand. There was consensus about which

works succeeded, but no agreement as to which works were discountable. In terms of visual appeal alone, very little looked all that great: obviously, "greatness" in a show that revels in egalitarian demographic vistas would be some kind of gaucherie. Some pieces made their points and nothing beside, while almost all appeared high on provisionality and insouciant about questions of high-art status. In terms of sheer getting-down-to-cases, Stephanie A. Johnson's installation of post-office boxes as sites for direct, if anonymous, monetary exchange took the prize for candor. Its instructions read: "In the spirit of Ujaama, take a dollar if you need one; leave a dollar if you have one. Dollars collected will be given to children for art." (The piece raised some $1,500 for children's art projects by the closing day.) The most elegant-looking sculptural object as such turned out to be a gold-plated missile-guidance system on loan from the Air Force Museum. There was no abstract art at all. (If, as the story goes, the success of "American-type" abstraction was a sidebar to Cold War politics, then some sign of it—at least in the form of an ironic commentary—seemed warranted.) Some thought the assembled works erred on the side of mildness. But the more or less consensual artists-and-curators' non-aggression pact with the Center's anticipated audience could be seen to jibe with whatever few, faint tingles of clearheaded pragmatism might be detected along the current geopolitical spectrum. Here Pritikin made his agenda plain: when asked about the decision to keep the show relatively tantrum-free, as against the scorn-and-scold barrages of other similar "identity" shows, he took the question as a measure of professional responsibility: "Multiculturalism is not the enemy," he told me. "Sloppy curating is the enemy."

Cumulatively, the facets of Pritikin's thesis allowed for a dazzling mingle of short- and long-term memories: the Cold War lasted nearly half a century; there were histories alluded to in the show which reach back hundreds (and in the case of Thompson's "Egyptian" room, thousands) of years, and still others that find their inceptions within only the past decade or so. By my calculations, the median age of the artists was 42, which yields an average birth year of 1951, or right about the time the terms of the Cold War era had settled into place.

1994

Things in Place

There's an apple on the table
It's dawn
I die
—Frank O'Hara

Within the momentous calm of Piero della Francesca's fresco of the Resurrection, the soldiers stationed at Jesus' tomb appear to fall apart from one another, as Roberto Longhi remarked, "like four quarters of a fruit." In Piero the world appears so abruptly fixed you sense it might explode in an instant. It's often noted that even his battle scenes smack of things scrutinized in repose, that he painted people as if they were still lives. A still life in the present exhibition, Manny Farber's *Cherry Pits, Onion Flowers*, shows a souvenir detail (the "sleeping-soldier" self-portrait with goiter at the neck) from Piero's picture and, diagonally across from that, a reproduction of a painting of three household vessels by Giorgio Morandi, the "little master" who, more effectively than any other painter in this century, continued Piero's rare type of "just-so" alchemy worked upon physical reality, albeit in a deliberately humbler, homespun fashion.

Farber's painting conflates his avowal of this tradition to which any painter might aspire (other figures in the tidy lineage are Vermeer, Chardin and Cézanne) with his willingness to work out what Samuel Beckett called "a form to accommodate the mess." The range of Farber's mess, its lush, unparsable whirl of debris, is plotted and observed from above and includes beside Piero, Morandi and eponymous flowers and pits—artist's utensils, strewn twigs and eucalyptus leaves, a flattened cigarette butt, a magnifying glass and several spots of what looks to be plain, scrubbed-on oil paint. Some of the brush marks arc or trail off so as to show signs of flux within the rigid no-dynamic of Farber's characteristic square panel format. Farber was an abstract artist until the early 1970s; the flat ground of his picture is divided into two shades of red that won't quite say "tablecloth."

Any still life, whether a painting, a photograph or most peculiarly in modern times, sculpture, tells a story of basic, momentary material existence external to ourselves but with which, by dint of shared conditions, our own existence is nonetheless inevitably linked. Whatever the associations, social or private, among the objects presented, the terms of elemental physics obtain: gravity, light and the surface aspects of solid bodies work their enigmatic spells across the hoard. As convention dictates, things of this world, portrayed in analogues of their known contours, masses and textures, rest along some satisfactorily stable-seeming, horizontal plane. And right there the drama, generally infused with sizeable waves of empathy for the transience of any earthly state, begins. An apple on one corner of the desk reminds some poet or goodly friar of the deliquescence of the flesh; lurking deep in the cornucopia is a ghastly skull, which, when shaken out, brings home the vanity of all our molecular fuss.

Denis Diderot, whose great immediate example was Chardin, recommended "a law for genre painting and for groups of objects piled up pell-mell. One must suppose

that they are animate and distribute them as if they had arranged themselves, that is to say, with the least constraint and to each one's best advantage." In the near world of still life proper, where a setup doesn't serve as incidental dressing for a more dynamic scheme, human presence weighs in as an attribute of inanimate stuff. "The pots and pans of the burghers," in deKooning's phrase, "are always in relation to man." Evidence that some human agency is implicated in the scene lends further urgency and/or poignance to an otherwise eerily static situation. It is also the only defense against Pascal's charge that painters compel us to look long at things so banal they normally would not merit any attention at all. A tabletop depicted with various things set upon it is a handy stand-in for the private psyche. In painting, where the spread of paint across the physical support often evokes permeations of consciousness or memory, the odds of symbolical resonance are thereby doubled.

The traditional basis of still life is silence. Following on the Dutch *stilleven,* the indigenous French term in Chardin's time was *la vie silencieuse* (or *la vie tranquille*). *Nature morte* came skulking in from Latin. Here silence is declarative, like a gasp, and stillness (the fixity of that which stays put long enough for one to contemplate it) is pro-visional, like the grammarians' idea of a sentence as a complete thought. Francis Ponge says, apropos Chardin: "If one takes the down-to-earth as a point of departure and neither makes nor wastes any effort trying to rise to an exalted or splendid level, every effort, every contribution….goes into transfiguring the manner of execution, changing the language, and helping the spirit take a new step." The history of still life is one firm (or trembling) but ever-inaudible footfall after another. For artists of Chardin's or Morandi's ilk, the balance of matter is a continual demarcation.

Time was—for roughly one hundred years, beginning in the 1860s—that still-life painting figured as a major avant-garde resource. Taken up and heightened by the likes of Courbet, van Gogh, Redon, Cézanne, Bonnard, Vuillard and the young Matisse, positioned to provide a ground zero for Cubism (Braque and Gris were still-life painters, pure and simple), as well as for much of the Surrealists' rummagings amid objects and their representations. If Cézanne turned the noise of phenomenology assembled shapelinesses, it fell to Morandi to patch things up, using the ruffled edges and slightly cockeyed consciousness of the aftermath. The mystery of pictures emanates from the juxtapositions of distinct but otherwise unexceptional things in an otherworldly, "metaphysical" light. In his better-known, later paintings (represented here by works from the final decade and a half of his life) Morandi extended the intensity of such encounters to arrangements in which the salient metaphysic is an almost axiomatic grace of dowdy fact. Surfaces overlap or touch, or if they don't, the area cast as a separation between them modifies on either side their characters and their relations and often takes up an individual life besides. Aligned profile to profile, jug, vase, pot, box and dish— members of a repertory company capable of infinite role-playing—achieve moments of ensemble votive perfection we know can't last but will be there, in some measure, whenever we return to look.

In the 1940s and 50s, students in Hans Hofmann's classes learned to negotiate the "push-pull" of Hofmann's Abstract Expressionism by working as the maestro himself did, from arrangements of fruit and crockery. Many Hofmann students—most

notably, Jane Freilicher, Larry Rivers, Nell Blaine and George Segal—became not abstract artists, but realists. The newness of Pop Art in the early 1960s was boosted by exhibitions with tried-and-true sounding titles like "New Realists" and "The New Painting of Common Objects," both of which were accurate (and more widely applicable than "Pop") insofar as what could be perceived as real and common among objects had significantly changed. Like any new realism (Manet's, for example), the bedazzling art of the 1960s restyled pictorial codes of recognition in terms of altered cultural appearances. In 1964, Roy Lichtenstein said: "Commercial art is not our art; it is our subject matter and in that sense it is nature." "Nature"—or the art of the comics, Hollywood and magazine and billboard advertising—was imitating, and as often as not, outstripping, traditional genre painting.

As the present exhibition amply demonstrates, the adventures of still life as a generative factor in venturesome new art haven't ceased, but their continuings in recent years have been mostly surreptitious. After Morandi, who died in 1964, the senior practitioners of the present company of artists are Manny Farber and Wayne Thiebaud, who were born within three years of each other, in 1917 and 1920, respectively, both, as it happens, in Arizona. Temporarily mistaken for a Pop artist, Thiebaud well-nigh single-handedly added a chapter to the history of still-life painting by choosing his motifs from beyond the private pantry—or modernist studio setup—and calling attention to their public aspects. In the world his paintings conjure, "display" is a keyword with at least two connotations: first, there are the ways the objects depicted present themselves (with lives aside from their service as social symbols); and second, there is how they have been designed and put on view so as to be somehow enticing to a general taste.

Like Morandi, whose method he once described as "weaving a kind of painted prayer rug," Thiebaud is schoolteacher-painter with a penchant for acting out the manifold possibilities of image making. Things in his pictures often look ordained and shoved onto the world stage by unseen forces, thence to establish, as he says, "an independent repose." Thiebaud is a master of the unappetizing confection—unappetizing, that is, to all but the ravenous eye. A lineup of donuts or candy apples is more communicative of fatty, knifed-on oil paint than of anything a pastry chef could write home about. The appeal of a Thiebaud image is strictly metaphorical, determined by intimations of character. Particulars count: each thing in a series projects, if not exactly an inner life, a vitality belonging to that one thing seen as it is.

Compared to Thiebaud's meticulous compositions, Farber's recent scatterings are a Heraclitean "heap of rubble tossed down in confusion" or just plain glee. In fact, they recall nothing so much as the mosaic known as the *Unswept Floor* in the Vatican (by a second-century Roman painter who, as luck would have it, bore the name Heraclitus, as well). Images of no small exuberance, they urge equal recognition of the flip side of plenitude: there is no stopping things, no end to the immoderate, chattering, centerless prolixity in which the average earthbound soul finds (or loses) itself, immersed.

Tom Wesselmann, who early on figured in the Pop emergence (outside advertising images of creature comforts seamlessly collaged as elements in classily composed domestic interiors), has since revealed himself as an even classier realist, whose youthful quotes from Matisse—most prominently in an assemblage that also

included a working black-and-white TV—meant business. When they first appeared, the collages and other constructions clearly involved smart syntactical fits of photographic imagery and found design with the look of ordinary mid-century life (which often enough amounted to the same thing). But the overriding elegance with which Wesselmann worked his pictures, the feeling of someone genuinely intent upon sympathetic magic, has intensified over time rather than faded. With his more recent wall-size canvases and cut-out aluminum pieces he joins the Matissean sodality as one of a diminishing squad of Apollonian hedonists engaged in improvising his own conservatory of delights.

In the mid-to-late 1970s, Audrey Flack went about personalizing the *vanitas* genre by melding its set symbolic inventory with particulars of her own life. Like Wesselmann, she reinvigorated the historical mode by delivering its appropriate iconography with a new technique (in Flack's case, photorealist airbrushings of acidic colors) and in a dilated scale calculated to appear monstrous on contact. In the eight-foot square *Wheel of Fortune (Vanitas)*, a frontal profusion of precisely limned details engulfs the viewer optically and, because of the fulsome allegorical import of everything in sight, mentally, as well.

By contrast, Susan Hauptman's charcoal-and-pastel prestidigitations, although also self-reflective, are reductive; where Flack trusts her sentiment and enlarges upon it through mechanical means, Hauptman relies on her drawing skills to locate the maximally suspenseful specificity of minutiae perceived in their separate dimensions.

Pat Steir's is a "vanitas of style"—personal to the degree that she makes room for her own assertions amid the gridlock of great historical painting idioms (along an avenue once putatively designated as all-male domain), impersonal in her need, as she puts it, "to show the humanity of things, that our works last, that they have a meaning for those who come later." *The Brueghel Series* transposes assorted styles into actual "flowers," of which images exist for further understanding and (lest we forget) esthetic pleasure.

In Steir's and Ross Bleckner's florals and Julie Heffernan's acrobatic heaps of fruit, the fabled fixity of still life, its traditional reason for being, is subverted. The pictures offer an excess of places for the eye to go, and so fewer points of rest for the contemplative gaze. Steir and Bleckner, together with Robert Mapplethorpe, share an irony about flowers that they are both beautiful and dead. Bleckner's specimen petals float on vapors of remembrance, while Heffernan's peaches and grapes are like bottles with messages enclosed. Equally subversive, Heffernan's identity theater—"raving, inappropriate," she calls it—takes on Meyer Schapiro's famous sighting of fruit as "an analogue of human beauty" by delighting in and probing representation's cosmetic veil. Images feed on images, or infest one another. Subtracting certainty of surface, Heffernan adds piquant consequence.

It makes sense that Stephen P. Curry, at 31 the youngest artist in the show, would see the same subject matter differently. Much as he projects a fascination with generic old-master looks comparable to Heffernan's, his closeup views of vegetable life seem to breed contemplative penumbras and ground fogs. Here too, however, something sinister is going on—or perhaps it's only the normal perturbations of memory held up for too-close-for-comfort inspection?

As designed for other than architectural ornamentation, the sculptural object as a portrait of another object is a recent phenomenon. Picasso's *Glass of Absinthe* and guitar

constructions and some of Giacometti's early works mimic pictorial still-life procedures. Duchamp's three-dimensional readymades are commemorative portraits of the actual things they still appear to be. Circa 1960, in the hands of Claes Oldenburg, Jasper Johns and Segal, the object-portrait in real space came alive, sporting contemporary lineaments.

It is from this short-term tradition that most of the sculptures in this show derive their impetus. At first glance, Scott Richter's redolent piles of oil paint resemble the papier-mâché caricatures on the shelves of Oldenburg's *Store,* but they are both more literal and more ambiguously felt. (Note the spin on deKooning's quip that "flesh was the reason oil paint was invented" put by Richter's wedge of raw meat on its metal palette/slab.) David Bates' cubed-off, painted-bronze oleander blossoms doff their caps to Braque and innumerable Mexican Day-of-the-Dead sculptors as exemplars of exquisite craftsmanship, whose company Bates joins with characteristic wit. (The conceit of the handy little tray as a sculptural base is Bates's own invention.)

The perils and pleasures of discrepancy are issues at hand for Stephen Robin, Cranston Montgomery, Charles Fine and Pam Gazalé. Robin's apt transformations of period ornament—stone florals and cornucopiae for courtyard, lintel, garden or grave—into hilarious monuments to desire precludes neither delicacy nor the feeling that sustenance, ultimately, is the subject. In Montgomery and Fine's handiwork, the distance between polished bronze and the offering represented appears unbridgeable, yet as characterizations, Montgomery's gleaming pantry items and Fine's huge, dry-docked marine pod, are jubilant. Gazalé's objects formed from saltlick blocks make planetary emergency explicit; their fastidious execution serves to deepen the sense of tender relations between all aspects of material life.

. Gazalé, George Stoll and Elsa Rady resemble Morandi in the care they take to expose the life-size quiddity of things, as Gertrude Stein said of saints, "in terms of their arrangements." As striking as Gazalé's pristine whitenesses are the closely adjusted colors of Stoll's wax renditions of Tupperware and Rady's porcelain vessels. The sometimes awkward poetry of "tenderest tangencies" that Fairfield Porter observed in Bonnard occurs likewise in Rady's and Stoll's family groups of lucent fact.

Sarah Charlesworth and Robert Mapplethorpe are the two artists in the show for whom photography is the prime medium. Charlesworth is especially sensitive to the unconnected dots between things as they are (or were), what we want them to be and what the photographic image shows us either way. Her tableaux are delays in glossiest Cibachrome of any consummatory fit of actuality (barely perceptible) with its representations (all too neatly perceived); her toughmindedness embarrasses gullibility and then kisses it off with a surplus of glamour.

Mapplethorpe once spoke of his photography as "a sort of lazy man's approach to sculpture." His photographs of nudes usually emphasize a carved, sculptural look that actually foils (without deadening) the viewer's sense of the live body as inherently in motion. In the pictures of sculpture and flowers, this effect is reversed; in closeup, implied motions are jogged, if not totally released. When his tulips languish you can be rocked by their exhalations; if he shows you a rose, he makes sure to show the sharp look the rose tossed in return.

Mapplethorpe was this century's preeminent poet of skin—the skin of men (doesn't the notorious image of Mark Stevens' genitalia laid flat on a table qualify in the still-life category as well as any bouquet?), the skin of women, of flowers, of marble and porcelain; the skin, finally, of photography itself.

A word on the performative aspect of still life: What A.D. Coleman, writing of Mapplethorpe, called "the directorial mode," in which the artist "consciously and intentionally creates events for the express purpose of making images thereof," is common to both photographers and most of the painters in this show. Mapplethorpe once commented: "With flowers I can always juggle things around. It can take two hours to just set up the lights." What Susan Sontag wrote of Mapplethorpe, that he wanted to show "not the truth about something, but the strongest version of it," applies to Morandi and others who followed from him.

Every still life is a shrine. This show is an invitation to watch closely as each of the artists here prods mobs of matter into a sacramental guise.

1997

A Poke at the Fogbank

If accountable to a mainstream timeline, the art history of the San Francisco Bay Area has leapfrogged whole decades. Thus, for the most part, San Francisco skipped 60s minimalism and Pop art and went directly to postminimal and conceptual art in some of their most idiosyncratic manifestations. Similarly, for the Bay Area, the 30s ended and the 50s, if they didn't begin, were at least heralded circa 1945, when Douglas MacAgy, having assumed directorship of the California School of Fine Arts, proceeded to introduce Abstract Expressionism into the local mix.

The general, continuous development in America and Europe during the 1950s and 60s toward a greater projection of physicality (or hyper-materialization, so-called) in the art object as such found its San Francisco exponents in the "blistered slabs" of Clyfford Still and the otherwise heavily pigment-laden surfaces of David Park, Jess, Jay DeFeo and Joan Brown, as well as in the assemblages of Bruce Conner and William T. Wiley and, somewhat later, the "dumb balls" and other materials-specific devices of David Ireland.

In the 60s, sculpture and assemblage were the forms most vigorously advanced in the Bay Area. Beside Conner and Wiley, think of Peter Voulkos, Robert Arneson, Robert Hudson, Richard Shaw, Ron Nagle and Manuel Neri. None of these had minimalist leanings, nor did the installation-cum-performance art that developed in and around Tom Marioni's Museum of Conceptual Art from 1970 on. (The forgoing of the rigors implicit in the minimal/Pop esthetic had negative consequences in the 80s, when, as Christopher Knight pointed out, the decade's salient artistic energies pretty much located in those places where a prior and intense minimalist experience had occurred.)

The first half of the 60s saw, concurrently: 1) the emergence in strength of a market for contemporary in the United States and, with it, of the "art star"; 2) the rise of the full-time, professional art critic; 3) the proliferation of art magazines and of reproductions via the four-color separation process; 4) the art-school boom; 5) the development of the contemporary art museum; 6) the establishment of abstract art as a cultural norm; 7) the codifying of formalism, the discipline of discussing art in purely formal terms.

In synch with some of these developments, the California School of Fine Arts in 1961 changed its name to the Francisco Art Institute; in 1965—coincidentally, the same year the National Endowment for the Arts was founded—the school's enrollment jumped to an unprecedented 600-plus, and plans were made to construct a wing, completed in 1969. By most accounts, 1965 stands as the end date of modernism, and the point from h the fabled "dematerialization of the art object" followed. (As David Antin says, depending on your definition of modernism, you get the postmodernism you deserve.) The 70s, with emphasis on the personal, pluralist, the communal and (however, wishfully) anti-institutional, was the perfect decade for raggle-taggle individualism of the kind the Bay Area has always, and best, fostered.

Local artistic traditions are relatively short-lived. Since 1980, certain truisms—that San Francisco art is funky, nary genteel or private, that paint here is muddy or the contours blurred, and so on—have been endangered by the rapidly spreading sameness of so-called "art-world art." But some of those truisms still hold. Most of the art here is school-based, because the schools are what bring the otherwise scattered elements together. As ever, much vibrant work finds its outlet in alternative spaces. Further, like other California urban centers, the Bay Area is rich in cultural diversity; many of the best artists working here now are African American, Latina/Chicana, Native American, Asian American. Urgency and power show up in those contexts, in other, conceptual and/or politically motivated work. (A side issue is that, if you tallied the number of significant artists working in any one medium here, photography would be the winning category.) As visitors are fond of remarking, artists here for the most part lead civilized lives. Why not make marvelous works?

1999

Ceremonial Surfaces: California Art in the Anderson Collection

Asked to name a unifying principle for the diversity of works that forms the Anderson collection, the curator Rachel Teagle answered readily: "Surface appeal." In a collection consisting largely of paintings, pictorially modified sculpture and other brightly colored, hybrid inventions, the salience of surface effects as such—variously beguiling, resonant, or both—should come as no surprise. Before or beside the creation of any spatial dynamic or image brought to view, the main charge to which painting responds is that of

making a surface that both literally covers and imaginatively supersedes the bare material support. Thus, a Richard Diebenkorn canvas, coated thickly or scantily with pigment, projecting sensations of landscape or, more abstractly, an airy translucence, will in any case candidly assert its existence as one surface among others, differentiated by the artist's highly visible esthetic purposefulness.

A painting's surface can offer itself as the site of much simultaneous discrimination, harmonious and contradictory by turns. Wayne Thiebaud's *Pies*, for instance, are so blatantly made of gobs of fat, smelly oil paint that even the truth and elegance of the pastries' colors can't make you want to eat one, no matter how visually compelling. The human figures in David Park's pictures, done from memory, are likewise fraught with paradox: timeless in their solidity and placement, they seem nonetheless fleeting in character; the more relaxed Park was with his paint, the sturdier they became. The frontally declared surface of Sam Francis's *Red in Red*, pulsates, exerting a virtual pressure at the frame edge to bring the mass of clustered nodules to a prodigious scale. For Deborah Oropallo, the exquisite skin of paint functions as a correlative to the threshold of consciousness, a planar membrane at which memories—public or private, sharp or indistinct—emerge, flicker, pile up or reduplicate. "As thoughts change, the painting does," Oropallo told me. "These paintings contain a lot of buried information."

From the early 1950s on, California painters showed themselves especially drawn to working at either or both extremes of the thick/thin range of surface making. The general, continuous movement in America and Europe during the 50s and 60s toward a greater projection of physicality in the art object found Northern California exponents in the postwar generation's variants on Clyfford Still's "blistered slabs" and the otherwise hypermaterialized surfaces of David Park, Jess (in his "translations" mode), Joan Brown and Jay DeFeo, as well as in the assemblages of Bruce Conner and the riotous, protuberant contours, enamel glosses and ceramic glazes of sculptures by Peter Voulkos, Robert Arneson, Ron Nagle, Richard Shaw, Robert Hudson and David Gilhooly. The thinly layered daubs of color in Sam Francis's early paintings, beginning in the late 1940s (he left Berkeley for Paris in 1950 and returned to live in Santa Monica in 1962), are congruent with the ethereal hues laid down by Ed Corbett and others who came under the sway of Mark Rothko's soft-edged "multi-forms" of the time.

In San Francisco and Los Angeles, respectively, William T. Wiley and Ed Ruscha, both born in 1937, started out like most of their peers in the 50s by trying on for size the Abstract Expressionists' loaded-brush, swing-from-the-shoulder attack. Wiley's early paintings reflect his studies with Frank Lobdell, the artist most thoroughly touched by the spirit of Clyfford Still in the late 40s; but the large paintings from Wiley's maturity in the 70s match up strikingly in their formats and multidirectional markings with Sam Francis's matrices of the same time (see the latter's *Beauborg Painting*, 1977). They also compare in rustic ardor with the "thicket" paintings—tree branches lashed together in allover crosshatch patterns and splattered with primaries—that Charles Arnoldi began making around 1970. Ruscha reacted away from Ab-Ex sooner and more abruptly than Wiley, when in 1957 he saw a magazine reproduction of a Jasper Johns target painting; by 1962, beside unfurling recognizable images in a wide array of graphic media, he was smoothing his paint in layers so fine they could be mistaken for printer's ink.

Sometimes I have the feeling that Los Angeles is only a surface that reflects light—that there really is nothing there: if one scratches away the surface there would be nothing behind it.
—William Leavitt

It's all in California, it's all a sea....
—Jack Kerouac

In the 60s, sculpture and assemblage were the art forms most vigorously advanced in California, both north and south. The main regional difference was the south's inclination toward a version of minimal art that, in its eventual blandness and lapidary perfectionism (hence the tag of "Finish Fetish" for the machine-tooled L.A. Look), aligned itself more explicitly than its New York counterpart with pop culture. By contrast, Northern California's bypassing of the rigors and cognitive assumptions implicit in the minimal/Pop axis had negative consequences in the 1980s, when the decade's artistic energies pretty much landed in those places—L.A., New York and sundry urban centers of Germany, Italy and Japan—where a prior and intense minimalist experience had occurred.

Instead of the squeezing out of all but the faintest vestiges of illusionistic space, famously accomplished by the likes of Frank Stella and Agnes Martin in New York, such Los Angeles artists as Robert Irwin, Larry Bell, John McCracken, Billy Al Bengston and Ron Davis presented space as ambiguous, phenomenal, built-in and objectless. For some of them, space and/or atmosphere—often the most noticeable aspects of a Californian's environment—translate into surface, the spread of which reaches beyond particular place to envelop, or stand in for, the psyche. The vaporously tinted surfaces across which Ed Ruscha casts a word or phrase partake of this atmospheric sprawl, as do the supernal fumes in Billy Al Bengston's *Lux Lovely*, and the spatial blandishments of Ron Davis's polygonal *Rainbow*. In much L.A. sculpture of the period, space *as* object, complete in, and full of, itself, parades as tabula rasa, bounded (like McCracken's lucid planks) only by whatever could be perceived to be its own limits—e.g., the very definition of surface.

More sociable, no less discrete than New York minimalism, the ritual blankness emanating from such art implies that information already abuzz in the beholder's mind suffices for an adequate number of quick recognitions to occur, to satisfy the situation with regard to meaning. A geometric form that appears to be made of hypnotic, unnamable colors in lacquer as bottomless as the reflections in a swimming pool triggers a surfeit of gangly, inchoate, yet palpable connotations. Think of the sheen on the pages of color photographs in Ruscha's *Nine Swimming Pools and a Broken Glass*, or for that matter of all the white pages left blank in that book, including nineteen at the back—a touch of luxury the artist prided himself on. Think, too, of the perimeter glare in David Hockney's 1978 *Sprungbrett mit Schatten (Paper Pool #14)*, where the wavelets and shadowy divisions of blue recall nothing so much as Francis's *Red In Red*, painted almost a quarter of a century earlier.

Surface appeal subsumes such matters as light, space and the coefficient by which both occur most palpably in the California consciousness—evanescence, along with its occasional end-product, transubstantiation. Tumbled in the ever-shifting coastal light, all solid bodies prove elusive; bringing any one of them into steady focus can take on the aura of a ceremonial act.

Robert Irwin's untitled disc sheds its more-or-less-sequential, momentary visibilities like a snake leaving behind its skin, an instance of what Bruce Conner once called "symbology of surface." Edge determines surface, but where edges dissipate, as they do in our experience of Irwin's perceptual puzzle object, surface and environs drift into one another—an unscheduled interchange that can be glimpsed with near-tidal regularity. As Irwin told Lawrence Weschler, "The question for the discs was very simple…. How do I paint a painting that doesn't begin and end at the edge? In other words, I no longer felt comfortable with that sense of confinement. It no longer made sense to me…. How do I paint an painting that does not begin and end at an edge but rather starts to take in and become involved with the space or environment around it?" Like Larry Bell's coated-glass cubes and Celmins' rectilinearly framed skies and seas, Irwin's disc partakes of an endlessness facilitated but unencumbered by idealist geometries and so may be said to be "beyond" scale. The disc has no scale, it simply palpitates in and out of mind.

Of course the words I use come from every source. Sometimes they happen on the radio and sometimes in conversations. I've had ideas come to me literally in my sleep that I tend to believe on blind faith, that I feel obliged to use.
—Ed Ruscha

There is no surface that isn't just crawling with information.
—William T. Wiley

California art is normally discussed as an art engaged with issues beneath or beyond any ostensible surface. Californians have traditionally tended to emphasize that California is where they are; they give "sense of place" priority, viewing it, appropriately enough, as a matter of spiritual opportunities. Where the opportunities have been missed or thwarted, the landscape will correspondingly send up distress signals. William Wiley provides an analog to the downside of informational glut in his vividly detailed watercolor *Lame and Blind in Eden*. A clearing in the woods is fouled by toolmakers' leavings: a hatchet, a deflated life jacket, a test tube, folders of documentation on atomic-energy research, surveyor's equipment—all represent habits, as Wiley sees them, of "measuring, dividing up, polluting….ignoring the environment" by putting man-made objects in front of nature. A comparable view of the same intrusiveness occurs in another painting in the Anderson collection, Mark Tansey's *Yosemite Falls (Homage to Watkins)*, which shows one of the great 19th-century photographer's favorite natural wonders reduced to a clattering flash flood of tripods and lens casings.

One of the pleasures of visiting the Anderson collection at its Quadrus headquarters in Menlo Park is seeing how the proximity of specific works to one another make traditional north/south divisions in California art look less pertinent. Immediately on either side of the entrance to the Quadrus lobby, for example, the visitor sees a pair of freestanding works by northerners, Robert Hudson's *Plumb Bob* and Tom Holland's *Vatto*. The two together form the base of a triad of which David Hockney's *A Visit with Mo and Lisa, Echo Park, Los Angeles*, on the far wall (behind the reception counter), is the apex. Within a stage whisper of one another, all three tease their respective categories: *Plumb Bob* is a quasi-figurative, weighty but loosely assembled polychrome sculpture, some parts of which can be turned on their individual axes in space; *Vatto* is an abstract painting in sculptural dimensions; like Hudson's and Holland's pieces, English-born, L.A.-based Hockney's panoramic gouache quickly engages the eye by its limber modernity, unabashedly loud, sunstruck colors, clean contours and playful handling of geometric forms.

By and large, however, the usual regional differences hold. Los Angeles continues to be sleek and efficient, more street-wise and edgy; milder San Francisco to shuffle along, dressed-down elegant or studiously raggle-taggle, civilized if barely urban at heart. Both have energetic art scenes that are school-based—the artists teach, their more accomplished students become artists who also teach—but Los Angeles has the high-pressure gallery system that San Francisco lacks. In San Francisco and environs (including, most prominently, the University of California campuses at Berkeley and Davis), the clear lines of descent, going back to the years when David Park and Clyfford Still taught at the California School of Fine Arts, have gotten fuzzier of late, if they haven't petered out. (Deborah Oropallo and Christopher Brown belong to the last generation of local painters to receive direct transmission from elders like Bischoff and Diebenkorn.) L.A., on the other hand, has developed a newer, live tradition that dates mainly from the late 1960s. (In the late 80s, for instance, Tim Hawkinson's teachers during his one year in graduate school at UCLA included Chris Burden, Charles Ray and Alexis Smith.)

That Ed Ruscha is the preeminent, archetypal L.A. artist nearly goes without saying. Twelve years ago, Peter Schjeldahl remarked that Ruscha "is indeed a regional artist of Southern California, in the sense that Matisse was a regional artist of France." That William Wiley likewise has come to personify the terms of Northern California art for the same period (roughly, since the mid-1960s) is less widely acknowledged but just as incontrovertible. The Bay Area's natural light and palette are captured definitively in Wiley's often-allegorical accounts of them, just as the rapturous ironies of what it is to exist in Los Angeles have long been Ruscha's well-nigh exclusive domain.

Both L.A. and the Bay Area are deep in car culture; but L.A. is ever the style-setter, phantasmagoric in every excess. Ruscha sees language while driving around; he writes notes without taking his eyes off the street. Car fumes in Wiley's pictures exist only by implication; otherwise, there is just the occasional putt-putt of a motorboat—or motions of more mythical vessels like the Brueghelesque half-fish, half-gondola in *Just to Mention a Few*, 1994. Wiley, who lives in rural Marin County, probably gets his visions while strolling on unpaved roads, sitting with his guitar or salmon fishing in the ocean

waters near the Farallon Islands outside the Golden Gate. Ruscha uses words—or more properly, images of words, among other things—as beacons or emergency flares in wide, bare spaces that feel both celestial and mental; his impersonal lettering is that of a concrete poet taking directives from an angel whose wings are billboard struts. Wiley's autographic jottings scamper every which way over his pictures. Ruscha gets discrete flashes (*Depths of Despair,* for example) one at a time, with no retakes; Wiley's accumulations are the marks of a mind that revisits familiar ground, like someone tending acreage. Both men are witty and love puns, though Ruscha's are subtler and Wiley's entirely shameless. (Both were influenced in their youth by the adroit, slow-fade pictorial deceptions of the Belgian surrealist René Magritte, who never was fashionable in New York but has his avatars among West Coast artists, including some younger ones like Carole Seberovski, Mark Tansey and Tim Hawkinson.)

Wiley's paintings contain strong allusions to landscape, albeit often in the manner of diagrams or maps. Ruscha, whose vistas appear abstract, speaks of his habitual "side-to-side paint action...horizontals that get into brushstrokes that get into everything," which in turn recalls Diebenkorn's remark that when he was painting abstractly "everything kept reducing itself to a horizon line." Ruscha, originally from Oklahoma City, has kept as much heartland attitude as Wiley, who was born in Bedford, Indiana, but spent his formative years in Richland, Washington. Both Ruscha and Wiley communicate their individual world views and spiritual aspirations in personal, seemingly offhand ways that nevertheless manage to announce each work's surface as the designated area for a specific ceremonial occasion. "Art's about the glorification of *something,"* Ruscha once let on.

In Los Angeles, Ruscha's early, soulful signage flows coincided with Billy Al Bengston's use of insignias in what Christopher Knight calls Bengston's "surfside mandalas" and preceded the smooth-coat, votive collages Wallace Berman began making with the help of a friend's Verifax copier around 1964. As a visitor to, and sometime resident of, the Bay Area during the 50s and early 60s, Berman had found a companion for his explorations of found imagery and complex symbolism in Jess, who himself had moved to San Francisco from Southern California some years previous, and who was then beginning to extend into large scale his intricate "paste-ups" full of snippets from old picture books, engravings, comics, jigsaw puzzles and science journals. During the 50s, Berman, Jess and Bruce Conner initiated much of what became California assemblage, a movement absorbed and furthered later by H.C. Westermann, Edward Kienholz, Wiley, Hudson and others.

Vija Celmins' first mature works were a series of gray paintings based on photographs of World War-II fighter planes done in 1966, a couple of years after she left graduate school at UCLA. Those, and her subsequent works in various media, proclaimed not just her own, but a more general taste among California image makers for closely modulated, grainy half-tone or grisaille surfaces, almost all of which have something to do with the look of black-and-white engraving or photography. This was the look that Ruscha espoused early on and then refined by the time he started using gunpowder for such drawings as *Liquid with Fly.* The way Ruscha's granules spread across the sheet is equaled in nuance by the high-contrast graphite specks in Celmins' *Untitled*

(Double Desert), and the delicate tatting effects Bruce Conner gets with his fluid medium in *Inkblot Drawing*. The large floral-pattern drawings in soft graphite that Ed Moses made in the early 60s belong in this company, too, and indeed may have shown some of his peers how to create works both lush and austere. Also relevant here are the half-tone glimmers of Jay DeFeo's paintings from the mid-1970s on, after she went through a phase (spurred by conversations with Bruce Conner) of inventive photomontage. Wiley's grisailles often retire to the corners and backgrounds of his paintings, viz. the far and side walls of the studio view depicted in *Never Conforms*.

"I explore a surface by drawing it," Celmins has said. Celmins, Conner and Ruscha have all made works on paper that move far from the gray range into the blue and/or blackness of night skies, a field broken in Celmins' and Conner's by many points of untouched white but irradiated in Ruscha's pastel by the light trail left by a single, small dot barely perceptible near the righthand edge. The articulations of both Celmins' and Conner's fields were the products of close attention to the media in hand. Conner painstakingly elaborated his ink flows, skirting the edges of tiny areas he eventually rounded off as what Conner likes to think of as "particles of light." Celmins' galaxies on paper had their sources in photographs but eventually "came out of loving the blackness of the pencil." When, in 1986, after many years of not painting, Celmins finished struggling to paint a similar image on a large canvas, she called it *Barrier* "because it was an obstacle to overcome and the overworked surface became a barrier to the image."

"I know that kind and quality of surface have something to do with the presence of the object...so the surface actually is *what the object is."*
—Robert Therrien

Robert Therrien uses resins, wax, enamels, stucco and raw pigments in ways to ensure that his sculptures' surfaces "read in relation" to what each work is meant to evoke. He speaks of the sculptures as "unitary constructs," a phrase with a distinct minimal/Pop ring: "Allover unitary image" has long been a good way of describing a Jasper Johns flag, a Frank Stella stripe painting or any painting by Andy Warhol after 1960, as well as sculptures by Donald Judd, Claes Oldenburg, John McCracken or Martin Puryear. Therrien explains: "Most of my things aren't really constructed in the sense of having more than one part." Instead, they are simple, compact, often disarmingly intense to the point of being funny. As icons, they function to prompt quick recognition, to which viewers add such further, unexpected associations as may come to mind. The generic, original snowman would be an ur-sculpture of which Therrien's featureless, nearly three-foot-high, polished bronze and tin figure, *No Title,* is a refinement. A series of items, including the snowman image—*Box of Shapes*—is a set of recognition devices, each palm-size three-dimensional silhouette humming in its little slot, ready to exercise its evocative potential like rhetorical figures in a memory theater.

Therrien's idiosyncratic bias is shared by other sculptors—Joel Shapiro, John Duff, Scott Burton, Carole Seborovski, Mark Lere, Tom Friedman and Tim Hawkinson are some—who from time to time have made varieties of what, *pace* Therrien, might be

called the Oddball Unitary Object (or O.U.O.), a category of usually one-shot, well-wrought absurdist forms which the Andersons seem particularly to favor. ("Enigmatic Presences," the former Anderson curator David Cateforis's term for Martin Puryear's works, would serve almost as well.) Historically, the O.U.O. is a figment of postminimalist sensibility geared to show off "quality of surface" with a vengeance, pragmatically—that, after all, is where the revelatory forces gather. Therrien arrived at his bent-cone image (depicted in the oil-on-cardboard *No Title*) as a kind of graphic pun on one-point perspective. Funny-ha-ha and funny-peculiar, at once, the bent cone finds its bigger morphological cousin in Puryear's *Lever (#4),* which Puryear calls "a wedge tapered to a cone and then turned back on itself."

Whereas Therrien stays with his shapes, even enshrining six of them in a commemorative box set, Tim Hawkinson wanders from one thing to another. What Therrien and Hawkinson have in common, beside a penchant for the oddities of reconstituted psychological content, is the same follow-through, drop-dead efficacy that made the L.A. Look flourish. There are no tentative contours or unfocused dramas. Hawkinson's untitled elongated dart board is a crazy-cum-thread-perfect rewind of an adolescent totem fixture. His freestanding *Untitled (Door II),* stripped nearly to the bare hardware, leads no place but around its skeletal remnant, the strange, scrawny limbs reaching out, at a loss, pointlessly. Like Magritte before him, Hawkinson is fascinated by framing devices, including ordinary store-bought frames as such, two of which appear to have collided and fused in one work to harbor a disconcertingly caved-in, *faux-craquelure* white surface. Essentially an object maker rather than a sculptor—the spaces around his pieces tend to accommodate them without being called upon to interact—Hawkinson lets curiosity, his own and the viewer's, stand out as the prime matter of his work. Having inspected the technically stunning, impish tricks, of which Hawkinson himself, in his wall texts and interviews, gladly makes full disclosure, you begin to sense the bright, duly bedraggled, independent-minded self that performs them.

Is Hawkinson's defeated-looking door a self-portrait? Certainly the Andersons have concentrated to a large extent on amassing artists' images of themselves. (Their holdings include rare self-portraits by Sam Francis, Mark Tobey, Arshile Gorky, Hans Hofmann, Franz Kline and others.) Robert Hudson's *Plumb Bob* can be read a composite self-portrait, just as his assemblage-tableau *Running Thru the Woods,* can be read as a personal, possibly commiserating response to Robert Rauschenberg's famous portrait of the artist-as-stuffed-goat in *Monogram.* So, too, can Wiley's *One Person Band Thus Ain't.* "Assemblage" in such instances is an operative term for uneasy, teetering sense of self. "All my....pieces are essentially assemblages," says the ceramic sculptor David Gilhooly, whose "frog bodies" are plainly hyperactive extensions of their creator's psyche. Both *Plumb Bob* and *Running Thru the Woods* show phases of the manifold artistic self's struggle to stand or make its way while enthralled by artifice; and both relate to yet another instance of loaded self-portraiture, Robert Arneson's *California Artist,* which depicts the artist as a short-sighted East-Coast critic would see him: exotic, provincial, an emptyheaded stoneware specimen. The composite self is a regular featured player in California ceramic sculpture, nowhere more prevalent than in the porcelain stick figures Richard Shaw makes by combining slipcast trompe-l'oeil replicas of real things—the blue

and white China dish for the ballerina's tutu in *Canton Lady,* for instance, and the dancer's fingers suggested by three stubbly pencils on one hand and a forked, black piece of bric-a-brac on the other.

Not a self-portrait, Arneson's *Colonel Nuke* is a composite beast, part of a series of "memorials" to nuclear disaster. Easily the most powerful image maker to emerge during the Funk era, Arneson regularly used himself as a model for any number of human conditions, including that of his own impending demise. In *Drawing for Ikarus,* another large drawing done a few years after Arneson had begun undergoing treatment for cancer, a fateful surge of the artist's virtuoso markings threatens to obliterate him. The "Ikarus" image hearkens back, half-ironically, to the whimsical sequence of *Sinking Brick Plates.*

Effaced rather than obliterated, the shadow self in the drawing Ed Ruscha contributed to a set of self-portraits commissioned by Revlon turns away in three-quarter rear profile, a head-and-shoulders repoussoir figure fittingly absorbed in its own dusky, cosmetic glow. The set, acquired by the Andersons at a benefit sale, features works by artists as diverse as Alex Katz, Jennifer Bartlett and Ellsworth Kelly—all of whom met the requirement of depicting themselves in a medium that might serve to symbolize the surface-y nature of all such representations: "makeup on paper."

2000

Viewing Time

The topic I'll address, more or less announced, is "Viewing Time," which presumes that one has some time to look at, to view anything (even to be here to discuss the possibility, for which I'm grateful). At CCA a week or so ago, Pierre Huyghe mentioned "free time" as a component of his work—the time he takes to play out ideas, the time you might take to look willingly at his films. Such time *versus* what we all know but Huyghe didn't mention, which is the Time Famine we all exist within, where "free time" is a complete anomaly—e.g., who has it? In the *New York Times* about 20 years ago—which to say, pre-Internet, even—an op-ed columnist identified Time Famine as a condition in which friends no longer can take the time to have lunch together unless there is business to discuss. Time Famine is antisocial and, as far as art goes, anti-nuance. One of the time factors involved in the works in this room is nuance. The world now is full of quick hits, 6-seconds-per-item museological view time, and so on. A public bred to have little if any patience for highly nuanced art.

In the early 15th century, following on Filippo Brunelleschi's experiment, Leon Battista Alberti theorized that to be experienced correctly the then new perspectival painting involved a determined—or "proper"—viewing distance. "Know that a painted thing can never appear truthful; where there is not a definite distance for seeing it." To properly see Brunelleschi's perspective construction of the view of the Baptistery in

Florence you would take a fixed, flatfooted position twelve inches from the twelve-inch square panel; there you would be aligned to face the point analogous to your "eye" (one eye for you, one for deep in the picture), the eye of God the Great Geometer. The freeze frame thereby provides a species of renewable eternity. But if such fixed relation on the viewer's part is compromised, instantly a time element explodes upon the perfect scheme, and there is trouble in God's-Eye Paradise.

Intermittence, duration, shifts in time: such aspects of viewing supposedly "static" art are seldom accounted for. Some works can be seen only by stages of seeing, or in various instances of focus; some literally disappear (without becoming at all invisible) as you look, or as you move and look. Others are obdurate, you have to work to see them—to dance out how to see them, so to speak. Another aspect might be called the "check-out time" for certain works: after how much of an impasse, for instance, does a putatively difficult work—one that may promise "nothing" at first, for several seconds or more—generally engage the curiosity of a viewer? and then for how long? Viewing time in museum galleries is obviously something further to find out about, and today we will experiment with that.

Time and moving in time is a big question in modern art. Wyndham Lewis, artist, writer and notable crank, wrote *Time and Western Man* to argue that the world of art had gone to hell in an excess of temporality thanks to the likes of Picasso, James Joyce and other artists who allowed the mess of time into the standard timelessness of great art. To see Caravaggio's chapel pictures properly you must move and twist with the images; in Tintoretto and Rembrandt you experience the gradual emergence of figures from various kinds of murk. In Monet and Cézanne the matter of quick sensation is spread out like a picnic—in analytical Cubism it's both chopped up and compacted—in Pollock, it's extended, made at once more specific and harder to define.

If Allan Kaprow were here, he would tell you that most of the works in this gallery are extensions of "the Legacy of Jackson Pollock." That is, they belong to the era where artist could say, as Pollock did, "art can be anything I intend." Most also belong to the era of radically reductive art—minimal, abstract (Ireland's *Good Hope* may be an exception, an image), and putatively "static." (The main exceptions of course are the video pieces—which I won't be addressing—and the Campbell, Rath, Kramer and Tinguely motorized items, if that's what they are.) Squares are static, no dynamics there; Pollock and Reinhardt work with square formats for important reasons.

Dan Flavin, "Monument" for V. Tatlin, 1969
Flavin calls it a "get-in-get-out situation….very easy to understand." As Frank Stella would say, you "get the whole idea without any confusion" and then you are free to wonder if the idea is all you are meant or want to get. Obviously, there's the beauty of the thing, if you see it that way: the light, the color of the light and how it affects the space around it, which you share. Presumably, you see it at the speed of light. (Or do Flavin's differently colored lights have variable speeds?) It doesn't really light anything in particular. Conceptually, there's also the beauty of the fact that the Flavin works as art only when it is, literally, turned on; if you unplug it, it's hardware. At that point, in a sense, the bottom drops out: *Where did the time go?*

Light pieces are sort of instantly compelling. But how long do you stay with a piece like this? To bathe in it? Or is it like passing a big orchid in the Conservatory? You enjoy the general look of the thing and keep going. About "check-out time": years ago, I got interested in how people came to a roomful of Robert Ryman paintings, *The Elliott Room* so-called, and generally passed it up: poke a head in, sniff "minimalism" ("There's nothing there") and head for wherever the action was; or enter, get puzzled, dismiss the puzzle, and quit. I decided to clock the ones who stayed; I arrived at a 20-second check-in/check-out rule—if you gave the work 20 seconds, you were likely to get involved and stay for a half hour or more.

Jim Campbell, Shadow (for Heisenberg), 1993-94

"Get-in-get-out" may be a little slower for Jim Campbell's *Shadow (for Heisenberg)*. For one thing, the title extends in at least two directions (or dimensions, perhaps) the sense of the thing. Here, what you get is absolutely contingent on where you are. The work senses when you are within so many feet of it, and fogs up accordingly. *Zen 101* is what it is. It's funny, the "smallness" of it in its compact cube, the philosophical toy that it is, with the barely glimpsed Buddha figurine inside, and how in fact the idea is very big—big in a friendly, tender way—unforced—and this has to do with the time you choose to take with it and how much you want to think about it. The longer you want to think about it, the more you will go back to see not how, but that it works.

Robert Irwin, Untitled [disk], 1969

The Irwin takes a certain time. In most museum situations you come at it with nothing else in view, alone on a wall; and accordingly, you tend to give it a lot of space. I've never gone right up to it. Instead, it seems to work from about here, ten feet or more. You look, you get this funny disappearing-act sensation; the disk "whites out"—all but the spectral black-gray middle—and you do, too. It's a little like fainting, blanking out. The disk makes you very conscious of yourself seeing (sensing, perceiving) as a device. Is this contingent on its being a solitary experience? Can we get there as a group? Here's a paragraph I wrote about another version of the same thing:

> Robert Irwin's untitled disc sheds its more-or-less sequential, momentary visibilities like a snake leaving behind its skin. Edge determines surface, but where edges dissipate, as they do in our experience of Irwin's perceptual puzzle object, surface and environs drift into one another— an unscheduled interchange that can be glimpsed with near-tidal regularity. As Irwin told Lawrence Weschler, "The question for the discs was very simple….How do I paint a painting that doesn't begin and end at the edge? In other words, I no longer felt comfortable with that sense of confinement. It no longer made sense to me…. How do I paint an painting that does not begin and end at an edge but rather starts to take in and become involved with the space or environment around it?" Irwin's disc partakes of an endlessness facilitated but unencumbered by idealist geometries, and so may be said to be "beyond" scale. The disc has no scale, it simply palpitates in and out of mind.

The operative (unspoken) word here is "sensation." Irwin is known as a "Light and Space" artist, part of an initially small group who had a particularly strong experience in a

sensory-deprivation chamber (John Cage had a similar one), which changed their ideas of what was interesting to do as artists. Sensation—Perception—Cognition: that familiar sequence, which can occur sequentially in time, but the parts of which certain art works, like the ones here, can isolate or emphasize, or scramble the sequence in interesting ways.

Jackson Pollock, Number 6, 1950

Pollock is a sensational painter—which means you get him first by opening your bodily senses to the surface as it is available to be seen. (I mean, eyes, but something else, more of the body is required.) You *travel* a Pollock to see it. This is as radical as Caravaggio: "You got to move," goes the song—alongside, back, forth, back again. This is a small Pollock. Pollock didn't general make the big, big pictures many people associate him with—only five or six of those exist. But even with this almost perfectly three-foot-square one you figure it by negotiating places from which to relate to what you are trying to bring into focus. It's very hard to make out a Pollock like this as a single, stable image; it keeps slipping. ("Fundamentally unstable imagery" is Rosalind Krauss's term for what already eluded people in Pollock's pre-drip early-1940s work, *Guardians of the Secret* at SFMoMA.) You look at it this way and that, indefinitely. Paradoxically, there's the persistent sense that the thing hangs together, is "composed" to that extent—but try and show me how. Instead, you dance it out. *Where* to see it from? As there are endless possibilities for this "where," that is the infinitude, the "no beginning and no end" (as he said) of Pollock's picture, which otherwise, contrary to lots of art-critical rumor, does have limits and is contained. One of the best ways to look at a Pollock—especially the very big ones—is to go to the back of the room and watch it as other people stand and cross in front of it, getting snagged in the energy field. No problem about not seeing the whole image; there's no such thing, only your partial shots. Meanwhile, proceeding through this or that view, you keep coming up against the hard stuff—the painting's materiality. The "legacy" that Kaprow wrote about has largely to do with this insistent fact of paint-as-paint that sometimes feels like the painting's fall-back thesis.

Jay DeFeo, Origin, 1956 / David Ireland, Good Hope, 1990-91

Kaprow's perception coincides with an interesting phase of gross materiality—or hyper-materialization—in the 1940s-50s, of which DeFeo's *Origin* is a terrific example and David Ireland's *Good Hope* a worthy inheritor. Just as with Pollock—and in some cases, more so—you are, as it were, seeing double: brute matter (paint and other stuff) worked heavily to a transcendent pitch. DeFeo's "origin" is that of creation itself; she called it "a symbol of beginning." The "swerve" of Venus that put all matter in motion, so that, too, you think you are seeing the process, how the thing was made, in the time it was made, as if it was being made in front of your eyes. This is always tricky: In "Action Painting"—Pollock or deKooning or the Frankenthaler downstairs—the painting is fast, looks done all at once, but usually wasn't. Pollock returned to refine *Number 6* with little, carefully adjusted touches; DeFeo's picture is full of marvelous bits of under paint—it was, she said, "the first painting I spent more than a month on." One way of looking, go close to see all the buried colors—cerulean, red, green, etc.—and something else takes hold. If you want to experience the intensity of the spiritual mode of the Rothko downstairs, go

close and inspect the way it's painted; a funny tingling will begin to gather at the back of your neck.

DeFeo and Ireland: Funny juxtaposition: The Ireland is the only piece we're looking at that you can walk around and see all sides. "Sculpture is something you bump into when you back up to look at a painting."—attributed variously to Ad Reinhardt and Barnett Newman. Ireland's assemblage stands next to DeFeo's painting like a saint beside a 15th-century Madonna. My guess is that the curator Lucinda Barnes had their mutual (literal) concreteness in mind. [Note: The question of what is cement and what is concrete came up. Answer: Cement is the material that comes in bags; concrete is what you get when the mixture of cement and water sets.] Good Hope is really questionable as to what it is. It takes time to see its terms. Start with its being something deliberately put together, you see its clunky unity— a stick figure whose parts fit in some kind of joke about prosthetics: clamps, clump, cram, dangle, dump, et cetera. (As deKooning said about realism, it gets funnier all the time. The figure somewhat forces you to take its parts slowly one at a time. The Cape of Good Hope is at the edge of South Africa. The map of Africa is the "ear" of Ireland's figure, which is also like a sail attached to the "mast" of the broomstick (two broomstick fragments, actually). The Cape of Hope is the legendary site of the Flying Dutchman's urge to get somewhere—an eternal urge—which sort of leaves us where we started, and out of time.

Notes for a gallery talk, 2007

Of Mildness or Authenticity: Notes on the 53rd Venice Biennale

In the Teatro la Fenice or the Chiostro Verde of San Giorgio one likes everything a little bit more than one might elsewhere.
 —Igor Stravinsky, *Conversations with Stravinsky*

June 4, the Nauman press conference. From the dais on the grass outside the U.S. Pavilion, the State Department's Maura Pally assures the crowd "Secretary Clinton and President Obama are true supporters of the arts," and when pressed by a reporter on the question of government support for future biennales, "Secretary Clinton believes in this idea of Smart Power." In place of support, let's mount a campaign to put Nauman's neon *Vices and Virtues* signs around the Capitol dome or Senate chamber much as Piero della Francesca's *Resurrection* once held sway before the deliberations of his hometown councils. As it is, *V&V's* appearance along the pediments of the oddly cramped pavilion here puts Smart Power to the test. It is 75 years since the day in June 1934, when Benito Mussolini, on first meeting Adolf Hitler, walked the Führer through the refurbished Giardini. (My parents, both on Biennale-related business slightly earlier that same month, met each other for the first time in the Giardini, too—but that's another story.)

In a small side room upstairs at Università Ca' Foscari, two Nauman plaster "Smoke Rings" disks fairly glow in local daylight. Had the plaster surfaces—one greenish, the other dirty white—been repainted? The green one has a verdigris cast that either picks up or matches the *intonaco* of the far wall. In an exterior court on the ground floor sits a white marble Niobe. I'm told Nauman has visited Venice a few times before; for pleasure, for fun—he likes it. Things go better in Venice. The care and lightness of Nauman's touch, always evident to those attuned to his insistent candor, finds broader definition here. Contemplation of a bafflingly hurtful world does no harm itself but stands in brave relief, a beacon in fact—miss it at your peril. Another aspect of the same thing is how Nauman keeps to such a clear, tidy scale, implicating images and arrangements that almost always feel, even when they are not literally so, precisely life size. And the plain existential horrors they depict are life size, too. "Days/Giorni," two enfilades of seven wafer-thin, white, square Panphonics speaker panels at the two separate Nauman show places away from the Giardini—names for days, Italian in at Ca' Foscari, English at the Università Iuav di Venezia at Tolentini—make an efficacy splurge, a lesson in prosody imparted by male and female voices syncopated as to character from automaton to intimate. Pleasure follows from this, at once intense and subtle—the recondite pleasure of authenticity. Nauman will put himself inside a structure or situation as built or imagined as if to ask what might follow from living there full-time. For those who don't get his veracity, Nauman must ever be a pain. Among my souvenirs, a subhead for Hilton Kramer's notice of the 1995 MoMA-Walker Art Center retrospective: "Idiotic Curators Present a Contemptible Nauman Show."

By Day Three (June 5) Nauman has won the Golden Lion for Best National Pavilion. No contest; surely no runner-up came close, although the Pole Krzysztof Wodiczko, the Spainard Miquel Barceló (sole national entry of large-scale, ambitious painting), the Dutch entry Fiona Tan, and (even if *hors de concours* at the Quirini Stampalia Foundation) Mona Hatoum all are showing important work. Spectacles are given in the Russian and Danish/Nordic pavilions, and by the Moscow Poetry Club, if they ever show up. But the best exhibits overall were Nauman's and the late Robert Rauschenberg's. Both are sculpture shows, and in Venice, as elsewhere, signs are flickering that sculpture as such counts anew in unexpected ways. (A retroactive exemplar in that much-confused, always confusing category is the—literal—glory of Lygia Pape's ceiling-to-floor, multi-directional strung-wire piece in the anteroom of the Arsenale; other beauties-in-the-round are by David Hammons, Anna Parkina and Rachel Khedoori.) Both the Nauman and Rauschenberg shows deliver plenty of *verbal* eventfulness, as well. Occupying fully half the Guggenheim, Rauschenberg's "Gluts" (begun in the mid-1980s, with a few completed as late as 1992) are accompanied by titles—*Gooey Duck Summer Glut, Filter Fish Glut, Primary Mobiloid Glut*-- projective of his glee, evident in any case, in making them. First shown as a series in progress, the "Gluts" resurface here after twenty-plus years of ill-considered critical confinement. "They were pooh-poohed then," the Guggenheim director Richard Armstrong recalls. "Yes, but not by me." "You're lucky," he says, "not to have been of the generation that had to put Rauschenberg aside." A sad determination, at best. True, Rauschenberg's impeccable foursquare layout method on

occasion spelled entrapment for him (especially in the overextended "Combines" of the 1960s), but not here. Here is what Gregory Corso liked to call "The Beauty Shot," the goods delivered with refreshment, brio, intently brilliant hands. (A type of vitality notably inherited, among younger artists in Venice, by Rachel Harrison and Michael Day Jackson in particular.)

> *I need another world.* / *This one's nearly gone.*
> —Antony and the Johnsons, "Another World"

Intentionally or not, the big shows in the main official sites assume an art world in its ever timely fashion, now functioning—somewhat contritely, as it were—as a synecdoche of widespread ruin. The prospects look bleak. So much money has gone missing, and the new/old pieties taught in the schools aren't working. Noticeably missing in Venice are big photographs occupying spaces once reserved for big paintings, as well as, by and large, big serious painting itself. Gone, too, or in abeyance are the political-tourism videos and other documentary devices reliably seeing into and into every variety of far-flung human mess. By way of painting, aside from Barceló's white abstract swathes and hulking gorilla glyphs, notable discoveries include Tony Conrad's *Yellow Movies* (an aging-process piece of cheap paint on thin paper) in the Espositioni followed by Martial Raysse's astonishing allegories, after Balthus and proto-Neo Rauch, and a particularly elegant Mark Bradford, both at Palazzo Grassi.

There are things the grandiloquence of the pavilions can't gloss over; in one telling instance, apt décor for a dilapidated palazzo: Teresa Margollese's canvas draperies soaked in the blood of those who died violent deaths in Mexico. Beyond that, it's a strange inventory, the overstock of big ideas that don't mean anything, beginning with Biennale Director Daniel Birnbaum's *Making Worlds,* which by default seems to have been jinxed by a lot of architectural models, light fixtures and globes—one of those made of construction paper and hoola hoops—and other things redolent of Fifth Grade classroom projects ("This week, children, we are exploring Ecuador"). The only genuine architectural achievement is Tadao Ando's conversion of the interior of the Punta della Dogana into a contemplative jewel-box setting for much of François Pinault's collection, more of which resides more raucously at the Grassi. Along the peripheries are theme shows with titles peeled from vintage drugstore paperbacks: *The Seductiveness of the Interval, The Fear Society, Unconditional Love,* and Russia's own *Victory over the Future.* Generally, the pavilions succumbed to a mildness that at first seems to be breathing a sigh after many years of resentful harangues, rage, outrage, and institutionalized "institutional critique"— or is it all merely symptomatic of fatigue? Mild, but scarcely playful. Captivated, it seems, by the marketplace of ideas, even the gentlest of curators get caught out thinking too hard and looking too little; they judge their selections by ideas without bothering to see if the ideas they find attractive have taken any shapes worth looking at. A lot of festival art leaves just the impression of conspicuous effort, some person or persons having labored long hours to small, if any, effect. Two rooms side by side in the Espositioni showed how things could be otherwise: one, an anthology of monochromes by Pape, Blinky Palermo,

Sherrie Levine, and Wolfgang Tillmans, with Philippe Parreno's film accompaniment to a recording of Edgard Varèse's one-minute composition *Desert* at the far end; the other, an exhilarating reprise of the sort of work that made the Gutai group of the 1950s and 60s so enviable in their taking charge—not of style, but attitude and possibility, and then again of possibilities that are *only* urgent.

> *The animals enjoy structure; we only understand it.*
> —Alfred North Whitehead, *Modes of Thought*

In its own quiet way, *Making Worlds* indicates, perhaps with deadly accuracy, an ethos waffling between demolition and total—nay, ultimate—build out. There is nothing quieter, after all, than an array of architectural models in a room. Contemporary existence is seen, at one stage or other, as one enormous, flailing Potsdamerplatz. Coursing through the Arsenale, the Dogana, the Palazzo Fortuny are motifs of architecture "makeshift and imaginary," city planning, interior design. With such tags in place there trundles along the keyword "infrastructure" made manifest in sufficient lengths of pulled-out rebar, excavated subflooring, not to mention obligatory fuzzy videos of airport and ground traffic systems, to awaken those presumed oblivious to what they'll never guess is around or under them. There are many corridors. Nauman doesn't "own" corridors, but it's hard not to think "nauman.corridor" when you go down one in an art show; even the best shot in Fiona Tan's Silk Road movie, a rhino squeezing into an alley, brings to mind his customary realization of space as absolutely germane to psyche. Art, we know, can be understood, partially at least, as a species of interior design, décor for city people, what is in the room that is neither the room nor those people. Margollese's bloody tarps could fit just as readily in San Giorgio Maggiore's refectory, the site for which Veronese's *Wedding at Cana* was commissioned in 1563, on three walls of which the master showman Peter Greenaway daily projects his film, animating Veronese's figures, interpolating voiceovers in scruffy Venetian dialect. It was courtly Venice after all that turned faster and more definitively than most of the imperium from plainsong devotion to aggressions of the Marvelous, jamming space with aerial acrobatics and traffic control. Halfway through Greenaway's film, the clouds break and a grisaille rendition of the picture, with the *giornati* by which the artist and his team worked blocked out in white, gets drenched, much like our embankment the night before (or when the full moon brought high water up all across the campos). Nauman's sign in a window has it almost right. Try saying it the other way around: *The world helps the artist by revealing mystic truths.*

June 2009

The Visitor: Vermeer's Milkmaid at the Met

Vermeer's painting of a maidservant pouring milk, on loan at the Met from the Rijksmuseum, is a work of extraordinary fullness in every respect. This feeling of uncanny amplitude is partly the result of how, in the way Vermeer made his own, sunlight coursing through a window (a cool graced light if ever there was one) acts on bits of earthly surface, affording a kind of extreme visibility to each thing exposed in its path. Light in Vermeer is such a fact of esthetic experience, so intrinsic to everyone's appreciation of his art, that it may have blinded us to a great deal else that shows up in the pictures.

Neither signed nor dated, on a near-square canvas nearly a foot and a half in either dimension, the picture, for all its grandeur, seems a hinge work of Vermeer's early maturity. Better known nowadays as *The Milkmaid,* it's an anomaly within his output generally, its worked-up surface and culinary subject matter stated comparatively coarsely, a less delicate image overall than the preternatural refinements soon to come. The Met curator and scholar of Dutch art Walter Liedtke places it historically in the company of other paintings, some of them in similarly smallish formats done around 1657-58, when Vermeer was in his mid-20s. Of these, the Frick's no less lovely and mysterious *Cavalier and Young Woman* is closest in size and format, and it's fairly obvious how the maid's ruddy countenance and heft are more suited to this brusque treatment than the finer features of the diminutive figure seated at the Frick.

Leaning gently into her task, this astonishing barrel of a woman shifts her weight away from the splendid, though nowise pristine, white wall, lips slightly parted in a smile as the earthenware pitcher releases a white skein from its rim. That smile holds its secret, murmuring, at one with the massive presence it seems key to. Liedtke says the woman's brawn and the vertically fluted folds of her skirt render her "like a caryatid," although caryatids don't bend or lean—but it's true that, in terms of construction, the maid keeps Vermeer's pictorial architecture aloft. Her brow forms a lunette answered by other lunettes upward and around her. Hers is a type of big, blunt form we know in different guises and moods from the peasant women of Pieter Brueghel the Elder and Piero della Francesca's *Sinigallia Madonna* and *Mary Magdalen* to Manet's barmaid at the Folies and deKooning's *Woman I.* No doubt encouraged by Northern-realist modes extending from Vermeer's great precursor Jan van Eyck, Piero's Sinigallia panel bears a special relation, with its slice of sun on bare wall and in the forward chamber (Piero's only domestic scene) the hugely commanding frontal mass of mother and child.

Vermeer's maid appears in the middle distance in the guise of some sort of lunar blessing. She is strength and help, appetite and caution, warmth and removal, privacy, decorum, daydream and delight. (In no way is she about careless sex—no matter how many corollaries to that effect women of her station may have in the iconography of her time.) It isn't much of a stretch to align her activity as a mirror to the painter's own, as he deposits colors onto a surface that then erupts with otherworldly incandescence. Contour-defining light at the right edge of her frame is augmented by skitters of white

paint down the silhouette, a device Vermeer resorted to mostly early on. She has the madonna attitude—complete with high, plucked brow—common to many women in Dutch paintings when neither simpering or lost in some workaday haze. The whole scene centers, subtly teetering, on her waist.

It's astonishing, too, how at ease, formally and then some, with one another the maid and the serviceable enclosure, a pantry maybe, with all its material life can be, and at the same time how much implied motion, directional thrusts this way and that, among the objects at hand, the painting holds. Varieties of shape—domes, globs, granules, cylinders, perpendiculars and slots—refract one another, all of them spread at levels on or above a simple reddish brown floor. The hanging basket takes its angle from the maid, the pail from her pitcher; the two geometric flats of window and picture frame are elaborated in the footwarmer's perforated box and the tabletop's odd rhomboid. There are rude Mozartian touches, tricks like trompe-l'oeil nails and vacant nail holes, the popcorn-like pointillé breadcrumbs, the vaguely messy floor, and the incongruity of the line of tiles that forms a kind of predella—Cupid and bow, a traveler with his staff and two others less legible, like animation figures. The milk pour and a rectangular bit of unfiltered glare where a segment of window glass is missing—equivalents in plain whiteness—sustain and refresh. Whereupon, two notes of corresponding high optimism in the yellow range are struck: a bright patch on the window jamb and a more evanescent hue on the jacket's sunny side. A third major white erupts as sunlit parts of the linen cap, veering back in the air like a prow, while the far wall blushes with shadows, variegated. As ever, Vermeer's infusion of sunlight galvanizes an atmosphere charged with implied, recombinant meanings. ("Deeds of light" said Goethe, perhaps with Vermeer in mind; and Liedtke himself ventures the thought that, beyond the visible fact, it is "as if meaning not milk were being poured from one vessel to another.")

All but a very few Vermeers have some forward, liminal impedence, a bulwark like a table or curtain or chair to keep us at some remove, discretely parallel to the world his people occupy. (The sharpest of these de-butments is the apex of the man's elbow in *Cavalier and Young Woman*.) Here, to preserve the discretion of the figure's placement, it is the lead edge of the table, its coverings littered with large and finicky still-life elements, leaving, in this instance, the woman's frame still half open to approach. As usual, too, in this pageant of particulars, the paint inspected up close is gruesome. The maid's head looks uncomfortably mottled, the plumb line of milk a gloppy paste. At only a little distance, such details resolve: the head resumes its formal dignity and the milk streams (recalling James Schuyler's "Trembling, milk is coming into its own") like the average sacrament it is assumed to be.

As she tends to these things, the maid and her charges are revealed as elements in the mythology Vermeer contrived for himself, out of what urgency we have nary a clue. Details and their gists are left meaningfully uncertain. Does the maid, as old songs go, wear her apron high? (Probably not.) What is that birdlike shape reflected in the shiny pail? (It's hard not to see it as a reduplication of Carel Fabritius's goldfinch, a painting long taken a source for Vermeer's technique.) For his part, Liedtke, who also wrote the most recent monograph on Vermeer, means to keep our understanding of Vermeer's genius (he allows as how it is such) and its topicalities well within what he calls "the

Dutch field." Understanding Vermeer means primarily understanding how he developed his mode of precision painting amidst the givens of art and life in the southern Netherlands of his time. Set on rescuing Vermeer from a century and half of the sort of esthetic flightiness generated by interloping enthusiasts, most of them from outside Holland, Liedtke wants him safely back in the professional culture that the greatest pictures leave far behind. This is fine as long as it doesn't exclude other, perhaps less demonstrable, but no less real, forces at work in the pictures. Liedtke's account of Vermeer's milieu is exclusively that of the painters: no changeable Dutch microclimates (from whence the undependable, but by turns clouded-over, then suddenly amazing effects of the sun); no literature beside the lewd tavern rhymes (meaning no Descartes, whose "natural light of the mind" seems ever applicable, or Spinoza, who once remarked on the monstrous look of a woman's beautiful hand when viewed under a lens); no furtive Catholic liturgy or Neoplatonist whispers. Of course Vermeer was well grounded, and so are his pictures, which is literally the basis of their sublimities. Likewise, anything one says in trying to account for the ultimate Vermeer experience is likely to be too much, but not to try is just as vain. The Met's wall texts would have us see each of *The Milkmaid*'s as a sign limited to one intensely local connotation, a Dutch in-joke projected by the doggerel, riddles and other oddments for which, everything else about him insists, Vermeer would have had little patience except that he saw how to transmute them, as his elevated patronage may have demanded, into the idiom of the spheres.

Vermeer was something of a visitor. It could be said that, devout as he may well have been, he envisioned humankind as specially designed to enter heaven, and made a kind of heaven analogous to that insight within the method of his art. How he raised the stakes of the painting culture he was given to work with can be explained, as Liedtke is wont to do, by itemizing his modifications of the various motifs and technical devices of other artists in Delft, Leiden and other neighboring towns. But accounting for the impact of what he did is something else. He defeated the low-style specificity of genre painting and Northern realism's tendency to over-describe and stop the flow of paint and pictorial fluency altogether. Vermeer styled his interior views as purposefully as Rembrandt, with nowhere near the stagey folderol but inclined, as Rembrandt wasn't, toward an extra measure of idealization. Virtuosity is the least of him. Together with memory and invention, direct observation of models arranged with their accoutrements in a room went into establishing a rudimentary image. (What sketching he may have done in chalk or some other medium has been subsumed by layers of paint.) This is realism based on immersion in the contemporary world but heightened beyond the commonplace, but more importantly the pictures argue for an understanding of the sacred and profane as terms converging with such coruscating intensity that each illumines the other. In Vermeer, there is no impact without the whole bundle of aspects taken as operative in the moment. A picture like *The Milkmaid* exists on that fulcrum between realism and allegory where the richest meanings thrive.

2009

Conversations

Fresh Air, with Robert Gluck

A Conversation in Robert Gluck's Kitchen, August 25, 2005

Robert Gluck: Are you ready for your close up, Mr. Berkson?

Bill Berkson: Yes.

RG: My first impulse is to start at the beginning, but instead, let's start in the middle. A glance at your bio conveys the picture that you are a citizen of both coasts, the East and the West. How did you negotiate that and how has it affected your writing? What is the poem that belongs on both coasts?

BB: *The Iliad*, maybe. Yes, I've been here for 35 years, I still say "out here."

RG: When I was entering the scene here, Bolinas was like New York School West. Lewis Warsh was directing the poetry series at Intersection, Lewis MacAdams headed the Poetry Center. So there was a strong sense of the New York School coming to California. That was recognized and felt and looked at by the local poets. I was already in love with the glamour and energy of the New York scene. I'm curious to know how it was for you?

BB: You mean coming to Bolinas?

RG: And becoming a citizen of the West Coast. You have given a lot of your life to institutions here.

BB: There was the shock, sometime after my sixtieth birthday, of realizing that I had slipped over a line and spent more than half my life in California. To the extent that I still say "out here," I still consider myself a New Yorker. I lived in Bolinas, I was kind of a counter-culture country gentleman for 23 years. You could say it was kind of like a marriage of the resident Bay Area poetics—people who had spun out to Bolinas in the Duncan/Spicer Diaspora—and poets associated with the New York School. How much time did those supposedly New York poets really spend in New York? Tom Clark, for one, who was from Chicago, schooled in Michigan, went to London, touched down in New York, got married at Saint Marks Church and left for California.

RG: My sense is that different poetics did not keep people apart.

BB: No, that's the nice part. The community, so to speak, was so various in Bolinas that when we got together as poets we would talk about firewood and septic tanks. When I asked Larry Kearney, who was then full of residual Spicer attitude, what Jack Spicer was like he said, he said, "He was the most serious man I've ever known." A very un-New York evaluation. As in any rural setting, daily life got very daily. Happily, there was no unifying poetics.

RG: What could be farther from the New York School than the Spicer/Duncan circle—with their vatic utterance and their metaphysics? At the same time, you can look at individual poems and see overlap. Maybe that's just the times.

BB: Yes. We had the pleasure of Phillip Whalen's being there too, along with Mr. Ecumenical himself, Don Allen.

RG: Ecumenical but also withheld. You weren't going to get much light out of Don.

BB: "Asp-ish as ever" is how Jimmy Schuyler described him when Jimmy visited. Yes, but it's just funny to think that here in the mini-Melting Pot of Bolinas was the man who did *The New American Poetry*, which included all these different vectors.

RG: And of course Creeley was there for a while, and Bob Grenier, both of them were my teachers.

BB: There were a lot of people who came and stayed. The New York School to begin with is an absurd designation. Even for the first generation New York School, Ashbery, Koch, and O'Hara and Schuyler had in common, if nothing else, a basic, and very sophisticated, reading list and an attitude about keeping their otherwise very different poems light and fast and airy, or as O'Hara said about "Second Avenue," "high and dry." But then afterwards, what happened was really the New American Poetry. Poets from dissimilar backgrounds and with different interests came together according to how they read the prior generation or two. For example, Jim Gustafson from Detroit, Tom Clark from Chicago, some like Joanne Kyger in the Bay Area, all had read the little magazines and Allen's anthology. As a young poet your first hit might be O'Hara in New York, but next you'd read Creeley, John Wieners, then Ashbery, and any number of people from other places under different affiliations in that book. The great thing that happened to our generation was that each of us had the opportunity to make a personal meld according to taste and necessity.

RG: There's a historicizing that isolates different groups, but if you go back and look at people's letters, and who they are seeing, what they are talking about, there's so much more overlap than the MLA papers that divide poets into schools, the New York School, Black Mountain, or whatever.

Then, who were you melding with?

BB: The names that I just mentioned are pretty close to representing what happened to me. First of all, even for a New Yorker, for example, at the end of the 50s, being the age I was, I headed off to college, having graduated from high school in 57.

RG: You grew up in Manhattan?

BB: I grew up in Manhattan.

RG: When you said, back there you mean....

BB: Back east.

RG: As you were saying, some people came to New York after they grew up, but you were there in the first place.

BB: And then I could have gone anywhere. After all, *The New American Poetry* had not appeared yet. In 1958, I thought all the excitement was in San Francisco because of the San Francisco issue of *Evergreen Review* and Kerouac's *The Subterraneans*. I came out to San Francisco that Thanksgiving with my parents, who had business out here, and I wanted to get a job on the *San Francisco Chronicle* on the police beat. Also I wanted to find the Beat Generation and I went to places I'd heard about and asking completely dumb questions like, Is Jack Kerouac here?

RG: I'm so glad to hear that. That's just what I did—except I went from California to New York.

BB: And somebody, I think it was Knute Stiles, the bartender at The Place, said, They're all in New York. It's like I trucked 3000 miles to find this dream that was really in my backyard.

RG: Were you writing like Ginsberg and Kerouac?

BB: Oh sure, yeah, and mainly like [Gregory] Corso.

RG: That was a question of mine, how did you—your first concept of being a poet—what was that?

BB: My first concept was T.S. Eliot.

RG: Well, your second concept, the contemporary one.

BB: Yes, the San Francisco issue of *Evergreen Review* came out, and with it a recording. The image of being a poet included there was the photograph, probably by Harry Redl, of Ginsberg very wide-eyed leaning forward with a cigarette between his fingers. As a teenager I looked at that photograph for hours and listened to him read *Howl*. Then as it happened, the prospect begins to become clearer to me that something is going on in the world and in my life. My father died and instantly I left Brown and returned to New York. I have to wait a semester before enrolling at Columbia, so I go to the New School for Social Research where I take a poetry workshop because there is one and it happens to be with Kenneth Koch. I go to his class armed with some poems, about which he's encouraging. Then, a couple of classes go by and I say in class, well what about *Howl*? And Kenneth allows as how *Howl* is a very powerful poem but after all, all that noise about "the best minds of my generation" and so on—the same generation as Kenneth, you see—is rather silly and exaggerated. This helped balance my view of things somewhat.

RG: It's an interesting moment when that happens. Sometimes my undergrads practically memorize Bukowski. I say, Why do you like him? And they say, He writes about life the way it really is. So, I start quizzing them about their experience and it doesn't resemble what he writes about in the slightest. So real life must be happening elsewhere.

BB: They relate to a life of marginalized suffering. It's one thing to read the poems and respect them and it's another thing to say I want to live this glamorous life of dissolution. What is the attraction of that? I don't think that anybody became a junkie reading *Naked Lunch*. But junkies might particularly enjoy it for the recognition.

RG: True. One looks for authenticity that one can recognize—that's what Koch was saying.

BB: So then I got my introduction, fast and marvelous, via Kenneth's teaching. He kept his poems in the background. But he was very forthcoming about O'Hara and Ashbery and also the connection with painting, which wasn't unique to New York. I just read a wonderful interview with Robert Duncan about the importance of painting for his work—and not just Jess's paintings, but what was contemporary for him, generally.

RG: Oh yes, there was the same heated relationship between poets and artists "out here," including poets writing reviews for the art press, like *Art Issues* and *Artweek*. That brings us to you and the New York School.

BB: Okay, the New York School. In 1965 there was a poetry week as part of the Festival of Two World in Spoleto. O'Hara made up the list of the American poets to be invited. Not all his selections were invited; they wouldn't invite Ginsberg because he had been

there a year or two before and taken his clothes off on stage. Maybe half the poets from the U.S. were New York poets, including me. Somebody had the bright idea to invite Stephen Spender to be the master of ceremonies. The first reader was to Barbara Guest, and Spender got up and said, "Barbara Guest belongs to the New York School of poets, whose main distinction, as I see it, is that they all write about painting." That was all he said about Barbara. So it was a putdown. He communicated to this international audience a sense that to be "New York School" was to be party to a cabal.

RG: Perhaps the antagonism between an English poet and this American team derived from feeling overlooked, because the American avant-garde often jumps over England to France.

BB: Ezra Pound was there, but he was not speaking. He gave a reading from the royal box in the first balcony. He didn't even read his own poems. He read Marianne Moore's La Fontaine translations and his son-in-law's translations of ancient Egyptian love poems and then sat down. Charles Olson thought he would have the ultimate confab with Pound but Pound wasn't confabbing in those days.

RG: I've meditated on the NY School since I was an infant, when I thought I was Frank O'Hara.

BB: Me, too.

RG: The earliest work of yours that I know is in the 1960s anthology *The Young American Poets,* and there are plenty of poems where you sound exactly as you do now. There is a good deal of consistency. People should never worry about voice. You think you're sounding like someone else, but you sound exactly like yourself when you look at it ten years later.

I think about the word "you." How the word "you" is used by the NY School and how it changed things. That very intimate "you."

As I was reading your poems this morning, in some poems I got an image pile, not a word stack, but a pile of images. Then there'll be the entrance of the word "you," which shakes the poem out like a blanket. And suddenly there's dynamics, relation; it's no longer a list, a pile, I have to rethink what came before, and what comes after occurs inside a dynamic that actually is pretty clear—if not clear like a story (though some of them are) then clear in the sense of how to frame each image.

BB: There is the "you" as in "you know," the "you" that is a substitute for "one," though more intimate than "one." It's one trying to extend from the first person singular to the more general case, right? The "you" you encounter in a love poem is otherwise. A lot of O'Hara's poems turn into love poems at the end via the deft insertion of a "you." That's a new you.

RG: Yes, a love poem that withholds the "you" till the end, a last line that will order what comes before.

BB: Yes, yes.

RG: What that "you" does in your poem "Blue Is the Hero" is give the sense of projecting a new narrative on what comes before. We have to rethink it: here are two people, a whole history that enters at the end, but only because it's placed at the end. You have to project backwards.

BB: In "Blue Is the Hero," I often wonder who is the hero and who is the "you" that enters at the end: "You are that helicopter." It's not self-reflection, an "I" talking to oneself, but it's not another person, either. When I read it, it feels like I'm talking to a distinct other. It's a sudden address.

RG: That's a good term. I like it.

BB: I was reading Richard Holmes's *Sidetracks*. He's a biographer of Romantic poets—Coleridge and Shelley. In an essay on Boswell's journals he shows Boswell writing of himself "you does" or, recalling the night before, "You was drunk and charming, as ever." Boswell was writing his journal for himself: "Last night you were thus and so," but the verb changes to "you was."

RG: The "you" is a very mysterious in these poems, in yours and in others. In some way it foils the muse a little bit: in the moment of the poem it makes a kind of community or presupposes a community of listeners.

BB: It's a way of immediately engaging the reader, because you're coming right at the reader, saying "you." John Ashbery has a poem that begins, "You have been living now for a long time and there's nothing that you do not know." And the reader responds: "Are you talking to *me?*"

RG: That is a very interesting new thing that happened in that time.

BB: It also sets up a kind of narrative. It's as if you're jumping into the middle of a narrated relationship.

RG: You know it reminds me of classical poetry. Those letters in verse for example. When I think of that poetry, I see it as open, as part of a group practice.

I also want to observe that you're extremely polite to the reader. You have a kind of courtly relationship with the reader. And even when gloom is intended, you'll say no gloom intended. I don't know whether that's something you think about, that relationship.

BB: Oh, yeah. I think that that's where the poetry of the previous generation, really cleared things up. Writers like Kerouac, Ginsberg, O'Hara, where—and I think this is true of the painters too, deKooning, for example, and Kline—how it's important to remember that art is a form of social behavior. It's not exempt from the everyday ethos, and while it may be a superior form of entertainment, it's not "above." The aspect of entertainment puts it back in social terms. Why do we dislike some poetry—or art, for that matter? Is there something in the complaint that's inappropriate? Then one angle of criticism is, How does this play out socially? Allowing for the fact that a work of art is an "as if" real-life situation. It's "other," but the terms are grounded in real life.

RG: Are there examples in a work of O'Hara where he criticizes your work?

BB: Well, I sort of do and don't know what he meant when he took a poem of mine with the phrase "what I hope is beneath my skin" and wrote this two-liner: "What you hope is beneath your skin / is beneath your skin." I've never been able to determine whether he meant that to be chiding or encouraging.

RG: I'm a fan of your art criticism—I used to pore over the *Artforum*s to learn about what was going on. It was important in my own practice as a writer to know what was happening in visual art. And you are one of the few critics who don't merely stay with a work of art or an artist, or attempt to assign ultimate value, but contextualizes the art and

artist, and speaks for them in a kind of brainstorm. And the writing itself is very beautiful. Did you have models?

BB: I have certain, good desktop models. I freely reach for my Edwin Denby, Whitney Balliett, Baudelaire, or John McPhee when I start writing or whenever I get stuck. I like those who write a companionable criticism. Fairfield Porter, for one, is a very elegant writer, but at the same time, he either won't or can't make a continuous argument—not one that is developed logically, anyhow. So his perceptions follow one another, sentence by sentence, seemingly just as they occur, which for me is pretty liberating to attend to.

RG: You recommended James Schuyler to me when I was looking for a model art critic, and he was a great help. I say about my own criticism: I'll write the topic sentences. Let someone else do the development.

Your vocabulary in your poems is large. Many poets, like George Oppen and Spicer, keep their vocabulary small. Is that a West Coast thing?

BB: I'm often seduced by ten-dollar words. Some of that comes from reading, and some from my background, the indirect language (some might call it euphemistic) of the upper middle class. It's just *in* me. Sometimes a word shows up in my critical prose and sometimes in poetry too; a big word that somehow shows up in the writing. I may look askance at it, unsure of what it means but certain that I've never used the word before, in either speech or writing. I look it up in the dictionary and, damn!, it's just right, *le mot juste.* Now how did that happen? There must be an inner vocabulary monitor that knew it; I didn't know it, except by osmosis.

RG: It's an attitude about the surface, but I don't want to use that word, because what does it mean?

BB: But I think it's relevant.

RG: I suppose when you make people aware of words, that's the surface. But then, what are words? Let's talk about bumping into those words that are indigestible even after you look them up.

BB: There's the word "sempiternal" in one poem.

RG: There's that word that has "elastic" in it.

BB: Anelastic.

RG: What a word.

BB: Well, there are poems that tell stories and then there are poems that are more accretions of words and phrases. The language is "out there," but, although I'm fascinated to write these poems, I'm also distrustful of some of these big words, because they plod in on their little silver feet, a bit too enticingly. Bernadette Mayer always tells me my poems are "packed in."

RG: Then, does the reader unpack it?

BB: It can be so packed in, intensified that it can't go on very long at that level of intensity. By the time you get to the end of the page you want to go soak in a bathtub.

RG: But you don't make these poems look overworked. They're as fresh and lively as poems in your other modes, poems that look like notation, for example.

BB: Normally what happens is that something gets down and it's over packed and I air it out.

RG: That's the final rewriting, isn't it?

BB: I don't know what the technique is called, but it's akin to a painter going back into the painting with white. It's not just cutting. It often can be adding prepositions and other connective words to give the words some elbowroom.

RG: Matisse said, "If you have a bright color, then put gray around it so the color can breathe."

Shall I ask you a silly question?

BB: Sure.

RG: Okay, are you true to your astrological sign? Regardless of whether you believe in astrology or not, everybody seems to have a take on whether they're true to their school.

BB: I'm Virgo. I think so. I've got some of the frustrating attributes of Virgo, but in time I think I've triumphed over them, or made peace with them. There's an appropriate rhyme about Virgo that I found and put into a piece of extended prose called "Start Over": "He's loyal, devoted / In fact he's a jewel / But critical often / And that's a bit cruel."

RG: I ask this in my classes sometimes at the beginning of term to get students to talk about themselves. And I also ask them to make a list of items, whether the work of an artist, writer, or composer, that they consider essential. What do you consider essential?

BB: Ah, the endlessly revisable list—well, here goes: One of John Ashbery's books—*Rivers and Mountains*, probably, or *The Tennis Court Oath*; Thelonious Monk as complete as you can have; Mozart's piano sonatas and *Divertimento 15*; a deKooning painting; if I had the freedom and money to choose, a Jasper Johns; if there was even more money, the right Vermeer; Balanchine/Stravinsky; Shakespeare's *A Winter's Tale*.

RG: And, of course, you need a good Romantic in the house....

BB: Yes, Keats. Ozu's *Late Spring*. Other things by Morton Feldman, Ellington, Basie; Jackson Pollock's *Number One, 1950*; Charles Reznikoff's poems; Kenneth Koch's poem "Paradiso"; Lee Friedlander; Piero della Francesca's *Resurrection*. I look at the Guston drawings in our home all the time. And Alex Katz. I have the Collected Frank O'Hara practically committed to memory. What else? The Kinks, Neil Young, Haydn, Josquin Des Pres, Willie McTell, Sondheim's *Follies*....and lots more songs I can't get out of my head. Nick Dorsky is another filmmaker whose work is continually amazing to me. I thank him in *Gloria* because a lot of the poems in that book come from a little book called *25 Grand View*, which was all taken from a little red notebook. During the time when I was still sick, Marie Dern asked me to give her sixteen pages for a bookmaking class. I wasn't writing a lot of poetry, I was casting about and looked at this notebook and began typing it up. Some of the pages were just stray notations, but here and there was a real poem. And this dovetailed with conversations Nick and I were having about outtakes. And I said, "What if you just made one minute films with them? Otherwise, so much marvelous stuff gets left out." We were talking about what constitutes a really "made" work of art. I dedicated that little book that Marie's class produced to Nick. I was continuing that conversation, not that it changed his way of working at all.

RG: You just went through a huge health crisis. It would be interesting to hear how it affected your life and work.

BB: Yes, as they say, a so-far-successful lung transplant is a miracle. When I was declared at end-stage emphysema, I understood quite shakily that I was headed for death via

respiratory failure, because if I got a serious infection it could have gotten that bad. Before my operation there was this rule of thumb that no one over 55 could withstand the rigors of a lung transplant operation. But the pulmonologist and surgeons determined that at 65 I might be a candidate if I got myself in shape. I was on round-the-clock supplemental oxygen and huffing and puffing, barely able to get down the street. And then, immediately after surgery, I was able to breathe normally. The doctor told me to get right up and walk, and as I stepped into the hospital corridor I noticed that I didn't have to stop. I don't have any determined life expectancy—I'm in my 60s, and, like Philip Whalen said, I could croak anytime. When the doctor told me I had end-stage emphysema, I was really shaken. I said, "I'm not prepared to die. I'm not ready. I haven't finished my work." How does it feel now? For openers, unless I am just dreaming in the afterlife, I'm aware of this bonus everyday: I'm actually alive. At the same time, I'm determined not to become evangelical. I've never been a person to make plans or New Year's Resolutions.

RG: So your attitude is that you're trying to resist a change in attitude?

BB: Yes, but I think I had the necessary attitude anyway. The outcome of the surgery and getting my life back was to make me more aware. It's one thing to know generally how fragile and precious existence is, and it's another thing to come face to face with the definition of that fact.

RG: Shakespeare says in your favorite play, "Thy life's a miracle." How lovely that you're having a new book *[Gloria]* from Arion Press. They make the most beautiful books, don't they?

BB: Yes, I know. I'll believe it when I see it. That's the other aspect of resuscitation!

<div align="right">2006</div>

In Conversation, with David Levi Strauss

David Levi Strauss (*The Brooklyn Rail*): I knew about your work as a poet before 1978, when I arrived in San Francisco at age 25. I know I had *Blue Is The Hero* by then....

Bill Berkson: Is that when we met, 1978?

Rail: Well, we probably met between 1978 and 1980, but our first substantive contact came in 1981 when I wrote to invite you to be part of the series of readings and talks that Aaron Shurin and I were putting together at Peter Hartman's theater at 544 Natoma Street, and you generously wrote back and ended up doing it.

BB: That was when I read Jimmy Schuyler and Edwin Denby, doing a talk on contemporary city poetry. That was terrific, thank you for that! *[laughter]*

Rail: And then I had the good fortune to publish your poems in my literary journal *ACTS,* in the second issue, and I think I also sat in on a seminar you did at New College on the sublime.

BB: And you wrote the most terrific note on the poems then, particularly on one called "The Hoole Book" that had been prompted by reading Malory's *Le Morte d'Arthur.* You did a complete reading of the poem, which I still return to.

Rail: That first letter of mine to you begins "I lived with a painter for three years"—in the past tense, as if it was finished. And now I've been living with that same painter (Sterrett Smith) for almost 30 years! *[laughter]* But our conversations and correspondence continued off and on through the San Francisco years until we moved to New York in 1993, and then it started again about 6 months ago, almost as if one of us had just gone out for a cup of coffee and then suddenly reappeared.

BB: That's the way it goes! *[laughter]*

Rail: I think everyone knows that you were a New Yorker's New Yorker for your first 30 years—a second-generation New York School poet coming out of the tradition of Frank O'Hara, John Ashbery, Kenneth Koch, Jimmy Schuyler....

BB: Well, for the first 30 years of my life, which means the first 10 or 12 years of my writing life—serious writing life.

Rail: And you were hanging out with the painters and sculptors of the New York School and began writing about art at a very early age. And then, in 1970, you moved across the continent to California, to the poets' town of Bolinas and became, in your own words, an "art world drop-out."

BB: I was an art world drop-out before then, because it was really 1967 or so when I began to feel uncomfortable with, not so much with art or even how the art world was going, but with how art criticism had turned professional in an aggressive and, I thought, egregious way. I was actually scared off because it seemed suddenly that one was required to take up and establish a position, like on a beachhead, and I didn't have any or think that's what writing about art should be.

Rail: And hadn't been until then.

BB: Right, I mean there certainly were people like Clement Greenberg and Harold Rosenberg who were expert position takers. People in those days spoke of allegiances and allies—the Cedar Bar was sort of like the Malta Conference! I don't know if even

Harold or Clement Greenberg thought of themselves as professional critics. Both were aspiring poets to begin with; Rosenberg had a snappy prose style but Greenberg was a master rhetorician and he certainly did make a profession of being an art critic, and therefore became a model for the professionals who emerged in the 1960s—young art historians, mostly. At that time, circa 1965, because the lively, archive-oriented revisionist art history had not yet begun, there was no more turf left to be occupied in old art—no more to say about Michelangelo et cetera—so the younger art historians invaded the territory of contemporary art, colonized it, and brought with them their fangs-bared killer instinct of the departmental paper chase.

Rail: Do you think other poet-critics from your tradition felt the same way?

BB: No. Well, right about that time or a little later, poets like Peter Schjeldahl and Carter Ratcliff and others began as critics and managed to get going perfectly well without acting one bit like the other critics. Carter certainly always has been a loner in the way of continuing as a poet and rigorously maintaining that art criticism is its own oddment, a vital sort of non-profession. One should maintain one's amateur status by all means necessary.

Rail: In Bob Gluck's interview with you last year, you say that your "desktop models" for art writing, to prime the pump, include Edwin Denby, Whitney Balliett, Baudelaire, and John McPhee. Denby wrote mostly about dance, Balliett wrote about music—jazz, and McPhee writes about everything but art.

BB: Balliett can cogently describe sets of live improvised music heard only once, which is quite a feat. Of course, in a true sense, we never see the same picture twice, either. John McPhee is sort of a model journalist, a writer of sentences and a guy who puts together a lot of information which is something I enjoy too, if I get the opportunity, particularly in a longer piece of art writing, or any kind of expository writing, as well as now sometimes in poems. Fact-driven writing, research—connecting often extremely diverse dots. McPhee just happens to do it in a very interesting way. The first book of McPhee's that I read was *Oranges*, about the orange-juice industry of Florida. And well, I like orange juice, but I read it because the writing is interesting to read. It's akin to reading Francis Ponge on soap!

Rail: Ponge on anything! *[laughter]* Ponge on wasps and spiders! The world of *things*. This brings up something that a lot of people don't often point to in your art writing: the scholarship is always impeccable, and the history is impeccable. I mean I've never caught you out, even when you're writing about Carleton Watkins or something with similar loads of historical and/or technical detail.

BB: Love of detail, curiosity about technique and materials and the material life of things, how things people make with particular purposes in mind arrive and figure in the world. My father's motto at International News Service was "Get It First—But First Get It Right." I'm as much an editor as I am a writer. In the case of Watkins, I sent the piece to Peter Palmquist, the preeminent historian of California exploration photography and also of Watkins. I never heard back from him, but I figured if I had something wrong, he would have told me. And I did get him on the phone initially to ask a few questions.

Rail: To check your facts.

BB: Yeah, this is like McPhee territory. Just really tracking it down. It's partly by doing this kind of art writing that I discovered the good student that had been hidden in me for all those years, certainly through college or high school where I was distracted and lacked good study habits. *[laughter]* I am now a scholar based maybe more in the character of a detective, a gumshoe. I really love to follow leads to their unexpected conclusions—which is really no conclusion, the case turns out to be endless, who did what, where, when, to or with whom....

Rail: You said in the Cal commencement speech [History of Art Department 2002 Commencement Address at the University of California, Berkeley] that you are "nearly crazy about facts." I guess this goes back to Fairfield Porter's dictum that "Criticism should tell you what is there." But I think this also has an ethical dimension to it. You want to add something to the collective conversation, the social, and you want to be useful while being beautiful, right?

BB: Yeah. Somebody said that what criticism does, besides telling you what is there, is to continue the conversation. It could even have been Pound, who also set about reminding us that the best criticism is ultimately the next word in whatever specific medium. But the sense that there is a conversation that includes all art forms—and probably that finally is what is called culture.

Rail: And if you're not contributing to the conversation, what are you doing?

BB: Well, it all depends what you call the conversation. If you call the conversation a "discourse," and you come up against somebody who has a "project" within The Discourse, then that conception of the conversation is quite different probably than yours or mine. If you say, as you did pretty usefully in that *Bomb* interview by Hakim Bey, "I'm a writer, I don't have a project," you are quite differently disposed. My project is the Manhattan Project! "Excuse me while I drop this thing on your pointed head!" *[laughter]*

Rail: You're not a manifesto writer, but the piece that opens your book *The Sweet Singer of Modernism,* "Critical Reflections," which was first published in *Artforum* in 1990, is close to a manifesto or credo. And it ends this way:

> *An art writer's self-importance is nonsensical. History shelves all but the few critical pieces that give pleasure and interest as something more than topical position papers. And it recognizes the next work of art as the criticism that matters most. If as a critic I remain relatively unprincipled—an amateur at heart—it's because I've learned that my pleasures come most fully from works that outstrip everyone's principles, and most especially my own—at which point everyone, even the artist, should feel amateurish, and a bit humble. Criticism should be modest in principle and quick or excessive enough so that everyone can enjoy how hypothetical it is.*

I think that one of the things that characterizes and distinguishes your critical writing is its *fierce modesty* about what a critic—any critic—can do, and even by extension (or perhaps it's the other way around), what any artist can do to change anything. It's what you've spoken of elsewhere as "our grand inconsequentiality." Do you think that's an accurate characterization?

BB: The grand inconsequentiality? *[laughter]*

Rail: This skepticism about art's agency, certainly criticism's agency. I think of it as a New York School trait: the New York change-up.

BB: Well, probably the best manifestation of the New York School ethos is the one that quite a few people find most telling, and it amounts to a dialectic. It's quite beautiful. In his recollection of Frank O'Hara in *Homage To Frank O'Hara*, John Ashbery wrote that he introduced himself to Frank when they were both at Harvard after overhearing O'Hara remark that an opera by Poulenc was greater than Wagner's *Tristan*—a remark that was arguably silly but, you know, not dead silly. Instead it was a kind of affirmation. As John said, everyone knew the comparison was off-register but it was important to make it because, and here's the exact quote: "Art is already serious enough; there is no point in making it seem even more serious by taking it too seriously." And so blowing off art's penchant for self-importance at times is actually to the point. The dialectic begins with the sentiment that art is crucial—something important to do and attend to—but the irony involved is both a corrective and sustenance.

Rail: That's the distinction. The skepticism and limit-awareness doesn't make the address any less urgent, or less consequential, in fact.

BB: But any sense of importance or of seriousness always has to be kept mutable or flexible. There are various scales and pitches. Another remark that is very important to me by O'Hara is about how certain artists will always go for the important utterance, which as O'Hara said, is not only not always available but not always desirable. Just as often, you need the ordinary thing—if only to clear the air, change the topic, or simply because it's so tremendously actual. I remember being on a panel discussion with a poet who said that when he wrote he always had Rembrandt in mind, and the Human Condition. I was just aghast and said "You do??!" It seemed to me completely inoperable.

Rail: You wouldn't write very much, would you, with Rembrandt's hot breath on your neck all the time?

BB: Yeah. That is one model distinctly to be avoided.

Rail: Again, I think there's an ethical stance when you talk about "the more open-air vicissitudes of art as a variety of social behavior, from which our aesthetic experience should never be thought to be exempt." But how is this different from taste?

BB: Well, there you go. Taste in that way is not fixed. If art is a form of social behavior—and I can't imagine it being taken as anything else—it exists as a sort of conversation: you make something and pass it along, across the room, so to speak. You show it. The addressee may be specific or a phantasmagoria. For a critic, if you think of it that way, the analogy is of being at a party—you're likely to meet various people, including people that you've met before, your circle of acquaintance, plus some new ones. Your relationship with each may vary from day to day. Someone met for the first time—an artist's first one-person show—may appear typical of your worst nightmares, or simply of no interest, why bother. Later you find out otherwise—you get it. That multiplicity is true to life. You find it in the vicissitudes of shows, books, the magazines that appear. Why should you expect to have the same opinion, or even a consistent attitude towards anything so elusive as an art work? In the end, all validation stickers expire. When I was in my 20s, I wrote a few reviews that were pretty nasty about certain

artists. One I particularly regret was about Roy Lichtenstein, I was just being a wise-ass actually, I look at that now and cringe.

Rail: It was in *Arts*?

BB: It was in *Arts*. Happily, in those days I occasionally got it right: once about Eva Hesse I was lucky, the first work of hers that I ever saw. Yes, you can make calls like that….

Rail: But you might be wrong.

BB: Yes, and you don't even have to say so later. For instance, Joe Brainard recalled an extended instance in which O'Hara attacked the value of Andy Warhol's work one night and a couple of days later was heard "defending him with his life," as Joe said. That's an ethos I would embrace. That's my idea of it—some days people piss you off, and others you love them with all your heart, they've completely thrilled you—unless they don't, and that's not necessarily anybody's fault, either. And there are fantastic gradations in between. That's the way it is among people, why shouldn't it be that way between you and the things people make?

Rail: Rather than staking out a position once and for all and defending it. It's important that criticism registers the vicissitudes, because it means that you can change, and that you can change even in front of the same work—that the aesthetic is not a fixed relation.

BB: But our arguments are supposed to be, if not fixed, at least authoritative. I remember one time, in exactly the right/wrong instance, I wrote a piece on Hans Hofmann and it was written very much sentence by sentence, where you could spot certain contradictions—well, those contradictions went with the territory, because Hofmann is a gloriously contradictory artist, you love and hate him at the same time, you know, it's love and disgust. But the copy editor said "Don't you think that you should insert *if, but, however,* and end up with *therefore*, to somehow ration out the argument because otherwise you're undermining your authority." I said "What authority?" Anyway, this is what Hans Hofmann is, it's all this ill-fitting conglomerate, visible all at once, and reasoned prose can't put it in the picture.

Rail: But it can try to account for it, and reflect it, in conversation. In your book, Hofmann is "the sweet singer of modernism." And in that Cal commencement address, you quote David Antin's statement that, depending on what you believe modernism was, you get the postmodernism you deserve. What postmodernism do you deserve?

BB: Modernism in the incomplete happenstance. *[laughter]* I don't know what modernism is, so I don't know what postmodernism is. I'm a stickler for the dictionary, so for me, and presumably for anyone who can read, postmodernism continues to be an oxymoron. I never knew what it could possibly be, literally. Modernism is a term that I am lately aware of, in a way. I knew modern art, and it seems there's a tremendous distinction—an opposition, in fact—between modern art and what became identified as modernism—which is usually identified with the wrongheaded Clement Greenberg, so what can it possibly matter? It matters, supposedly, according to some of our very good friends, that Greenberg was the only person who had a system, and therefore a definition. But we knew modern art as an unsystematic adventure in making kinds of things that had pretty much had never been seen before. That you could pretty much make a work of art that nobody had even imagined making. We continue in this two- or three-hundred-year era

of "freely conceived art"—a term that Thomas Crow has usefully advanced. The post-patronage era, post-princely era—of art that nobody asked for, that artists to some extent invented for themselves.

Rail: It was *unauthorized*.

BB: Yes, although one bears in mind they were—and still are, like it or not—also playing the market. Playing the market wasn't invented yesterday in Chelsea or in the 1980s—playing the market means try this, and will they go for this? Playing precedes "strategizing," one hopes! How anyone determines what will fly is very interesting. Enter this idea of the avant-garde—Baudelaire wasn't playing the market as a poet, neither was Rimbaud, but what was it that intervened as the market? The sweet smell of *succès d'estime?* Sense of history? Exaltation? Rimbaud could enter the Parisian poetry scene and say, You guys are all full of shit and I'm going to show you how it's done. And Paris then, and New York now, isn't the court, but it's comparably the stage you appear upon. So where did we start? Oh, postmodernism. What became the Tradition of the New was an adventure that eventually, logically proposed that art can be anything. Pollock said, on one hand, This is art if I say it is, and on the other hand he turned anxiously to Lee Krasner in the studio to ask "Is this a painting?" fearful that he had gone off the rails. At this point, nobody really cares if it's art or not, unless there's nothing else to call it, or unless it's so wonderful you can't find any other word to put in the face of it. So much for Negative Capability. We live in the assumption that anything can happen under the rubric of art but it's not going to be a breakthrough situation. Is it interesting? Does one stay interested? That may have spelled the end of the avant-garde. Certainly, also, because modernism, at least in the museums, had this idea of progression, and now we're out of progressions. We're happily out of anybody's idea of the forced march toward art's final essence and toward the "right" kind of art. No progress, but destiny. The destiny of the grand conception of art itself—capital "A" art—may be only to wither away; no more, too bad. A single artist has specific destiny. Destiny is like deKooning saying, I think in the 30s or 40s, that when he went through the turnstile in the subway, he thought he could hear the bell ring a little louder for him. *[laughter]* That's destiny, you're carrying something that has been laid on you, you've been admitted to a field—like the meadow in Limbo where the circle of ancient poets opens to welcome Dante to the club. Something other than strategizing, positioning yourself for your neat little career.

Rail: What art historians are useful to you?

BB: There are those who love the work, who are not doing a "job" on the work, you know? It's a different thing. T. J. Clark and Anne Wagner, whom we see in Berkeley, are marked exceptions. For one thing, these are people of wide general culture, a rarity in the art scene nowadays. Thomas Crow, too, has a very interesting mind, and certainly his book on Paris in the 18th century is illuminating. William Hood, a professor of art history at Oberlin College, put together a lovely book on Fra Angelico at San Marco. These are art historians who do the digging to find pertinent information; they conceive of pertinence. Contemporary art history is great insofar as it has gone to the archives to find out the circumstances of the work, and you have scholars who aren't art historians, like John Montias who got into the archives of Delft and found out all kinds of things about Vermeer's family and his milieu, and James Banker on Piero della Francesca and San

Sepolcro. That sort of work really is invaluable, and changes things in the way of a social history.

Rail: Do you feel an affinity or in community with other critics? When I think about it, your precise generation of critics, people born in 1939 and 1940, is quite an extraordinary group: Dave Hickey, Tom McEvilly, you, Peter Schjeldahl's a couple of years younger. This group is what the academics would call "belletristic" critics, coming out of poetry and fiction. (You closed a recent letter to me "Best we fumble along, 'irrelevant' belles-lettristes that we are…") Do you feel any sense of community with this group?

BB: No, regrettably. I mean I think that there was at a certain point, this may be different now, but in the 80s, I became aware that artists weren't talking with one another or visiting each other's studios. I remember one artist saying, "I never let other artists into my studio, they'll steal my ideas!" Then I found out that the New York critics weren't talking to one another, either, because they were similarly competitive perhaps, or simply had nothing to say to one another, or disagreed and didn't feel like hashing it out. That indicates a scarcity of intellect at large, I guess. Nobody agrees, they're all snotty in private but nobody has the nerve to do battle in public. I don't feel there's any company of critics to converse with. Poets talk to one another all the time. You're the only art writer that I talk to, and usually we talk about what's wrong with art writing from the point of view of people primarily interested in poetry! *[laughter]* How art writing has gotten the worst name ever—at least between us! Belletrist writing is not taken seriously by the magazines and certainly not by the academic critics. It's shunted aside, not part of the discourse. Too much about actual experience, sensations, thought as sensation, what's actually there. Too little about Karl Marx's nose-and-ear hairs! Nothing you can lug to class and teach the little tykes who need a structured universe of clear—e.g. wrong—ideas. Like that little book by James Elkins, *What Happened to Art Criticism?* It's nonsense to say that criticism fails in being beautifully descriptive and insufficiently opinionated.

Rail: That it needs to be more judgmental.

BB: Yes, more judgmental. Do we have more responsibility to call these shots? Is too much slipping by us? It doesn't slip by for long. Time sorts things out pretty well. True, many wonderful artists get lost in the shuffle. I don't think that museological history has served the 20th century very well. When you see what has survived as the canon, it's regrettable that the official sense of importance is too often gauged by whether something changed the history of art instead of whether the work—and this is the same thing in poetry—is, let's say, extraordinarily, or even ordinarily, pleasurable.

Rail: We don't agree about everything (our aesthetics are very different), but we agree that one of the best reasons for writing about the things you love is that only things that are cherished survive, in most forms of art. In "DeKooning, with Attitude," you write about the importance of vulgarity in Abstract Expressionism. "Strictly speaking," you write, "'vulgarity'—or call it simply any rude sampling of vernacular energy wafting in from street level—has been a constant sign in Western art of where the action is. It is what everybody knows, as against the cloistered, protectionist assumptions of official taste." Where is official taste now?

BB: When people like you and I were growing up we were immersed in what is often considered low culture, but one cultivated specific habits, tastes, within what was generally available. In high school I began to meet people who hated modern life and the culture that went with it. They wanted to live in the Renaissance; everything had been downhill for them since 1700 or whenever. They wanted no part of our modern vulgarity, whereas I was so deeply immersed in it I came to fine literature quite late. I read comic books and pulp novels if I read anything at all, and whatever was required for book reports, you know, and I watched endless movies, and it's like what Creeley says in that lovely poem: I did, maybe still do, have "a small boy's sense of doing good," and "ride that margin of the lake." A small boy's notion is that of a knight on horseback by the sparkling water—in *Idylls of the King* perhaps, but no, it's Robert Taylor in love with Elizabeth Taylor in a Technicolor *Ivanhoe*. To disdain such a homegrown culture would be untrue; instead you develop a taste for what's great within it, according to what you really know and go for. Even so, alas, our Euro-American culture is pretty degenerate right now, seemingly more so up top where the art is than in the less self-important realms of entertainment. T. S. Eliot said that poetry is a superior form of entertainment; instead of complaining that art is acting like pop entertainment, critics should urge artists to get their acts together and be more apropos.

Rail: And to be more connected, more engaged, more *necessary*.

BB: Yes, but we're complaining about the state of the art at street level. I mean, there are people who are doing really wonderful, marvelous, necessary work. Marlene Dumas, William Kentridge, Elizabeth Murray, Alex Katz in his very touching landscape paintings, Lee Friedlander. I think that's true in poetry, too, even more so. Poetry, as all the art people would tell you, is beside the point. No cultural currency, they say, because the attendance figures are so low. Phooey. Poetry strikes back, gloriously beside the point. It does its work and leeches into the general culture, which it seems to have done for the past millennium, practically. Arguably, the art world at large—curators and critics, not to mention a lot of artists—could do worse than to start reading some better poetry, if in fact they read any at all. Most of the literary references I see in catalogues and magazines—aside from those to the latest varieties of high-market, low-protein theory—wallow in the middlebrow range.

Rail: Before we stop, I wanted to ask you about the 500-word short review. This is a form that I've spent quite a bit of time in (for *Artforum,* since 1989), and I consider you one of the best practitioners of this form. In your "Critical Reflections," you say the 500-word review is "in its compression and flexibility comparable to a sonnet," and that it is a form that was created by the magazines—I guess created by *ARTnews* and *Arts?*

BB: When I worked at *ARTnews* the reviews were of variable length. In those days, the 50s and 60s, *ARTnews,* under its previous management, reviewed every show in town—well, there were few galleries at that point, and some of those shows got one-line reviews, that's why Fairfield Porter in his little manifesto about criticism says "Importance is measured by the inch."

Rail: So when did the 500-word length become established?

BB: I don't know. When I started writing for *Artforum* in 1985, they told me flat out, "Our reviews are 500 words." I became intimate with that form. But all the same, I

always thought of those blocks—the look on the page of a review in *ARTnews* was about a square, was very much the format of a Shakespeare sonnet. That struck me as a good form, your typical review, whether by John Ashbery or Irving Sandler, about two and a half inches in every direction. *[laughter]*

Rail: At 500 words it's mostly beginning and ending. There's little room for development, or argument, it's all beginning and ending, and trying to reflect the light in between.

BB: I like that. I liked the compression of the form very much. When I began writing longer pieces again for *Artforum* and *Art in America* and elsewhere, when it was going to be more words, I thought the rest is padding, or else it's a chance to describe more, which is what I most enjoy. But really, within those 500 words or less, you can pretty much say everything that needs to be said about what's on view.

Rail: But every word has to be in the right place. It's actually quite unforgiving.

BB: That's the fun, too, just as in a fourteen-line sonnet. Every word counts; I try to pack every word with a special wallop. You do work hard to get it right. When I started writing criticism again, and when I was old enough to think about such things, I thought, okay, I know this is going to be tough at the beginning but it will get easier because I will develop a style and become more fluent. *[laughter]* And it never got any easier. And when it got less and less easy in terms of working with overwrought magazine editors, then it was really no fun, and as a result, I now prefer to write catalogues where the heat is off a little bit in terms of worrying about the general reader or whatever confusion it is that causes all that invasive busywork in editorial offices.

Rail: They think they have to do *something,* and they reflexively do it to everything, whether it's needed or not. Too many magazine editors fail to distinguish between different kinds of writing. I've stuck with *Artforum* for so long because they tend to leave it alone, in the reviews section. Consequently, there's still the possibility of distinctive voices in that section. But the worst is to have to try to incorporate someone else's imagination of who the reader is. That's deadly. Like deKooning said, "It's a necessary evil to get into the work, and it's pretty marvelous to be able to get out."

BB: Well, I think that's true of writing anything, in a way. There's that beautiful if somewhat spooky account in *The New Yorker* recently, the profile on John Ashbery that begins and ends with the proposition that John is "supposed to write some poetry today"—this funny off-pitch bugle tunes up in the middle distance—whereupon you learn all that John does to avoid the evil of confronting his blank sheet of paper that day. Usually that's the case for anyone except when you're inspired or you see or hear something that argues strongly for an immediate response, and boom, you're off.

May 2006

Questions of Taste, with Jarrett Earnest

Jarrett Earnest: To begin, what interests you about taste?

Bill Berkson: That the word goes in so many directions. It breaks down according to what experience is at hand. If it's food, you say, "This hamburger doesn't taste right," "This pineapple tastes too sour"—so it's not to your "taste." And that seems categorical—if you say "This pineapple is definitely too sour, it may be over-ripe," or if it's "too sour for me," that's categorical—so much for food. Otherwise, a friend of mine has a country house, it's really for his wife and their agreeable and disagreeable children, he doesn't go there very much, but he says about the house, its location and furnishings: "My wife has excellent taste." Those considerations seem quite distant from taste in art, because when you raise the question of taste in art the term spins off wildly in many directions, many of them contradictory. For instance when I was, so to speak, growing up in the New York art world, and New York art was paramount, with a self-proclaiming dominance, a work might be dismissed as being "tasteful". For instance, *ARTnews* reviews in the 50s —a typical short short review might read in its entirety: "X shows tasteful watercolors of summers in Maine"—and that's all you need to know about what X has been doing lately. Then one reader will think, "I love tasteful watercolors of summers in Maine" and go and buy some and have a bunch of them over the toilet in the bathroom, you know. 1950s contemporary French art was dismissed as "all cuisine," which meant "tasteful." Certain artists—Motherwell was one—were suspect to their colleagues in the New York School as being too tasteful. Or else, writing of deKooning or Hofmann—I remember this wonderful phrase—Thomas Hess said of deKooning, I believe it was, "He has the bad taste of genius."

If you get the full painting education at the San Francisco Art Institute, most of your professors are going to criticize what you're doing at one time or another as "too decorative." Those people are like eighth-generation Clyfford Stills. We all grew up in this ethos of toughness, whether it was conceptual art or painting or theatre, that art had to be tough, challenging, not decorative, not over the couch—which brought any assertion of taste or "tastefulness" into question. Clement Greenberg did a very odd thing: his sense of aesthetics was that the "good" work hits you in your gut and that establishes its quality and accordingly its importance. For Greenberg, the job of the critic is to rationalize that involuntary gut feeling. I guess you can say that is a kind of taste, the taste of gut feeling. But then that is your hidden taste, or latent or even "deep" taste, which is other than your conscious or declared taste. Greenberg on another occasion spoke to the effect that good art shouldn't "meet your taste more than half way." If your taste is easily satisfied it probably verges on "easy," academic in its own terms. That's a funny number.

JE: Art that looks like Art!

BB: Yeah, so that, historically, this distasteful quality became a sign—a veritable touchstone, in fact—of Modern Art. Gertrude Stein said that things that are truly modern and important appear ugly at first. It may even have been true of Giotto, Masaccio and other innovators, but their violations of common taste were ultimately

theological. The Baroque—the term itself indicates unease where taste is concerned. When Poussin, who wants to hold to traditional values, says of Caravaggio that he meant to kill painting, he means that Caravaggio is jettisoning classical taste. Then Manet, the "ugliness" of Olympia is a hallmark, a typical Modern gesture. I find it very irritating in a way because it's become such a routine. I was on a critics panel in New York and Vincent Fecteau's recent exhibition was up for discussion. Robert Morgan said that he saw Fecteau's sculpture as "symptomatic but not significant" and I sort of exploded; I mean, what if it is beautiful, you get pleasure from it, and it is neither symptomatic nor significant, but just that. In fact, a week or so before the panel Roberta Smith had written a piece for the *New York Times* that said pretty much what I was feeling: she was baffled by the work but found it intensely pleasurable—a rare admission on Roberta's part. But in some ways these perfectly simple terms are not even part of the conversation, so the moderator just sped on to the next topic. Pleasure is still a conversation stopper—a crazy state of affairs to me. On the other hand, I wouldn't make a general principle of pleasure as significance, either. People are too principled when it comes to evaluating art. There's a rush to judgment every time. It's interesting when something comes along that violates and proves more interesting, more provocative and generative than anyone's principles. I suppose that is close to what Greenberg had in mind, although he kept drawing lines in the sand, a whole desert's worth of scorecards!

JE: I'm interested in the way the cliché action—something that is categorically bad taste for the "mass" is totally converted into good taste, and what that means as a gain or a loss in the encounter of a work of art.

BB: Well, what Stein followed up with is that after a while this great Modern Thing isn't so ugly. It risks domestication, I suppose, right there on Gertrude's salon wall. A little earlier all those Monets, Manets, Pissarros became comfortable household objects, especially in the happy homes of American financiers. Then the double irony of T.J. Clark's turning the Manet so that it shows all these terrible things that capitalism is doing to the countryside—you thought it was all about pleasure but it was really about alienation! *[laughs]* All of sudden, Manet is telling, say, Mrs. Havemeyer the same thing Picasso said to the German officer when he asked about Guernica: Did you do this? and Picasso said, No, you did.

JE: I almost feel like that about Andy Warhol—when I see some little fashion student walking around with a Warhol tote bag—I'm sure he would have liked it though.

BB: Yes and no. It's not exactly like Monet painting his own heaven, making a heaven for himself, which is what he did, turning his back literally on what fascinated Manet in the modern world. Andy saying, "Pop Art is about liking things." Pittsburgh, PA, Byzantine immigrant working-class taste—why should Andy or anyone from such circumstances have anything else? He saw then that America was leveling out, which is not true, but believed that everyone was going to have Campbell's soup. He didn't foresee Whole Foods, or that, thanks to his pal Ronald Reagan, there would be a wider than ever disparity between the rich and poor and that Campbell's soup was going to get worse rather than better and Democracy less democratic. I don't know if you mean the images of the car crashes or the death of Marilyn Monroe. Yeah, but that's Mad

American Catholicism for you—ceremonial, rapturous and very perverse. Everyone has to understand that about Andy.

JE: When did we start talking about the difference between good versus bad taste? Because even around Andy Warhol, I feel that some reasons for liking Andy are "Good Taste" and some reasons are "Bad Taste."

BB: *[laughing]* You know the term I used to hear, that in a certain way sustained the dream of democracy, which now is gone, the term is "educated taste." To a certain extent we all have educated taste. Ours is not educated in the way Thomas Jefferson probably intended, or our teachers, because most of us educated our own taste. The idea of education was that you come in with no taste and instructors show you the way. The museum was a corrective device for the mob chaos of democracy. One selling point for the National Gallery in England as opposed to the Victoria and Albert, for the National Gallery in Washington and eventually the Met too was that people who come into this Temple of Art will be elevated to essentially "our" level of taste and therefore will rise to become functional citizens of the Republic, e.g., they'll vote the ticket. It's a terribly perverse argument for critical method. Because the terror of democracy has always been that those people will be making decisions en masse. Better bring them along! A very interesting thing because you have to look very hard at the five-foot shelf, what is being taught in the Great Books curriculum, what Johnny needs to know to be a good citizen. Well, Champ, what is civics? Interestingly, I doubt there's a civics class in the land that includes a rundown of how the banking system works. You just might like to know what pays your tuition; start with the check ready for deposit and work backward.

JE: With educated taste isn't there this lurking specter of philistinism—someone who is using culture to elevate themselves socially?

BB: That's a different type. Ivanka hires you to take her around the museum. Next stop, Geoffrey Beene. I don't know if this happens anymore, but what does happen is people get taken around by art consultants who virtually tell them what and why to buy. Aggressive. Later at dinner those same people, having learned to talk the talk, tell you at length what everything is about.

JE: I guess the question is that given the differences in the art world even 50 years ago and now, does "taste" exist, or what is in its place. I don't think one could say: "This is bad taste" and get away with it in relationship to a work of art now.

BB: I don't hear it. I think the operative term, and what became a sort of escape hatch, is the word "interesting." Most of the art that new collectors have—types of big installation art, which actually can be accommodated in the happy home—once they're there they're conversation pieces. Much of this art exists functionally as an aid for expenditures, a demonstration of wealth, power and being to some extent "with it." Of course you can say that's true to a certain extent of a lot of art through the ages. It's just that lately the cover has blown away—there's no pretense at religious, mythic purpose or simple grandeur, or entertainment or even fun. It's raw power showing you what it's got. There's a whole discourse around this conundrum of meaning and placement.

The weird thing that occurred with abstract art, which was sort of the culmination of the modern taste for suggestibility—for the suggestion, for the presentiment of meaning—if you look at a Barnett Newman, or Ellsworth Kelly, or

Ryman, there may be a kind of program that goes with it, like with Mondrian, supposedly, but finally you are left flat footed facing this thing. If you look close enough, openly to what is happening to your senses, the synaptic events, there was a spark of possible meaning you could talk about endlessly because it were all unplanned and uncertain, no matter how intelligently worked. And this other thing—the way that conceptual art, if that is what it is, has come to be, is that the terms, the conversational terms about it are already set—there in the wall notes: "The price of bananas in Honduras today." OK, I get it. There's nothing more. Dennis Oppenheim said that the crisis for the original conceptual artists two or three years into it in the 1970s was the realization that what they were doing was, as Oppenheim put it, devoid of visual interest. Most video today is void in that department due to a lack of care for the image, even to the point of allowing these shoddy projections of low-resolution DVD matter where you can barely make out anything but the subtitles.

JE: I'm struck by—when we went to the Yvonne Rainer lecture and she begins by making the point that "expressivity is in the eyes of the beholder," and yet she is now producing this highly aesthetic work that fits within very narrow disciplinary boundaries and was really unwilling to address that.

BB: Well, the films take some big risks, I mean, it's just that at that moment, the moment of so much focus on the phenomenology of everyday life, so much opened up, but whether by the artists or their critics, the categories got more refined. Merce Cunningham called it "movement" instead of dance, and Rainer might have too. Now the dances are on stage that used to be in the round at the Judson Church. Luckily no one resorted to calling it "freedom." There's just so much you can do—you can include in the dance vocabulary walking across a floor with a mattress on your shoulders, and that's not *Swan Lake*. If you're worried about it's being dance, call it movement.

The same thing happened in music. It was like the game was up the minute all these people started howling about freedom, trying to align it with civil rights, especially Coltrane, and all it showed was that if you're going to call it music, and Cage never pretended otherwise—"organized sound," he said—still there's just so much you can do under that rubric. Free jazz—what it always does is get faster and louder and then it quiets down for a while, injects some lyric passages and then builds back up to more mayhem. It actually gets more limited than Duke Ellington or Dixieland, the more it pretended to be really free the more limited it seemed. The one thing it did shake loose of, it didn't dawn on me till much later, was that what they wanted to do, just like Yvonne wanted to do, to get off point and get away from Martha Graham-style, expressivity, symbolism, mythology and so forth. Jazz needed at that point to free itself of standards—meaning, not taste or quality, but "standards" in the sense of the Broadway and Tin Pan Alley tunes the players had been ringing their changes on. With Yvonne it was also the proscenium. The White Oaks Project preserves what was done at Judson and what is still done at Saint Marks Danspace or in Douglas Dunn's loft, but on an elevated stage. For people who were there in the 60s it is sad to see it elevated this way because it used to be just here, people running just past you—and now it has a museological distance.

JE: The same thing happens in performance art. I'm totally horrified by Marina Abramovic, who had this wonderful body of work and then for the past ten years seems absolutely hell bent on destroying everything that was respectable or interesting about her. Culminating in this ridiculous reenactment.

BB: I don't understand what she's doing. I'm mean up to the live-in-the-gallery project, the only time I ever saw her live was in Venice where she did her piece about Kosovo, sitting there washing a heap of blood-caked bones, and it was really marvelous, powerful. But this remake business sounds awful, and it also sounds as though everyone has slammed her for it. The response hasn't been good.

JE: But what is the disconnect, between these big corporate museums, which basically are what museums are—corporations that need to turn a profit?

BB: Well, they have to break even, anyway. They have to pay excessive salaries, insurance, shipping charges, world-class architects and all that and then somehow or other break even.

JE: But is there a disconnect between museums now and what their "role" is suppose to be as a historical entity. And that has to do with taste, because they hold the DNA of culture, which future artists have to deal with.

BB: The trouble is, it's not about taste anymore. If you're at the Met or the Frick or the Morgan Library you're still charged with exercising some taste and presumed to have some to exercise. But if you're at the Modern in either town, New York or here, it just doesn't have to do with that. You have a sense of history and significance and you may be held to that, and all of these places, including the Met, are deep into marketing, which isn't about anything but bringing people in. And for no ostensible purpose, just to bring them in, just to keep the institution going. The public justification for probably the last 20 years or more has been that, in order to have public funding, museums cover themselves with an educational mission. Now we have the museum as combination arts institution and community center with atriums about as friendly as the interiors of your average big banks. It figures because the money now is CEO money of the kind that defines the institution as a business to be run accordingly to measurable standards—membership and ticket and gift shop sales in this case. I'm struck by the fact that if I go to SFMoMA or the Legion of Honor, either way, if you're dealing with contemporary, modern art or old masters, there just isn't any operative taste. We have this thing called "museum quality" art. The Rothko now at SFMoMA was six million dollars, it's the non-identical twin to the picture in Berkeley. Before it arrived, I asked a dealer friend, What about this Rothko we're getting? "Well it's a museum quality Rothko," he said. And I thought, "Museum quality—what is that?" It's like FDA—the art has an institutional stamp of approval, it's certifiably a Rothko, albeit of a certain size, period and provenance, and as a painting it's OK. Sometime after it arrived, I went and sat with it for an hour. I got up and looked closely at how it was made. That is how the sublimity of a Rothko often gets to you—you look at how the thing is painted and the hairs on the back of your neck begin to tingle. Before I left, I addressed this work as if to say, "You are a very well- painted picture, but I do not love you." There's a difference; the one in Berkeley has the edge.

But if you go around the country and go to museums, as I have had the opportunity to do over the past year doing readings in places like Milwaukee, Minneapolis and St. Louis, Boston, et cetera, and you go to these places, especially the contemporary and modern museums, their collections consist mainly of "examples." Examples are not a matter of taste. It's just a fucking "Rothko." There was a curator at the Fine Arts Museums some years ago who told me, "There are still some things we would like for the collection." "Like what?" I asked. "Well, we'd like to have a Poussin." Who wouldn't, but what does that mean?—That any Poussin that comes down the pike would do? No master is that faultless. The topic of taste is very interesting in that way, but what if there isn't any, and what if nobody cares? And in the museum world that used to be the criterion, that a curator has "distinctive" if not "superior" taste.

JE: Does that have to do with a loss of history, or a loss of broader cross-disciplinary knowledge?

BB: It has to do with the absence of poetry. I maintain that the art world reads only trash. They read Eurotrash theoretical literature, hastily and probably sloppily translated and middlebrow fiction, and probably no poetry and no serious philosophy, either. There are few exceptions to this loss of general culture and its concomitant, easy brassbound sense of history. Very weird business, because on the one hand there is the belief that the developmental progressive view of history that culminated in Modern Art ended. Once that game is up—a strange game anyhow, created within the academy to rationalize what had happened—if that's rejected we are left—happily, I think—with a kind of delta that just spreads out into a field called art where different things happen, different modes appear and circulate, in no demonstrable sequence. Someone at San Diego State University in the back of the room asked, "How did 9/11 affect your poetry?"—a very interesting question. But the weird thing is that the people who believe there was a culmination in history keep insisting on next year's product. Been there/done that—where do we go now, as if there's still some kind of progression. All it is really is good old modern boredom, the Inertia of the New.

JE: For me the most significant show, that deeply troubles me, is the New Museum triennial, "The Generational: Younger than Jesus."

BB: There you have it. Such tasteless trash. *[laughs]* I mean "tasteless" and "trash" in quotes but not sneer quotes. My feeling was that the curators made the show look the way it did and probably some of the artists are perfectly OK, although it was a cumulative trash scene, going mostly for this pervasive tone of resentment. There was nothing even of the Beautiful Loser ethos. There was nothing of Beautiful Loser "heart," or anyone that was interested in going for anything that could be called beautiful or communicative. But I've talked to people who enjoyed it. I never found out why. Then you could say, as I have been saying with alarming frequency of late, "It's not for me." That's an older guy's taste limitation.

2010

No One Who Knows Me or My Writing Will Believe It

The Writing for Curators class met with Bill Berkson on September 23, 2009. The students were asked to prepare questions for Bill based on pre-assigned readings, but the conversation in class never got to most of their questions. I asked Bill to extend his visit by answering their questions on line.
 —Renny Pritikin, California College of Arts, San Francisco.

Susannah

1. While I agree with your statement, "liking or not is often not the point, or is an ulterior point" (from the Art Forum piece) does the critic or art writer have a responsibility to both describe the show and work objectively and give an opinion? Certainly, as the reader I want to know the writer's opinion; the subjectivity keeps me interested. Is there a difference in what is revealed between writing a review for an artist you have an affinity for (you mentioned Philip Guston among others) and one whose work you don't?

"Responsibility" — where have I heard that word? Your question includes many such assumptions, all of which make me want to draw you aside and say "Listen, where did you get this idea? And...." Well, and have you considered that the whole situation, like most of your experience, is in free-fall and so absent is the logic (syllogisms) that would argue anything's being responsive to reliable order that persuasion (the business of rhetoric) occurs only by dint of the most elegant bait-and-switch word games?

That's one reality. Here's an example from the annals of curatorial practice: John Caldwell, a very fine, earnest curator at SFMoMA died in his forties of a heart attack. He had curated big shows of the likes of Gunter Forg, Luciano Fabro, Jeff Koons, etc. At his memorial, the director Jack Lane spoke affectionately of John's amazing press-preview talks—how he could go on about what this and that work showed us about our culture's failings (I thought of when he said that Koons' porn work showed how sex had deteriorated in our time and how Koons himself stepped forward, "But John," he said, "I actually like sex!"). Lane said: "The thing was, that John really loved the work he showed, but he didn't know why, so he made up these wild stories about it."

There is no objectivity, there's is only envisioning the different things, imagined, that might be said about what you see, and among those things, the set that matches somehow what you feel—if you feel anything—about it. You are neither required nor expected to feel anything. Most of the time you probably don't. So like John Caldwell you start talking, or writing, and something like a response begins to manifest itself.

2. You mentioned a revisionism of art and a redefinition of cultural parameters that occurred with the professionalization of art criticism. I was incredibly interested in the idea of art critics like Rosalind Krauss creating an intellectual turf that gave art criticism a legitimacy but also served as a battleground for "personal axes to grind." What kind of effect do you see this having on how the art world engages (or doesn't) with art writing, then and now?

For the most part, that is how "the art world engages (or doesn't) with art writing, then and now." Most criticism is based on turf wars, tenure grabs, and/or esthetic-political self-definition with the optional ambition to achieve the really dubious (and short-lived) distinction of 'public intellectual' with a major in

art. It stinks. OK, the rest is fairly straight, tedious but god knows, responsible journalism—something to accompany the color plates. A small contingent of esthetes, pleasure seekers among those on the forced march of looking, rise above or make fanciful end runs around this ideational dump. They may be careerists, too, but of a gentler more playful sort—they just want to have fun within the more lively or glamorous (to them) part of the art world. Or else, like me, they are writers interested in describing and interpreting—and lastly, evaluating—works of art as somehow exemplary of what people do with various purposes in mind.

Benoit

1. My question was about the role of the critic. Should he/she only have to take the pen when he/she likes the work? Or does he/she have to take position, sometimes against a work, to defend a point of view?
The critic often works on assignment and so can't always choose what to write about. This is a healthy situation—lifelike, insofar as one shouldn't be confined to seeing only the people one likes.

Erin

1. What connection do you see between poetry and art writing?
Writing as such is the connection. I try to keep to that, to make art writing be what I call really writing. "Innate love of words" and the awareness that the distance between the thing said and the thing seen is bridgeable only by an imaginative 3-way contract between writer, text and reader. Can you say what you see? is the unanswerable question.

2. What are the difficult parts of writing a good piece for you, and how have you learned to make these parts easier?
It never gets any easier. Getting the first words down on paper in some generative way is the most difficult.

3. Do you feel like you have refined your writing style or do you fee like a style is something one develops over time?
No. I thought when I came back to art writing I would develop a style and the writing would eventually get easier. It didn't.

4. How did you become involved in writing for art magazines? To whom did you write when you composed those articles?
Serendipity. I was trying to impress my mentors and/or those whose art writing I admired.

5. What advice would you give to those of us who are interested in writing for art publications?
To be honest, I would advise against it. Failing that, I would say, look at the magazines, decide which you like best, and start submitting sample writings once you have some.

6. Who are some of the people you learned from when you were beginning to write about the arts?

Frank O'Hara, Thomas B. Hess, John Ashbery, Harold Rosenberg, David Antin, and lots of artists, the way they talked and wrote. The artists included Willem de Kooning, Jasper Johns, Philip Guston, Andy Warhol, and later, Fairfield Porter and Robert Smithson.

Amanda

1. When (at what point) does the curator become the critic?
Who would want such double duty? Well, there is written criticism, and then there are all the other kinds of criticism. Curating is a critical act. That includes what hangs next to what or in the same room.

2. Do you still consider yourself an "amateur"?
I am an amateur on the scale of amateur-professional in an age of hyper-professionalization. On that scale, I maintain amateur status at the rank of 6, which is one notch over the median line. I am professional insofar as I meet deadlines, work with editors, do what I perceive to be the job of looking, perceiving, thinking (if need be), and then struggling to make the best piece of writing for the occasion at hand as determined by the recipient (editor). I am an amateur in the sense of a lover of art when it is loveable.

Charlie

1. In the 1990 *Artforum* article we read you talk about a typical response to one of your works: "'That was an interesting piece of writing, but I couldn't tell whether you liked the work or not.' Liking or not is often not the point, or it is an ulterior point. The main point is to give people something to read, to be accurate about the work without saying the same thing over and over." Can you elaborate on this a little more? Maybe you could speak about why Roberta Smith went crazy for the Picasso show in New York and wrote in a way that I for one felt was far from typical Roberta Smith.
I spoke of this in class a bit: how opinion really is so slight, and mutable - or else should be mutable. The whole business of value judgment in art is subject to dismissal: I like it - who cares? "All taste is relative" (a conversation stopper, for sure). Do you think these things can be nailed down so that there is good art and bad and that's that? No, the conversation goes on and the terms keep changing. One view (Greenberg's): esthetic judgments are involuntary ("gut"); criticism is rhetorical, a way of making persuasive and articulate those responses that actually are irrational and pre-verbal. I think that's not entirely true but worth considering.

2. Can you talk about the voice you use when writing for Artforum versus Aperture or any other publication? To me there is a clear difference between the pieces written for *Artforum*, *Aperture*, and "Herriman and Friends."
Writing for magazines is always adjusted (or infected) by the Editorial Voice; catalogue writing tends to be freer, if only because it's seldom as heavily edited. That's true for those writers invited by a curator to write for a catalogue - the curator usually is more at the mercy of the in-house editor.

3. Have you ever written a review about a show or an artist,s work and then a few days, months, years, or however long later you realized that you missed something or wished you could rewrite it with a different approach?
No.

4. I am very intrigued by the discussion of the critic as having the role of someone who does not communicate like or dislike. The desire to stay away from "cold" criticism seems like an interesting approach. I get this feeling that there is a tremendous desire to stay almost impartial, that discussing in great detail the exhibition or the object is more important than offering an opinion. Why is this?

Fairfield Porter wrote, "Criticism should tell you what is there." Please think about this. But there is no impartiality; partiality is part of what is there, including the limits of eyesight, mind, acculturation, taste, principles. However, a curator or critic may be interested in certain phenomena, what's going on, without necessarily approving of them; you may want to lay out the drift of a kind of work that's "in the air" just to see what it is, and its implications.

Liz

1. Knowing that in the world of criticism and curation you don't always get to pick your projects, how do you manage to write an interesting piece about an uninteresting or uninspiring work or exhibition?

The first review I wrote for Artforum *was assigned against my pleas that I didn't want to begin by reviewing a Bay Area artist for whose work I had no taste. The editor insisted. The artist was Robert Hudson, the show a retrospective of his work at SFMoMA. I ended up spending so much time looking that I developed a lot more respect for the work than when I walked in, and I wrote what I thought was a fair-minded review. Someone at the Art Institute who had followed Hudson's work closely came up to me in the hallway and told me I had performed a miracle - I had really seen what the work was about, its failings and its strengths. A week later I walked into the gallery that represented the work and one of the gallerists called me into her office and proceeded to ask me if I categorically hated Northern California art; then I heard along the grapevine that Hudson's wife was after me "with a brickbat." The fact is, I wasn't being charitable: if you spend enough time looking at anything you will find something interesting, if not necessarily likeable, about it.*

2. Have you ever given a really negative review of an exhibition? Can you tell us about it?

When one is young and intolerant, one is quick to insult; when older, though no less intolerant (but in far different terms), one needs to have learned to avoid expending energy unnecessarily on what one wishes simply to go away. Yes, in my 20s I wrote a lot of wiseass negative reviews—about half of which I now regret.

3. Who is the audience that you are writing for? You talk in the article from Artforum about art writing really only being read by art world insiders, if even by them. Do you really only write for the art world? If not how do you seek to engage a wider audience with your work?

I have in mind a reader who enjoys the writing, and envisioning through my writing what is, or was, there to be written about. But I do care about it being writing for a reader who cares about words and how they're put together, and also the funny business of matching up words with the experience of looking.

I do not write for the art world, it just happens that the magazines and catalogues I am asked to write for circulate almost exclusively within the art world. That's a losing proposition—for me, anyway—because most art world people don't have any appreciation of what I write or really of my view of what is important about art. As for the wider audience, I see no way to engage it—I sort of hope that

my books, articles and so on—that the news of them so to speak, trickles out into the culture. I feel the same way about my poetry, which has an even smaller audience.

But behind this is a larger issue—the issue of the audience as wide or narrow, general or elite. I have no argument with any art's popularity if that can be achieved; but neither do I think that it is necessary for art or literature to "reach" a wide public or general audience. The idea of that necessity is not democratic really, it is mercantile and has to do with the creation of publics via technological happenings like the printing press and portable tube paints and cultural ones like the gallery/auction system and museums. If you are going to be a curator with these issues in mind you have to realize two things and understand them well: one is how recent these notions are, and the other, why they arose. A good place to start is Thomas Crow's Painters and Public Life in Eighteenth Century Paris, *and also to think about Baudelaire's dedication to* The Salon of 1846.

David

1. With so many bad or unhelpful critics writing today, can you suggest a few that you feel are writing good criticism and should be followed?

I am by turns very sour and very neutral about this. The only art critic I find consistently interesting and a pleasure to read is Holland Cotter in the New York Times; *it is worth subscribing to the* Times *online to get his pieces. Others of some interest are: David Carrier (in* artcritical.com *and elsewhere), David Levi Strauss, Carter Ratcliff (whenever he publishes, which is rare). In other fields, well, the* Times' *Alistair MacCauley on dance.*

2. How do you start your writing? Do you focus on the opening sentence, closing statement, overall thesis, etc?

I try to just start writing, but also am prone to taking/making lots of notes, and the notes cover sheets in very random all-over patterns, "constellations"—which probably show better than the final piece of writing what my thought about the art actually is or was. Then again, writing isn't thought.

3. In your Frank O'Hara piece you state that, "I know museums aren't supposed to be studios, I'm talking about looking at really good paintings or sculptures, which frequently has little to do with locale or condition." This is a very powerful statement, and I was wondering if you could elaborate more on this idea?

I don't remember this. Did I say this? Where? No, I think it's O'Hara in his Kulchur *art chronicle. If it is it's funny he'd say this. We are so aware now of where anything is and why. Museums were indeed designed to disguise location and allow a place- and time-less esthetic experience. It's always interesting, though, when things change locale and/or condition. I just saw some sculptures in a gallery that I thought looked much too blasé in the artist's studio. In the gallery they looked so elegant and intense through and through, and for now I trust that second impression.*

Michelle

1. Could you please tell us the difference in mental process you use and the feeling you get between writing a poem and writing a critique. And does the process of writing the critique gives you at any time the same adrenaline as when creating poetry?

I am not sure of the difference. Unfortunately, my poems are hardly ever written to order. Obvious exceptions are birthday poems, Valentines and other so-called occasional poems. Thus, the poems arrive

or get written as unscheduled events, whereas reviews and essays are scheduled, have deadlines, destinations and are distinctly about the particular topic as assigned. As for "adrenaline," well— there's always the feeling that the writing could be otherwise, and, despite that, every once in a blue moon, I think "Hey, this is pretty good, did I write that?!" (gloat).

2. How do you auto-edit yourself in order to not be too poetical or in order not to break the rules of words and writing as poetry may do? Do you edit yourself?

Yes, no one who knows my writing or me will believe it, but I do restrain myself, or edit, sometimes to reduce the fancifulness of the writing to more straightforward communicability. But still I wonder what "rules" you mean. In a review or essay, I guess, the rules are that your write in sentences and those sentences add up to paragraphs, neither of which are to be too long, too taxing for the gentle reader. Fair enough. When I began, I asked Thomas B. Hess at ARTnews how one should write a review: he said, "Write it as if it were a letter to an intelligent and sensitive friend, but one who also won't sit still for your or anybody else's nonsense."

2010

Publication History

"Divine Conversation: Art, Poetry & the Death of the Addressee," Lecture, School of Visual Arts, 2008; Yale University School of Art, 2010.

Pounding the Pavements
"High-Density Ossorio," *Art in America,* November 1980
"Robert Hudson/ San Francisco Museum Of Modern Art," *Artforum,* December 1985
"Robert Mangold/ University Art Museum, Berkeley," *Artforum,* January 1986
"Tom Stanton's *Palace Rudel,*" *Expo-See,* February 1986
"Image Word: The Art of Reading" /New Langton Arts, *Artforum,* February 1986
 "Robert Arneson/ Fuller Goldeen Gallery," *Artforum,* March 1986
"Joel-Peter Witkin/ San Francisco Museum of Modern Art," *Artforum,* April 1986
"Tom Marioni/ Oakland Museum; Eaton Shoen Gallery," *Artforum,* May 1986
"Terry Allen/ Gallery Paule Anglim," *Artforum,* Summer 1986
"Italo Scanga/ Oakland Museum,"*Artforum,* September 1986
"Mark Rothko/ San Francisco Museum of Modern Art," *Artforum,* October 1986
"Bill Dane/ Fraenkel Gallery," *Artforum,* November 1986
"Rupert Garcia/ Mexican Museum; Harcourts Gallery," *Artforum,* December 1986
"Alan Rath, Jeanne C. Finley, George Kuchar/ San Francisco International Video Festival,"
 Artforum, January 1987
"*Second Sight/* San Francisco Museum of Modern Art," *Artforum,* February 1987
"Nell Sinton/ Braunstein /Quay Gallery," *Artforum,* March 1987
"Diane Andrews Hall/Fuller Goldeen Gallery," *Artforum,* April 1987
"Nayland Blake/ Media," *Artforum,* May 1987
"Gordon Cook/ Oakland Museum/ Charles Campbell Gallery," *Artforum,* Summer 1987
"George Lawson/ Khiva Gallery,"*Artforum,* September 1987
"Leon Borensztein/ Fraenkel Gallery," *Artforum,* October 1987
"John Roloff/ University Art Museum, Berkeley," *Artforum,* November 1987
"Sam Tchakalian/ Modernism," *Artforum,* December 1987
"Christopher Brown, Gallery Paule Anglim," *Artforum,* January 1988
"Andrew Noren, San Francisco Cinematheque," *Artforum,* February 1988
"Viola Frey/ Rena Bransten Gallery," *Artforum,* March 1988
"General Idea/ Artspace," *Artforum,* April 1988
"Robert Ryman/ San Francisco Museum of Modern Art," *Artforum,* May 1988
"Doug Hall/ Fuller Gross Gallery,"*Artforum,* Summer 1988
"Yvonne Jacquette/ Brooke Alexander," *Artforum,* September 1988
"Deborah Oropallo/ Stephen Wirtz Gallery," *Artforum,* September 1988
"Roger Hankins/Fuller Gross Gallery," *Artforum,* October 1988
"David Park/ Stanford University Museum of Art," *Artforum,* November 1988
"Wayne Thiebaud/ Stanford Art Gallery," *Artforum,* November 1988
"Hung Liu/ Capp Street Project," *Artforum,* December 1988
"Richard Hickam, Paul Klein/ Jeremy Stone Gallery," *Artforum,* January 1989
"Michael Tracy/ Artspace," *Artforum,* February 1989
"Harry Fritzius/ Bruce Velick Gallery," *Artforum,* March 1989
"Richard Shaw at Braunstein/Quay," *Art in America,* March 1989
"Don Van Vliet/ San Francisco Museum of Modern Art," *Artforum,* April 1989
"Larry Rivers/ Marlborough Gallery," *Artforum,* April 1989
"Robert Mapplethorpe at Robert Miller," *Art in America,* April 1989
"Michael Gregory/ John Berggruen Gallery," *Artforum,* May 1989

"Masami Teraoka/ Iannetti Lanzone Gallery," *Artforum*, Summer 1989
"William Tucker/ Gallery Paule Anglim," *Artforum*, September 1989
"Poe Dismuke/ Susan Cummins Gallery," *Artforum*, October 1989
"Catherine Wagner/Fraenkel Gallery," *Artforum*, November 1989
"*10 + 10*/ San Francisco Museum of Modern Art," *Artforum*, December 1989
"The Museum of Jurassic Technology/ New Langton Arts," *Artforum*, January 1990
"Henry Wessel/ Fraenkel Gallery," *Artforum,* February 1990
"Group Material, University Art Museum, Berkeley," *Artforum*, March 1990
"Inez Storer/ Jeremy Stone Gallery," *Artforum*, April 1990
"Elmer Bischoff/ John Berggruen Gallery," *Artforum*, Summer 1990
"Yayoi Kusama/ Center for International Contemporary Arts," *Artforum*, Summer 1990
"Dan Connolly/ Gallery Paule Anglim," *Artforum*, September 1990
"Jim Barsness/ Susan Cummins Gallery," *Artforum*, October 1990
"Francesc Torres/ Capp Street Project/ AVT," *Artforum* November 1990
"Lee Friedlander/ Friends of Photography," *Artforum*, December 1990
"Frank Lobdell/ Campbell-Thiebaud Gallery," *Artforum*, January 1991
"Jeffrey Beauchamp at Susan Cummins," *Art in America*, January 1992
"Rosemarie Trockel at University Art Museum, Berkeley," *Art in America*, February 1992
"Bruce Conner at SFMoMA," *Art in America*, November 1992
"Jay DeFeo at Fraenkel," *Art in America*, November 1992
"Tom Field at 871 Fine Arts," *Art in America*, February 1997
"Henry Wessel at SFMoMA," *Aperture*, August, 2007
"Gabriele Basilico at SFMoMA, *Aperture,* Fall 2008

American Figures
"Alex Katz," *Awards Program, Skowhegan School of Painting and Sculpture,* April 1980
"Wayne's World," composite from "Objects of Affection," *Vogue*, May 1994, and
 "Wayne's World," *Modern Painters*, Summer 1998
"The Elements of Drawing," Paul Thiebaud/ Lawrence Markey galleries, 2010
"Susan Hall," Ovsey Gallery, 1989
"Apparition as Knowledge" in *Deborah Oropallo*, Stephen Wirtz Gallery, 1993
"Questions of Moment: Rupert Garcia," in *Rupert Garcia*, Haggin Art Museum, January 1988
"Paul Harris, Secret Agent," Iannetti Lanzone, April 1989.
 "Among the Poets" (Joan Mitchell), Tibor de Nagy Gallery, 2002
"The Mysterious Mister York," *Mills College Art Gallery Bulletin*, 1993
"Presenting Surface: Judith Foosaner," *Judith Foosaner: Works on Paper,* Space Gallery, 1995
"Inez Storer's Identity Opera," *Theatrical Realism: The Art of Inez Storer*, de Saisset Museum,
 1992/2003
"True to Type: About Willard Dixon," Hackett-Freeman Gallery,1998
"Working with Joe," Boulder Museum of Contemporary Art, June, 2001; *Modern Painters*,
 Fall 2001
"Empathy in Daylight," *Edward Hopper/ John Register*, Modernism, 1996
"Linda Fleming," *Wilderness. Study. Area.*, Oakland Museum, 1995
"About Bill Scott," Prince Street Gallery, 1997
"Chaos Dancer," Bonami Gallery, 1996
"About Ernie Gehr," Walter/McBean Gallery, San Francisco Art Institute, 1995
"From the Land of Drawers," John Berggruen Gallery, 1998
"Some Guston Papers," *IO*, 1994/2009
"Jackson Pollock: The Colored Paper Drawings," Washburn Gallery, 2000
"The Abstract Bischoff," Salander O'Reilly, 2002
"Join the Aminals," Jernigan-Wicker, 2001
"George Schneeman's Italian Hours," CUE Art Foundation, 2003

"George's House of Mozart," in *Painter Among Poets: The Collaborative Art of George Schneeman,*

Granary Books, 2004

"A New Luminist," in Tim Davis, *Permanent Collection*, Nazraeli Press, 2005

"Visionary Babcock," in Jo Babcock, *The Invented Camera*, Freedom Press, 2005

"Ultramodern Park," *David Park: the 1930s and 40s*, Hackett Freedman Gallery, 2006

"Adelie Landis Bischoff," Salander O'Reilly, 2006

"Seeing with Bechtle," *Robert Bechtle/Plein Air*, Gallery Paule Anglim, 2007

"Dewey Crumpler's Metamorphoses," in *Of Tulips and Shadows: The Visual Metaphors of Dewey Crumpler*,
 California African American Museum, 2008

"Introducing Nathaniel Dorsky," introduction to film screening, SFMoMA, 2009

"Dean Smith in Action," *Dean Smith*, Gallery Paule Anglim, 2009

Word on the Street: Critics and History

"What Becomes a Legend," *Art in America*, October 1984

"Critical Manners," *Art in America*, February 1981

"Dutch Details," *Art in America*, March, 1984

"What People Do All Day: A Memoir of New York Styles 1959-65," adapted from a slide lecture,
 San Jose Museum of Art, 1997

"Factum Fidei," forward to Rebecca Solnit, *Secret Exhibition: Six California Artists of the Cold
 War Era*, City Lights Books, 1990

"Reliquary Days," *Sight Vision/The Urban Milieu 3*, Gallery Paule Anglim, 1992; *Artspace*,
 September 1992.

"True Guston," ["The Consummate Insider"] *Art in America*, June 1987

"The Pollock Effect," *Art in America*, December 1997

"Poets and Painters Coda," in Stephen C. Foster, ed., *Franz Kline: Art and the Structure of
 Identity*, Electa/ Fundació Antoni Tàpies/ Tate Gallery, 1994

Occasional Pieces

"The Art of the 1980s," Collectors Forum, San Francisco Museum of Modern Art, April 1989

"What Are we Celebrating?", "Over-40 Panel," *The Agenda for the 1990s*, April 1989; in Carlos Villa, ed.,
 Worlds in Collision, International Scholars Publications/ San Francisco Art Institute, 1994.

"For the Ordinary Artist, " "Questions of Quality," *Contexual Symposium: A Challenge to Institutions*,
 April 1990; in Carlos Villa, ed., *Worlds in Collision, Dialogues on Multicultural Art Issues*,
 International Scholars Publications/San Francisco Art Institute, 1994.

"Does Timelessness Count?," *San Francisco Art Institute Journal*, Fall-Winter 1990-91

"The Salon at Mission and Third," Report from California, *Art in America*, June 1994

"Things in Place," in *Table Tops: Morandi to Mapplethorpe*, California Center for the Arts
 Museum, Escondido, CA, 1997

"A Poke at the Fogbank," *Illustrious History 1871-Present*, San Francisco Art Institute, 1999

"Ceremonial Surfaces" in *Celebrating Modern Art: The Anderson Collection*, SFMoMA, 2000

"Viewing Time," Gallery talk for "The Measure of Time," University of California, Berkeley Art
 Museum & Pacific Film Archive, February 11, 2007

"Of Mildness or Authenticity: Notes on the 53th Venice Biennale," *artcritical.com*, June 2009

"The Visitor: Vermeer's Milkmaid at the Met*," artcritical.com*, November 2009

Conversations

"Fresh Air, with Robert Gluck," *SFAI Eye* (excerpts), 2005; *Jacket 29*, 2006

"In Conversation, with David Levi Strauss," *The Brooklyn Rail*, May 2006

"Questions of Taste, with Jarrett Earnest," *Talking Cure* 2, June 2010

"No One Who Knows Me or My Writing Will Believe It, with Renny Pritikin's Curatorial
 Writing Class," April 2010